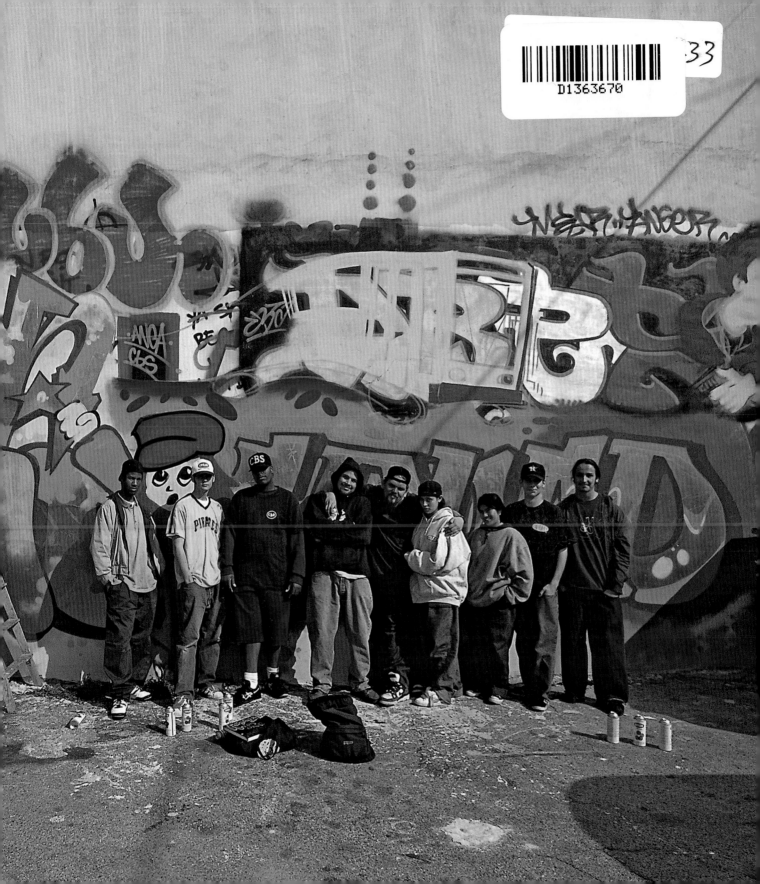

STREET STYLES AND ART
GRAFFITI L.A.

by Steve Grody

Abrams, New York

Foreword by James Prigoff

CONTENTS

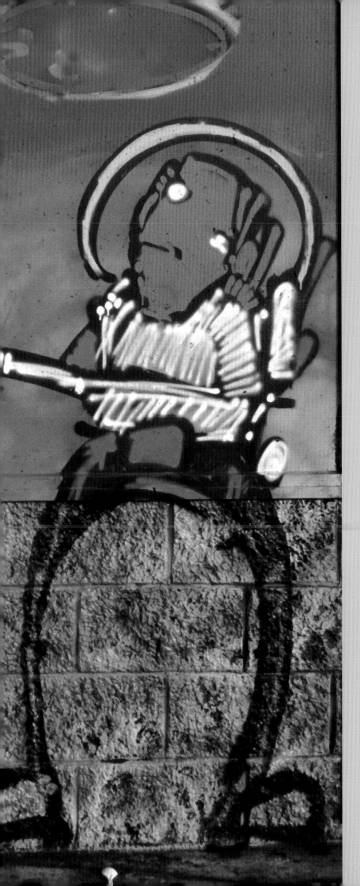

FOREWORD

James Prigoff, co-author of *Spraycan Art*

Major art shifts and trends are often harbingers of social change and political thinking. The Impressionist painters of France had to show "down the street" in the 1800s because their art wasn't really "art" in the sense of current art ideology. Most recently Pop Art and abstract artists of the 1950s and early 1960s struggled for acceptance in those years as art critics and buyers had to adjust their concept of what was considered important. Consider then another art form that was so totally different from mainstream art, since it had developed from scrawls on public walls to become highly controversial multicolor murals. Even more difficult for the art world to accept was the fact that this was the artistic creation of high school dropouts, not yet in their twenties.

To understand "graffiti" and the current "art of graffiti," now often referred to as spraycan art, it is important to understand that people have been painting and marking walls since the earliest of times. Cave dwellers drew pictures on their walls; graffiti was uncovered in Pompeii when the lava was chipped away; Spanish conquistadors left their names on Inscription Rock outside of Gallup, New Mexico; Frenchmen scratched their names on the walls of Angkor Wat in Cambodia; and a navy inspector in the 1940s named Jack Kilroy drew his famous logo "Kilroy Was Here" to indicate his completed inspection and a funny face appearing over the wall was co-opted by GIs all over the world. Graffiti and other forms of wall writing in the late twentieth century became an important method of inner-city communication.

Alienated urban youth, exposed to the ghetto life of New York City in the late 1960s, many with older relatives fighting a very unpopular war in Viet Nam, and also affected by the civil rights movement, were searching for an identity not found in the traditional educational system. Living in a star culture that appropriated public space with images of celebrities and products to buy, New York City youth began to write their "tags" on public space and later in the subways when they found they could send their names from the Bronx to Far Rockaway. It was a race to get one's name up as many times as possible.

Quantity was equated to peer fame; few worried about good calligraphy. It was only a matter of time that spraycans with their multiplicity of colors would become the paintbrush of choice, and the only art form ever developed by youth was on a roll. The outsides of subway cars became canvases for the more artistic and soon a rolling art gallery was traveling the subway lines of New York City.

Throughout the centuries, artists have signed their names at the bottoms of their canvases, but the new youth art became a celebration of a "tag" name exploded in large, stylized, colorful letters that filled the entire space. Artists relegated to subway surfaces,

Welcome to Los Angeles, **SINER**, Hollywood, 2005. Page 1: **CBS** crew, Melrose, 1993. Skate with arms around Anger and Blosm. Pages 2–5: **NASA** crew, Huntington Beach, 1992

exterior walls, and public handball courts, having no access to galleries until much later in the movement; artists without any formal art training or access to mainstream art channels, driven to be noted and respected despite the threat of fines and even jail, triumphed in their development of "graffic" expression. Their art influences were many, but significantly the hip-hop culture itself, the experiences of inner-city life, comic book characters both national and Japanese, and an innate sense of color and design.

Los Angeles had a history of *cholo* gang tags dating back to the 1930s. When images of colorful names and b-boy characters reached the city in the mid-1980s, the youth were ready to assume the role of "graffiti writers," influenced by what they saw coming from three thousand miles away, but early on ready to develop their own styles, shapes, and messages. No matter how artistic the early writers' "pieces" were, no matter their cultural and social statement, the youth creating them were lumped under one umbrella called "graffiti" and were generally considered a scourge to the establishment. In essence, war was declared by law enforcement on those who would sally forth in the dark of night to create their art and leave their mark.

Many have called them urban warriors where once others had called them high school dropouts. In *Graffiti L.A.,* Steve Grody undertakes to guide the reader through the streets of Los Angeles, perceptively examining the culture and at the same time gaining the confidence of the artists in order to get their stories in print, many for the very first time. The interviews in this book reveal many insights and details about "the fraternity of the streets," in this case called crews. As writers (as they prefer to be called) matured over the years, they developed understanding of motivation, influence, and the almost manic devotion they had to the art of the streets. In the beginning, writers painted just for fun. But as time went by, like the griots of another age and place they needed an audience to pass down the word. Steve becomes that bridge to tell the stories, document the art, and present an analysis of the growth and development of the art form.

Having said all of the above, I am mindful of the phrase I have heard through all my years of documentation . . ."show me the pictures" (and then show me more). Street art lasts from just hours to years, but mostly is very transient. Being there when the paint is barely dry and getting the picture "clean"—without any tags—was a lot easier twenty years ago when there were many less writers. Knowing where to go and when to be there is a challenge, particularly in a city as spread out as Los Angeles. This book has a wealth of detailed, sharp pictures from places both public and private. It is a remarkable record that traces the current art from its inception, helping the reader to see and understand far more than just the blazing color, carefully sprayed lines, and often the brain-twisting shapes that writers have mastered. Knowledge creates a whole new sense of viewing these young artists' pieces. Many of the writers who learned their craft in the streets have now been included in gallery shows and museum collections. Today, writers travel around the world showing up at jams such as the annual gathering held in Brighton, England. There they meet and paint with other writers from as far away as Japan and Australia, exchanging ideas, styles, and concepts with each other. Los Angeles is a major city center for graffiti art/spraycan art, and writers from every corner of the globe have passed through it, spraying their unique images on the walls, often working in close contact with the local talent.

In the early years, photos were exchanged by "snail mail" and style information was slow to make the rounds. Today, with the Internet, literally thousands of Web sites post images of daily activity. Hundreds of magazines circulate throughout the world, telling parts and pieces of the whole story. L.A. writers are an integral part of this whole dynamic. *Graffiti L.A.* is a visual feast and a learning experience, but most of all an intriguing insight into a facet of the world of graffiti and street art that will pop your eyes and stimulate your brain.

↓ **RELM** and **RIVAL**, Sanborn yard, 1991

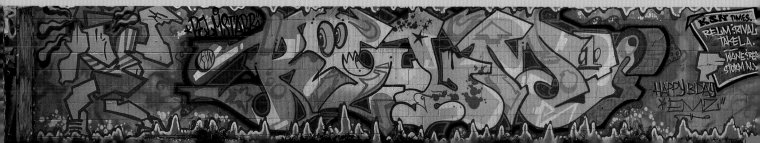

PREFACE

Steve Grody

Graffiti writing has been a part of the Los Angeles landscape since the early 1980s, and its early influence, *cholo* (gang) graffiti can be traced back to the 1930s. But until now, there has been no book solely devoted to the rich history of graffiti art in the city from its beginning to the present day. In addition to the longstanding tradition of *cholo* writing, whose distinctive letterforms are still used today, Los Angeles street artists from all walks of life draw from a unique confluence of cultures—including Latino, pan-Asian, African-American, Jewish, and Christian—that has led to regionally and personally distinctive styles, as seen in letterforms, characters, and thematic works. Along with the myriad styles these artists have created, they have also evolved world-class graphic skills now comparable to the best aerosol work anywhere. Los Angeles is home to one of the most visibly active graffiti communities in the world, and today is part of a larger, thriving art scene. Graffiti and street artists from around the world now come to Los Angeles to pay respect to and work with the artists here.

The vast majority of graffiti writers are extremely dedicated to their craft and to the preservation and growth of graffiti culture, but more and more of the general public has become passionate for the art form. Today there is not only general cultural interest, but, as graffiti is present in the worlds of advertising, design, fashion, and art, there has never been greater need to better understand its visual language. To that end, this book examines technical elements such as line quality, color palette, and graphic design. Though it is street art, graffiti is still a powerful graphic expression that uses the principles of visual media, albeit intuitively. Though some writers have had formal art-school training, each of these artists possesses technical prowess that deserves scholarly attention. Of course, there are also writers who are not interested in art-world status, but are attracted to the illegality of it all. The personal motivations of these writers for taking the physical and legal risks inherent in street art are also examined here, along with views on ethics within the graffiti community and relative to the public.

There are written and unwritten rules in the graffiti world that emphasize respect, passed down by the older generation of graffiti writers who act as mentors to the younger genera-tion. Deep social bonds are formed, built not only on friendship, but also as a means to protect the graffiti writers' way of life. Not surprising, many are highly guarded and very secretive, which is why the interviews in this book are integral in telling the history of Los Angeles graffiti.

In 1984, when I first saw spraycan graffiti murals start to appear in Los Angeles, I was immediately struck by the expressive creativity. When I later realized how fugitive these works were—mural pieces taking many hours to create, yet sometimes disappearing in a day—I became inspired to capture them on film, and that turned into an obsessive passion. Getting the images often involved venturing into unwelcoming territory and no small amount of difficult search. I also had to gain the trust of many graffiti writers who identified specific sites, which enabled me to photograph their extraordinary body of work over many years.

There are many versions of any history, particularly when it's a largely underground one, but I have tried to get the most broad and accurate story possible of the good, the bad, and the ugly from a variety of sources. I present the opinions of the writers inter-viewed. There is no universal view in L.A. graffiti culture, but rather a diverse range of opinions regarding everything from graffiti history, to who influenced whom, to technical terms, to what are acceptable or unacceptable locations for graffiti. Furthermore, I've had to leave out many worthy artists, owing to space limitations, and many grate-ful props (acknowledgments) made by the artists interviewed, who all credited their mentors, crew members, and other respected crews. In a subject as dense and informal as this, it is inevitable that I will get some details wrong, and I apologize in advance. Also, in this book, I emphasize the crews and writers that cover the gamut from tags to large-scale productions, and leave those primarily doing only tags or throw-ups, and gang-related taggers (tag-bangers) to other authors. As each artist is introduced, so are the crews with which he or she is associated. Finally, the dates listed in the captions for each photograph indicate when the picture was taken: the piece, with luck, may have been painted much earlier.

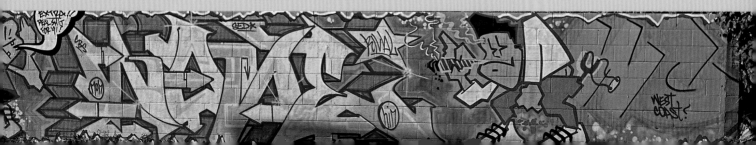

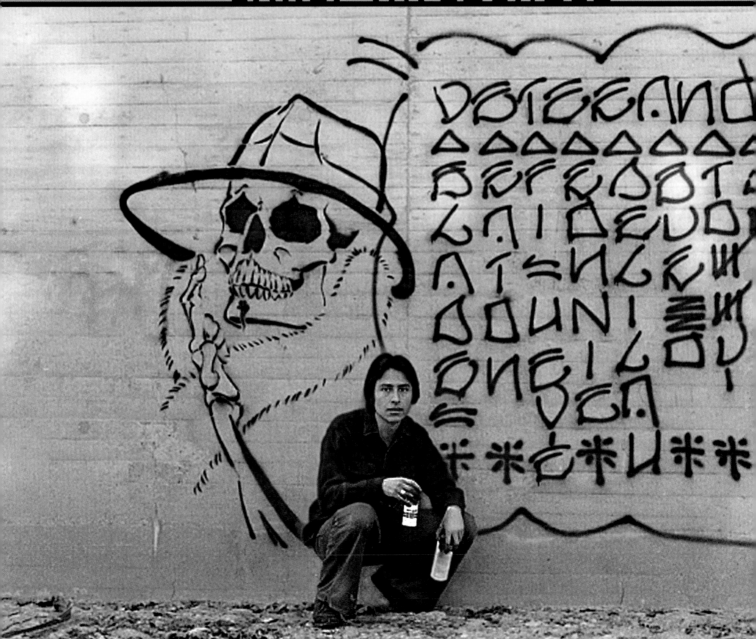

While graffiti may seem to be a contemporary issue, the aspects of human nature that have inspired it have been in existence since ancient times. Looking at the anthropological record, we find that long-buried ruins uncovered in desert regions include slanderous political writing on walls. Later, in the 1930s, photographer Helen Levitt documented children's sidewalk chalk graffiti. Graffiti on freight trains and train tracks ("hobo graffiti") has been documented as early as 1914. However, to say that graffiti has long been part of our history is not to deny the legitimate complaints about defacement of public and private property, but rather to try to put it in context.

There are many common misconceptions surrounding the modern graffiti movement. Though there are some who are only interested in tagging, there is a rather diverse range of graffiti work, and some of the most complex pieces are out of view to most citizens. Many graffiti writers even find much of what is in the public eye to be blight. And contrary to popular belief, graffiti was not born out of hip-hop culture, though the movement's influence is undeniable.

Hip-hop culture began to take shape in the 1970s. Its expression soon penetrated fashion, language, art, music, and dance, creating a lifestyle for its adherents. Though graffiti writing began to appear in Philadelphia as early as the 1960s, both it and hip-hop were made popular on the streets of New York. The earlier phenomenon, graffiti, became the visual art expression of hip-hop. In the early days, b-boying (break-dancing), MC-ing (rapping), and DJ-ing (scratching and beats) were all a part of the same scene. At parties, a performer could be seen break-dancing at one moment then writing graffiti the next. In Los Angeles, many of the earliest writers were introduced to graffiti through b-boying. Although graffiti and hip-hop were separately formed entities, hip-hop helped bring graffiti writing to the mainstream.

To understand how graffiti evolved in Los Angeles, however, one must look further into the city's history. Long before hip-hop, *placas* (plaques), the calligraphic writing of one's *barrio* (neighborhood), or gang, had been established; it can be traced back to as early as the 1930s, when brushes were used before the invention of spray paint. While this style of graffiti is strongly associated with East L.A. (east of the Los Angeles River), it can be seen in many areas around the city today, particularly in predominantly blue-collar Latino communities. *Placas* are used as declarations of territory and loyalty that emphasize the Neighborhood name first, followed by a "roll call" of gang members. Writing one's individual name alone was rare in this style, which was written either in Blackletter, though generally referred to as "Old English," or creatively angular derivations, emphasizing upper-case letters to convey prestige and serious intent. Variations of this *cholo* style, including Gang block, sometimes done with three-dimensional edging, were seen around the city from the 1930s to the present day. Though no distinction may be made between gangs and graffiti crews in the public's mind, there is actually quite a bit of difference. Most graffiti writers limit illegal activities to painting. By contrast, gangs involve a much wider variety of crime and violence. Despite this, gang writing has made perhaps the greatest impact on L.A. graffiti style, both in its letterforms and in the addition of roll calls to pieces, which are used almost universally by all graffiti crews today.

It is safe to say that the current graffiti movement would have developed in Los Angeles with or without its gang writing predecessor of the 1930s. Hip-hop brought graffiti to the masses, but other youth Pop movements already present in Los Angeles from the 1970s to the 1980s also contributed to L.A. graffiti's development, including the punk and heavy-metal music scenes. Graffiti writers emerged from many different spheres of youth culture.

A participant described the early 1980s scene: There was this weird private communication for teenage kids, and the whole world of adults, parents, and teachers outside of that didn't mean anything. Our whole concern was just who was doing graffiti and the rumors surrounding them. It was basically like Misfit Island . . . weird young kids who, for whatever reason, weren't happy with what was going on in their lives and felt they wanted to create this alter ego. So they chose or were given a nickname and started spray painting around town, got hooked on it, and got attention from it. And as we get older, we realize the vanity of it and how ridiculous it is and stop . . . or don't. If you're getting more attention or excitement out of being "Miner" than David, then that character takes over. Not only were we practicing writing our names, we had to get good grades, not get arrested, not get beat up on the way to school because we weren't getting dropped off by our parents.

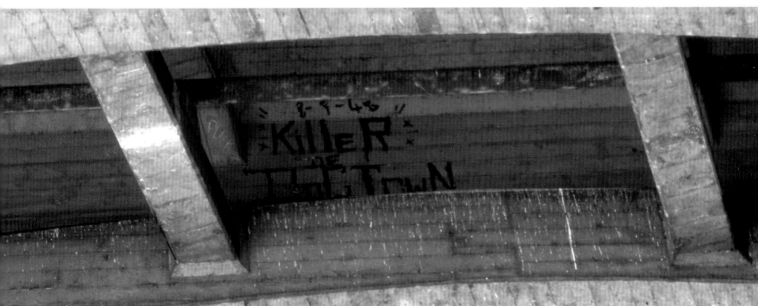

↖ Neighborhood hand styles, **PRIME** ↑↑ Avenue 43 *placa*, Highland Park ↑ *Killer de Dog Town*, 1948. Tar applied with a brush. Preceding page: **CHAZ**, Arroyo Seco, 1975

LOS ANGELES STARTS UP

Graffiti writing had been developing in New York City throughout the 1970s, so when it hit the West Coast in the early 1980s, it didn't take long for Los Angeles artists to begin experimenting with the full range of writing. By around 1984, four main modes of graffiti had emerged: tags, throws-ups, pieces, and productions.

Tags, the calligraphic writing of one's name, were the first form of graffiti to appear around the city. Written with markers or spray paint, there is generally no outline involved in the letterforms. Risk of WCA crew lists the tagger's markers of choice: "The mini-wide was half a Uni [a wide brand of marker]. And the Uni and Ultra were the same thing, about a three-inch-wide marker, both with chisel tips. Marsh brand ink was highly sought after for standard and home-made markers." A tag is either self-given or on occasion bestowed. The fewer the syllables the better appears to be the rule. The tagger may write only his or her name, only the crew name, or both. While some writers are in only one crew, many are members of several crews. Some go for cleanly written tags, some for "drippers," tags with deliberate drips.

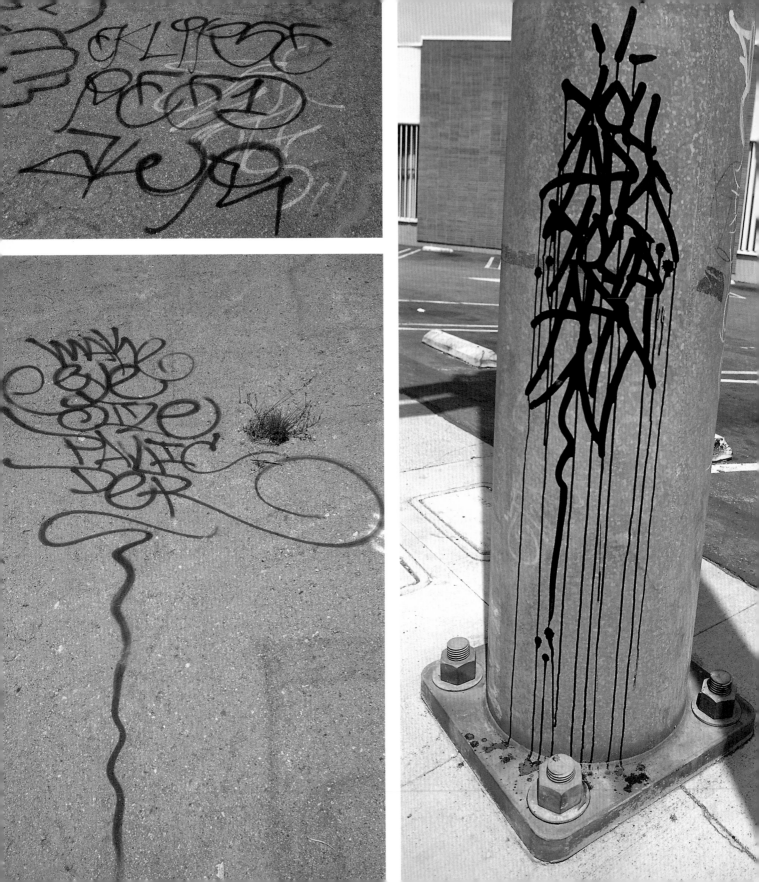

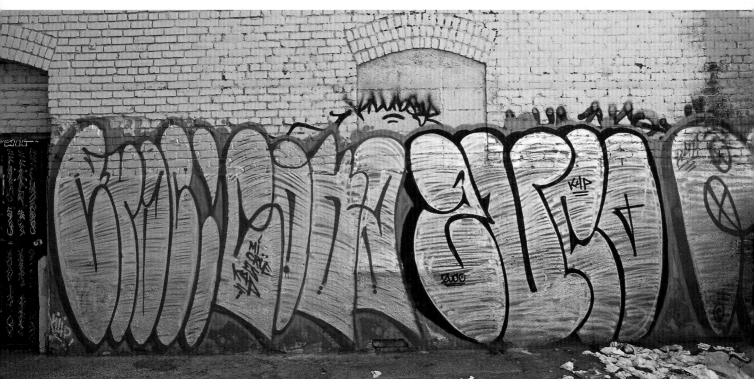

↖↖ **AWR**, Motor yard, 1993 ←← **STN/SH**, L.A. River, 2005 ↖ *You Are Your Art*, **KR**, Artist District, 2006 ↑↑ **RF/UTI/TPS**, Mid-city, 2006 ↑ **K4P** crew, Downtown, 2006. Previous page: **2SHAE** and **PLEK**, Artist District, 1996

Throw-ups emerged shortly after tagging. Named because they are quickly thrown up onto a surface, throw-ups generally consist of simple letter outlines done quickly, possibly with a single stroke, and filled in with a single color. They may be done in a variety of styles, but are most commonly done in "bubble style," named for the use of rounded forms. Block letter outlines done in spray paint, or solid letters done with house-painting rollers, or "block-busters," are also included in this category. Images of faces and figures may also be done in the manner of throw-ups.

As styles became more sophisticated, "pieces" began appearing. Short for "masterpieces," pieces are more elaborate efforts that involve highly personalized and modified letterforms (the term is now generally used to describe anything that takes more work than a throw-up). Pieces may take anywhere from an hour to weeks to complete. A piece might be done using relatively straight letters as well as "wildstyle." "Wildstyle," originally developed by the early New York subway writers, was the term used to describe the creative manipulation and abstraction of letterforms. While any graffiti muralist acknowledges the history, the term wildstyle is rarely used now.

As graffiti writers became more organized and crews started to form, production work soon followed. If a writer, or more likely a crew, creates a series of pieces, or a collaborative piece, tied together with a background, it's referred to as a "production." A crew might primarily consist of taggers and bombers (those doing illegal throw-ups), or be focused more on painting pieces. Commonly, crews do tags, throw-ups, and pieces, each according to location and how much time may be available.

Glass scribing and acid bath tagging on glass were used as alternative media when it became illegal for anyone under the age of eighteen to possess spray paint in public. Tagged stickers ("Hello, my name is . . .") first began to appear on buses along with marker tags. A little later, "slaptags," (mass-printed stickers with an image or name) joined the activity. These media became popular because they could be applied to a surface in an instant. To a lesser degree, because they take a bit more time and space, stencils and posters applied with wheat paste have also become a part of the graffiti scene.

Personal tags, throw-ups, or pieces may be anywhere, in contrast to gang markings, which usually stay within a specific turf. For that matter, it's a goal of many writers to be "all-city," that is, up in as many areas as possible.

Ironically, gangs are generally considered a bane to piecers, who complain as bitterly as any business owner about the dismal lack of respect that is exhibited when their pieces and productions get tagged or dissed (defaced by tags, throw-ups, or cross-out lines) by gangs, random taggers, or rivals.

ANGER (CBS CREW): The person who creates the tag, creates the mural, creates what is beautiful about graffiti, what brand-name companies want, to be part of the streets—that hip-hop urban image. That still comes from the tag. Before the piece was the throw-up, before that the tag, before that were gang tags, and before that hobo writing.

WISE (KSN AND AWR CREWS): Pieces would not exist were it not for the tags and throw-ups preceding. Graffiti doesn't follow a hip-hop path anymore. In the early days it was connected; now the argument is that it was an add-on. In the early eighties you wouldn't have done graff without knowing about hip-hop.

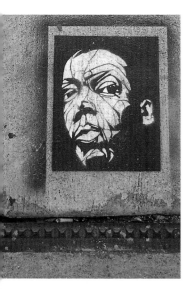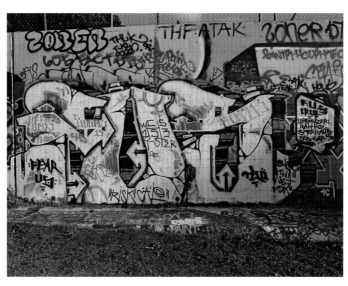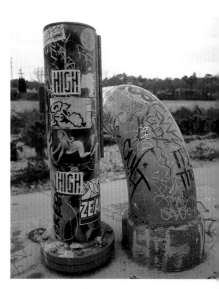

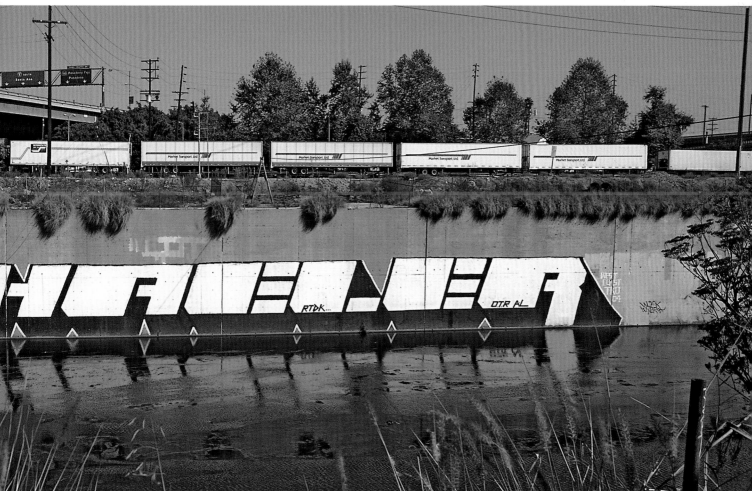

←← **FATE**, Soto yard, 2005, app. 7' tall ↖↖ Sidewalk stencil, Artist District, 2005 ↑↑ Gang tags written over piece by FUS, Belmont, 1991 ↗↗ Mixed media, L.A. River, 2006 ↑ **HAELER**, L.A. River, 2004

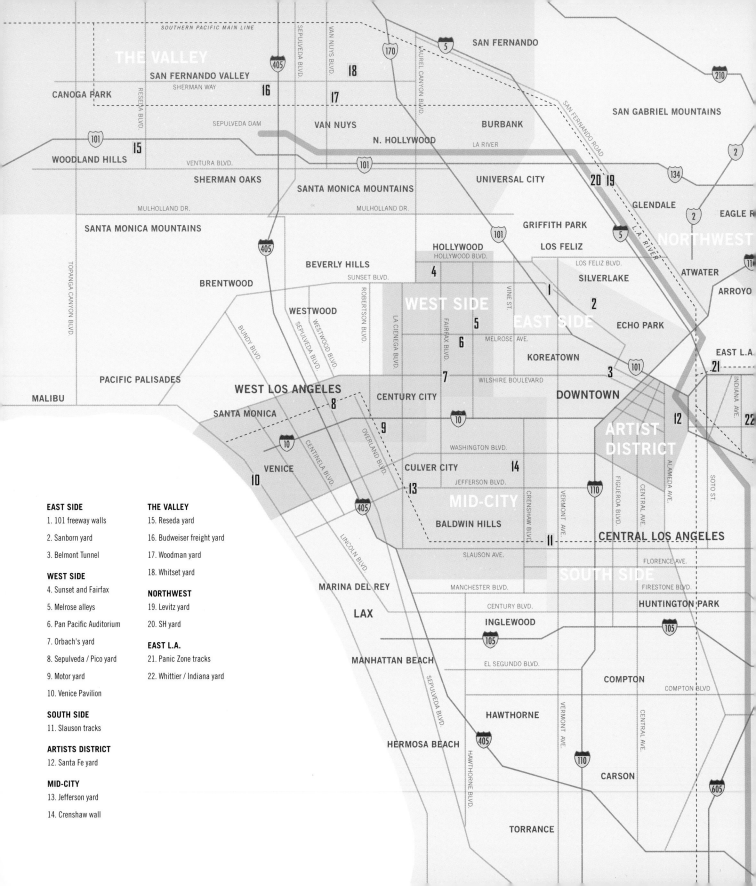

THE VALLEY

SOUTHERN PACIFIC MAIN LINE

SAN FERNANDO

SAN FERNANDO VALLEY

CANOGA PARK

SHERMAN WAY

18

16

17

SAN GABRIEL MOUNTAINS

VAN NUYS

BURBANK

SEPULVEDA DAM

WOODLAND HILLS

15

N. HOLLYWOOD

LA RIVER

UNIVERSAL CITY

VENTURA BLVD.

SHERMAN OAKS

SANTA MONICA MOUNTAINS

20 19

GLENDALE

MULHOLLAND DR.

MULHOLLAND DR.

NORTHWEST

SANTA MONICA MOUNTAINS

GRIFFITH PARK

ATWATER

EAGLE R

HOLLYWOOD

LOS FELIZ

ARROYO

BEVERLY HILLS

HOLLYWOOD BLVD.

4

LOS FELIZ BLVD.

BRENTWOOD

SUNSET BLVD.

WEST SIDE

SILVERLAKE

VINE ST.

WESTWOOD

1

EAST L.A.

5

2

EAST SIDE

ECHO PARK

6

MELROSE AVE.

KOREATOWN

21

PACIFIC PALISADES

7

WILSHIRE BOULEVARD

3

101

22

WEST LOS ANGELES

CENTURY CITY

DOWNTOWN

MALIBU

8

ARTIST
DISTRICT

12

SANTA MONICA

9

10

VENICE

WASHINGTON BLVD.

CULVER CITY

14

10

13

JEFFERSON BLVD.

MID-CITY

BALDWIN HILLS

CENTRAL LOS ANGELES

11

SLAUSON AVE.

SOUTH SIDE

FLORENCE AVE.

MARINA DEL REY

MANCHESTER BLVD.

FIRESTONE BLVD.

LAX

HUNTINGTON PARK

CENTURY BLVD.

INGLEWOOD

MANHATTAN BEACH

EL SEGUNDO BLVD.

COMPTON

COMPTON BLVD.

HAWTHORNE

HERMOSA BEACH

CARSON

TORRANCE

EAST SIDE
1. 101 freeway walls
2. Sanborn yard
3. Belmont Tunnel

WEST SIDE
4. Sunset and Fairfax
5. Melrose alleys
6. Pan Pacific Auditorium
7. Orbach's yard
8. Sepulveda / Pico yard
9. Motor yard
10. Venice Pavilion

SOUTH SIDE
11. Slauson tracks

ARTISTS DISTRICT
12. Santa Fe yard

MID-CITY
13. Jefferson yard
14. Crenshaw wall

THE VALLEY
15. Reseda yard
16. Budweiser freight yard
17. Woodman yard
18. Whitset yard

NORTHWEST
19. Levitz yard
20. SH yard

EAST L.A.
21. Panic Zone tracks
22. Whittier / Indiana yard

TOOMER (TKO CREW): Nothing beats bombing. I'd rather do throw-ups across this whole block. Bombing is the heart of graffiti. I can't tell you how many times someone comes up to me while I'm working on a production wall and tells me how much they like what I'm doing but how much they hate the graffiti scrawls down the street, and my response is always the same: If it wasn't for those chicken scratches on the wall, you would never get to this. You don't just buy a gigantic piece of paper and practice in your backyard.

AROUND THE CITY

Los Angeles is a city of great diversity. Residents take pride in their neighborhoods, each of which represents different aspects of the city's demographics. Not surprising, this aspect became a part of graffiti culture and different styles of graffiti began to emerge in various neighborhoods across the city.

The geographical boundaries of the East Side and West Side, as defined by L.A. writers, have little to do with how average residents of Los Angeles distinguish the two areas. To L.A. writers, the West Side begins at the beach areas of Santa Monica and Venice, with the eastern border somewhere between La Brea Avenue and Western Avenue, which most Angelenos simply consider part of Hollywood. The East Side starts at a vague border of the West and continues on to the L.A. River. This includes what most residents consider the east half of Hollywood—Pico-Union, Echo Park, and Westlake just east of downtown where Belmont High School and Belmont Tunnel, a center of East Side activity, are located. East Los Angeles proper is east of the river, but most of the writers who consider themselves East Side grew up west of the river. Major *yards*, open areas where walls were painted (legally, quasi-legally, and illegally), were classed accordingly: Pan Pacific Auditorium in Hollywood was on the West Side and the Belmont Tunnel near downtown was on the East Side, even though they are situated barely five miles apart. MC Force, the only crew that was formed in East Los Angeles proper, disappeared sometime after 1986. However, many crews actively paint in East Los Angeles. Regardless of the initial start of activity where people connected or concentrated, writers quickly started to travel as word spread around the yards. Though a crew may have started in one area, they may maintain a close social bond with crews in other areas, and a number of crews have members around the city, so they do not consider themselves as being either East or West Side, just an L.A.-based crew. And though any crew member takes particular pride in his crew, most writers cite artists from many crews as personal inspirations.

It is generally believed that tagging and piecing activity began in Los Angeles around 1983, and was mostly done by individuals not associated with a crew. The only brief exception, Artists In Style, proved to be short-lived and had little influence as a crew, although many of the individual artists went on to become widely respected in other crews. Within a year, individual crews began to crop up, most of whom were unaware of the formation of other groups until they began to run into each other at the yards. And by 1985, the number of crews in Los Angeles had multiplied. Some of the most influential ones formed at that time are still active today.

Map of Los Angeles with areas of graffiti activity defined by graffiti writers

MEDIA EXPOSURE

During this time, the release of several important books and films aided in the wider dissemination of graffiti culture. *Subway Art,* the seminal book by Martha Cooper and Henry Chalfant was published in 1984, but was not easily available for some years and was therefore a prized possession. In that same year, PBS aired *Style Wars,* a documentary on New York's graffiti movement. And the movies *Beat Street* and *Breakin',* fictional accounts of hip-hop-graffiti culture, were released, reaching even wider audiences. *Spraycan Art* by Henry Chalfant and James Prigoff was published in 1987. That book and and *Subway Art,* both of which are still in print, have now become invaluable resources for young writers. *Can Control,* originally the *Ghetto Art Newsletter,* became the first L.A.-based graffiti publication in 1988. *Bigtime* was published intermittently from 1996 until 2001 and became one of the first DIY magazines to print in full color. And locally, the documentary *Bombing L.A.* was released in 1988. But much of the recounting of this history is less than precise. Young writers at the time were unaware that this youth-originated art movement would have such an impact. For those same reasons, good early photographs are sparse. Many young writers either didn't have easy access to cameras, felt film and processing were beyond their usual means, or didn't think beyond getting up.

BIG 5: I was a breaker, then became a skater—vandalizing everything with "skater guy" and "skate and destroy." In 1985–86, some older guys were handing down to me bubble sketches to emulate, but then I saw *Subway Art* and that was it for me.

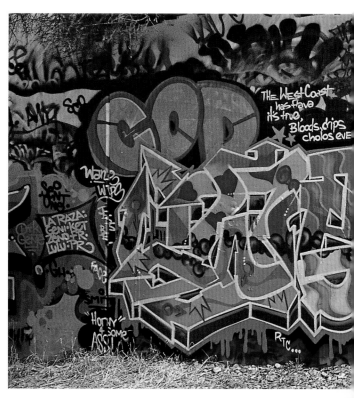

THE NEW YORK CONNECTION

For those with access, graffiti books and films were great sources of inspiration, though in practice, learning the craft was typically done in trial-and-error fashion. But as New York began to clean up subway graffiti, its writers started to travel. Some of these now-legendary pioneers visited Los Angeles to paint and work with emerging writers there. And who better to learn graffiti from than the very creators of the craft.

SINER (LTS CREW): The New York writer Soon was around our Mid-city neighborhood and influenced us. He also taught Risk and Rival of West Coast Artists crew. LTS was very New York at first and I like to acknowledge that because that's where everything originates from and mad respect is due to those pioneers. Kase 2, in *Style Wars,* talked about "computer rock," and flipping his style . . . just the way he spoke about his styles was the way I wanted to flip my shit. And Dondi was always coming up with different styles, as well as Vulcan and many writers from out there.

BABA (MSK CREW): I was very influenced by Zephyr [an early New York train writer featured in the PBS documentary *Style Wars*], who was out in L.A. a lot. Soon was extremely important on the West Side. If it wasn't for Soon, Pan Pacific wouldn't have been what it was.

TELER (STN AND UCA CREWS): EO came from New York—that's who first taught me the technical vocabulary, even though he had only written for a couple of years.

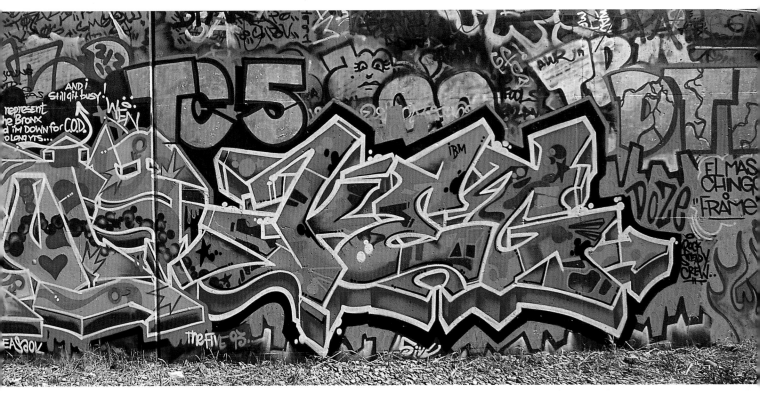

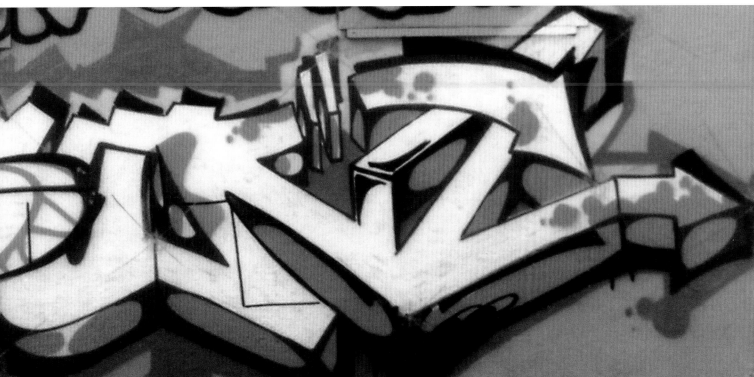

↑↑ New York heavies, **WEN** (COD crew) and **DOZE** (RSC crew), Motor yard, 1991 ↑ **SOON**, Pan Pacific, 1984–85

THE EAST SIDE

Within a short amount of time, many writers and crews had begun to emerge on the East Side. LABS (Los Angeles Bomb Squad), formed in 1984, was the first crew that many kids around the city became aware of. They were followed by K2S (Kill to Succeed), STN (Second to None), DV (Double Vision), KGB (Kids Gone Bad), OTR (On The Run), MAK (Modern Art Kids), and UCA (Under Cover Artists). But at the forefront of the East Side graffiti movement, writer Rick One, aka Crime, became the first major influence in the development of East Side style, using thick gang-block influenced letters with sharp edges. Crime also became the first known L.A. writer to street bomb, doing full pieces illegally on street walls with such referential slogans as "A Quickie by Rickie," "A Fast One by Rick One," and "On the Run" written next to a running stickman.

RICK/CRIME: We were all poor kids in the city. We were using oil paint, engine paint, and floor paint. Hairspray was even used to create a glossy effect on pieces. We did all these little experiments because we didn't know any better. We didn't know that there were spraycan tips, so we used stock tips, and got our paint from Chief Auto Parts.

RICK/CRIME: When I saw *Dreams Don't Die*, I thought, "Wow! That's exactly what I want to do!" In late 1983 the movie *Body Rock* was in production and being a breaker, I was an extra. Ozrock was a New York breaker and one of the panels that he spray painted in the background said "Rock." If we saw it now we would consider it very simple, but at the time when I saw it, I was a kid maybe fifteen, sixteen years old and my eyes just went, "Boom! What is that!" To me it was gold. Also in 1983, the New York City breakers came to battle the L.A. branch of Rock Steady Crew, and they wrote on the walls and I saw it . . . they just did throw-ups and outlines—I remember seeing one that said "Brown Sugar" and one that said "Dave" and those are my first recollections of New York graff. '85 is when we started seeing a lot more names, and crews becoming a trend. You started seeing different color spraycan writing (red, green, purple, true blue) replacing gang writing in the streets. In '85, we came across other writers at Pan Pacific, Reynaldo's, Belmont, Radiotron, and the MacArthur Park bandshell where Zender, Geo, Krenz, and Ozrock did significant pieces. But we started to go outside of the Belmont yard because there was starting to be too much gang activity.

By the mid-1980s, territorial disputes began to break out among writers and crews over various areas on the East Side, particularly over the Belmont Tunnel. LABS, K2S, and DV—the first crews to paint at Belmont—claimed ownership of the area by closely monitoring anyone who wished to paint there. Prime demanded that writers ask for permission and show sketches of their work before painting on the walls.

Not only was animosity beginning to penetrate the East Side, but conflicts with neighborhood gangs was becoming an issue. By 1986, a number of gang members began to cross over into nongang graffiti crews, lured by the less violent, less constrained, but more expressive lifestyle. These desertions threatened East Side gangs, who occasionally reacted with violence. As a result, graffiti activities were severely curtailed on the East Side. Some writers traveled to the newly active West Side yard, Motor and National (often referred to as "Motor yard"), to find a place to paint in relative peace.

VOX (CBS, WGS, AND W24/7): That tag-banging thing screwed up a lot of things; a lot of people didn't have the skills or balls to go out and do good graffiti and represent, so the way they got it was beating up or shooting people.

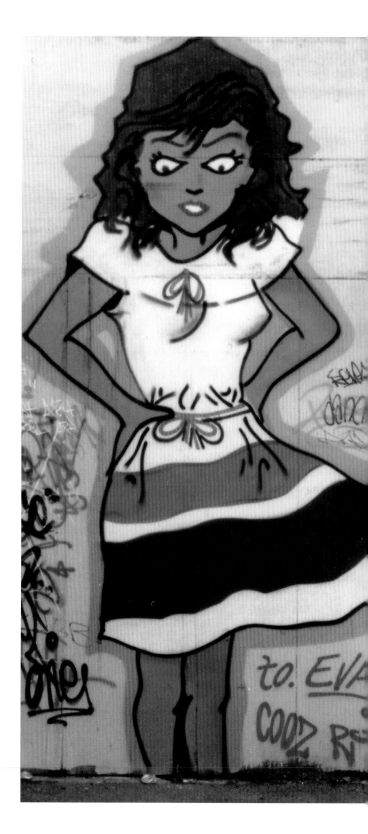

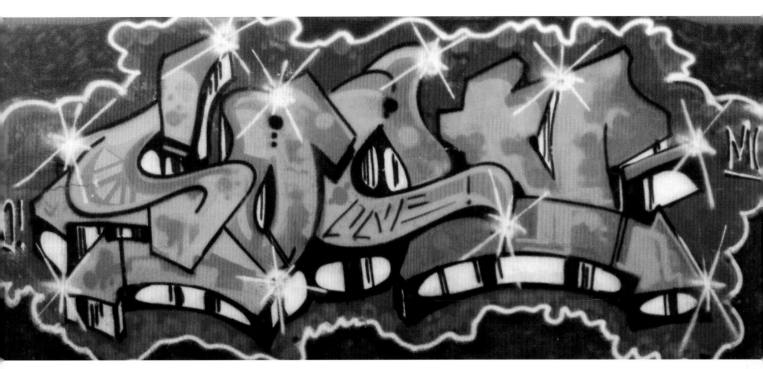

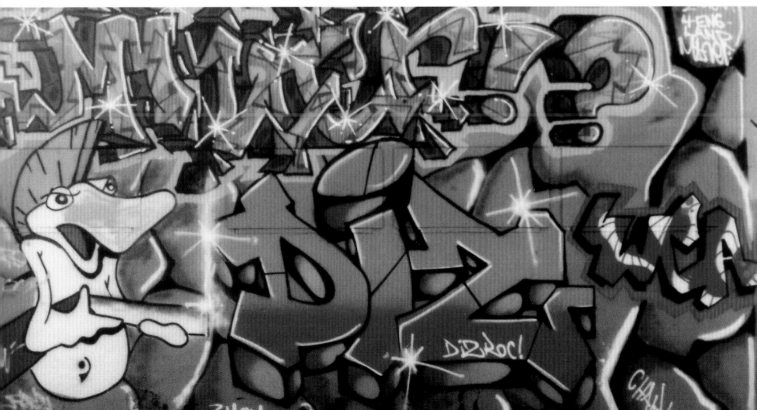

↖ **COOZ** and **RISK**, Pan Pacific 1984–85 ↑↑ **SOON**, Pan Pacific, 1984–85 ↑ **MINER** and **DIZ**, Pan Pacific 1984–85

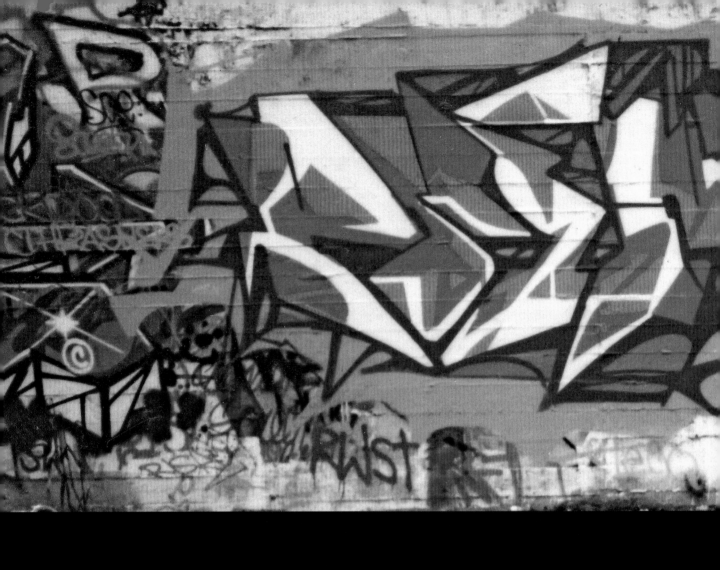

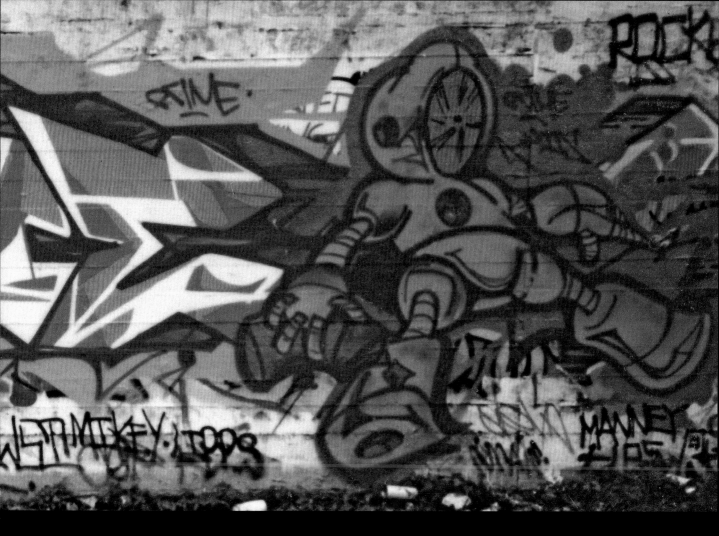

THE BATTLE

In a graffiti "battle" two writers or crews paint at the same location and are judged by other writers based on skill, style, and creativity. In most cases, battles are played out of friendly rivalry rather than real animosity, but battles can also help resolve differences of opinion without violence.

As more and more crews ran into each other at the yards, it was inevitable that competition began to form. In 1986 Crime's East-Side crew, K2S, met the West Side's West Coast Artists (WCA) crew, challenging each other to one of the first graffiti battles to take place in Los Angeles.

Prime, Defer, Skept, Sine, and Carlos Cartoon painted for K2S and a full contingent of writers represented WCA. KS2's Prime was considered the winner. WCA kept within the New York style of graff, while Prime did things no one had ever seen before, with unusual color patches, cuts, and arrows. He created a geometrically based L.A. style entirely different from New York style, using gang block devices such as backward or upside-down letters and thick letterforms. Prime also added the A.F.C. Blinky character from the *Bucky O'Hare* comic, even though he had never attempted to paint a character before.

←← **HEX TGO**, Hex/Slick battle at Levitz walls, 1990, which was televised on Fox network, giving early national exposure to L.A. graffiti. Photo courtesy of James Prigoff ← **SLICK**, Slick/Hex TGO battle, Levitz walls, 1990. Photo courtesy of James Prigoff ↑↑ **PRIME**, Belmont, 1985

THE WEST SIDE

The West Side was a breeding ground for the development of a number of graffiti styles, but they were initially most commonly associated with the New York style, which consisted of more rounded letterforms, a contrast to the thick, blocky, and sharp-edged forms of the East Side. Many crews emerged on the West Side, including West Coast Artists, who rose to early prominence. Though viewed by their Eastern counterparts as "rich kids," some of WCA's members had the distinct advantage of having artist and professional parents, who were able to teach them about canvas, paint, and media.

RISK: In the early 1980s I was into art, but I was a hoodlum, so graff was perfect for me. As I got into it, I would drive into the city searching for graff because I knew of New York graff and we had break-dancing here, but I didn't see any around. I thought maybe it's downtown because that looks more like New York, but it was just desolate. Then at Radiotron I found things, and the cool stuff was by Soon. I started to track him down through the city by following the concentration of tags, then throw-ups, then pieces, and finally I came across Venice Boulevard and realized he's got to be around here because there was tons of stuff. I found Dead Man's Alley where he painted during the day because every single garage door was done. I finally met up with him and started painting with him and his crew, YL (Young Lords).

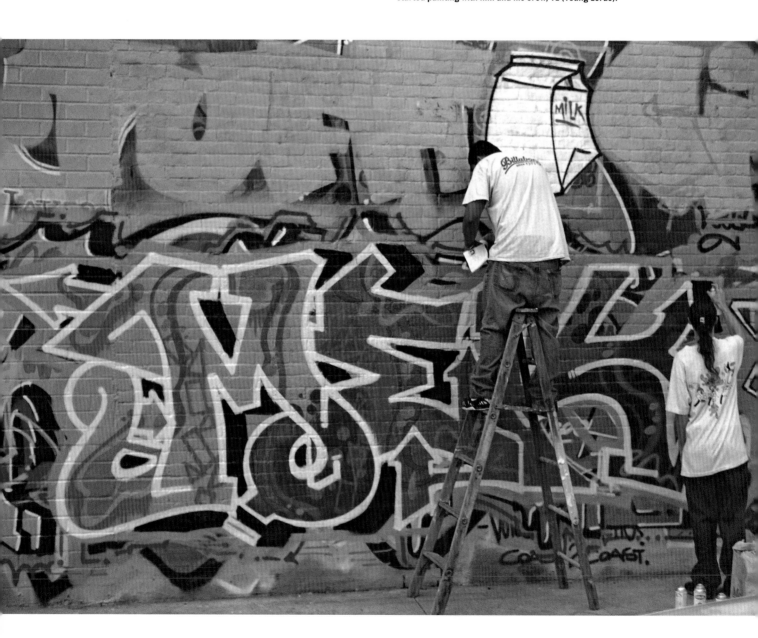

A short time later, Risk joined with writers Rival, Pjay, Miner, and Cooz to form WCA (West Coast Artists), a crew that became both close friends and rivals with KSN (Kings Stop at Nothing). In 1984 KSN founders Grave and Rev saw an article on graffiti in *High Times*, and with the inspiration that provided, they started "getting up" at Pan Pacific auditorium where they would meet future KSN writers Grem, Wise, Plex, and Krush.

GRAVE: We [KSN] were in between WCA and K2S stylistically. I always loved K2S the most because they kept L.A. style, as did LTS. KSN did more original stuff than WCA, who was very "New York," because KSN were punk rockers. KSN was, for a time, doing the nicest productions . . . *the* crew. West Coast was good but still tagging and bombing, while KSN focused on productions.

KRUSH ONE: WCA and KSN developed independently and had friendly influence and rivalry. Risk and Rise's rivalry of friends pushed everybody to be better. 1986–88 was a great period.

A number of other crews formed on the West Side made a significant impact, including CBS (Can't Be Stopped), still one of the most active crews today. They formed in 1984 at Hollywood High School, with Hex, Theory, Frost, and Demo, who was from New York and helped spread the word of graffiti's burgeoning scene. When Hex, Mosh, and Volt moved on to help start LOD (Loks On Dope) in 1988, Hex handed the reins of CBS to a newcomer named Skate who went on to be a major graffiti fatherfigure to many high-visibility writers. Skate brought up a very active new generation of CBS that included the present

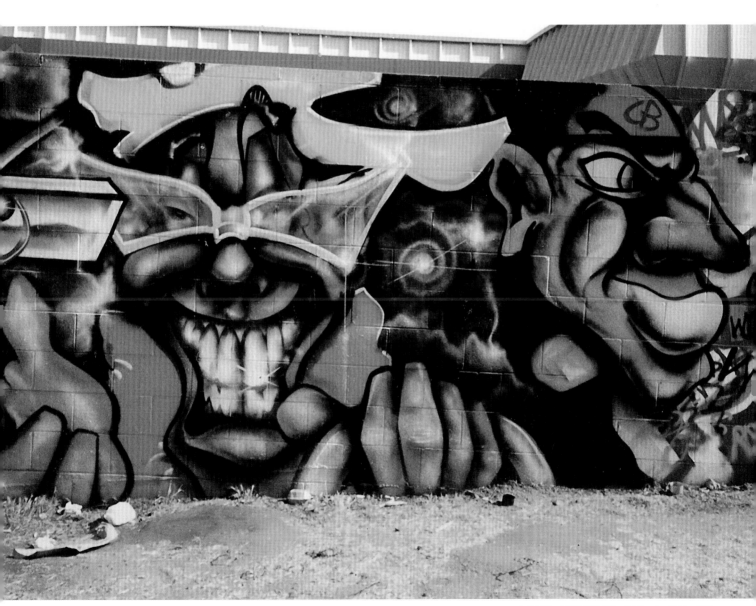

↖ **MEK** on ground, Tough City Squad member on ladder, Melrose, 1993 ↑ **REV** and **COOL BOY**, KSN yard at Sunset and Fairfax, 1987

leader, Anger. CBS had a close friendship with TCS (Tough City Squad), another Hollywood-based crew, and it was common for them to collaborate on walls.

Another crew to start around this time (1986–87) was USC (UnStoppable Criminals) with members in West L.A. and San Fernando in the North Valley. An offshoot of WCA, BC (Burning the Competition) was formed in 1987 by Wisk. Primarily a bus-tagging crew, the group's acronym also stood for Blue Crew, for the blue buses that ran to Santa Monica. However, some members, particularly Dye5, Clae, and Ash became strong piece artists.

Of all the L.A. crews that have achieved international respect for their depth of talent, influence, and far-reaching representation, AWR (All Writes Reserved) is widely regarded as one at the top of the heap. Founded in 1988 at Culver High School by Eklips One, AWR was one of the few crews during the 1980s and early 1990s to travel widely from Calabasas to Orange County, southeast of Los Angeles. AWR formed a highly creative association with MSK (Mad Society Kings) in 1989. MSK was formed by Baba, a close friend of Eklips, and an important figure in a number of seminal L.A. crews.

The relationship between KSN and MSK became so close that "MSKSN," was often written on pieces. MSK became a stepping stone for AWR. Many younger unproven writers had to join stepping-stone crews to earn the privilege of being in a more respected crew.

BABA: I was in STN and then got into KSN and we were always anti-West Coast, so I went to Motor yard one day and dissed a bunch of West Coast stuff just after getting into KSN. This was before I understood that the KSN/WCA battles were friendly. Rise was furious with me and I almost got court for it. Eklips was spending a lot of time with me and the KSNs had already formed AWR, but they hadn't established themselves as the world-respected crew they were to become. I was angry at the society I was in and it reminded me of a British band, Mad Society, so I started Mad Society Kings right then and there. I moved to New York and when I came back, Eklips had built MSK up to maybe thirty kids, so I would never take credit for turning MSK into what it is; it was strictly Eklips and the crew.

SOUTH CENTRAL

Los Angeles's South Central neighborhood, often portrayed in the media, is a lower-income area located south of downtown Los Angeles, with a heavy gang presence. It is widely considered to be one of the roughest places in the city to grow up in.

Formed in 1986 by writers Skill and Snap, UTI (Under The Influence) were originally known as bus mobbers, who tagged single buses as a group, and landmark writers, who got up in obscure or difficult-to-get-to spots so the pieces would stay up longer. But between 1987–89, UTI became a full-blown piecing crew active in the San Fernando Valley and South Los Angeles. By 1992, the crew widened their presence through their involvement in hip-hop related events (film, music, magazines) and with Hex TGO's and Omega's The Hip-Hop Shop, one of the first graffiti supply stores. These ventures allowed the crew to segue their underground painting activity into a legitimate and profitable aboveground endeavor. TKO (TaKingOver) was founded in 1988 by Toomer, Primal, and Mae 2 at "Homicide Park," the nickname for the rough South Central area. TKO has become a strong presence, both by bombing and by finding property owners willing to let their exterior walls be used as legal sites for painting, or permission walls. A number of their members

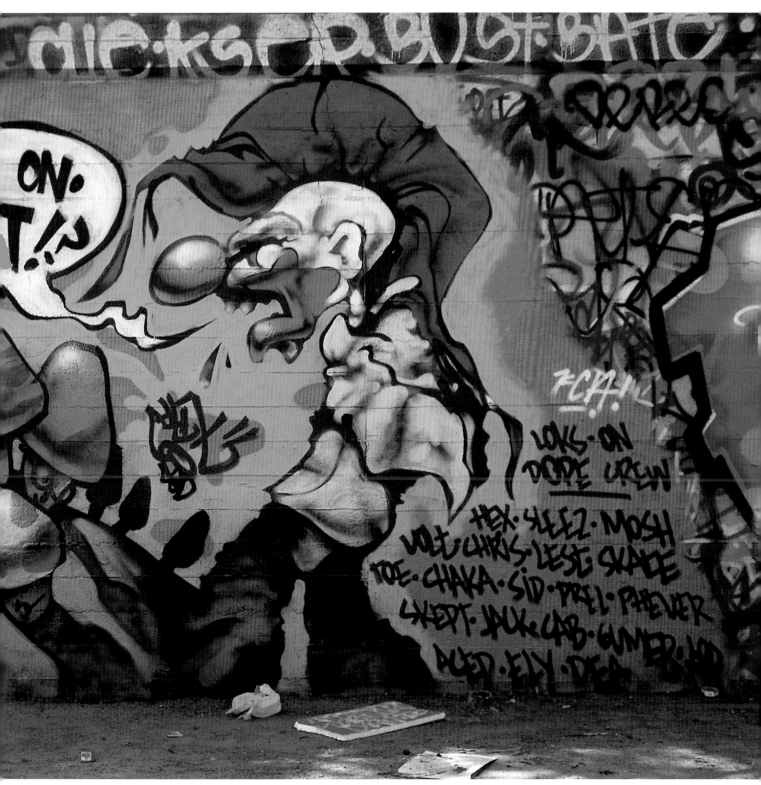

HEX LOD, Belmont, 1991

are known for being particularly adept at interpreting Blackletter fonts in wildstyle piecing. Other prominent neighborhood crews include K4P (Kill For Pride), founded in 1988–89; RTN (Rocking The Nation), formed in 1989 with a focus on piecing; COI (Cause of Insanity), founded in 1989 by Sacred and based in Southgate; and GAW (Ghetto Art Warriors), formed around 1992.

A number of walls along the railroad tracks running west along Slauson Avenue became important permission walls, being one of the few places where writers could paint in public in peace without worrying about gangs or police, or by a particular crew who controlled the yard.

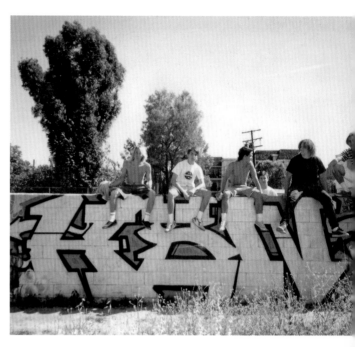

MID-CITY

Communities located north and south of the 10 freeway, between the 405 freeway to the west and the 110 freeway to the east, are in the Mid-city district, which consists of both middle-class and lower-income neighborhoods. The rougher neighborhoods have a strong presence of gangs, predominantly Bloods, but also Crips, which is why the Baldwin Hills community was nicknamed "The Jungle" by those who lived there, including writers of UCA (Under Cover Artists), founded by Chase in 1985–86. Many Mid-city kids were pressured into joining gangs, while others had to find something else to do that would not present a threat to the gangs.

SINER: LTS (Last to Serve) formed from those in the Mid-city neighborhood inter-ested in either piecing or catching tags. Mark7 was the leader of a crew nearby, and my older brother, Sane, met up and formed LTS in early 1987. The RTA (Rapid Transit Artists) yard started in early 1985 near Jefferson and La Cienega. Back in the day, most of the main crews had a yard where they could go paint, and that was like my playground growing up as a thirteen-year-old kid. I didn't want to just put everybody into LTS, so KOG (Killer Of Giants) a freight-bombing crew was formed in 1992. It was a stepping stone for new people coming up. The name was taken from a charac-ter that my brother had done with that written on its chest and I thought 'That's down! That's a cool name for a crew.'

THE VALLEY

"The Valley," short for the San Fernando Valley, is situated between the north side of the Santa Monica mountain range, and the south side of the San Gabriel Mountains. To the west of the Valley communities are the suburbs Agoura and Thousand Oaks, and farther east is Pasadena. All of these areas contributed writers to the larger L.A. graffiti scene. Though there was much less gang activity in many of these upper- to lower-middle-class areas, kids often gravitated toward rebellious or mischievous activity. Artists In Style, the first crew in the valley, consisted of Jero, Jack, and Duke, who all became respected mainstays in later crews. They sparked activity in the area with tagging and some pieces, but faded as a crew. Crews to have greater impact in the area were GFA (Graffiti Force Artists), DTK (Down To Kill), and TCF (The Chosen Few). GFA was formed in 1984–85 by local Burbank and North Hollywood high school friends Plex and Grem. Grem has been credited by L.A. writers for bringing legitimacy to the Valley with the quality of his pieces and the distinctly punk-rock influence in his imagery, using skulls instead of b-boys. DTK was formed in 1985 with Charlie, Blinky, and Genius. Charlie had a major impact on

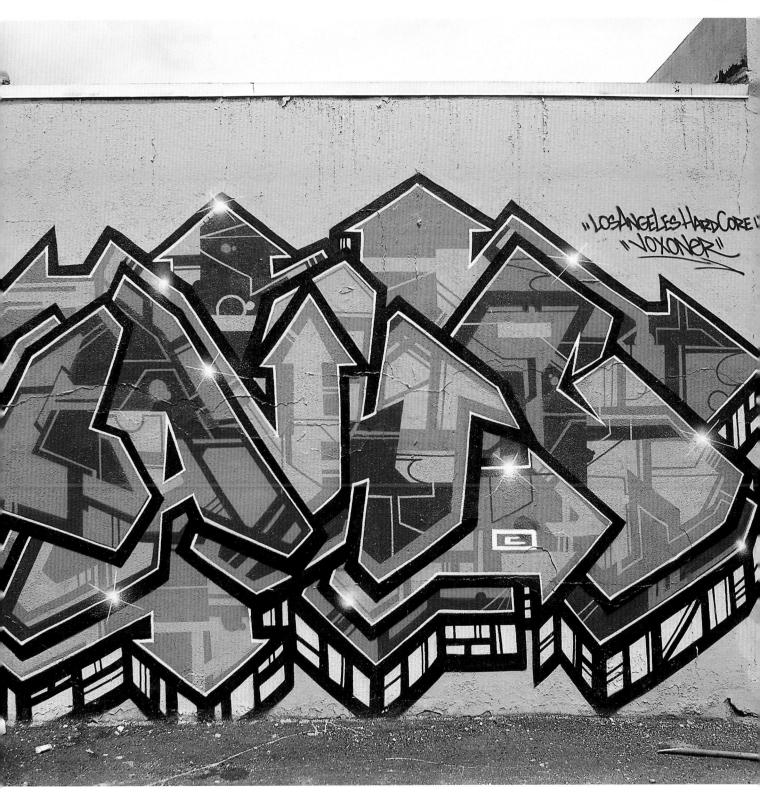

↖↖ **KSN** crew, Reseda yard, 1987 ↖ **WISE**, Reseda yard, 1987 ← **PLEX**, 7th and Santa Fe, 1993 ↑ *LAHC* (Los Angeles Hard Core), **VOX**, East L.A., 2006

important L.A. writers for the style of his letters, while Blinky and Genius became known for their character work. Blinky's work appeared cartoonish and Genius's anatomically sophisticated. Wise, from the west side of the Valley in Woodland Hills, formed TCF (The Chosen Few) with Rage, also in 1985. While both were skilled painters, they are most known for their leadership of TCF and KSN. Even at this early stage of the scene, hierarchies had been established. To be considered a serious writer in L.A. you couldn't just paint in your neighborhood; you wanted to be good enough to paint at the prominent yards, including Pan Pacific auditorium or Belmont Tunnel, so young writers worked hard on their skills.

By the late 1980s more crews formed in the Valley areas, including SKA (Spray Kan Art), UFK (originally Us Five Kings), WGS (We Got Skills), and PDB (Please Don't Buff). SKA, established in 1988 in the San Gabriel Valley, emphasized painting in back streets, "away from city eyes." UFK started in the Valley in 1988–89 at Woodman yard on commercial building walls near the railroad tracks and was active until 1991–92 when ICR (the combination of In Control and Civilized Revolution crews) formed. WGS was founded in 1993 by Vox, who was known for his controlled straight outlines and distinctive trompe l'oeil fills that gave his pieces atmospheric or granite-looking appearances. In the same year, PDB (Please Don't Buff) started in the Valley area but was more active on the city side; its members have an interesting range of letter approaches from calligraphic to the altered traditional fonts.

NORTHWEST

The Northwest district is situated between the San Fernando Valley community of Burbank on the west, Pasadena on the east, and the L.A. River on the south, and includes the communities of Highland Park, Eagle Rock, and Glendale. SH (Seeking Heaven) was founded in 1989 by friends in that area. Writers in the Northwest have close ties with East Side writers in OTR, UCA, and LOD. The "SH" yard was initiated in 1993 by Bash and Dmise. Originally a relatively relaxed place to paint along the L.A. River, many high-quality pieces and productions were done there. It has become less active owing to a combination of police attention, even though it is not close to commercial or private property, and gang tagging. El Serreno, a community between downtown and San Gabriel, has a number of active crews based there, including VC (Visions Crew), who focus on clean productions either unified by the *fill* (the designs inside the letters) or by theme.

ORANGE COUNTY

Orange County, a little over twenty miles to the southeast of Central Los Angeles, is considered a generally conservative area, but has been home to a number of prominent writers integrated with the L.A. graffiti scene.

The most prominent crew to emerge out of the area, NASA, formed in Cerritos in 1985 after their primary members, on the way to a hip-hop event, passed by Belmont Tunnel by happenstance and were struck by the verve of the pieces they saw. "We wanted to form a crew with all the heads that liked to paint. My ex-girlfriend at the time suggested we call ourselves NASA, and it stuck. The only problem was we didn't have a meaning, so we brainstormed and came up with No Art Survives After," recalls member Rich One. Renowned for their virtuoso collaborative style, NASA crew members integrated faces, bodies, and interesting objects such as motorcycles into their letterforms.

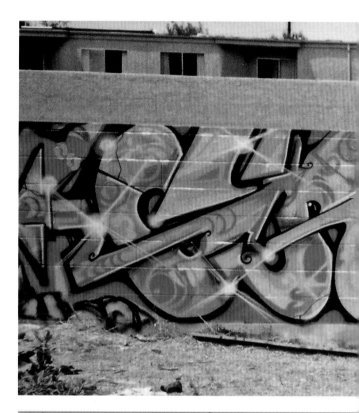

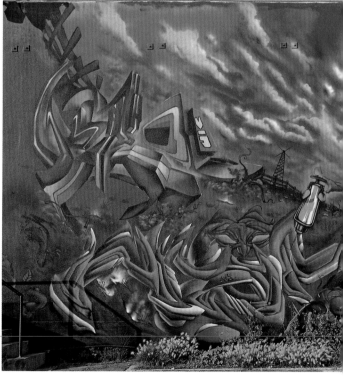

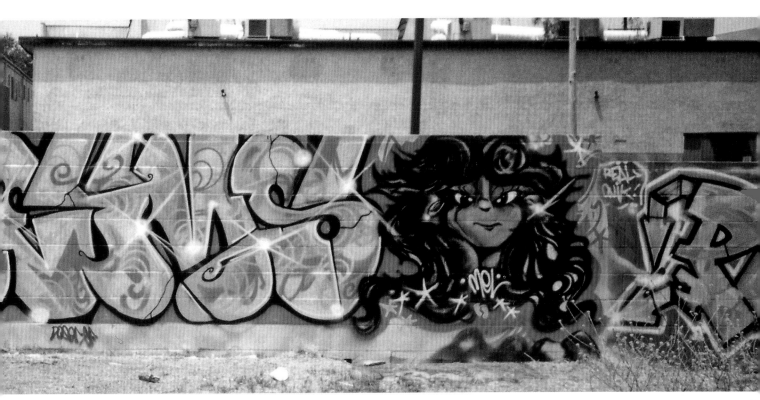

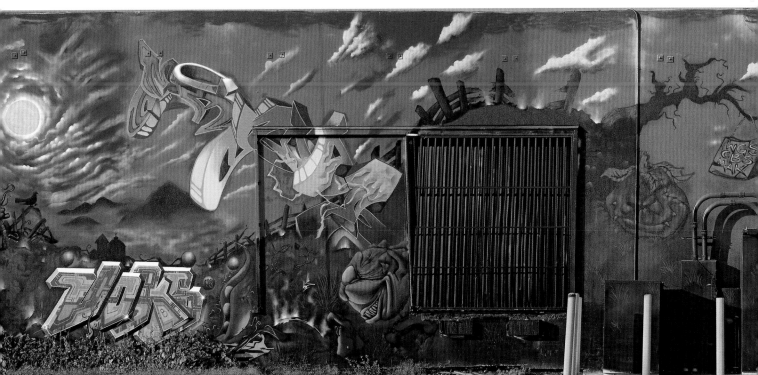

↑↑ **GREM**, Reseda yard, 1987 ↑ **VISIONS CREW** members **KEO** and **WRAM**, with **VOX** (**WGS**), and **MANDOE** (**MAK**), Lincoln Heights, 2003

Aside from NASA and DCV (Def Crown Vets), which was formed by Fear in 1988 in the Bellflower/Cerritos center, graffiti activity in the Orange County area was minimal. But writer Krush helped to bring legitimacy to O.C. graff, particularly in the Laguna Beach area. He also became an important link between Valley writers and AWR on the West Side.

ALL-CITY INFLUENCES

While crews formed across the city and early writers painted in limited locations, some sought out larger visibility and worked to become all-city presences. These more ambitious writers were not only more heavily active, but also more daring in the places they chose to paint. Locations that writers needed to climb up to access, "heavens," were especially appealing not only because these pieces garnered greater respect from other writers, but also because they had the chance of staying up longer. Ser of YR (Yard Rats) was the first writer to "catch" the back of a freeway sign in Los Angeles. But the larger ambitions of many all-city writers also carried greater risks. Chaka, one of the most prolific all-city taggers of his time was arrested in 1991 for graffiti vandalism, sentenced to a year in jail and more than 1,500 hours of graffiti cleanup. Gkae, arrested in 1997, also for graffiti vandalism, spent seventeen months in jail for a three-year sentence and was charged $100,000 in fines. Oiler also has spent time in jail for graffiti vandalism.

REVOK: The things that Ayer (LTS) and Zes were doing really changed L.A. graffiti. There have always been eras in L.A. graffiti, where there was somebody that was at the forefront of things, not just the quality of things, but things that were somewhat revolutionary, that made everyone step their game up, take things to the next level. Early on you had guys on the West Side, who did tons of buses. The first person I heard about was Chaka. Before, everyone did these nice wildstyle, flowing, scripted tags, and Chaka came out writing super simple with big fat-cap tags and was up everywhere and on a wall littered with tags. His would make the biggest impression being so simple and legible, so everyone started doing fat-cap print tags like that and that changed the game a little bit. But the guy that got me hyped up the most as a young kid was Oiler; he was up everywhere! He was all-city from Anaheim to Ventura county; you couldn't go anywhere without seeing Oiler up.

ZES: Chaka brought in the fat-cap tags, but Oiler was one of the guys that brought in the throw-up.

REVOK: I think one thing that Oiler brought to the table and made people take notice of was getting really good landmark spots, like climbing up on the back of heavens, getting up high on poles, or the back of street signs that hang next to traffic lights, climbing up on bridges to do hangovers. He went the extra mile to get his name up in spots so far out of reach that he knew would ensure their longevity, because it was such a headache to get to it that the buffers and toys would pass it up. And that's why you can drive around the city and still see Oiler tags from the early '90s.

ZES: I think arrests made '93 the last friendly year he had. And he's back in jail now. But he was a big influence on me to not just tag on a wall, but to catch spots that are going to stay up for a long time. And more than that, when I was fourteen or fifteen and I started getting into trouble and ended up in juvenile hall, I would see his name in places where you didn't even have a place to stand! As you get older, they put you

in different places, and at each of those places I saw him up, even in boot camp. I was never in for graffiti itself, but when you enter into graffiti at a young age there are other things you enter into as well—stealing, fighting. So because of graffiti lifestyle, yes, I was arrested. Oiler took it to the level of a competitive sport because it was physically challenging as well.

REVOK: The person I see that came along next—there were many people that put in lots of work and did many notable things—and took it to the next level and raised the whole bar for L.A. graffiti was Gkae. Because up until that point, Oiler would do little throw-ups, little silver or white and black bombs. At that point, there was a distinction between piecing and bombing; bomb graffiti was sloppy, unrefined, and piecing was like hanging out at a yard, spending the whole day and doing a really nice piece with a bunch of colors; there wasn't really a middle ground. Gkae formulated this kind of middle ground so that he was up everywhere. Here was a kid that lived in a suburb out west of the Valley, and you saw him up everywhere from South Central to Long Beach to Watts, Compton, East L.A., downtown Hollywood, Mid-city, West L.A., and other cities and states as well, on bridges and the backs of freeway signs, and this wasn't just with tags, but simple pieces; they'd be silver or gold and maybe a little bit of color, but it was a piece with hard edges and structured letters with connections, with a highlight, and another color in the 3D, and another color in the border. And he was doing this with the same mentality as Oiler, getting up in difficult places to assure the longevity of his efforts against toys or buffers. At this time, a lot of writers were staying mostly in one area, and Gkae was going state to state, Rosarita Beach in Baja [Mexico] to Canada. And now that's what every writer does. He was the person I looked up to because he, at that point, was the ultimate bomber—he did the dopest shit, he did it the most, and he got the best spots.

SABER: Heavens came into focus in '93. My big splash was with Gkae on the 5N bridge. People had done hang-over roller blocks before (hanging over the side of a bridge with a roller extension, writing upside-down and backward, from the writers' perspective), but nobody had ever climbed out there and outlined it and did "cracks" before that piece in '95. Gkae would climb from the top out and over like a rat, and my fat ass would come from the side. I moved very slow and carefully while he would skip around that thing like a jungle gym! He outlined most of the piece and I did all of the cracks. Up to that point, nobody had done details like that on an outside of the bridge piece. We also did a 710 freeway bridge, a three- or four-color piece—the first time that had been done. All of the missions I went on with Gkae were his missions.

REVOK: The person that came along next and took it further was Ayer. Ayer did what Gkae did, but a thousand times better. Not only was he getting up everywhere, but he was getting even crazier spots than Gkae, and he was getting them with twelve-color pieces! And he wasn't just doing simple letters; he was doing them on a bridge better than most people could, hanging out all day at a legal wall on a bridge with an eight-inch ledge and a three-story drop: the most death-defying-insane-crazy-ya-gotta-be-fuckin'-nuts-to-even-consider-doin'-that-shit type circumstances.

ZES: . . . also Ozzie, Use, the YRs (Yard Rats)—got to give them a lot of credit. They were coming from the energy of Gkae and trying to take it to a new level. But Ayer was one of the first to do color backgrounds and spell-outs like "Killer of Giants" or "L.A.'s toughest sport."

→ OILER, Hollywood

REVOK: Ayer made me fall in love with graffiti all over again. Ayer pushed me more than anybody has ever pushed me; this kid was blowing me away. He made me hungry to evolve and excel, test my limits, face my fears, and step out of my comfort zone. He made me what I am today and I'll always be eternally grateful to him for that. I feel he's the single most influential person in everything you see going on in this city.

ZES: He's the one responsible for getting public recognition that there could be illegal art, not just the usual tag vandalism, and nobody has surpassed that standard. There were people before Ayer that were doing a lot of nice work, but it was in yards where nobody would see it; Ayer took it to the streets where it would be seen.

REVOK: Before him, you didn't have to work that hard to get some respect, but he made it so you really had to work to get some love.

SABER: Before Ayer, only Gkae and Fate had done heaven pieces, but they didn't climb out as far as he did or bring as many colors to the table. He made it kind of wild. And he developed a squirrelly style because you can only reach so far when you're out on a ledge, and that's why it all leans and loops to the right—because that's the range and only direction you can move your arm when you're on a six-inch ledge, hanging with one arm. And everything comes to a point. And fuzzy too, because you're reaching as far as you can. And maybe doing one letter at a time, outlining it, highlighting it, and moving on to the next, instead of doing the whole piece and filling it in. People liked that style and started to copy it in wall work. Gkae was before Ayer, and he was the one that spent the most time on the outside of a bridge—nobody had taken it to the point where Gkae had taken it; he was the first one to do full pieces on the front of heavens, on the backs, the outsides of bridges, on ledges as opposed to underneath bridge structures, and as opposed to just doing a quick fill-in or outline. He was one of the first to do a four-color piece. A more blocky, old-school piecing style, rather than a more modern scratchy style.

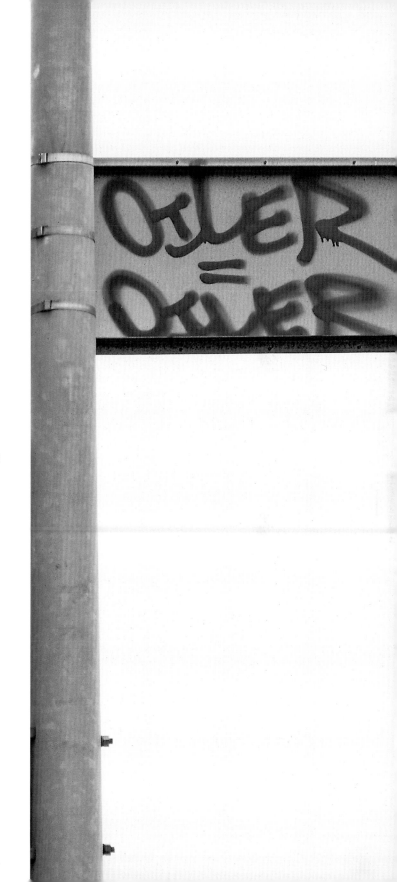

BUSES AND FREEWAYS

While all-city tagging increased a writer's visibility and popularity beyond the domain of their own neighborhoods, writing on buses provided the opportunity for one's tag to travel all over the city. Inspired by New York subway car writing, where trains were transformed into movable exhibitions, some writers began to focus their attention on L.A.'s public buses. Bus tagging diminished greatly after 1989 due to increasingly effective law enforcement, including GHOST (Graffiti Habitual Offenders Suppression Team) who placed undercover officers on buses.

CRIME: There are people known for piecing, for bombing, and those just riding the bus all day. The early bus kings were Alski, News One, Triax and, a little later, Ser. But then there was Chase in '85 doing throw-ups, and the first guy to do it with numbers on them. Wisk was at the same time. But Geo was before all those guys, and he was the RTD (Rapid Transit District buses) guy, the bus king. He didn't go to school: he caught the bus from one area to another and did all-city, going to places none of us had been to. There were many writers at the same time, but they were in the South Side so we kind of fell into their realm, meeting up with them in Hollywood where I had to catch the bus for school. Others from around the city were Miner, Rival, Piro, Price, Cube, Siloe, Test, and Dye. Then Dead started on the East Side and downtown, and he was writing with a kid named Pone, and it was funny because they used to write LAPD—L.A. Pone and Dead. They wrote "Vision One," "L.A. Death Squad," "A massive graffiti writer," and "Do It." We never met, but would write messages back and forth to each other on the bus, "What's up? Rick One K2S, hit us up." Gin, known for big silver bombs, also was a bus writer.

Writing on walls or bridges along the freeway also became popular as another alternative to capitalize on a single tag, piece, or throw-up. With the high concentration of car traffic, they had the chance of receiving as much attention as a bus tag. A number of crews primarily focused on freeway bombing formed, including IFK (Interstate Freeway Killers) and FB (Freeway Bombers). Some of the most notable early freeway bombers include Angst, Mural, Tent, Key, Cab, Esk31, Esel, Rask, and Duem.

Downtown L.A. heaven with **WISK** and **CHAKA** tags. Photo courtesy of James Prigoff

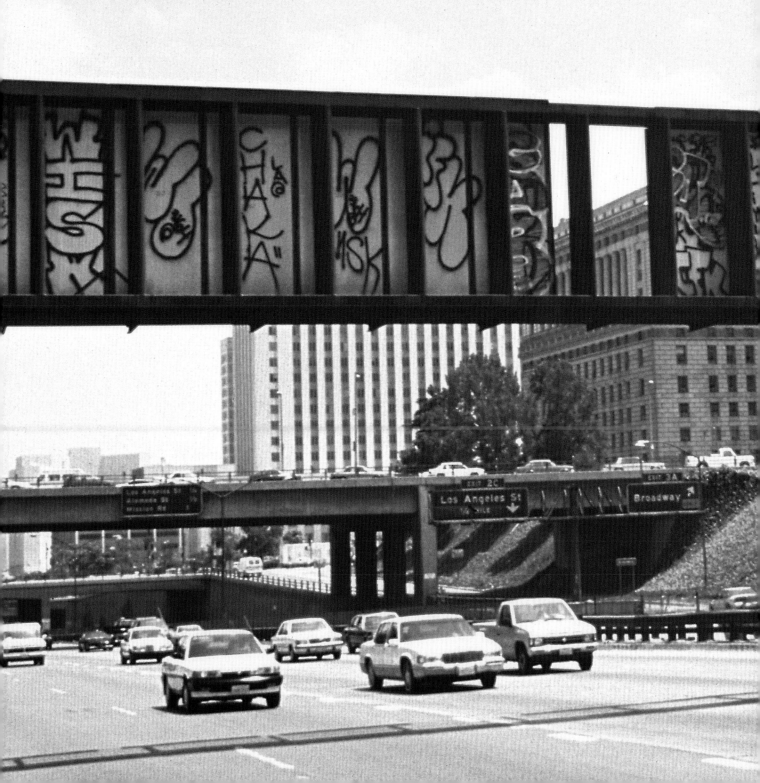

L.A. GRAFFITI MILESTONES

1970: First exhibition of graffiti at Pomona College Art Gallery, organized by Hal Glicksman, showing Bob Allikas' photographs of East L.A. gang graffiti

1984: 01 Gallery exhibition with **CHAZ**, Big Daddy Roth, and Robert Williams. Formation of L.A. Bomb Squad, West Coast Artists, Kids Gone Bad, Out of Control Artists, Can't Be Stopped, Graffiti Force Artists, Down To Kill, and Young Lords

1985: **K2S/WCA** battle. **PRIME**'s piece has major impact. Formation of Kill To Succeed, Second To None, On The Run, Kings Stop at Nothing, Modern Art Kids, The Chosen Few, No Art Survives After, and Under Cover Art

1986: First writer's bench at Olympic and Fairfax. Formation of Under The Influence

1987: Formation of Last To Serve and Beyond Control

1988: First Graffiti Expo organized by Frame. Formation of All Writes Reserved, Def Crown Vets, Spray Kan Artists, TaKingOver, Kill For Pride, and Us Five Kings

1989: First aboveground graffiti exhibition in L.A., *The Burning Desire*, at Pico House. Featured artists include Hector Rios (**HEX**), Richard Wyrgatscht (**SLICK**), Armando Santiago (**MANDO**), Eric Montenegro (**DUKE**), and Jahnos Ferrari (**SKILL**). Formation of Mad Society Kings, Rocking The Nation, Cause of Insanity, Loks On Dope, and Seeking Heaven

1990: First **SLICK/HEX** battle at Levitz walls. Formation of Amongst Majority's Garbage (AM7)

1991: Graffiti Arts Coalition established. Raleigh Studios exhibition of live painting by many city writers. The event is sponsored by the Graffiti Arts Coalition. Graffiti Summit at Getty Museum. Fox 11 News airs interviews with bombers. Formation of ICR.

1992: *Undiscovered America*, first city-commissioned mural by graffiti artists, Earth Crew, through SPARC (Social and Public Art Resource Center). Formation of The Private Sector, Killer Of Giants, Ghetto Art Warriors

1993: 01 Gallery premieres *Next Step, Directions in Graffiti Art*, a group show organized by **CHAZ**. ICU (In Creative Unity) first show, *Word From the Underground* at Conart. Formation of We Got Skills, Please Don't Buff

1996: *New Directions In Graffiti* exhibition with **CHAZ** and **FUTURA** 2000. Formation of Rapid Fire

1999: *A Day in the West* production, Belmont. **SKILL** organizes a gathering of 200 L.A. writers to paint all of Belmont for the backdrop of a documentary on rappers.

2002: Man One establishes *Crewest* Gallery.

2004: Farewell to Belmont *Timeline Production*

ZES heaven, Lincoln Park, 2006

TECHNIQUE AND AESTHETICS

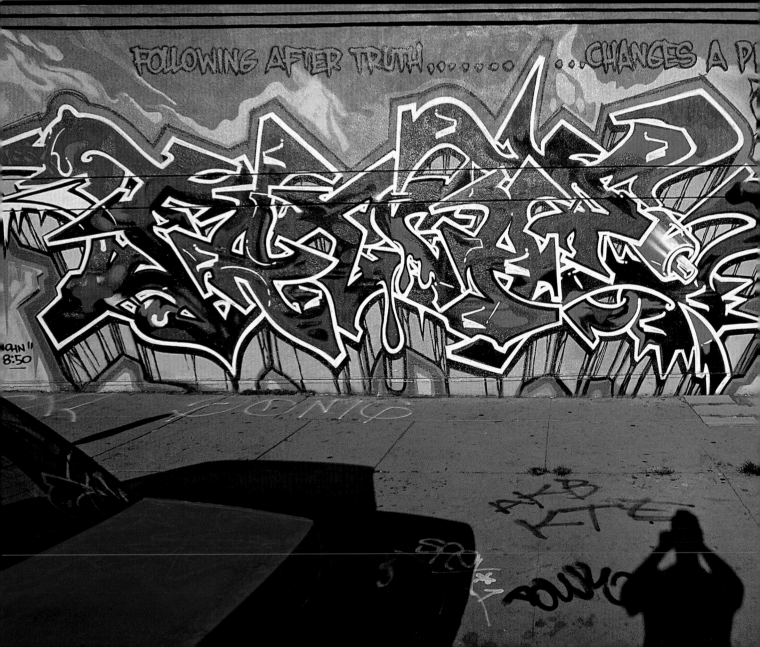

Regardless of the vernacular nature of graffiti, its technical and aesthetic development has evolved to an extremely high degree. As in any art form, authority of creative expression develops through committed practice and thought. These writers may not be familiar with formal art terms such as "warm/cool split" or "figure and ground," but they use these ideas intuitively.

The general visual style of graffiti as we know it today evolved from a confluence of both sociological and material elements. Owing to graffiti's illegality, writers learned to paint quickly. The reason that writers use spray cans for anything beyond a small tag, is that the spray can, easily concealable and portable, can cover a large area quickly, yet with control. And even though in some cases, painting may now be done in a relaxed, legal manner, the stylish and often spontaneous look of the finished product comes from those roots of the movement.

REVOK: To me, what's always made Los Angeles graffiti the best . . . distinctive and unique, is that L.A., before hip-hop graffiti, already had a long tradition of *cholo* graffiti. As kids, many of us saw these bold, hard, super-high-contrast letters, just black on white or gray, Old English letters that had a really aggressive, arrogant, dark, intimidating presence. You'd look at these letters and read these names and it had a bad-ass, kick-your-head-in, you-don't-want-to-fuck-with-us presence; the big gang blocks, the thick hard black lines, and that is in the subconscious of all L.A. graffiti writers. It had a huge impact on Los Angeles aesthetic style. The subliminal message that comes through with the angles, and the shapes, and the colors, and the boldness has always been unique to Los Angeles graffiti. You look at graffiti from the mid to late '80s, the early '90s, the mid-to-late '90s, which I think was the golden era of Los Angeles style—when it was really some raw L.A. stuff, but had evolved and improved over several generations of being passed down, each generation adding their own little elements into it. It looked unique and different from everywhere else. New York had its own aesthetic: you take a piece from '94 from Brooklyn or the Bronx and put it next to a '94 piece from South Central, Mid-City, or West L.A. and you know which is from New York and which is from L.A. K2S/STN were obviously pioneers, and the West Side pioneers were KSN and WCA, each having their own unique styles, and from those camps have come several generations of great writers.

WISE: K2STN was in their own world, and started L.A. style. K2STN was influenced by what they saw, the gang graff and Old English, while the West-Siders were influenced by what they saw, which was more the Hollywood Sunset Strip advertising. But I do think the Los Angeles look is a Latino look. New York comes through more in WCA/KSN. At first, writers were just trying to get confidence in doing arrows and bubbles, not trying to expand on it. You're intimidated by the can and control of the colors. Also, what was considered "acceptable" back then was limited: if you did something with Old West style letters, that would have been considered too odd. It took time for the possibilities to expand. It was only eventually that the openness to creativity could include Old English and a wide variety of fonts, hip-hop elements, 3D, various highlights; stuff that wasn't being done or combined in the mid '80s.

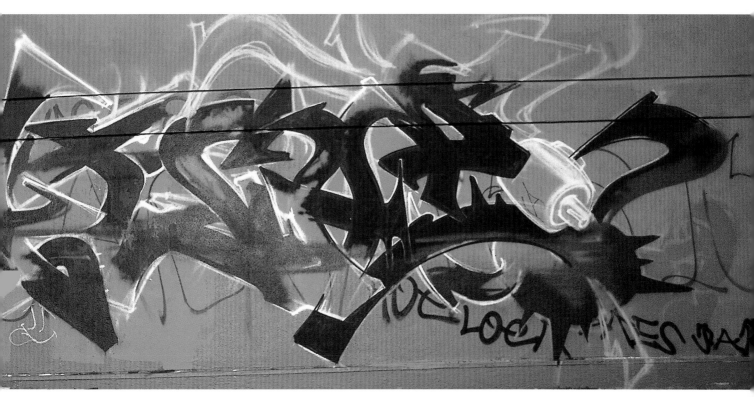

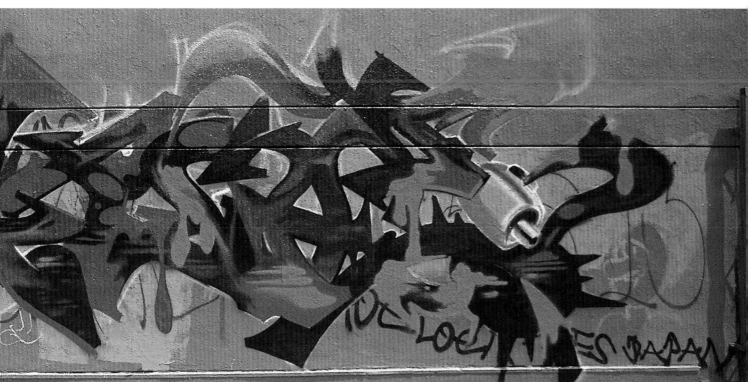

Earlier stages, **HEX TGO**, Melrose, 1993. Previous page: The completed piece, **HEX TGO**, Melrose, 1993

EARLY TECHNICAL ISSUES

The pioneers of graffiti writing in Los Angeles were all confronted with early technical challenges. Writers quickly discovered that standard spraycan tips, or caps, produced an unwieldy spray pattern, making it difficult to control lines, so alternate tips were sought after. In learning about paint consistency, which varied among brands, young writers experimented with different colors, though they were limited early on. But as in many creative traditions, the paucity of user-friendly materials and adversity of the entire endeavor gave rise to exceptional results.

SHANDU: In the beginning it was just stock tips. We had to switch fingers to last or we'd get cramps, and hope your hand lasted to the final outline. Time was of the essence . . . done, gone. Maybe you didn't finish and you put your little sign up "Not done, too cold, can't see, too fucked up, ran out of paint, or started raining."

PRIME: Paint from auto parts places gave limited color choices, which meant we had to be creative, use more technique and thought . . . we had to make the best of it.

WISE: You got your materials from someone's garage or Thrifty's. It was very limited. It was all experimental; you wanted to get cleaner lines but didn't know how. You didn't know there was that much difference in paint brands. You even tried to make your own markers at home.

SWANK (SH CREW): Tools are designed for graff now; before you were using tools that weren't meant for that application, tips, paint thickness, and consistency, valve assemblies, the pressure (the standard was too much . . . the paint shoots out all over). Before you had to adapt what was around, and that's what made it creative; tip modification secrets . . . how to get the effects people did.

TYKE (AWR AND NASA): Everything was more precious back then. It was hard to get your hands on a graff magazine, or good tips. People took more pride in it.

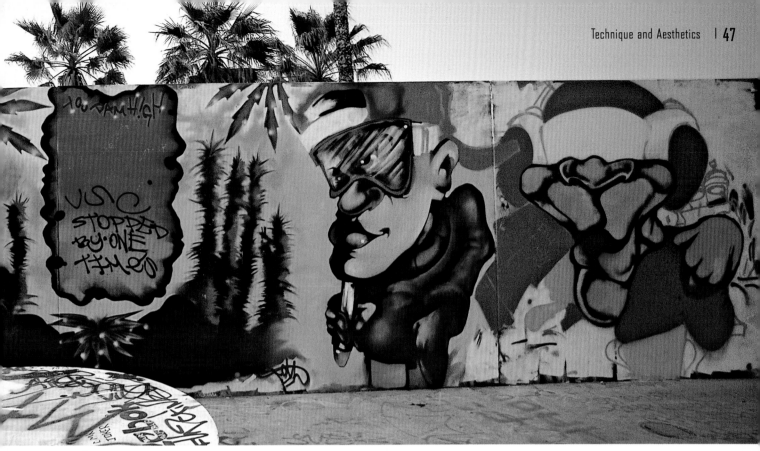

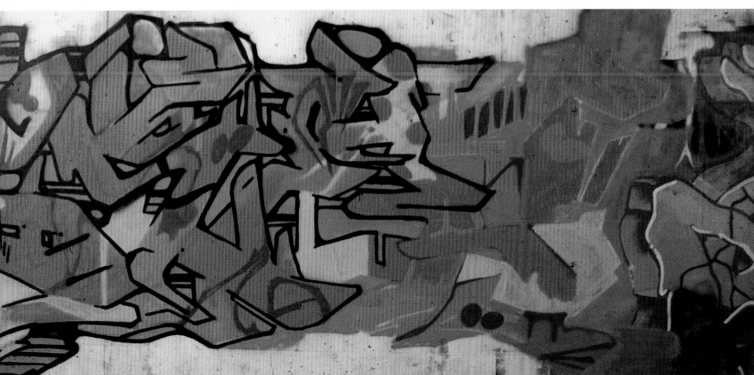

↑↑ *Stopped by One-times* refers to police, USC, Venice Pavilion, 1993. ↑ *Not done, please respect*, writer unknown, SH yard, 1997

PAINT, COLOR, AND TIPS

Even in the early development of full-blown pieces, writers were clearly thinking about how to put colors together, and while many writers still have a bright-only, or use-every-color sensibility, the best writers may have a very sophisticated and intuitive color sense. Before the present availability of many colors, a writer could be identified just by his custom colors or subtle palette.

In the early days when limited colors were available, custom mixing using a DW-40 plastic tube between cans of different colors was a guarded method amongst the best crews like AWR. Now, with brands like Belton and Montana, paints made specifically for graffiti writers, a broad palette of hundreds of colors is immediately available

There is no universal set of terms relative to caps. Confusion lies in what is being described—the cap itself or the spray it makes. Most writers refer to the spray, and so the term "fat caps" refers to the spray, whose size is about the diameter of a softball,

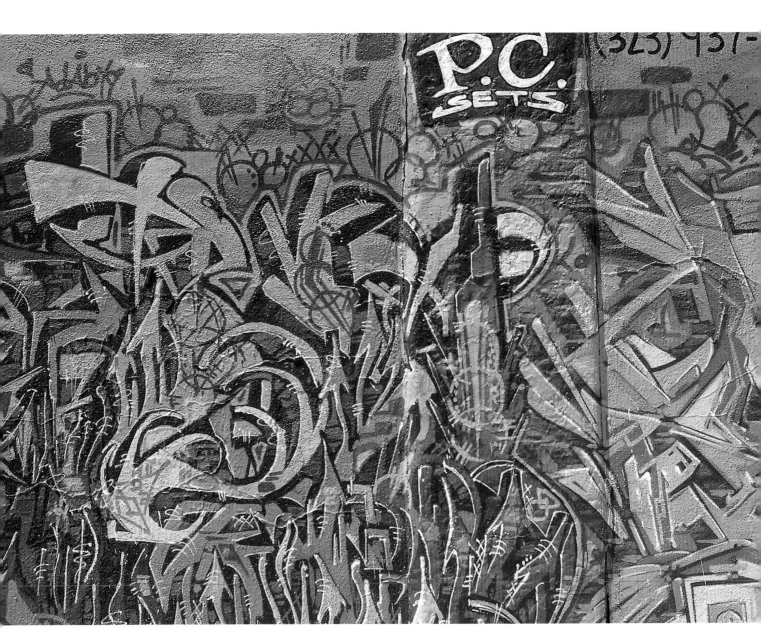

↑ **AYBON** (right), **KLEAN** (left) detail, Mid-city, 2004 ↗ **BLES**, Motor yard, 1992 → **STRIP**, Artist District, 1992

which is why they are sometimes called "softball caps." Oven cleaner and glass cleaner tips fall into this category as well, and also produce spray sizes similar to softball caps. Wider spray diameters are used for tagging or filling a broad area in piecing, but not for detail work or outlines. Caps may also be referred to by how many fingers' width of a line the spray makes. Also, the plastic that forms the actual hole where the spray is dispensed sometimes has a color identifying the spray diameter, so some writers use terms such as "gray dogs" or "pink dogs" and other colors to identify the line width.

Different writers favored different brands of paint according to the colors, thickness, or even how it mixed with other colors when "over-spraying," the effect referred to when a strong pressure releases the paint, though not solidly covering an area.

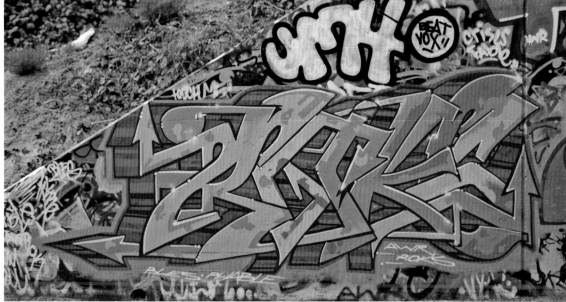

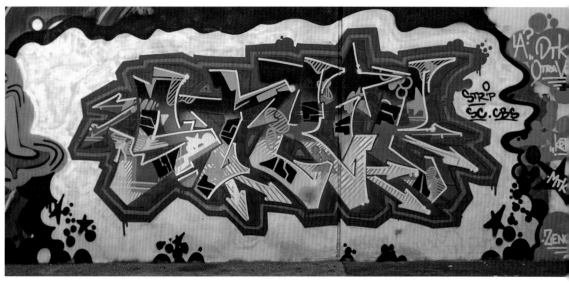

RISK: Fat caps off of Grumbacher art supplies were not for paint but for fixatives. It gave a crisp line about an inch in diameter. It releases the paint slower and gives you really good control and is a lot easier to paint with. With a fat cap, you might be able to take three seconds to do a crisp, clean line where with a stock cap it might take one second, giving you that much less control. So that technical discovery was revolutionary, and something we learned from Soon. Most stock tips allow the paint to come out with a lot of pressure, so you have to be quicker to have a controlled line without drips. The fat caps were around for a long time, but not known about by writ-

ers at first. West, from New York, showed us where to get the caps in bulk. Different tips come with different cans. You want a female cap with a male can for switching: throw the others away. Certain caps were cherished. Testors, from small cans for painting model cars, gave a good line but always clogged. A lot of people think the Grumbachers are Testors because the caps are both white, but it's a different cap There are probably a hundred white caps, as we found out when we started going to the factories and buying them by the trash-bag full. We then discovered there are also different numbers—sevens, nines, thirteens, giving minute differences in

↑ **SINER**, Hollywood, 2005 (detail) ↗ **SINER**, Hollywood, 2005

spray diameter and characteristics, but you couldn't really tell the difference and it depends on how far from the wall you are, anyway. So Testors became the standard name for caps that allowed you to produce a clean, controlled line.

SINER: I like to use stock tips because it sprays out of the can faster and has a better feel to me. It doesn't slow you up when you want to swing your arm. The paint just follows as fast as you want to move it. I may use skinny tips for textures; it depends on how you feel and what cans you have to spare. Some cans work better with certain tips; if you want to get a glowing effect, I like to use stock tips because

I like the overspray, and when you use a Testor tip, everything is so chiseled it's hard for me to paint with them. There was a phase when we were using buff paint (wall paint or primer) and brushes and various mediums to do our pieces. For the big Ayer piece, we (LTS/KOG) did the "A" and another person did the "yer."

RISK: LTS, that's some of the coolest stuff I've seen in a while because it was such a different look. A lot of people were using caps that made it easy to be clean and crisp and LTS broke that genre. There was a time when we abandoned the fat cap because we thought that the fat cap was a crutch. And if you're really good enough, don't use it.

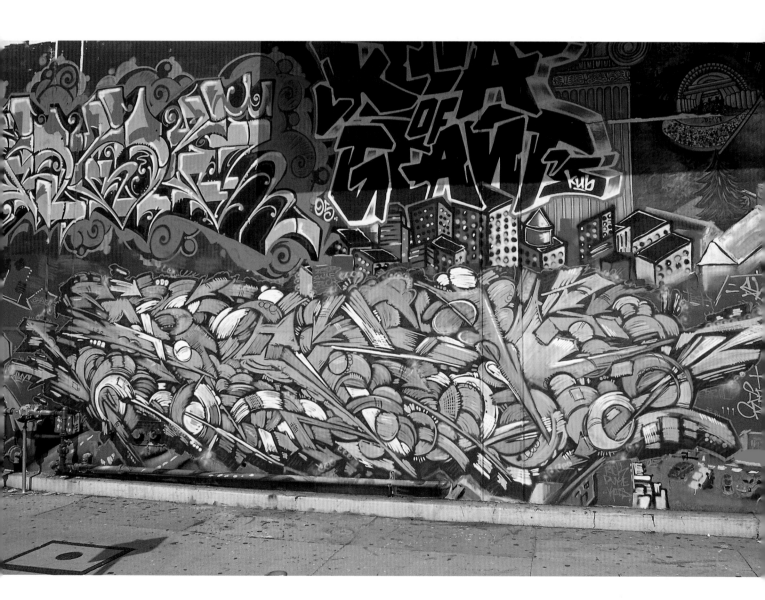

AYER memorial, LTS/KOG, Belmont, 1999

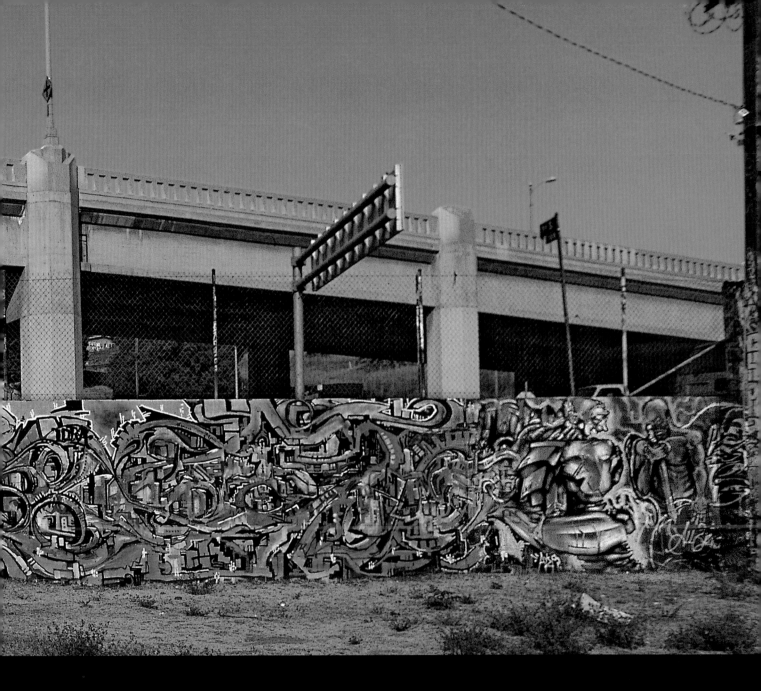

CANNED SPRAY PAINT was invented by Edward Seymour in 1949. Although aerosol cans had been used for dispensing insect repellent in the army, it was Seymour's wife, Bonnie, who first suggested the use of an aerosol can filled with paint. The first paint color to be put in use was aluminum, originally used for industrial purposes such year to manufacture his spray paints and is still in business today, manufacturing a wide range of industrially oriented aerosol products. Ironically, it's not a favored brand of paint amongst writers. Even more ironically, one of Seymour's products is a paint stripper called "graffiti remover."

TYKE: I custom mix Krylons, because a lot of the paint available these days . . . they have great colors, but I don't like the touch as much as Krylons, the way it scrapes when you paint. I like how sometimes it's watery, and with the new stuff I can't paint the way I'm used to.

ALOY (SKA, MSK): Some people say they can't paint unless they have their special Montana and Belton paint, and some German micro-Lamborghini-back-to-the-future-tips: if you like graffiti and you're down to paint, use whatever you got.

REVOK: Working loosely or with sharp control are of equal value: there's more than one way to paint a picture. It's an outlet for emotions, experiences, ideas, and fantasies, so there's no one right way.

PANIC: Bash, of SH, is very creative and has come up with various trickeries such as with special ways of adjusting can pressure to get certain effects; these things have made painting easier for us. Core SH/LOD members Size, Bash, Acme, and myself

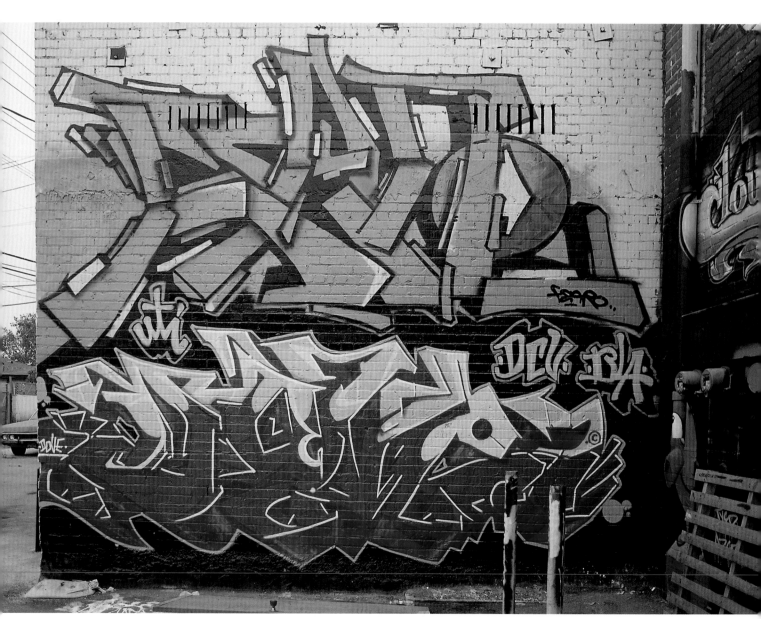

↑ **FEAR** (above), **DOVE** (below), Melrose, 2005 ↗ **KRUSH**, Huntington beach, 1993 → **ALOY**, Hollywood, 2006

in particular have been working closely together and encouraging each other for the last ten years, so I don't buy any special tips. But not only do you have to know how to decrease the pressure, you have to know how to use it, and each tip has its qualities.

FEAR: When I was young, I thought my pieces wouldn't look good without using Testor tips, but now I know it isn't about that. And on trains, a stock tip gives it a more old-school New York look on the metal, and when you hit bumps on the surface, the spray still shoots straight, whereas with a Testor, it fans out when you hit a bump.

RISK: Because we knew about fat caps before the word got out about them, our crew had the crisp, clean stuff for several years, but when the word got out about the tips and everybody was doing clean stuff, to distinguish ourselves we threw away the fat caps and went back to stock caps, which implied the question to others "Can you still paint without fat caps?" Probably not. So that put us back at the top of the game again. Then the fat cap came back because the point was proven, and now you see people using the stock cap again; kind of the new trend.

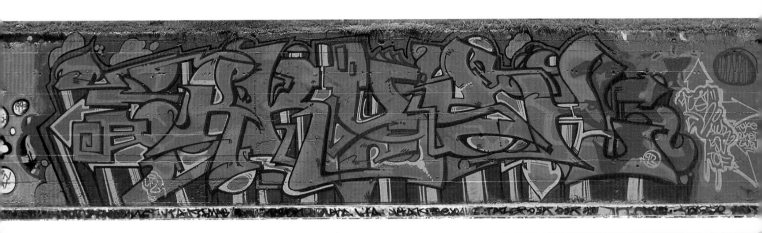

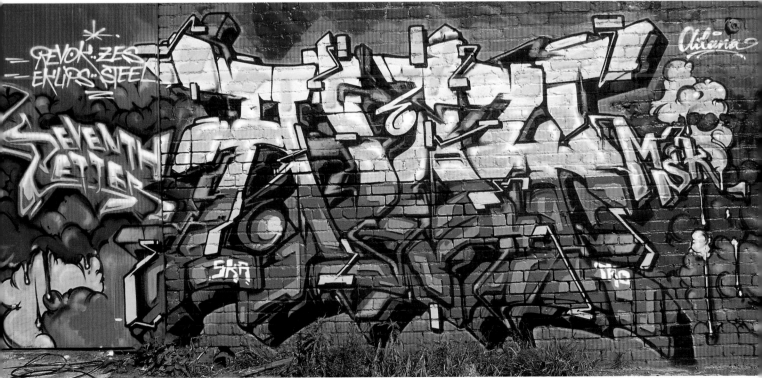

SIZE AND SCALE

The scale of a piece is often determined by three dominant cofactors: the size of the available space, the natural reach of the writer, and the amount of working time available. If an entire wall is available and there is owner permission, then a top-to-bottom production might be done with the aid of ladders and even scaffolding. Whole-wall productions are also done illegally if the location is obscure enough. At the beginning of a whole-wall production, the writers will usually mark out the area that each artist has available to work on his piece in the production, as well as other production features such as figures and cityscape background scenes that are integrated with the letter-based parts and which tie the production together visually. What is usually referred to as the sketch or beginning outline in a spraycan mural is the equivalent to the "lay-in" in traditional art terms. Normally, the scale is determined by the natural range of the writer's arm to make one letter, and then the rest of the piece progresses from there. The assistance of a shopping cart turned on its side or an empty five-gallon container is often used for the writer to stand on in order to extend his or her range.

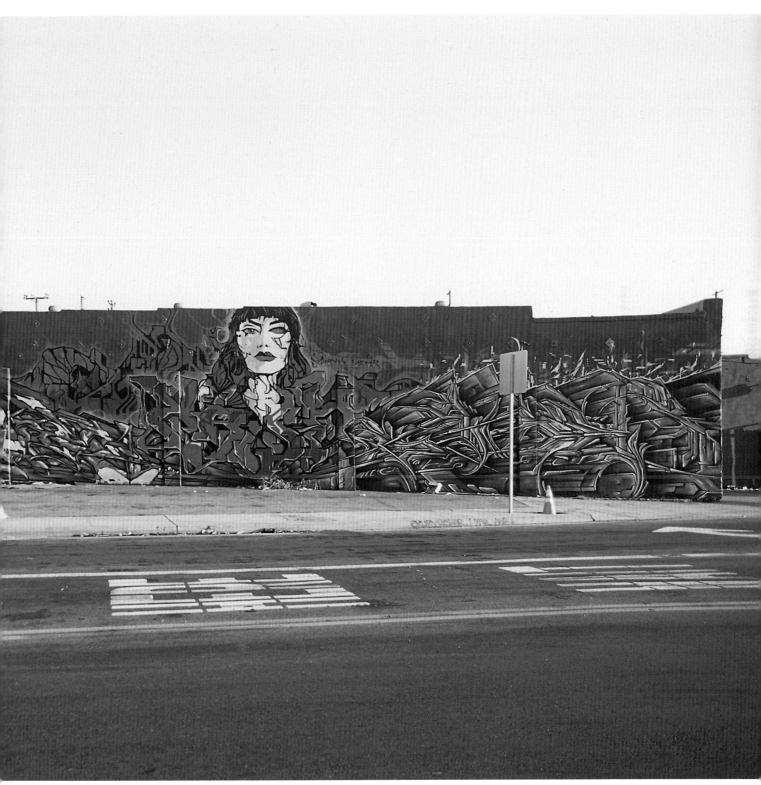

REVOK, **KRUSH**, **SABER**, **COAX** (character on far left), Downtown, 2004

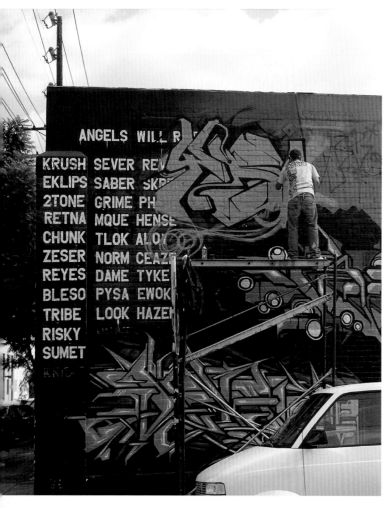

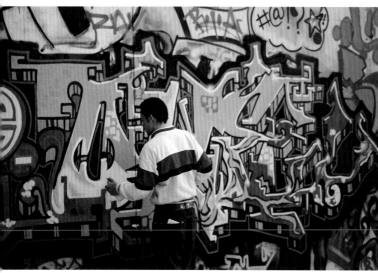

SKETCHES

Ideas regarding letters and colors are often worked out on paper or in sketchbooks before executing full-size pieces on chosen spots, but each artist develops an individual relationship to sketch preparation.

SINER: If I'm working with a group that wants to freestyle, then I don't want to come out with a sketch, but there are times when I really want to do a piece that I sketched out and I'll bring it, and those are pieces that I really love. You still make choices with what cans to use, but I like to have a basic idea in the sketch, although pretty much, you're just flowing. Sketches are just sketches and I erase a lot, so you take it from the freestyle you did on the paper to the wall, but flip it a little sicker.

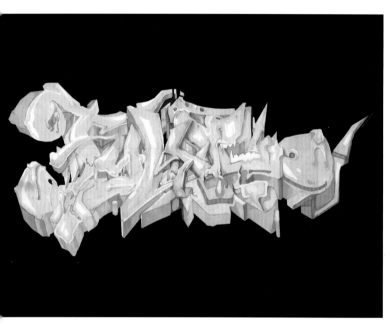

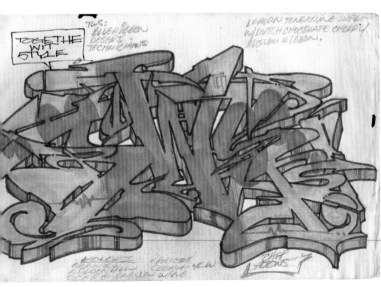

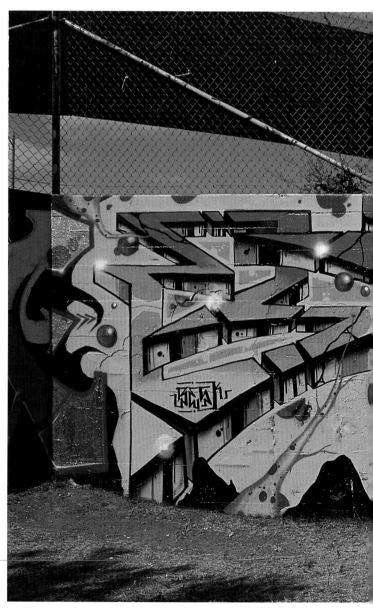

BESK (UCA): I try to stick to my sketches as much as I can, although I leave the fill until I'm there at the wall. There are times when because of space limits or when it looks better on the page than the wall, then I'll change something.

PRIME: Everything got developed on the spot. I might have a sketch or something on a piece of paper or a napkin, but none of the colors were worked out, partly because we didn't always know what colors we would have that day.

ALOY: Sometimes I'll work from a sketch and it comes out wack, so I'll buff the whole thing out and start from scratch and it'll come out better. Or I might ask a friend there for an idea because I'm feeling blocked. Sometimes I draw better when I'm stressed or pissed off, like one time when I looked at what I drew while I was arguing on the phone with my girlfriend (I always have a pad of paper there, but not on a wall). Sometimes I like to do a rugged piece on raw unbuffed brick; I like the way that looks.

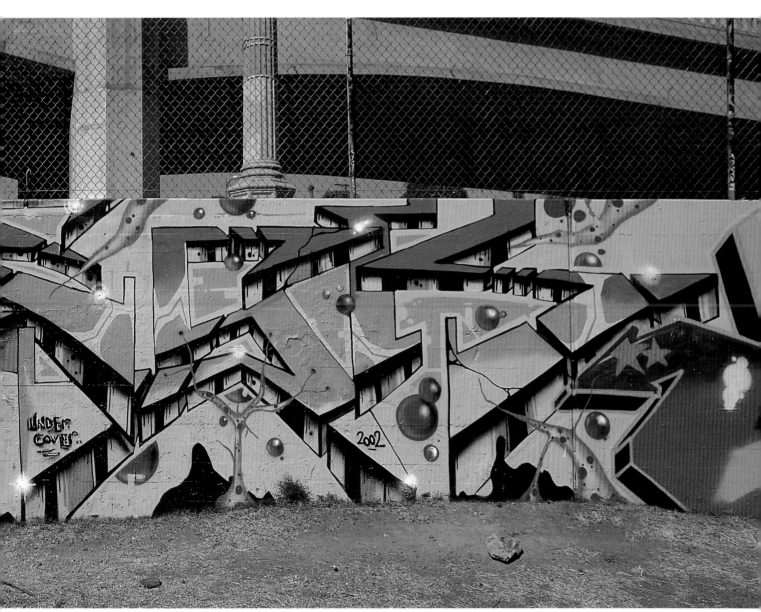

↖ Sketch, **TYKE WITNES** ← Sketch, **TOONS** ↑ **BESK**, Belmont, 2002

RETNA: I stopped doing drawings to work from because I might take eight hours to do a sketch, and then I'd be there at the wall confused about what line goes where because it was so intricate, but I met up with people that inspired me to freestyle. I realized I could save time by working it out on the wall instead of translating it from the paper. Now I draw the "R" and the "E" as the sketch and don't draw the rest of the piece on paper. That tells me more or less where the piece is going to go.

PANIC: Ninety-five percent of the time I freestyle, although there are occasions when I'll do a sketch, but it's more fun to work straight from your brain because you go through the same process and might as well bypass the paper process and go directly to the fun part. I have tons of alphabets in my head that I like to fiddle with and when I go from a sketch, it's totally different; the paper piecing is nice, but in a field of its own, and you're restricted from using your whole body when just piecing on paper; on a wall you can get a curving six-foot line and follow it through the whole piece. The spray can is the most enjoyable medium for me.

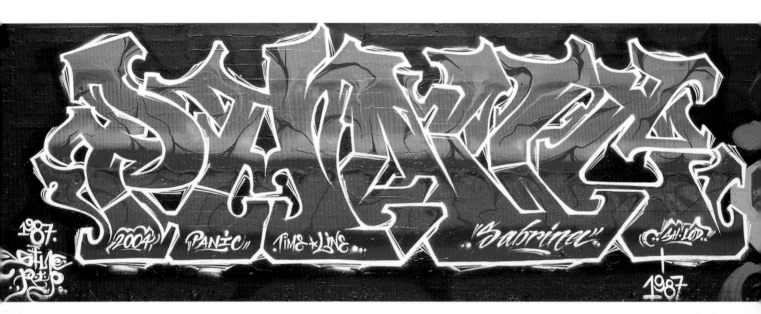

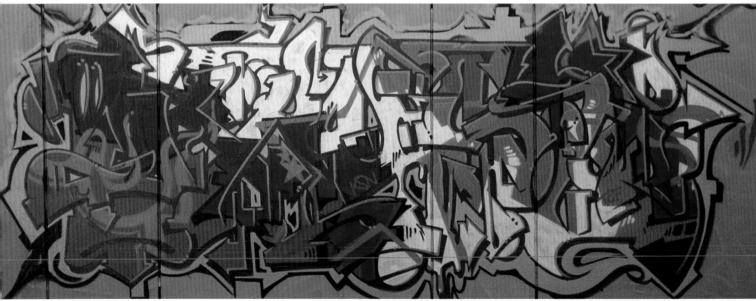

DOVE: I freestyle out of necessity, because it was difficult to duplicate my sketch on the wall, so I decided to draw on the wall to begin with after talking about it with Skill. He told me, "Your sketch isn't there to be reproduced. It's there to use as a reference for letter connections, patterns, brackets, little pieces of flavor that you produced at the moment of drawing . . . however you were feeling the drawing. The way you cut a bracket over a letter, the way you brought an arrow around, that's what your sketch is for. You take that to the wall and you implement those tactics."

KRUSH: It's the Zen of graffiti; go to the wall and let it come out. I look back at some of the styles I did and don't really know how I did them.

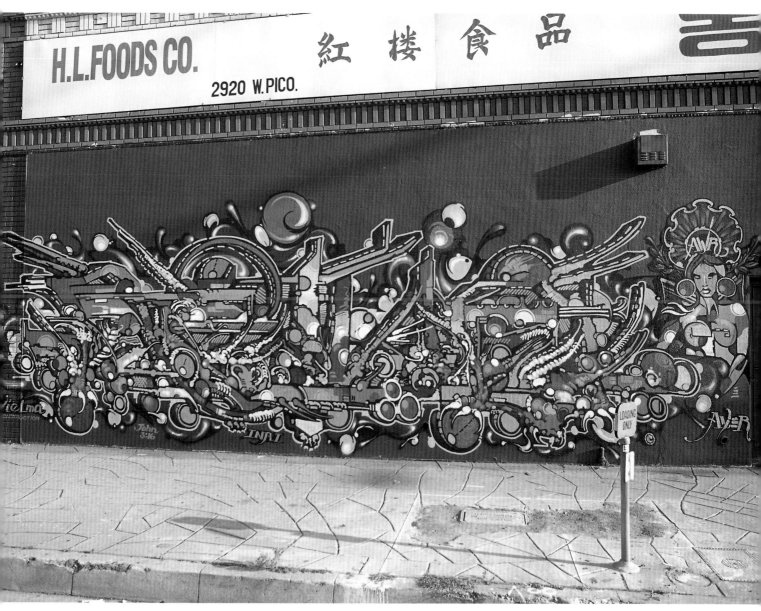

↖ **PANIC**, Belmont, 2004 ← **KRUSH**, Venice Pavilion, 1995 ↑ **RETNA**, Mid-L.A., 2004

ANATOMY OF A PIECE

A number of New York-derived visual devices were inherited by Los Angeles writers before being spun to one degree or another. This included blended letterforms, fill, outline, border, 3D, sometimes called the "coin" by L.A. old-schoolers, bubble background, transparent overlaps, bits, cuts, arrows, shines, cracks, sparkles, and connections. The term "bits," used by Panic, is taken from "bits and pieces," but various writers have their own terms for the same things. Kofie calls a group of bits a "cluster," while Fear refers to bits as "brackets." The visual effect that bits produce is of pieces breaking off of the main form, changing up the visual rhythm. "Cuts" serve the same purpose but in a more subtle way, and often emphasize alignments in the design of the piece. This complements form blends, or *ligature* in typographical terms, where natural breaks between letters are eliminated. Implied motion through arrow forms may be used, but are often less important than general design dynamics and visual flow. Cracks in the form, as though the letters were made of stone, imply weight and history or importance, as though it were an artifact of an early civilization. Lightning in and around pieces implies power gener-

ARROW FORM TRANSPARENT OVERLAP

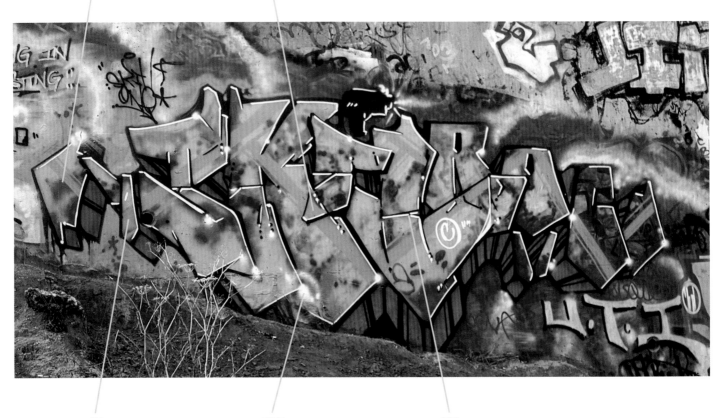

BIT SHINE CUT

↑ **SKILL**, Motor yard, 1995 → **DREAM**, Artist District, 1992

ated by the image, and bubble forms surrounding a piece may be rendered to make the piece look like it is cooking up out of the surface. "Connections" may be extensions from any part of the letterform, or an arbitrary construction felt visually necessary. Some artists have focused more on blending letterforms while others have gone in the opposite direction, pushing the segmenting of forms. And of course these approaches are combined. The combined effect that writers strive for with these devices is a work that conveys spontaneity and energy, almost as though the piece burst into existence on its own.

ARROW FORM **FILL** **OUTLINE** **BORDER**

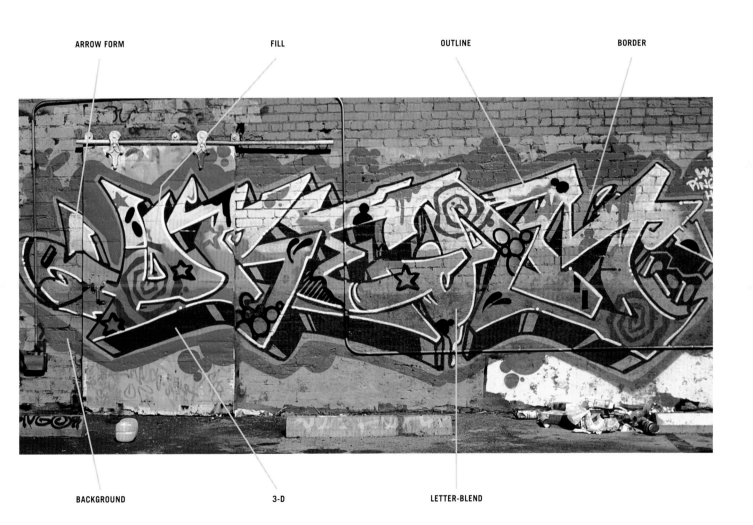

BACKGROUND **3-D** **LETTER-BLEND**

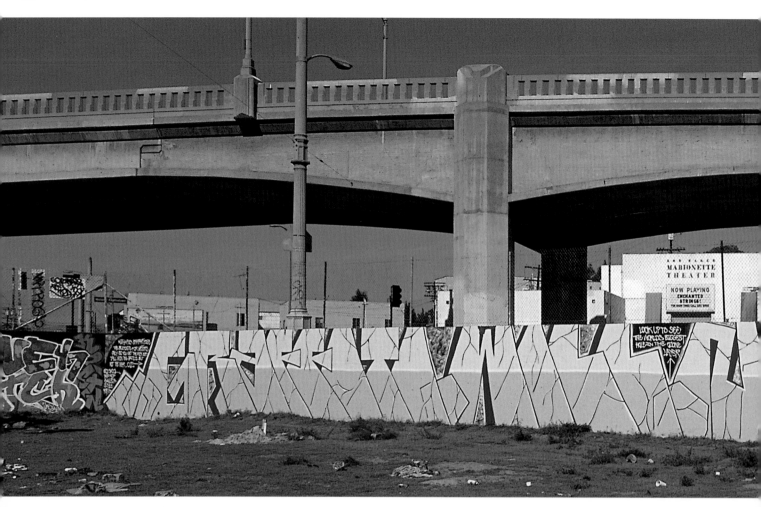

↖ A mix of segmented and blended letters, **FUSE**, Motor yard, 1992 ↗ A single sparkle, **PISTOL45**, Motor yard, 1995

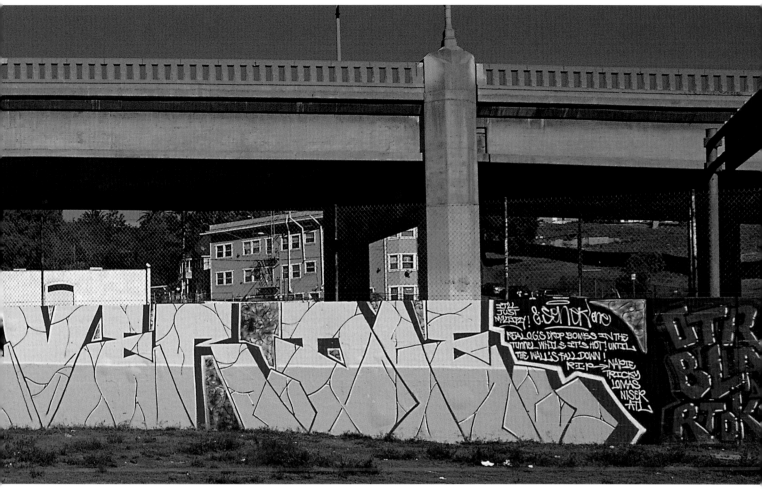

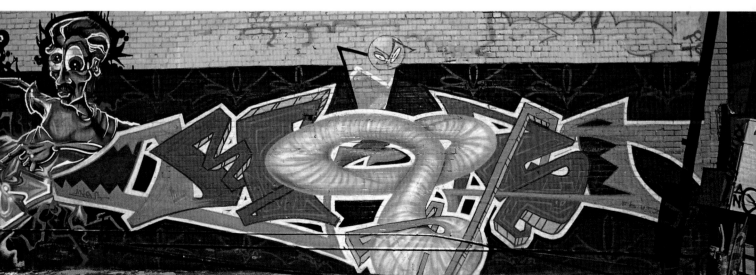

↑↑ *Graffiti Will Never Die.* An example of cracks on gang block style letters, **SONEK**, Belmont, 2004 ↑ Letter connections, **ANGST**, Artist District, 1993

SIGNATURES AND SHOUT-OUTS

"Shout-outs" are the names of crew members, other crews, and respected writers, girlfriends, or whoever else the writer or writers want to say hello to. These names are usually very legible and may be written inside or around the piece. The signature of the writer or writers is usually more prominent than any of the shout-outs and accompanied by the crew or crews of which the writer is a member. Sometimes the entire roster of a particular crew is listed by the side of a piece and is referred to as a "roll call." Some writers numbered their pieces, but this practice diminished, as many writers were suspected of pumping up their numbers. "C/S," meaning "con safos," may be seen by the side of a piece. This is a Chicano *placa* tradition that literally translates as "with safety" or "respect," as in respect this piece.

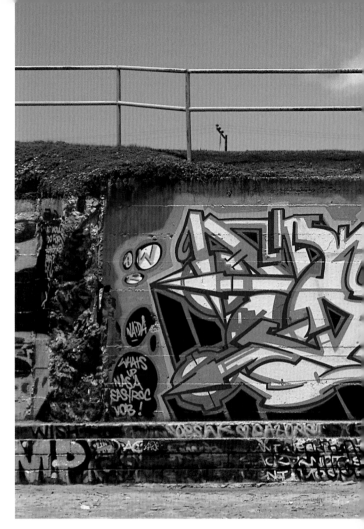

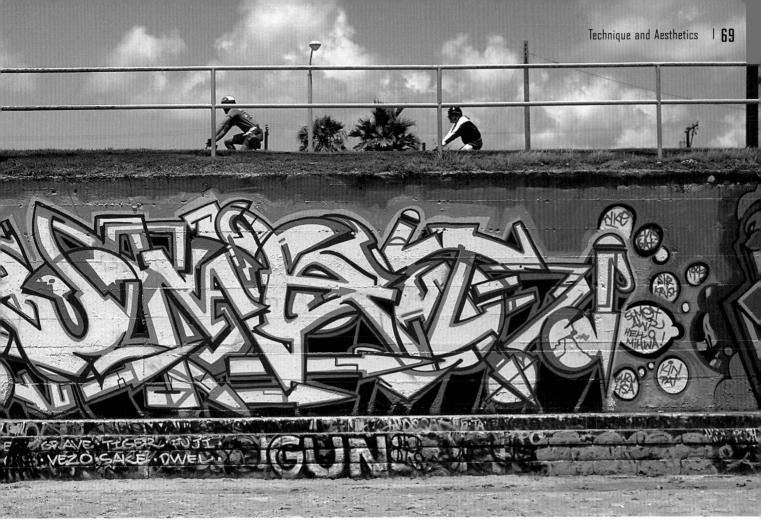

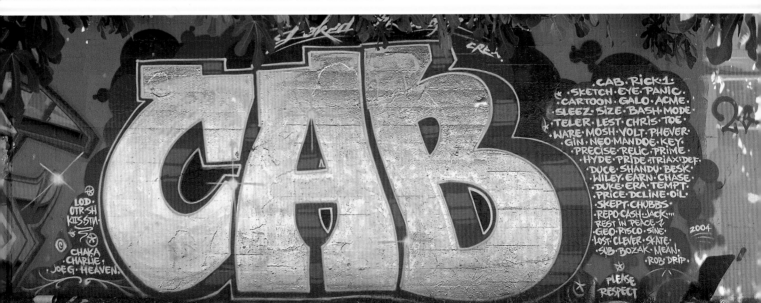

↑↑ **SUMET**, with shout-outs, Huntington Beach, 1993 ← **AWR** roll call, Motor yard, 1992 ↑ **CAB** with roll call, Belmont, 2004

FLIPPING THE SCRIPT: LEGIBILITY

One of the first things a viewer might notice in a piece is the axis of legibility to illegibility. On one extreme, there are traditional fonts. On the other extreme, there are wildstyle abstractions of letter forms. While the roller pieces using straight "block" letters may be immediately legible, wildstyle pieces may only be legible to the artist who painted it. People outside the graffiti world are sometimes puzzled that so much effort would be put into a work that is not easily readable, but the concept is exactly the same as in the Western art world axis between realism and abstraction: letterforms are the springboard for formal and creative exploration, or "flipping the script," in the same way that the figure served for twentieth-century figuratively based abstract artists from the cubists to De Kooning. Legibility is a secondary issue: a distinctive personal style and visual logic is primary. There are all degrees on the axis between clear letters and ones that are not necessarily meant to be read. In the Western art tradition this concern with aesthetic effect is referred to as "the poetics of the plastic,"—the "plastic" being the materials that are used. Many ancient cultures have writing traditions that value aesthetics over function in expressive letter formation, such as "Grass Style" Chinese calligraphy, as well as Celtic and Islamic religious texts.

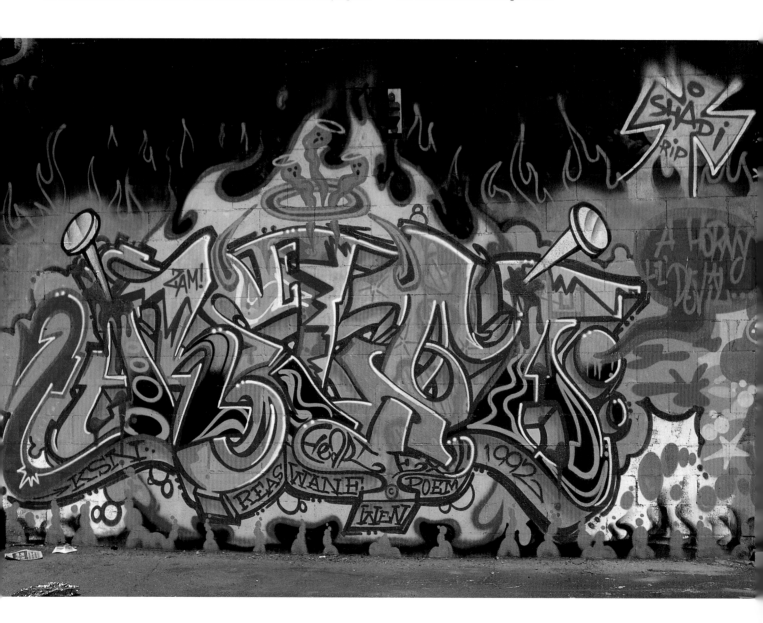

On the other hand, while these pieces may easily be appreciated purely for their abstract aesthetic value, then that appreciation is greatly compounded if the letterforms are recognizable, because then the viewer is able to see the creative play of the letterforms, how they were altered, and how the connections and other devices are used for formal contrast and balance. The implied questions in these cases are "What is the essence of a given letter? How far can that essence be pushed for visual effect but still be maintained? And how can that be applied to the relationships in a series of letters?"

CRIME: It's not about numbers of tags and throw-ups, it's about letters: everybody's excited about the next kind of letter that's going to come out, about who's pushing the envelope and creating a unique letter form.

Writers have drawn on many sources for their letterforms including contemporary block fonts, capped Humanist fonts, cursive, and Black Letter styles. The serifs or any element of the letter may be emphasized, modified, or eliminated according to the writer's whimsy, and in conjunction with "connections" (extensions from any part of the letterform, or an arbitrary construction), may carry as much or more visual weight than the body of a letter itself.

↖ **RELM**, Artist District, 1996 ↑ **RELM**. Fill eliminated to show letter alterations and relations.

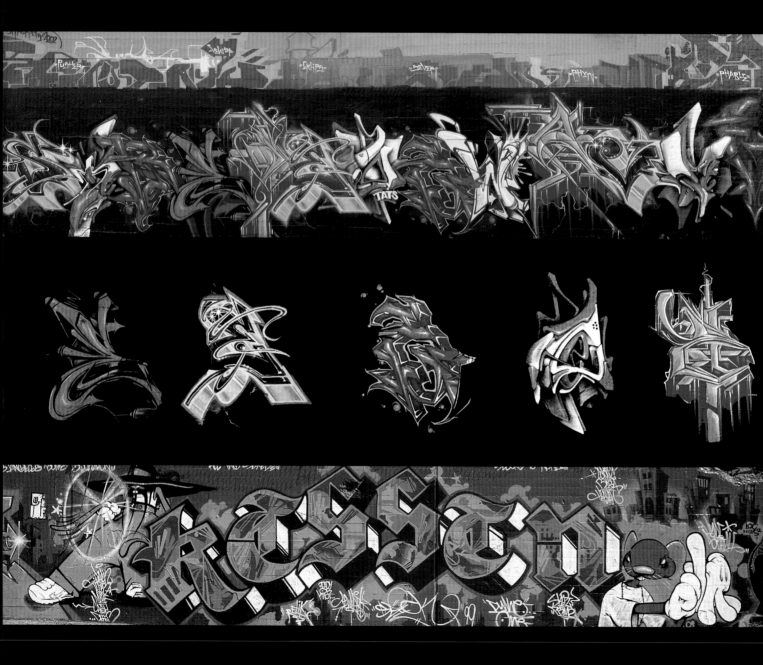

↑↑↑ **SEVER**, **TOTEM**, **EWOK**, **REVOK**, **SABER**, Highland Park, 2003 ↑↑ (from left to right) *"E"* **EWOK**, **SEVER** *"E"* **REVOK** *"E"* **TOTEM** *"E"* **SABER** ↑ *K2SSTN*, blackletter style, **DUKE** and **TEMPT**, Belmont, 1999

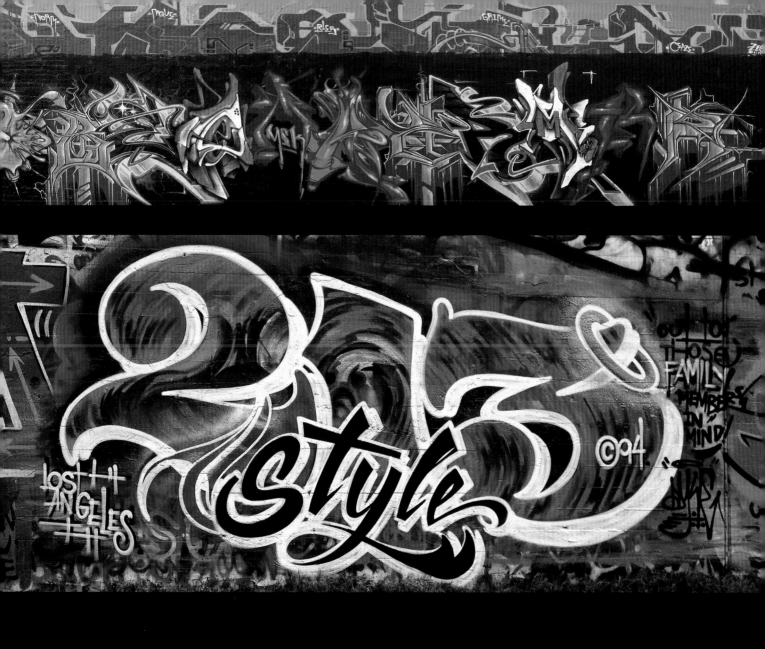

CAN CONTROL

RISK: Everybody that does graffiti gets to a point where they think a drip is beautiful, and when you get to that point, you've reached a true inner artist and now you can realize what's beautiful and what's not.

"Can control" refers to the consistency of line quality and general control of the paint to get the effects desired. Many early New York train writers had extremely crude can control, but by the mid 1970s, quality had greatly developed. While there is a common effort to show skill and control of the medium, some writers will include deliberate drips in contrast to drips from lack of skill. Carefully painted Pop art–style drips and splats are common as part of the letterform, on the letterforms, and in the fill. Can control also plays an important role in the relationship between the thickness of lines outlining the forms, and to the width of letterforms themselves: weak lines tend to result in weak pieces.

Some writers think there can be too much control or lack of old-school spontaneity and have developed styles based on a very loose let-the-paint-look-like-paint approach. Siner, head of LTS crew, is widely regarded as the foremost exponent in Los Angeles of the raw, spray-painterly style, sometimes called "dirty," along with crew members Braille, and former crew member Retna. In referring to Western art tradition, the LTS style would be considered "naturalistic," in contrast to the "realism" of sharp-edged pieces, where the quality of paint is not evident to the uneducated eye. LTS members use brushes in their work, as well as Saber of AWR, who has painted full-scale pieces with brushes in the same speed at which a spraycan is used. As is often the case when somebody takes a new creative approach, Siner's raw style puzzled and alienated many writers at first until they finally understood the aesthetic, and now hold him up to be a top writer.

SINER: The music that went along with graffiti was hip-hop, so the writing reflected a similar movement—bending your letters to seem like they were flowing. I remember really loving graffiti at one time because it was really loose and we would go up and do a piece in a couple of hours. And then it got to a point where everything was so tight it became more technical. So I just had to come back to the reason I got into it in the beginning—to have fun. I got away from all the technical shit and got loose with it, because I know that when I step back, it's sharp. And what comes out is the style . . . I don't care about how clean it is. I want to flex that style and flip that "S" and that "I" and all the letters in there so they have a feeling that they flow together. I don't know how it is that I do what I do, but it seems to come out naturally, and I'd rather do it loose than to confine myself to do something clean and pretty.

SINER: (speaking about an LTS production piece done in a show open to all artists, where the roof area was reserved for graffiti writers) People look at some of the graffiti and think it must have been done with an airbrush or brush, but you look at that and there's no mistaking it as anything but graffiti . . . we're splattering paint, using cheap paint and good paint, and whatever we had. We never had a finished goal, like it just kept going. Every other crew there had their wall where they were doing burners of their crew names, and our wall was marked off and they wanted us to do a piece that said such and such here—it had to do with the party opening—and we said, "No. Skip that. We're going to paint this shit." And we didn't even come with a sketch. We just went off and everybody in the crew, whoever wanted to paint, came through and added their two cents to it. Ayer, rest in peace, was part of it.

→ Rooftop production, **LTS**, Downtown L.A., 1997

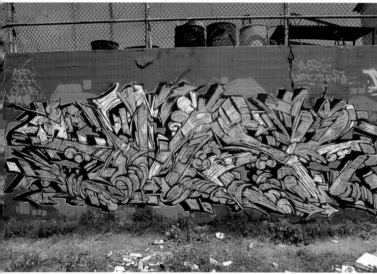

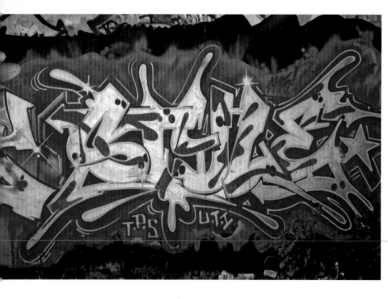

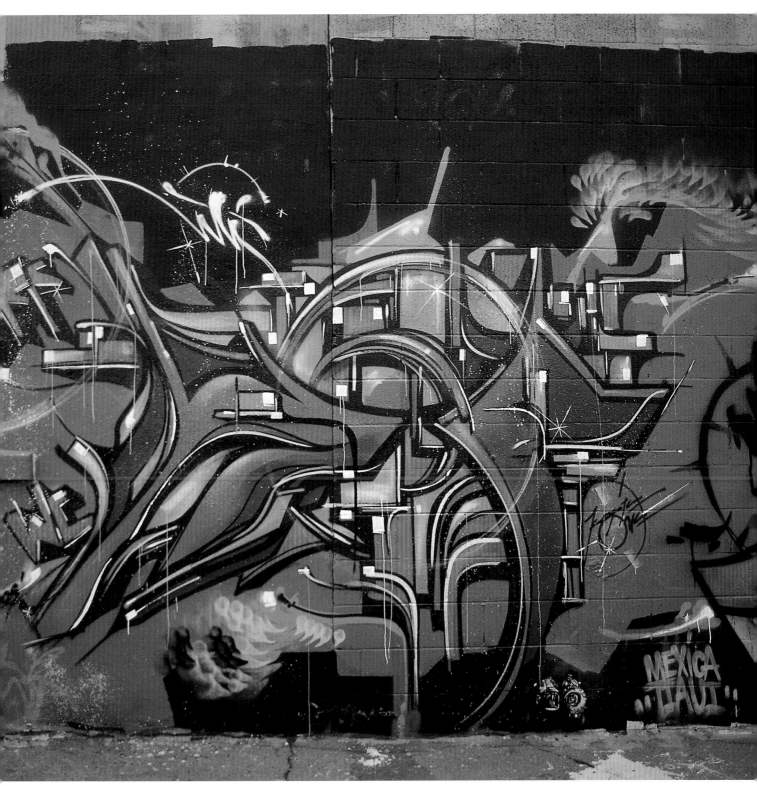

↖↖ **TOONS**, Melrose, 1991 ←← **SINER**, Belmont, 2004 ↙↙ *Style*, **JO JO**, Motor yard, 1995 ← **SABER**, Melrose store commission brush piece, 2001 ↑ **KOFIE**, East L.A., 2005

FILL

When given enough time to do a full piece, most writers consider the fill inside the letters to be an important element of their creativity, often equal to the letterforms themselves. Common fill forms include blended organic forms and edged forms, stars, circles, and free-form lines, which have been adapted from the New York tradition. Paint may also be sprayed into the can lid and then flung at the surface to create texture. The fill is often used in a highly dynamic relationship to the letters, with the interaction varying from emphasis of the letterform it occupies ("obeying" the letter edges), to a visual counterpoint, the fill scheme moving independently from the letter edges with a naturalistic progression across a piece as a related but independent design element.

SILVER PIECES

Skept of K2STN introduced Los Angeles writers to "silvers," after seeing pieces done in this color during a 1985 visit to New York. Silver pieces, which consist of an outline color and a silver fill, create an interesting bridge between throw-ups and full-color pieces. As a demonstration of skill and creativity with letterforms alone, writers use silver pieces to pay homage to throw-ups and the evolution of the graffiti art form. While some writers have been accused of using elaborate colors to distract from their weak design and execution, in silver pieces the technical and creative abilities of a writer is laid bare.

Using silver can also be both beneficial and convenient. The color stands out well, even at night, though white, gold, or any other bright color might be substituted. And in situations in which writers have to climb onto a rooftop or other illegal place—where they may want to work and quickly exit—traveling as light as possible is desirable. And in high-risk situations, simple designs may also be preferable.

EKLIPS: "Simples" are legible, simple letter styles, two-color, maybe with a drop shadow, in contrast to a throw-up, which is bubble style, one-line, no corners or edges. You would rock a simple on a freeway wall, but a throw-up on an off-ramp!

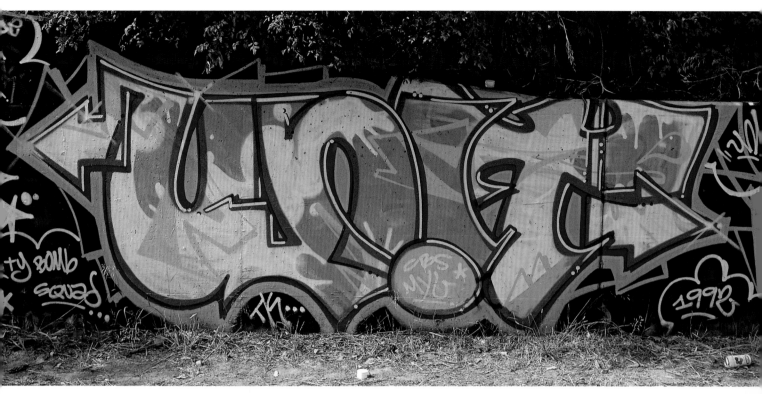

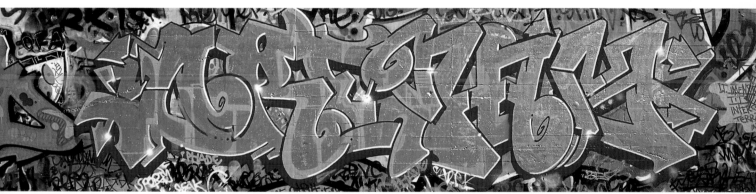

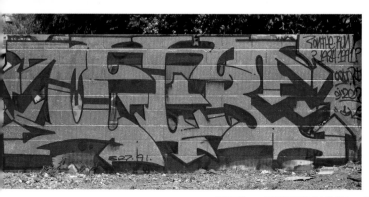

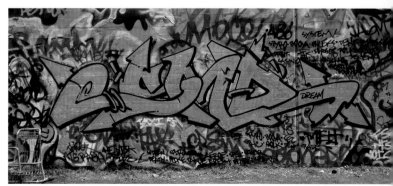

↖↖↖ Flung paint fill, **TOONS** (detail), Melrose, 1995 ↑↑↑ Counterpoint fill, **UNIT**, Motor yard, 1992 ↖↖ **SKEPT**, Arroyo Seco, 1994 ↑↑ **DREAM**, Belmont, 1991
← *ANC*, **BENX**, Belmont, 1991 ↖ **ODIN**, Sanborn yard, 1991 ↗ **DREAM**, Belmont, 1991

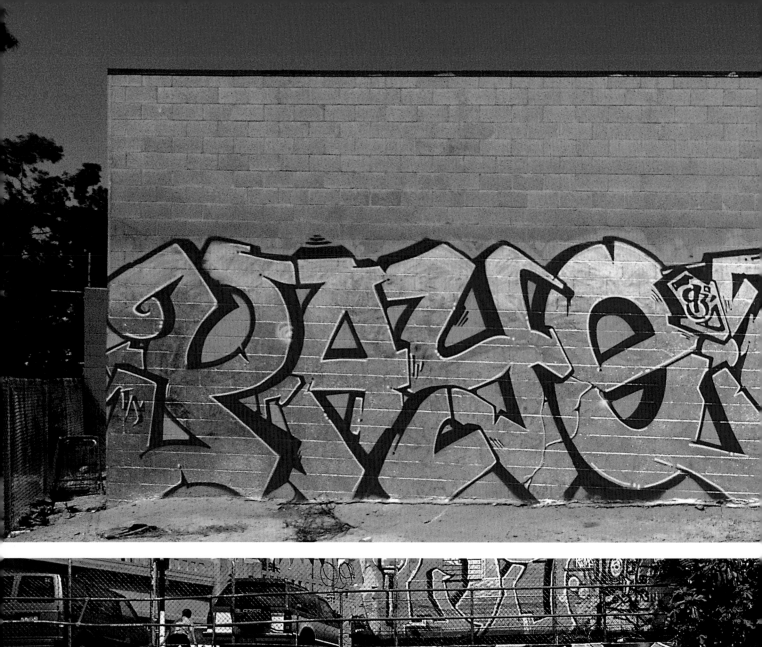

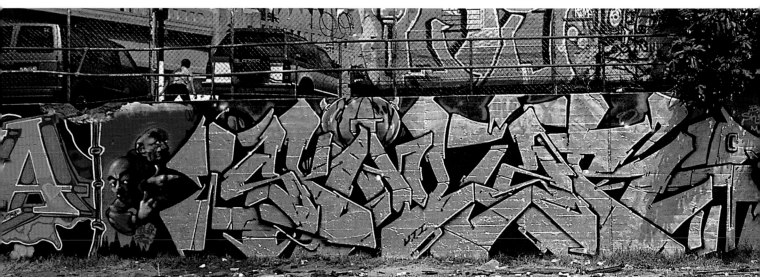

↑↑ **PALE** ("Payel") and **TOLSE** (R.I.P.), Whitsett and Sherman Way tracks, 1993　↑ **SKILL** and **PANIC**, Belmont, 1997

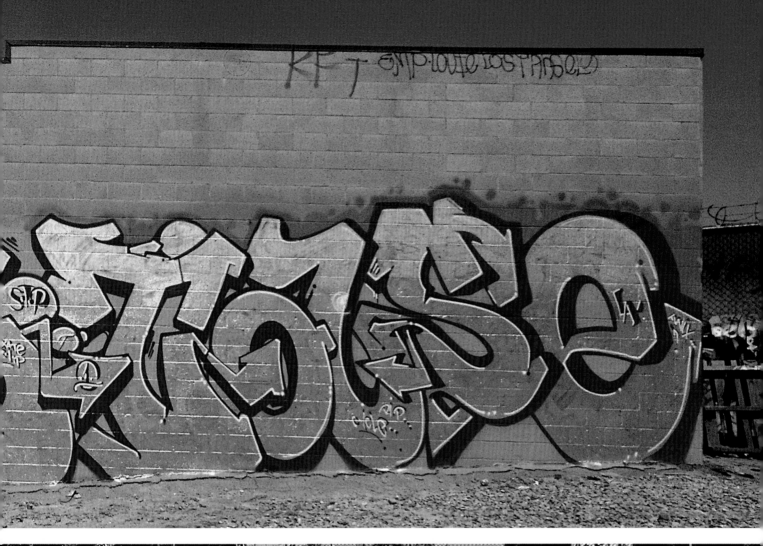

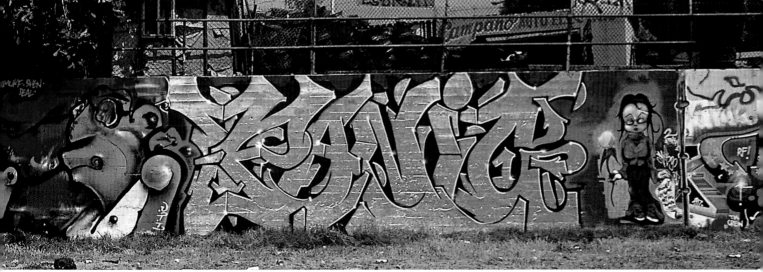

DIMENSIONALITY

The representation of dimensionality in graffiti began in the pre-wildstyle days of gang letters, where depth illusion was added to a flat surface, usually at a forty-five–degree angle, an idea taken from the earliest forms of signage. Early wildstyle quickly adopted that device, and writers started to run with the idea. Early L.A. pieces incorporated not only finely feathered shading, where forms cross over one another, but also in fill forms. Generally, the letterforms are sketched in before adding the three-dimensional element.

Some writers began to add further modeling to the letter surface, pushing it beyond a flat single plane. Tyke used subtle gradations of color to give his surfaces texture, depth, and form, and Crayola used close colors to make his surfaces seem to ripple. Deas, Aeroe, and Split used modeled rounded forms. Ewok and Potna render surfaces that seem bio-morphic, or like forms in nature. Writers such as Slick began to use established air brush technique for representing rounded chrome surfaces as well.

These kinds of dimensional illusions are a different issue from the representational aspects found within the fill of letters represented on a flat plane. The final stage added

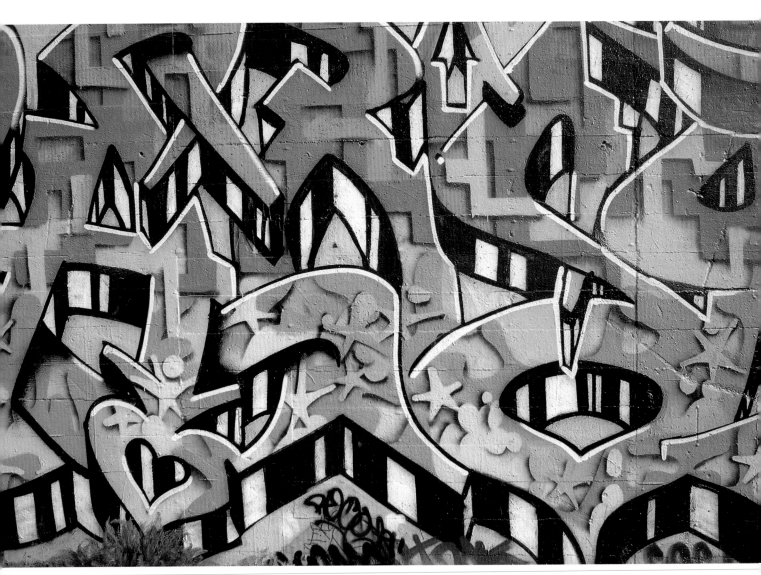

↑ **MANDOE** (detail), Belmont, 1990 ↗ **OZER**, Hollywood, 2006

to letter dimensionality is "full 3D," (simply referred to as "3-D" pieces) where the letter surfaces are treated to appear at different planes of angles to each other. While some writers regard full 3D as the pinnacle of virtuoso graffiti, weak design and letterforms are still possible. When letterforms do not stand up two-dimensionally, three-dimensional treatment can be used as a cover-up. 3-D pieces require skill, but the end result can sometimes appear sterile in all of its control.

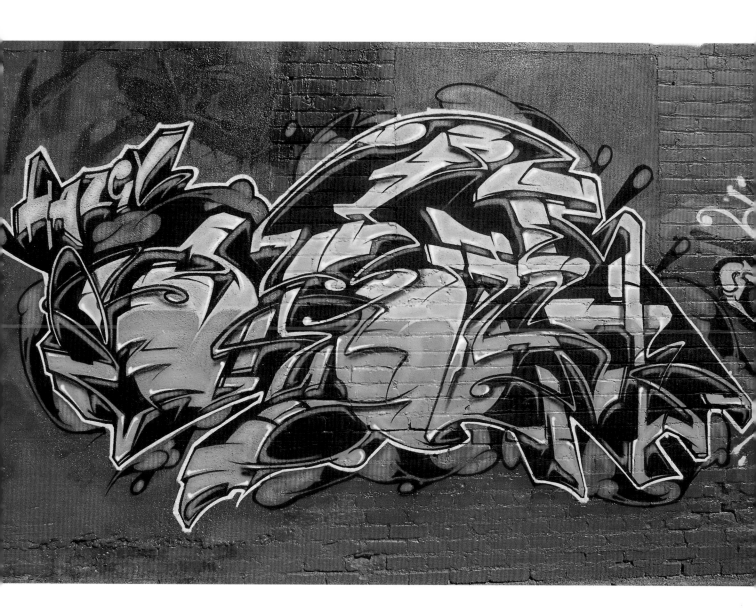

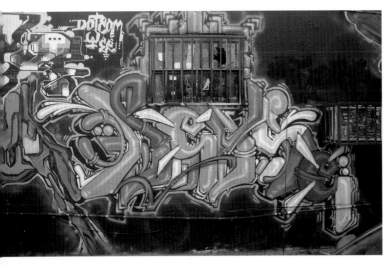

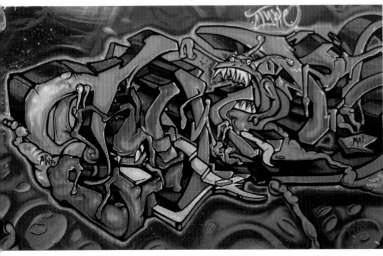

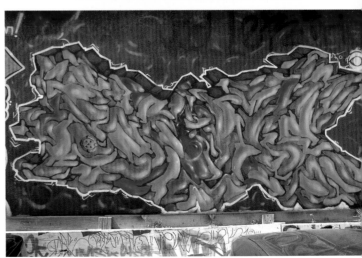

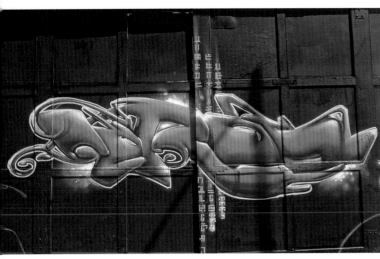

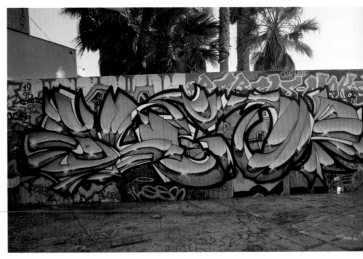

↖↖↖ **DEAS**, Melrose, 2005 ↗↗↗ **POTNA**, South Central, 2004 ↖↖ **TYKE WITNES**, Melrose, 1997 ↗↗ **SPLIT**, Melrose, 2002 ↖ **AEROE**, El Serreno, 2002 ↗ Artist unknown, Venice Pavilion, 1995

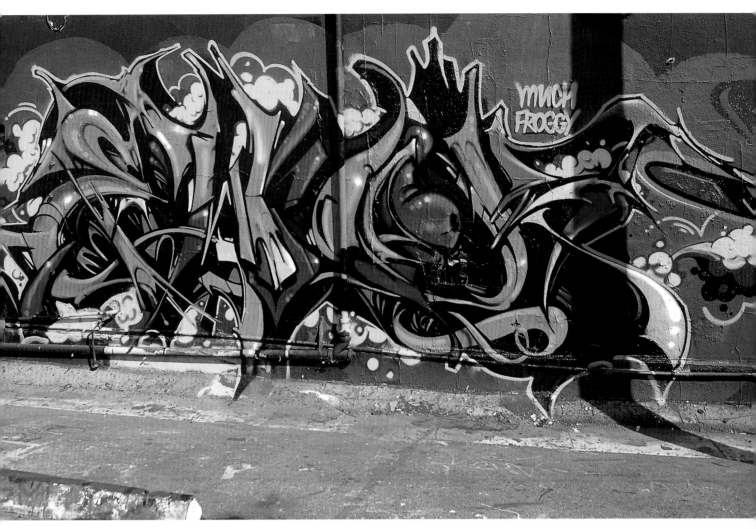

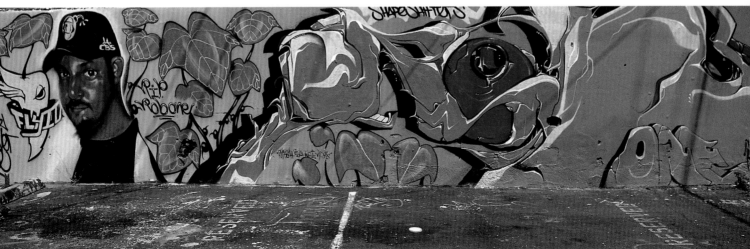

↑↑ **EWOK**, East Hollywood 2005 ↑ Rob One Memorial, **CRAYOLA**, portrait by **PHEVER**, Melrose, 1994

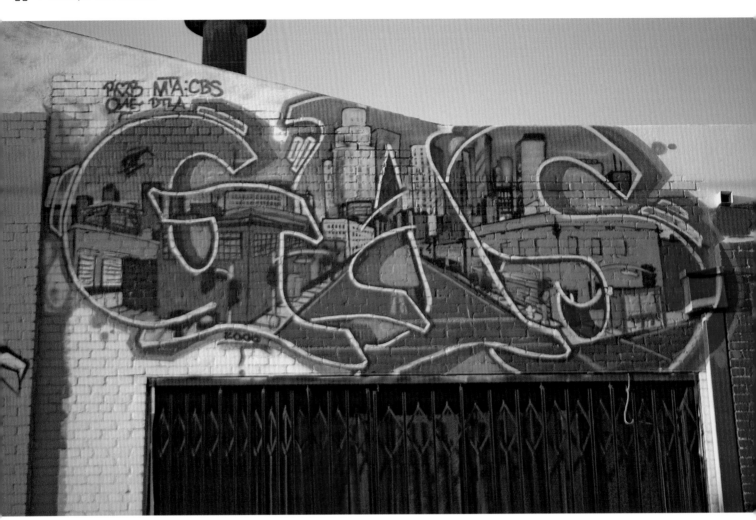

Representational scenes as fill. ↑↑ **GAS**, Hollywood, 2000 ↖ **NERV**, Slauson tracks, 1993 ↗ **KATCH** (detail), Conart, 1996

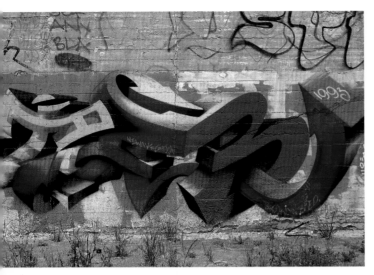
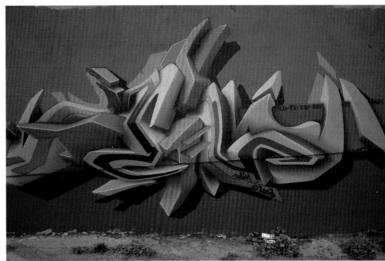
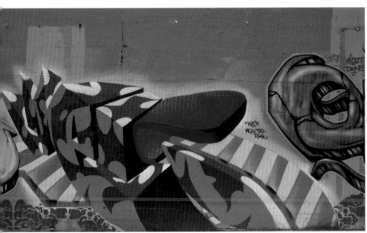
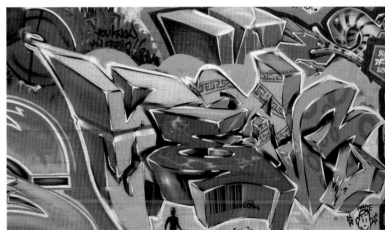
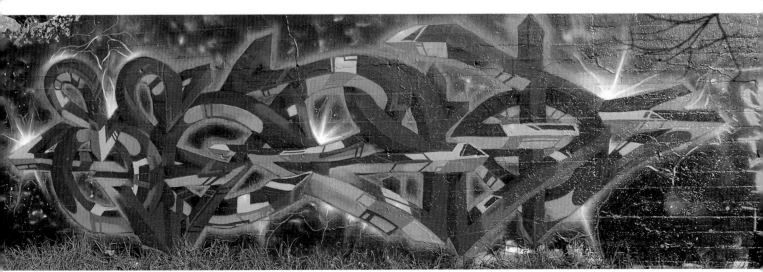

↖↖↖ **ERNIE**, Artist District, 1993. This Brooklyn writer was an important early 3D inspiration to L.A. ↗↗↗ **DAIM** from Germany, East L.A., 2003 ↖↖ **KEO**, East L.A., 2002 ↗↗ **MEAR**, Melrose, 1995 ↑ **SECRET**, Belmont, 2001

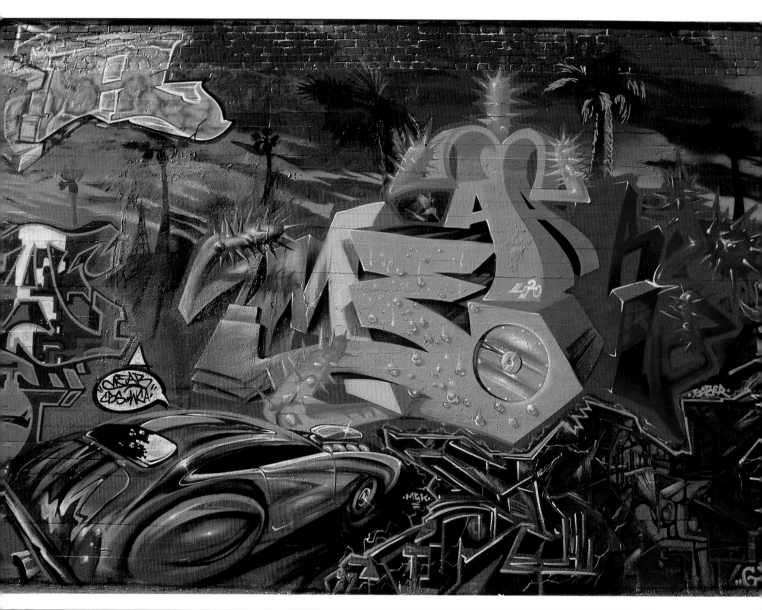

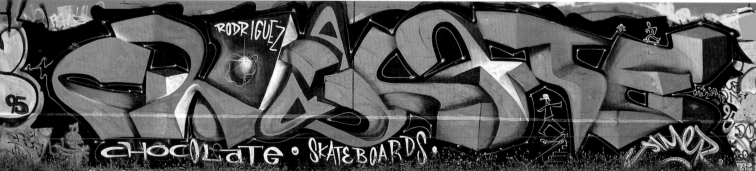

↑↑ **MEAR**, Melrose, 1997 ↑ *Chocolate*, **JIMER**, Jefferson yard, 1995

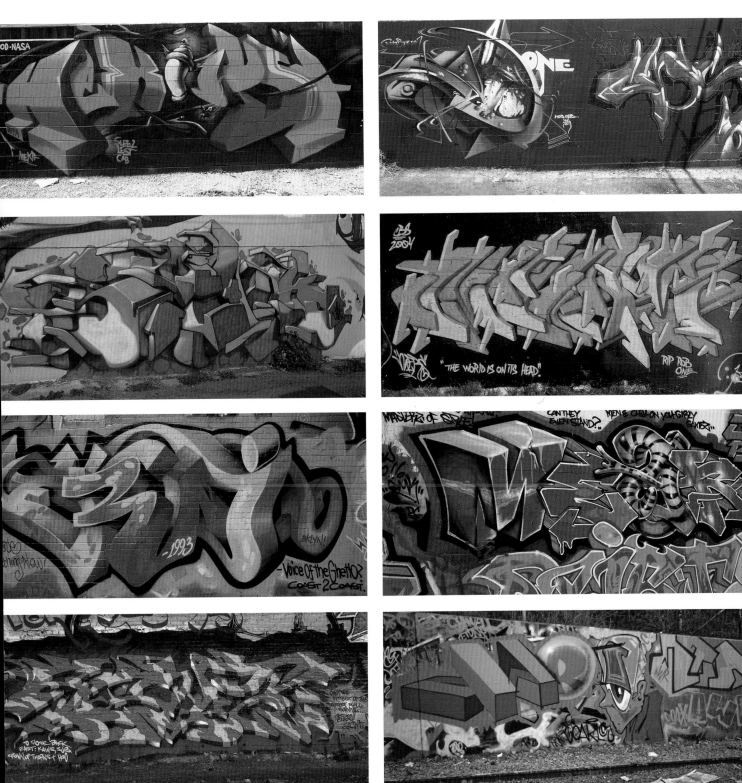

⟵⟵⟵⟵ **HEX LOD** (left), **JUST195** (right), Melrose, 2004 ⟶⟶⟶⟶ **RUKUS** (left), **DYTCH** (right), 2005 ⟵⟵⟵ **SWANK**, East L.A., 2002 ⟶⟶⟶ **MERS**, Belmont, 2004 ⟵⟵ **ERNIE**, Artist District, 1993
⟶⟶ Mixing of flat and modeled surfaces, **MEAR**, Melrose, 1995 ⟵ **T-DEE** (from New York) East L.A., 1995 ⟶ 3D before Earnie's visit, **COAX**, Motor yard, 1992

REPRESENTATIONAL ELEMENTS

Early representational elements in graffiti were inspired by popular cartoon characters like those of Vaughn Bode, caricatures of homeboys, street life, crew members, or the artists themselves, and spraycans and markers as tools of the trade. Characters are often located in or around a piece, sometimes with figures or objects that substitute for letters. While a deliberately old-school approach to characters may be used, numerous writers today have developed high levels of skill in either an idiosyncratic, self-taught way, such as Kofie, Asylm, and Midzt, or in conjunction with traditional art school training, such as Swank and Mear. Classical representational devices such as core shadows, cast shadows, reflected light, and highlights can be seen in the most technical character work.

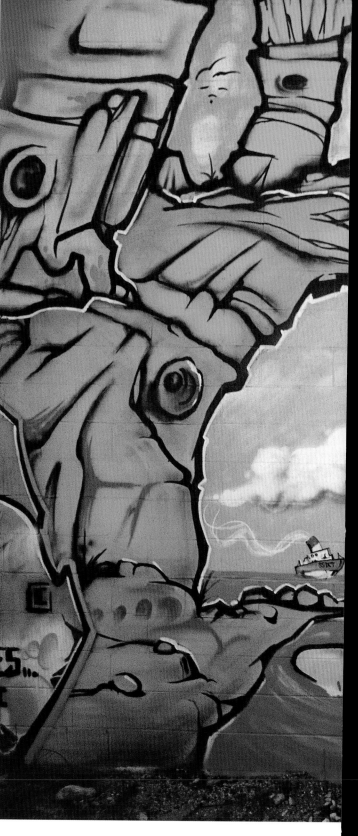

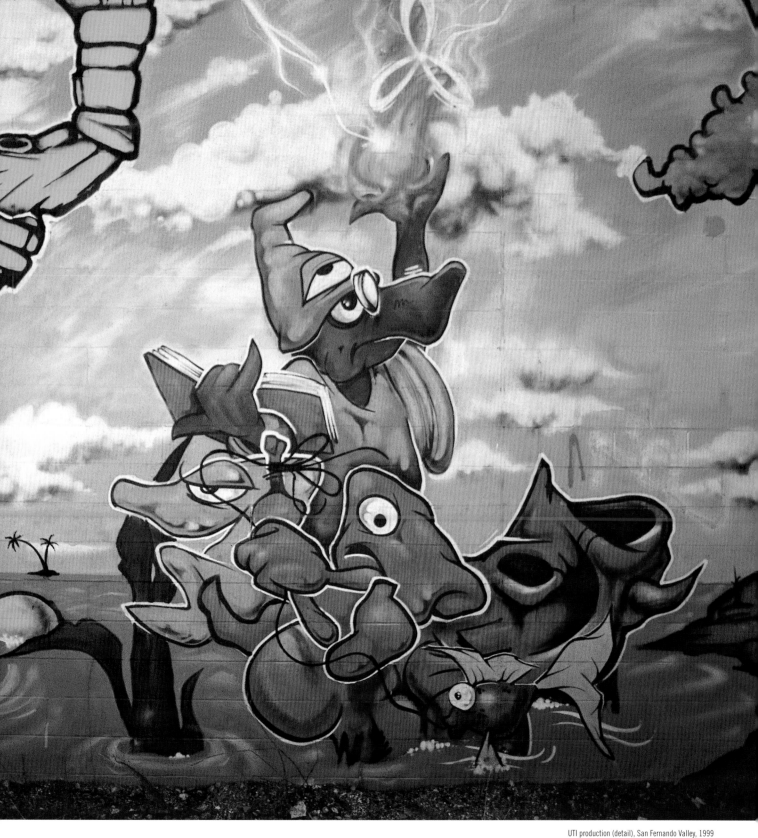

UTI production (detail), San Fernando Valley, 1999

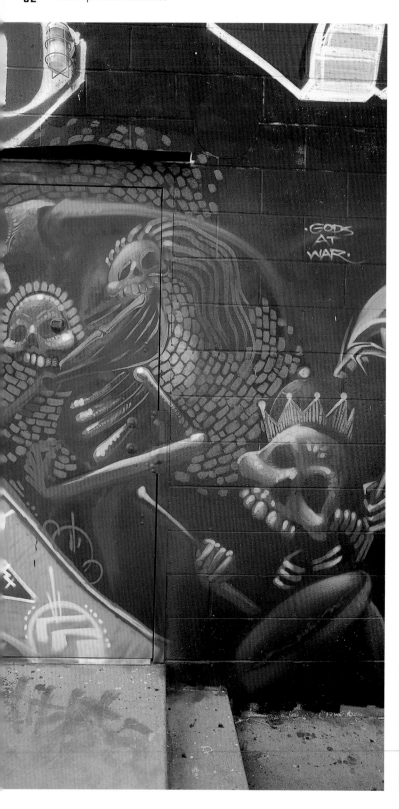

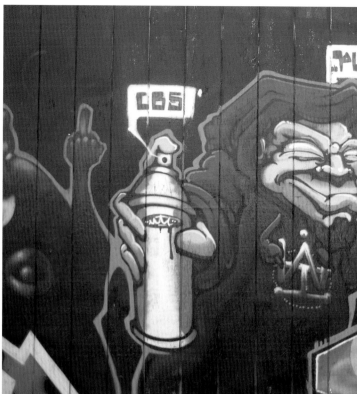

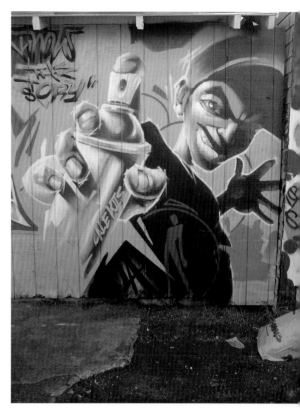

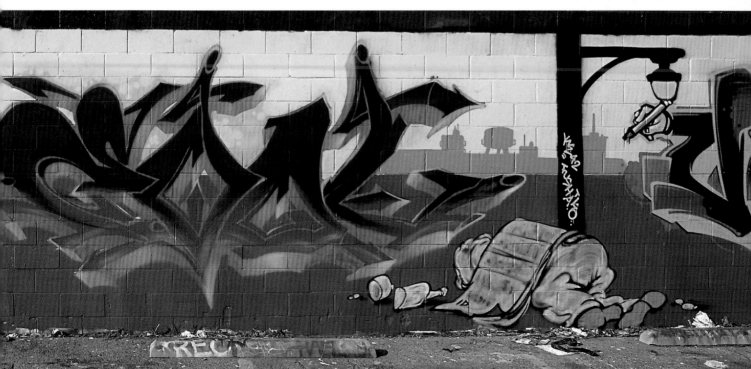

←← **MIDZT**, Highland Park, 2003 ↖↖ **PLEK**, El Serreno, 2005 ↑↑ **SEIZE**, Melrose, 2005 ↗↗ **CALE**, Melrose, 2005 ↑ **EVOL**, TKO production, South Central, 2004

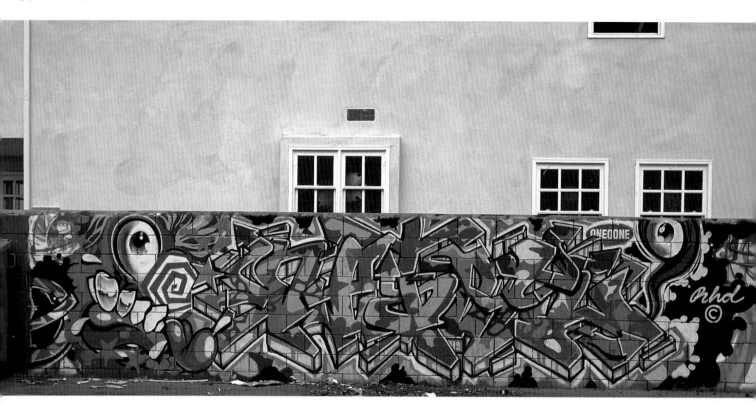

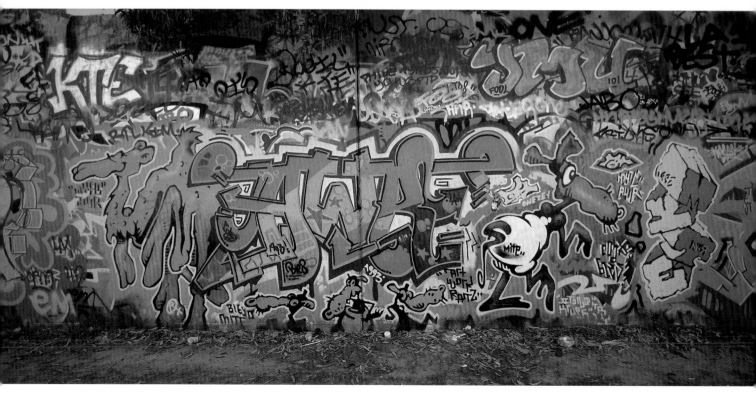

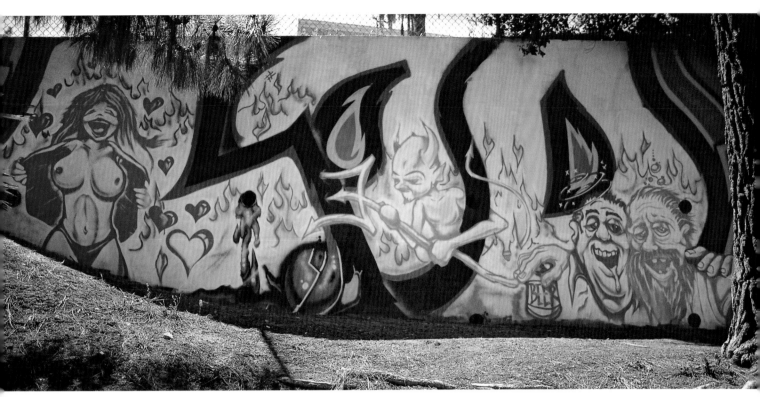

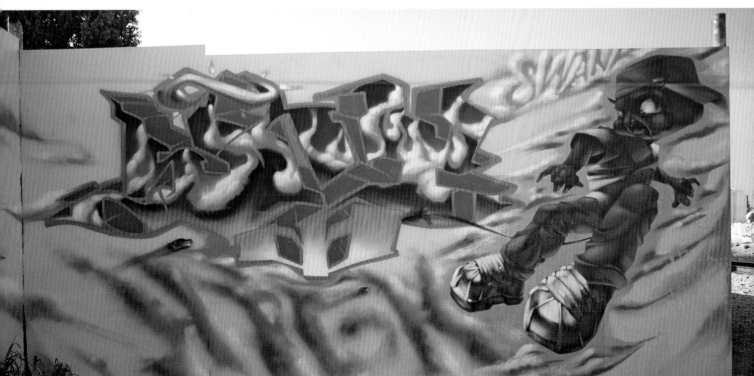

↖↖ **SEVERE**, Hollywood,1991 ↗↗ **LOD** crew, characters by **BASH**, Hollywood, 1995 ↖ Characters by **MYTE**, letters by **BLES**, Motor yard,1993 ↗ *Sky High*, **SWANK**, Commerce yard,1996

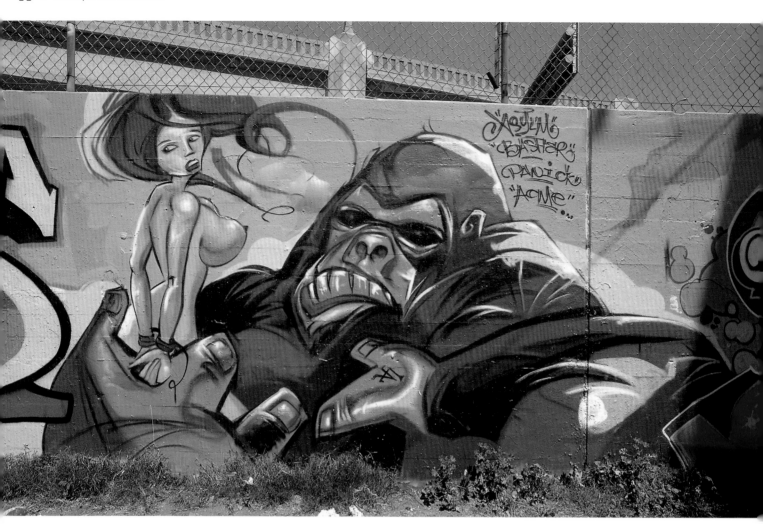

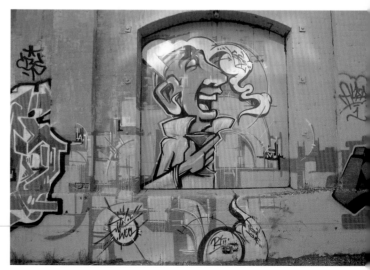

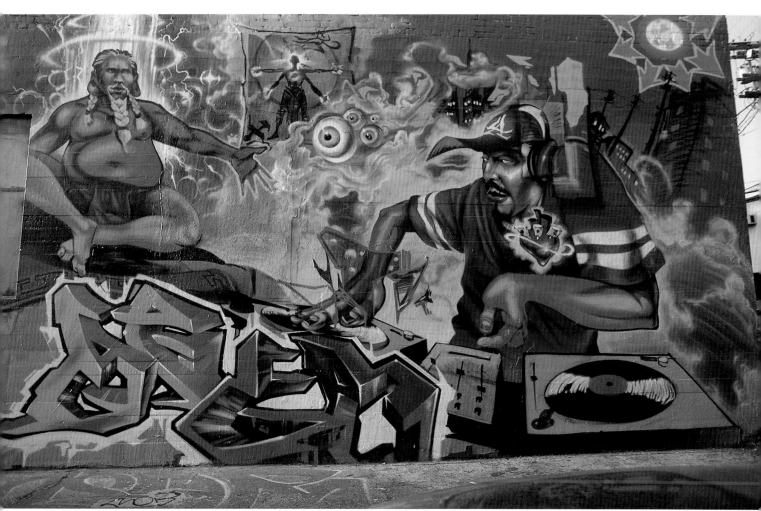

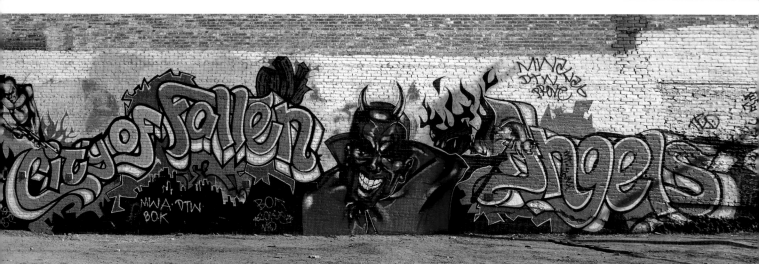

↖↖ **ASYLM**, Belmont, 2004 ↑↑ **SKATE** and **ROB ONE** memorial, **MEAR**, Melrose, 2000 ←← **MIDZT**, Mid-city, 2003 ← **KOFIE**, Artist District, 2003 ↑ **STN** crew, Sanborn yard, 1991

CONTENT

In the vast majority of pieces, the artists' or crews' names are used alone, even when the background and characters represent a cultural narrative or fantasy scene. If there is enough space, names may be altered, giving the writer more letters to work with, so Bash can become Basher and Size can become Sizer. Political productions may be inspired and sincere—and then there are the more insipid variety of protest. But not all these productions have left-leaning political statements, though the majority tend to be "counter-culture" or revolutionary in pose.

As for the crew names themselves, the acronym can have more than one meaning. AWR, generally stands for "All Writes Reserved" but may also be written out as "Angels Will Rise," "Art Work Rebels," or "Always Rockin'." CBS can be written as "City Bomb Squad" or "California Bomb Squad," but most often as "Can't Be Stopped." LTS may be written out as "Last To Serve," "Last To Survive," or even "Leaving Toys Stunned." UTI primarily stands for "Under The Influence," but can also be written out as "Unite To Inspire" and "Unleash The Imagination." The meaning of each acronym often depends on the audience. To outsiders or if painting on a permission wall, a writer from WAI may write the acronym out as "Wild Art Images," but to a different audience "Art" can be replaced with "Ass." Similarly, to outsiders UFK may stand for "UnForseen Knowledge" but to the crew members, "Us Fucking Kings." "King," often a self-given term, denotes a writer who is at the top of his or her craft.

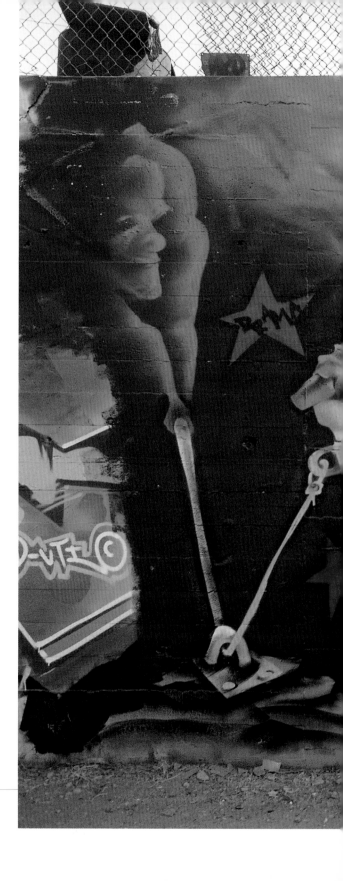

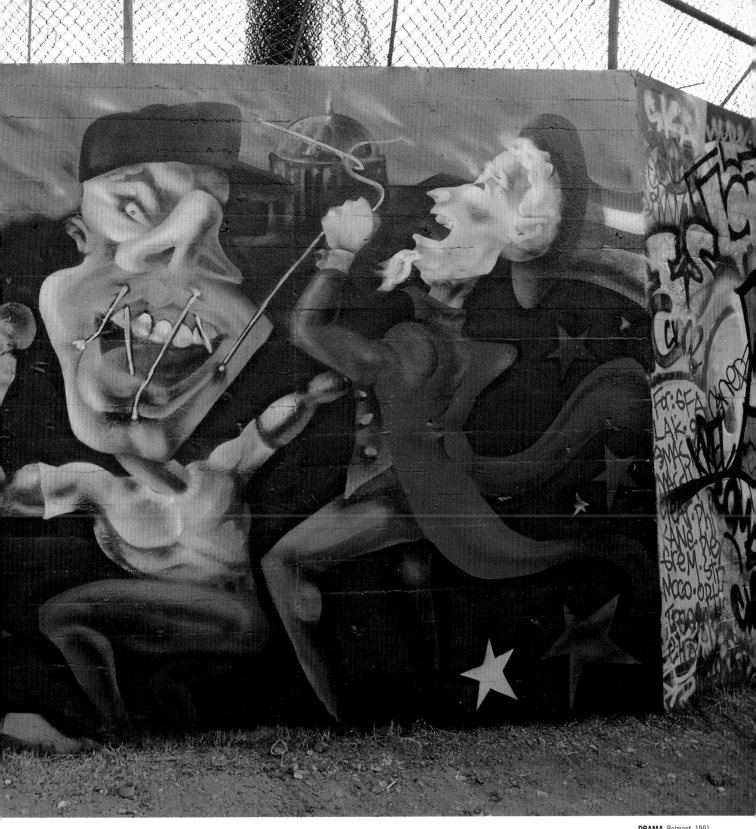

DRAMA, Belmont, 1991

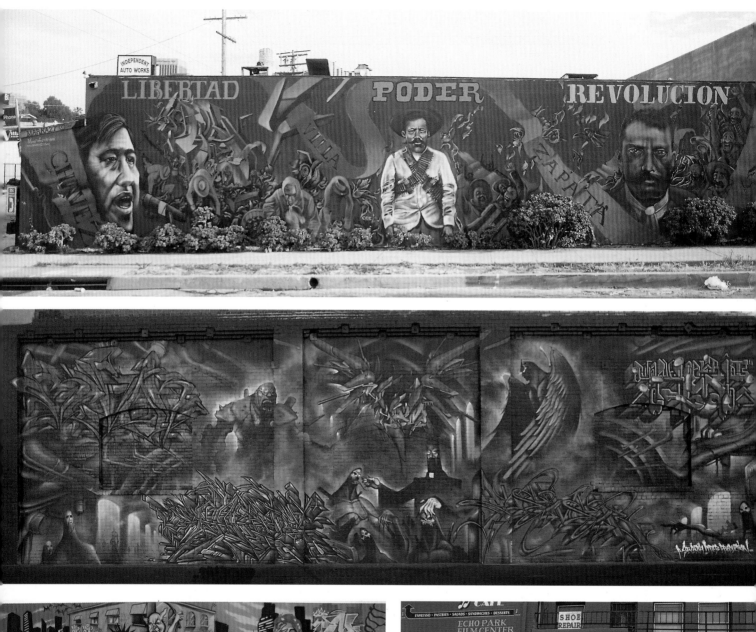

↑↑↑ *Liberty, Power, Revolution,* **MARKA27**, Downtown, 2004 ↑↑ **REVOK**, **TOTEM**, **JUST195**, **SABER**, and **SEVER**, Artist District, 2003 ↖ **MEAR**, Venice Pavilion, 1997 ↗ **MEAR**, Echo Park

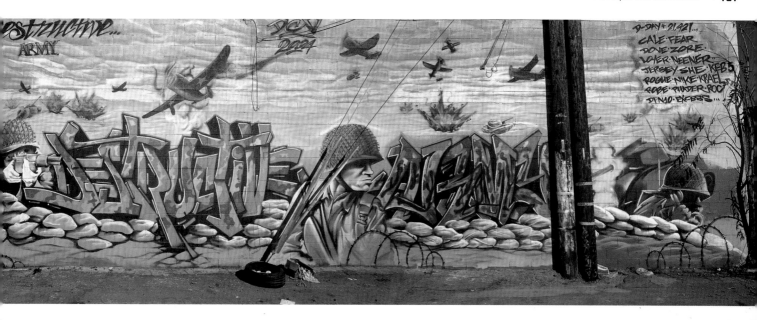

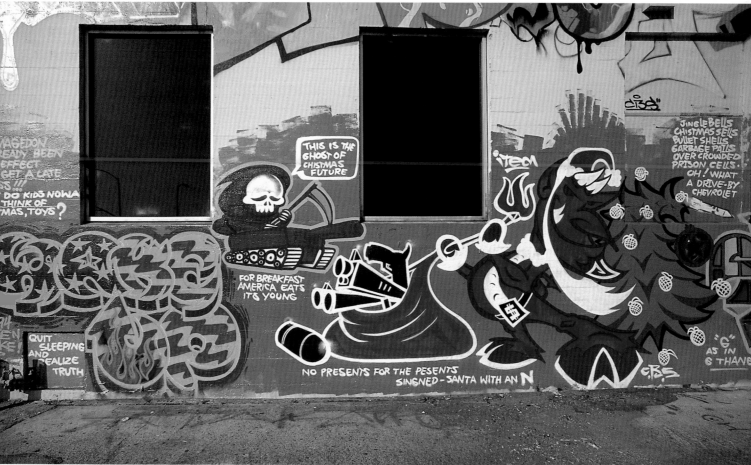

↑↑ *Destructive Army*, collaborative production honoring 50th anniversary of D-Day, East L.A., 2005 ↑ **ITEM**, Melrose, 1994

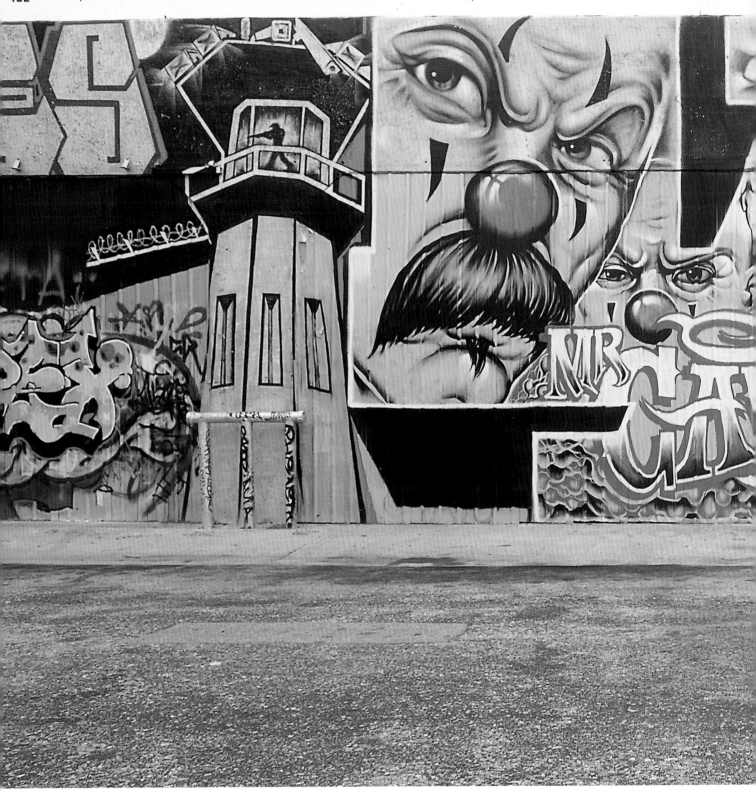

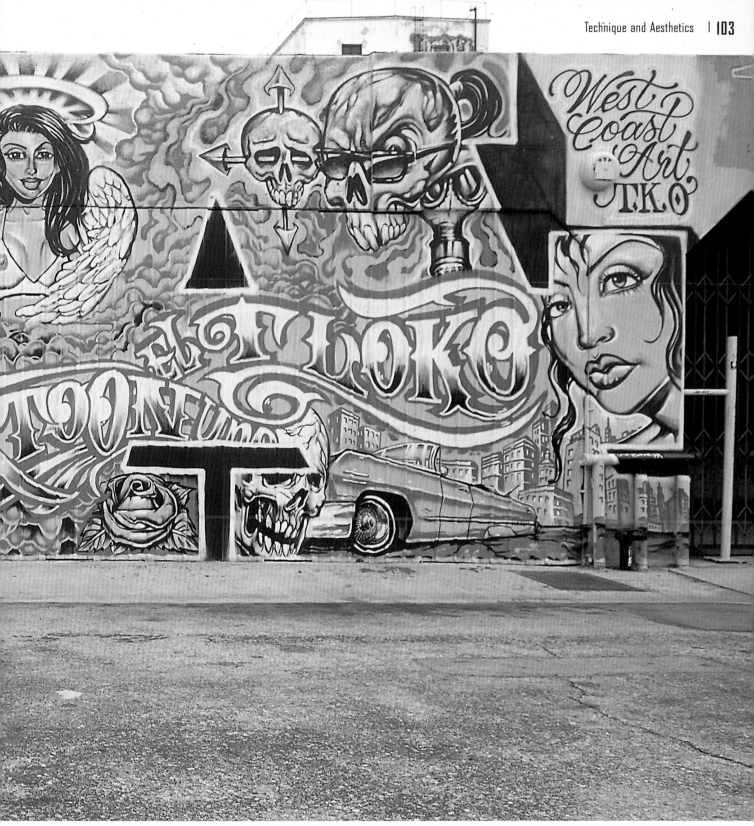

L.A. **MR. CARTOON** and **TOOMER**, Artist District, 2002

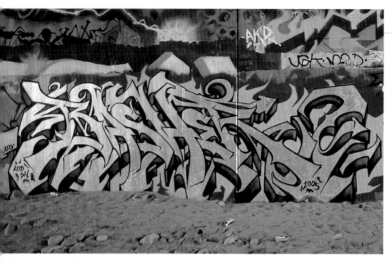
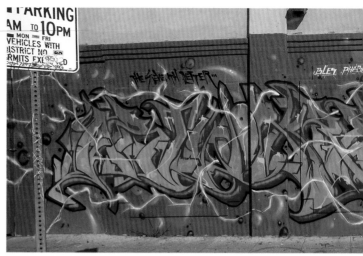

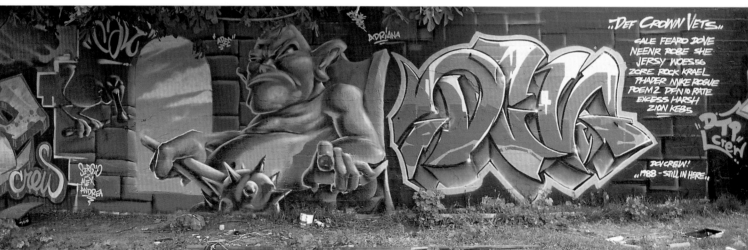

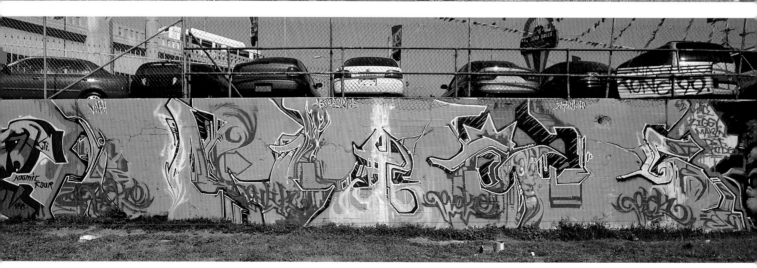

↑↑↑ *Basher*, **BASH**,SH yard 2005 ↗↗↗ (left) *Art Work Rebels*, **SABER** and **REVOK**, Hollywood, 2003 (right) *Last 2 Serve*, **RETNA**, Hollywood, 2003 ↑↑ *DCV*, **CALE**, Belmont, 2004 ↗↗ *CBS*, **SHOW**, *LODM* (Loks On Da Mota), and **SIZE**, Belmont Hill, 1993 ↑ **WAI**, Belmont, 2001 ↗ *I2W*, **PISTOL45**, Belmont, 2002

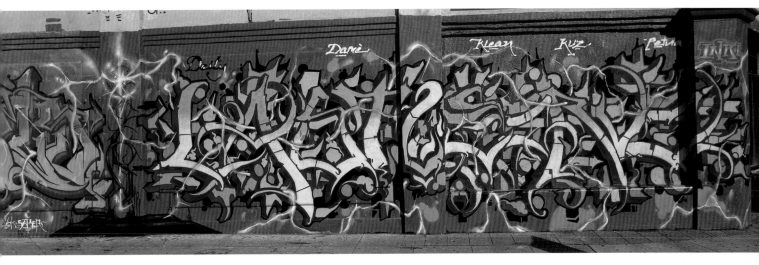

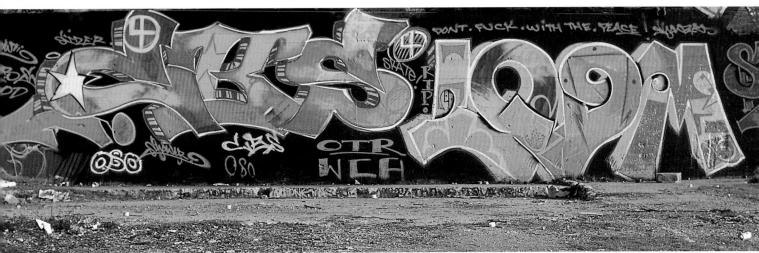

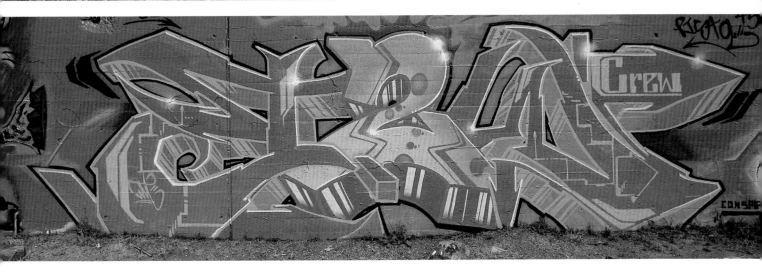

MEMORIALS

As in art traditions from the pre-historical to the classical western and vernacular, portraiture of friends, family, and cultural icons are consistently used in graffiti memorials and are often accompanied by posthumous dedications. One crew in particular, The Lost Boys, devoted themselves to tags using the names of now dead writers.

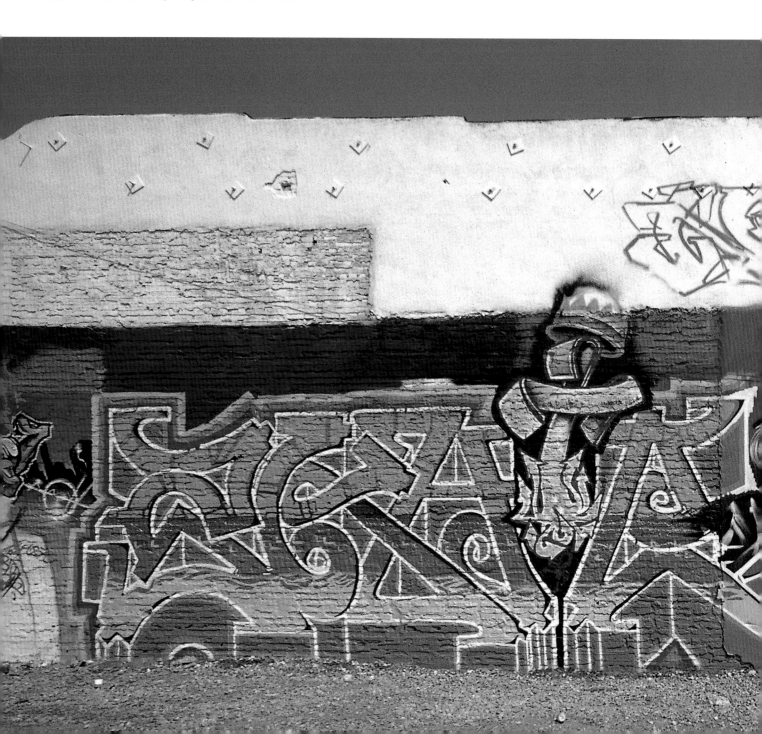

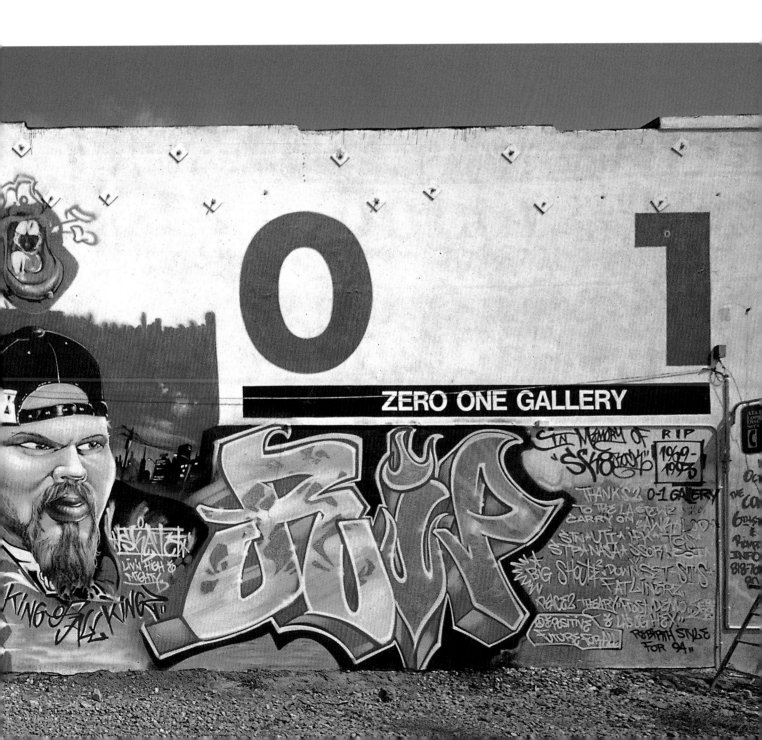

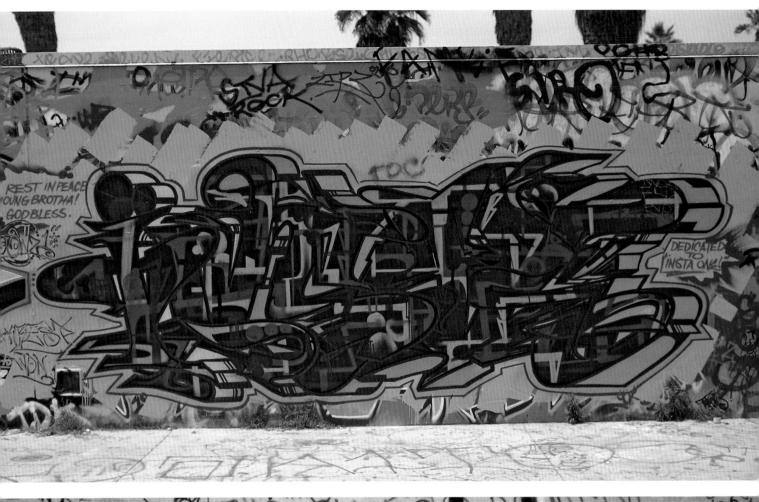

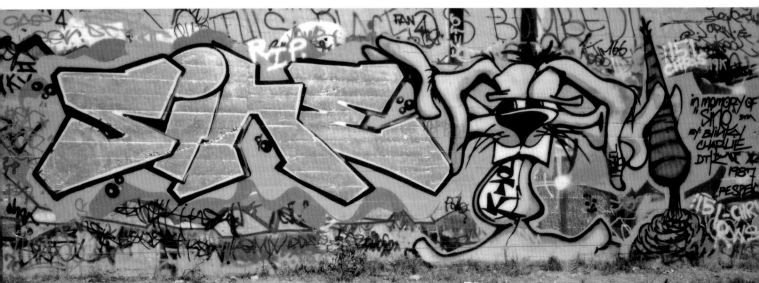

↖↖ **TOONS** memorial to Jose Arca, a writer shot in a confrontation with an outraged citizen, Venice Pavilion, 1995 ↗↗ *Pure*, **KRUSH**, Melrose, 2004 ↖ Sine memorial, **BLINKY** and **CHARLIE**, Belmont, 1987 ↗ Geo memorial restoring Geo's original piece, **DEFER**, **CHARLIE** and **GUY**, with character by **GENIUS**, Belmont, 1987. Previous page: Skate memorial, **ANGER** and **MEAR**, Melrose, 1993

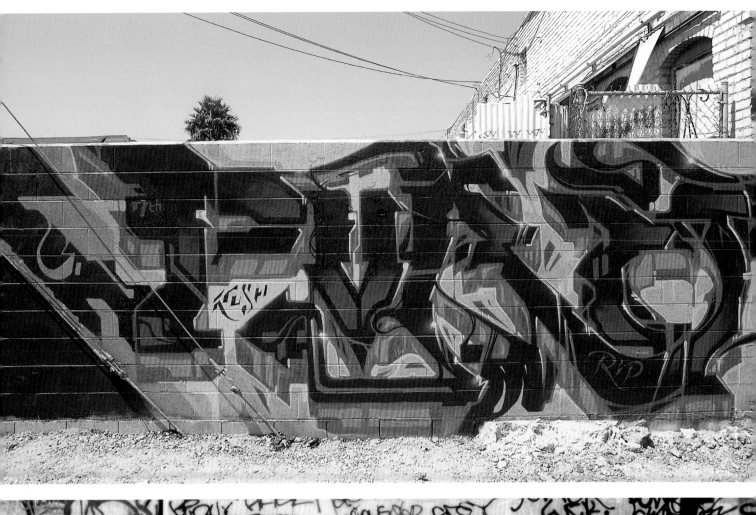

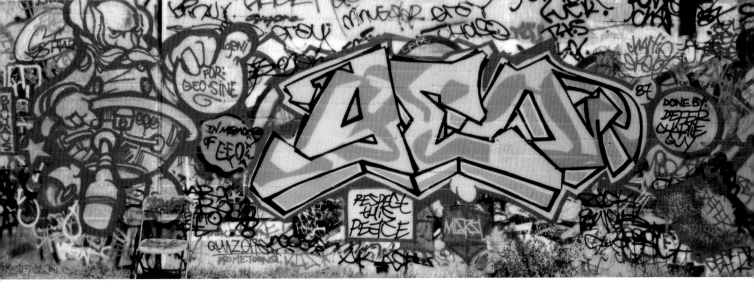

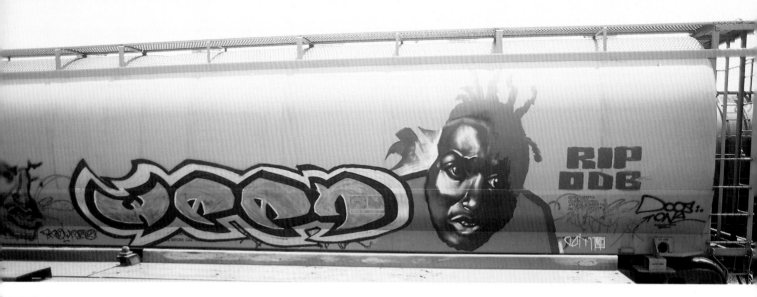

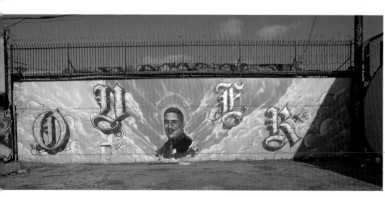

↑↑↑ **DOB** (Dirty Old Bastard) memorial, **WEEN**, El Serreno, 2006 ↖↖ *Skate Rock*, **ROB ONE**, Melrose, 1993 ↗↗ **ZENDER**, Highland Park, 2002 ↖ Over memorial, South Central, 2004 ↗ Memorial by **PANIC** and **PRECISE**, SH yard, 1995

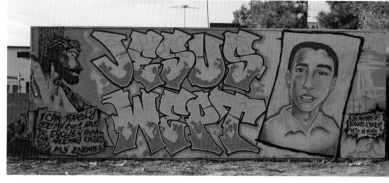

↑↑ **TOONS**, Melrose, 1993 ↖ Memorial by **HYDE**, Belmont, 1996 ↗ Artist unknown, San Fernando Valley, 1993

↑ *DJ Rob One*, **GAS**, Hollywood, 1999　↗↗ *SK8*, **MEAR**, Melrose, 1994　→ *Skate*, **TOONS**, Melrose, 1994　↘↘ *SK8*, **ANGER**, Melrose, 1994

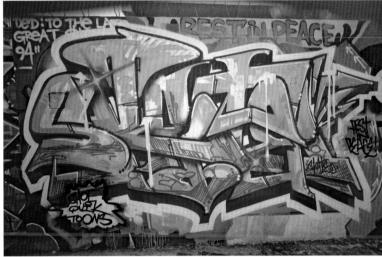

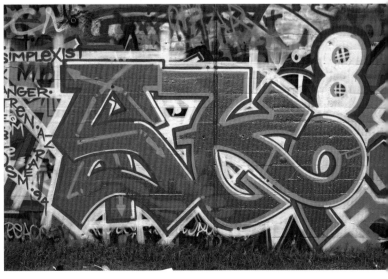

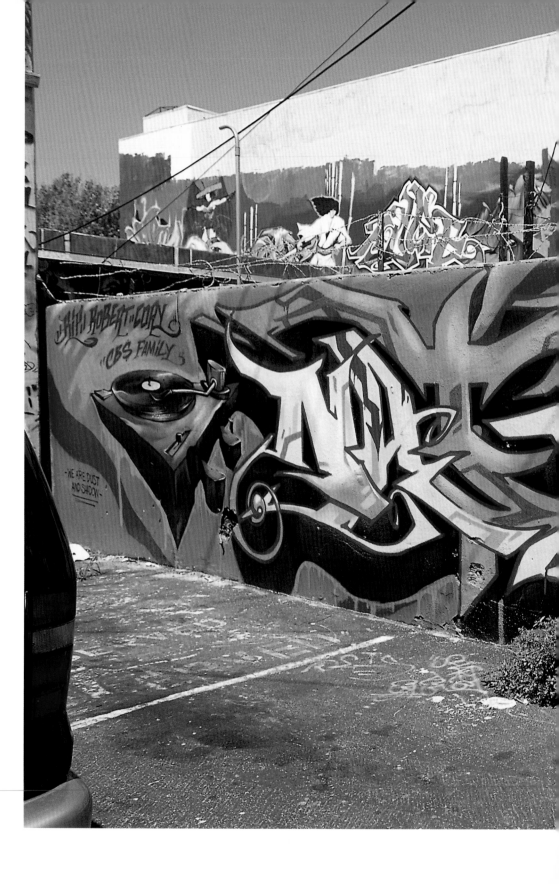

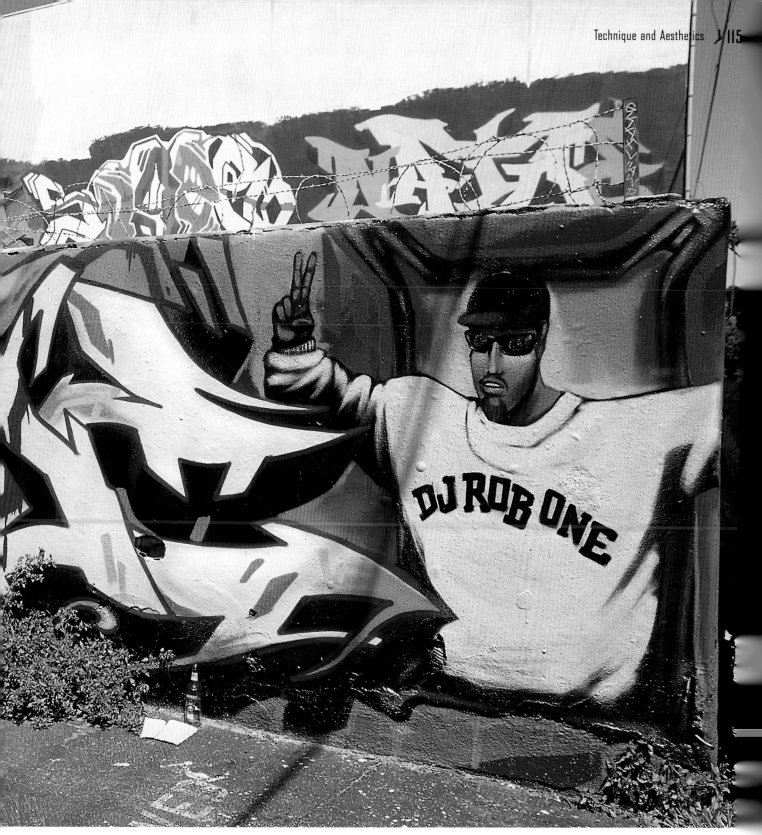

Rob One portrait, **NATOE**, Melrose, 2003

REGARDING STYLE

A central goal in graffiti is the development of a distinctive visual style. This is the single determining factor in how a writer is judged among his peers. Various writers may be known for other attributes such as can control or color palette, but without an inspired creative letter style, a writer will never be considered in the top tier. Writers strive for authority of technique and "pulp" energy in their work despite the time limitations and the knowledge that the work will probably be gone in short order.

WISE: Graffiti goes hand in hand with the "brand," instantly recognizable status imagery, like Coca-Cola. Graffiti artists are part of that drug of Western culture, bombarded by these ad images, so why wouldn't we emulate that to create, essentially, our own instantly recognizable "brand" image in the form of your name and your tag. And taking that inspiration from the fame derived from New York subway graffiti, you become a product in a sense, advertising and trying to get that recognition.

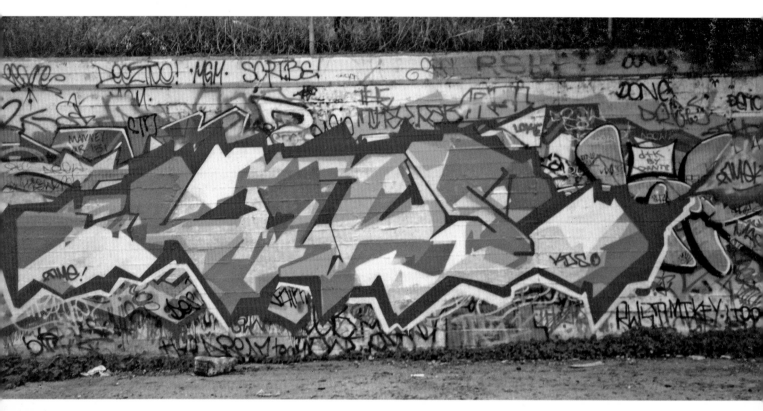

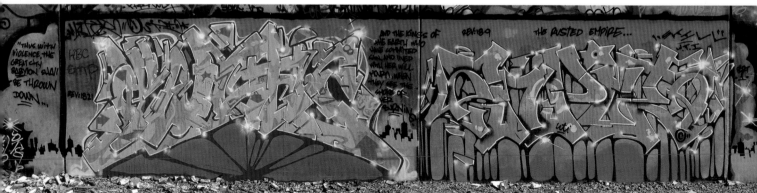

↑↑ **PRIME**, Belmont, 1985 ↑ *Rusted Empire*, **MASTER** and **SKILL**, Motor yard, 1991 ↗ **RICK ONE**, Belmont, 1994

EARLY L.A. INSPIRATIONS

Each writer has their personal influences, and views on who was important in the development of Los Angeles's graffiti. But certain names come up consistently, and not just along lines of crew loyalties: writers from the West Side crews often cite East Side inspirations and vice versa, setting aside crew rivalries to acknowledge respect and inspiration from beyond their own crew.

NEO: The guy that inspired pretty much all of us that grew up in the area around Belmont was Crime; the way he did pieces, the way he colored. I look back at it now, and think about the pieces that my friends showed me, Mandoe and other artists, and it goes back to him. K2S/STN, *that's* L.A. style. You look at that and you look at New York, and of course we also do arrows and wildstyle, but K2S/STN had those sharp edges. And Prime's imagination was way ahead. Sine and Geo, too. Geo's writing was way beyond; I never saw any "Gs" like that, very creative . . . he would make a masterpiece out of a tag.

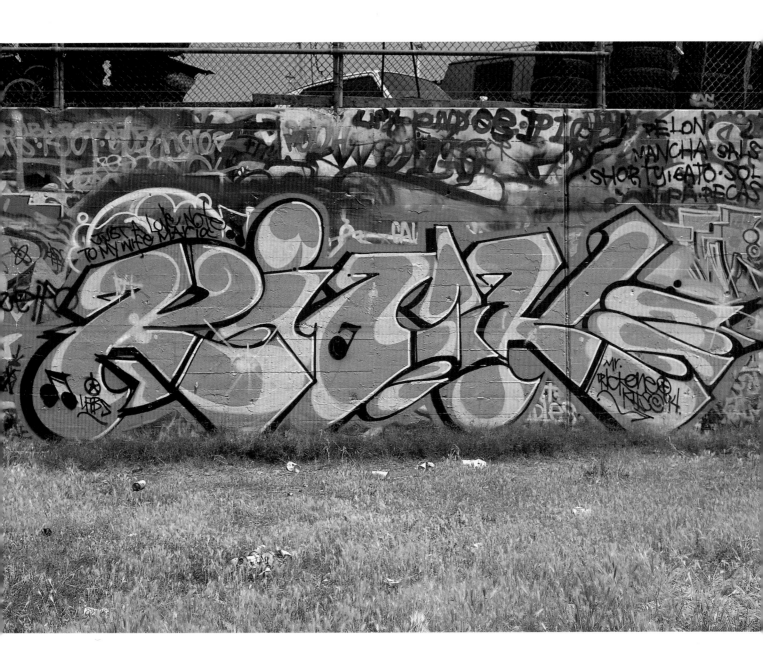

PRIME: Rick (Crime) has a beautiful flow, almost like water, from the "R" to the "C" and back again. He would try to incorporate design features into the fill that he would see in the environment, whether from a car design or a skyline—I got that from Rick.

EKLIPS: K2S/STN by far the most original graffiti in the history of L.A. But Skill and Siner are the two most important individual icons of L.A., along with Charlie, Risk, and Rev.

WISE: I don't know if styles like Saber and Revok would exist without Grem. Grem brought the darkness and was one of the guys to break the hip-hop mold by bringing a punk-rock vibe to the piecing. Skulls and monsters, thinking outside of the hip-hop box. Flame, too. You started to see independent thinking. It progressed from the early days of "What is this can?" to the struggle to do a "Pop!" or a "Breaking" piece, to getting good technique with control and color.

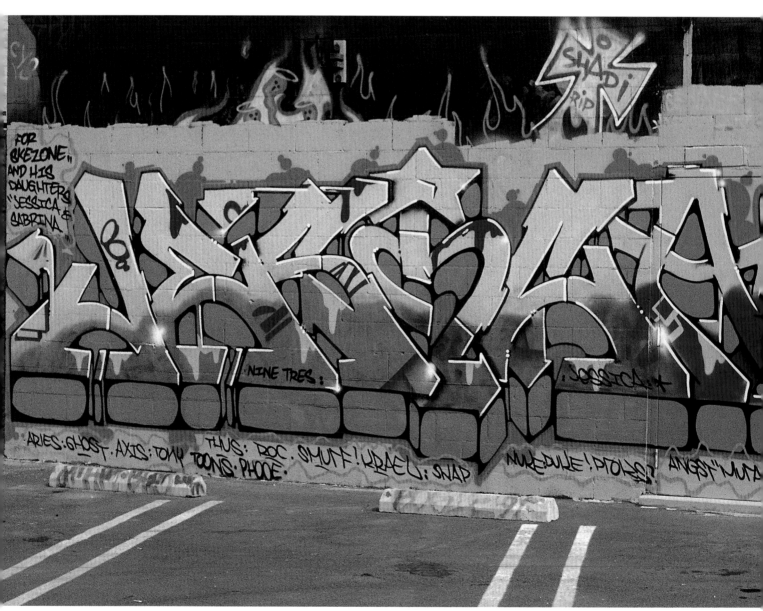

↑ *Jesica*, **SKILL**, Artist District, 1993 ↗ **RICK ONE**, East L.A., 1995 → **GREM**, San Fernando Valley, late 1980s ↘ *Señor Suerte*, stencil and spray paint, **CHAZ**. This stayed up from 1969 until the 1984 Olympics.

RISK: My style looks so old-school and outdated to me now, antique to what I'm seeing nowadays. That bothered me for a while, and then I talked to the people I look up to like Revok and Saber, and to hear them saying "Hey dude, if it wasn't for you, we wouldn't have this." *That* makes me feel real good. Then I feel comfortable and OK with it.

WISE: Risky is the most important writer in the history of L.A.; he was the embodiment of what you wanted to become, with style, technique—good at what you did whether dirty or clean—that brandability, and he inspired others to be better.

PLEX: He (Risk) put a sweetness and soul into his pieces. He went to New York to learn, which was rare then. Now it's a lifestyle.

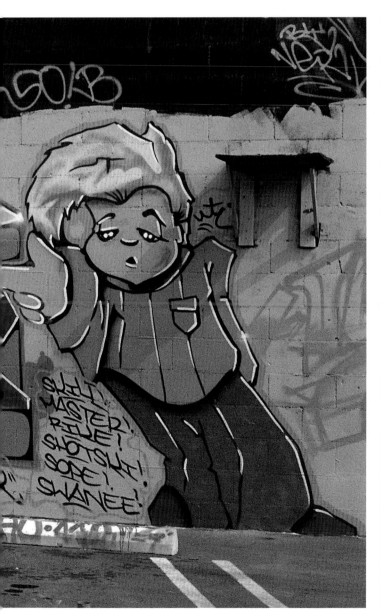

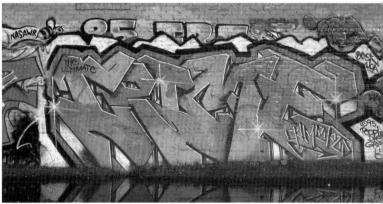

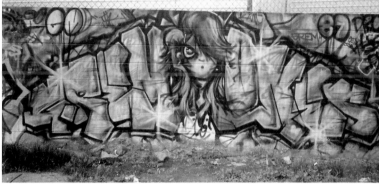

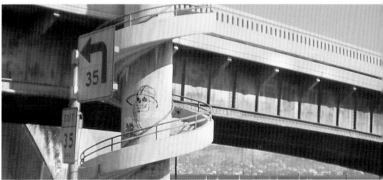

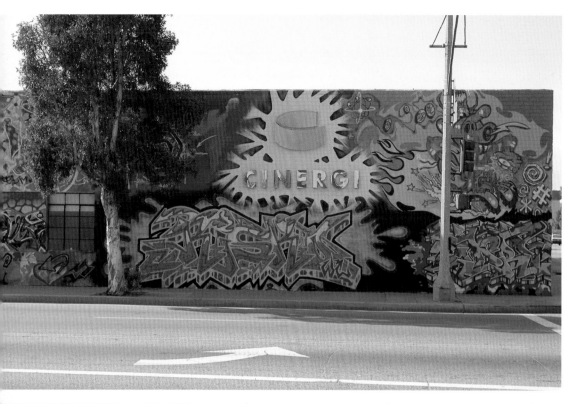

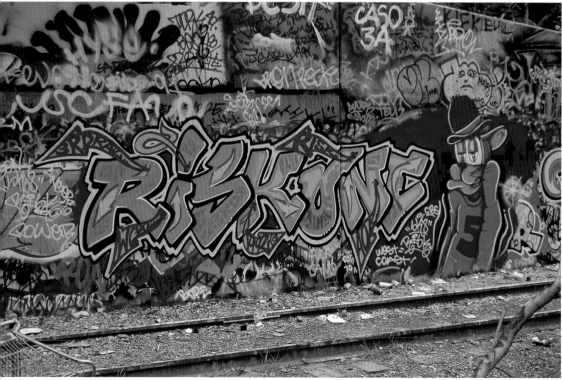

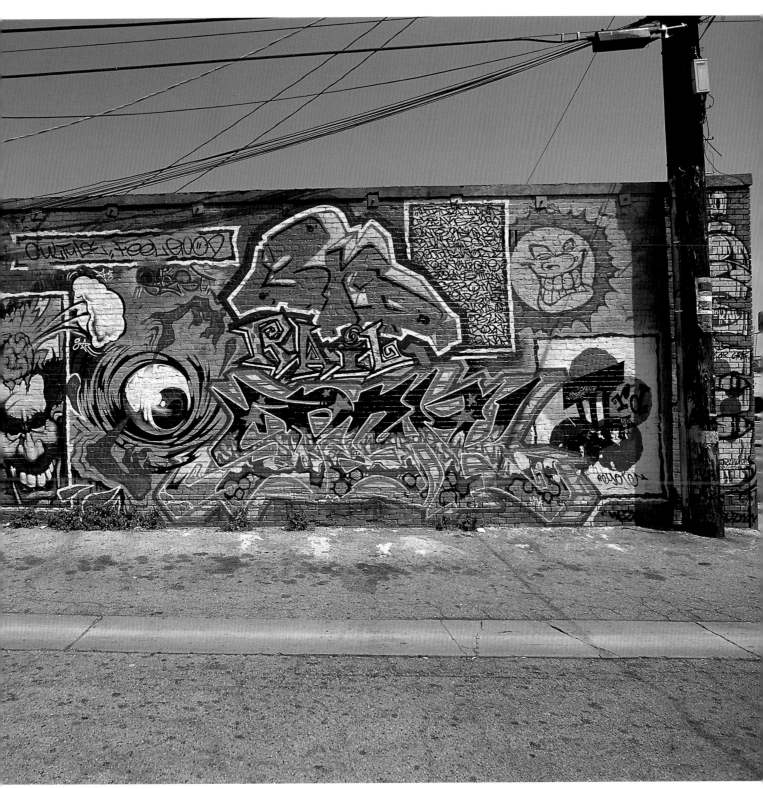

↖ **RISK**, character by **SKATE**, Motor yard, 1992 ↙ **RISK**, with **SEVERE**, **RELM**, and **SLICK**, Santa Monica, 1992 ↑ **RISK**, **DANTE**, **SLICK**, Hollywood, 1993

SABER: I see some of us as a hybrid of New Yorkers—Krush from L.A., gang-hand seasoning, bright colors, and that element of the sun that we have here. Without the New York pioneers, there wouldn't be a graffiti scene. Crises of AWR is the one who really taught me, and Bles, also AWR. A lot of things play a big part in wildstyle: robo-tech/transformer, bio-mechanicalism, kung-fu; it's similar in pieces because you want that letter to have that attitude of chin down, hands up, the way you strike . . . you want that letter to have a certain combative gesture, a fighting stance.

Another train of thought regarding style would be represented by Ghost, from New York, where it's more cartoonish with rounded edges, giving a look more funky and playful rather than angry and mechanical. Revok, here in L.A., can use pink, purple, and orange in a piece and it still looks mean! There's also a "Charlie" philosophy: he's a good hybrid of both, where his letters have anger, but funk as well. As far as I'm concerned, in L.A., Charlie is king, the dopest. And Skill was always a big influence on me. I shit in my pants when I stood in front of the 'Mobsters' piece in Commerce yard. I hoped to one day be that good. That Old English hybrid in that piece is off the

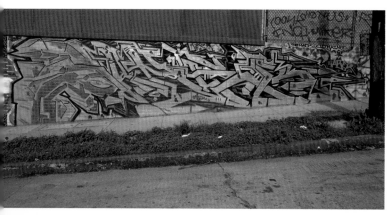

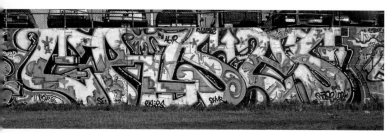

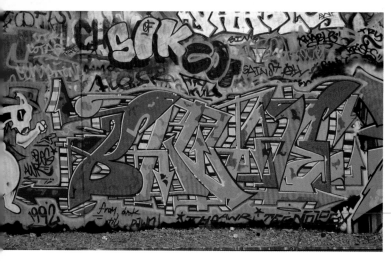

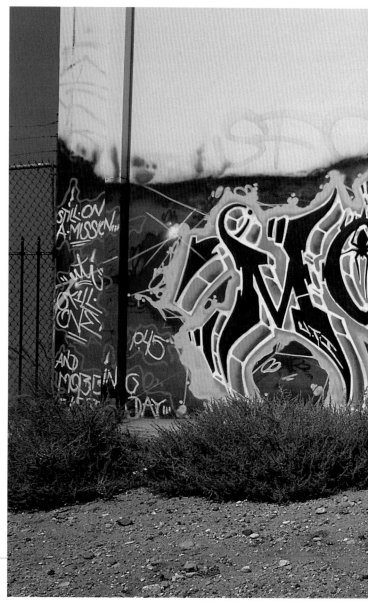

hook. Skill has probably done three or four of my favorite pieces. Skill represents the L.A. hybrid of taking Old English and the gang influence and turning it into a graffiti style. K2STN had more funk in their letters, Skill was just straight-up angry. The angrier the piece, the better, I think. Prime did some of the nicest pieces ever: K2STN took the L.A. gang block and put a New York twist on it, hip-hop-ish but still tough. But they didn't really break down the next element, which would be the "spaghetti" style that Skill did, which is breaking down the square footage even further, like fractals; that is, doing more with each bit of space.

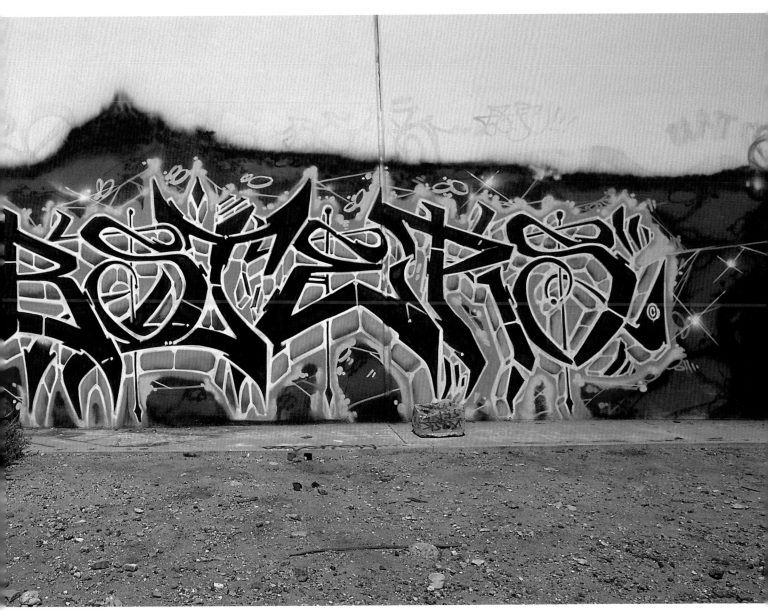

ᴋᴋ **SABER**, Hollywood, 1997 ⬅⬅ **CRISES**, Belmont, 1994 ↙↙ **BLES**, Motor yard, 1992 ↑ *Mobsters*, **SKILL**, Commerce yard, 1995

SABER: Skate was a heavyweight in presence, an all-around king. Not the most technical pieces. I remember the first time I met Skate was out in Calabasas in a little tunnel, and I was painting a little piece, and here comes this huge ZZ Top-biker-looking killer walking up behind me. And I'd heard stories about him so I thought this has to be Skate, and in a booming voice said, "Your piece is kind of small! You must paint BIG to impress," and he stretched out his arms to emphasize the point. He then stood in the water going through the tunnel and did the biggest throw-up I've ever seen in my life. He did it in one flowing motion—beautiful to watch. That's when I decided to do huge letters.

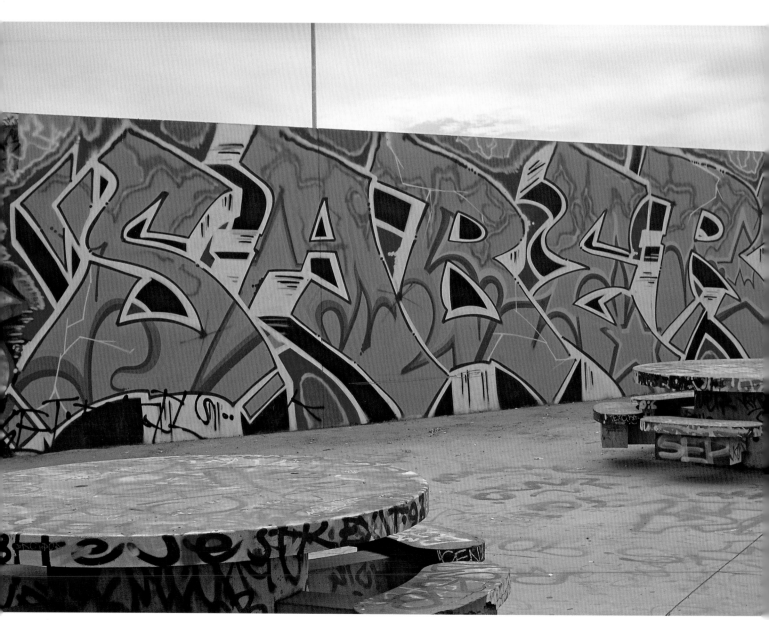

↑ **SABER**, Venice Pavilion, 1994 ↗ **SKATE**, Sanborn yard, 1992 ↗↗ *Skate, Size*, **SKATE**, Motor yard, 1992 → *Kas*, **SKATE**, 7th and Santa Fe, 1992 →→ **SABER**, Artist District, 2002

RISK: Saber, in my opinion, was one of the first to succeed with coming out with such a different style and doing it with such conviction. He's an intense person when you talk to him. He's an intense person when he paints . . . everything about him is intense. When he came out with new styles, he thought they were the shit and they *were* the shit. And his L.A. River piece is a force to be reckoned with. So Saber pioneered the Going Big, the Large and In Charge.

TOONS: I got so much from San Francisco and so much from L.A., but it's never been territorial to me: the world is ours to paint in. The gang aesthetic that's in my stuff is from a Latino base and Chaz brought that out in me. I adapted that into my tag. It's less about braggadocio than pride and tradition, not something to scare people off, but something you stand for.

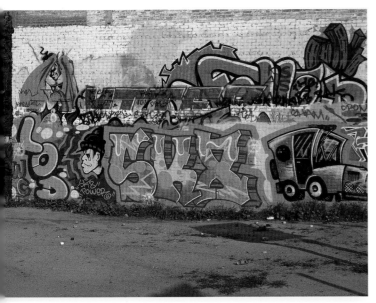

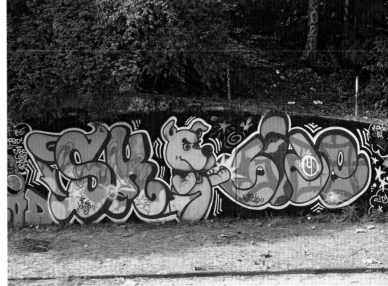

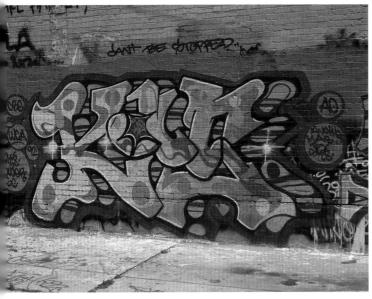

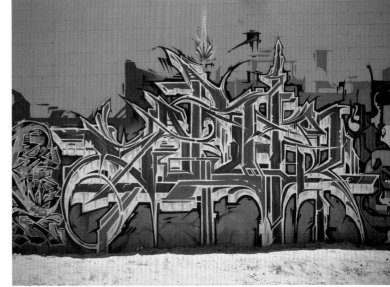

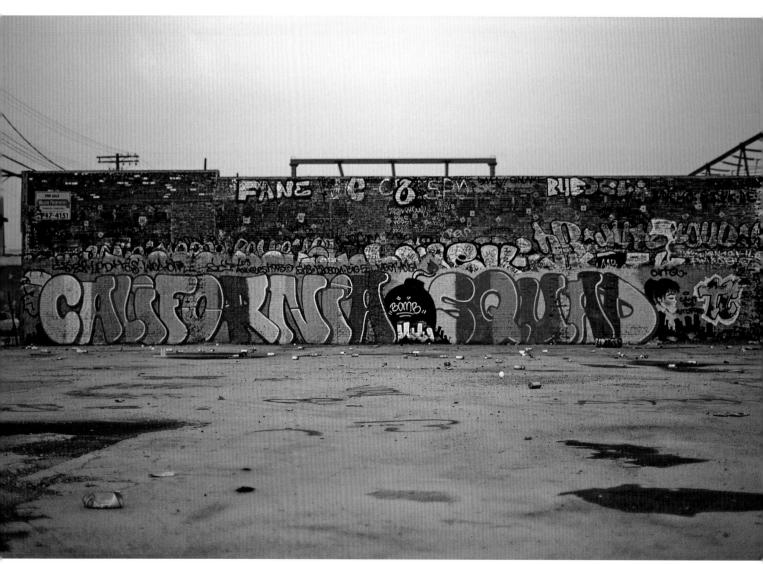

↑ *California Bomb Squad*, **SKATE**, 7th and Santa Fe, 1993 ↗ **SABER**, L.A. River, 1997. 250' x 55', 97 gallons of paint

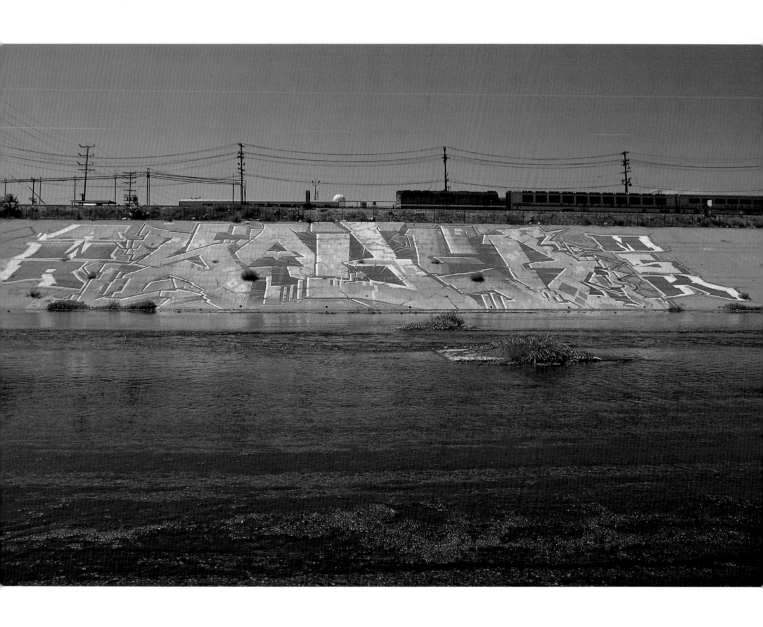

RETNA: I was highly influenced by Thesis3 (AKA Self/SE One/Wreak). Before I saw his pieces I was doing more rounded forms, and I was being schooled by Duse from Flying High, and he turned me on to Self's work, probably in '95, and my pieces really changed from that. His pieces had that very imperial look with some gangster blockiness to it, and a classic style that I wanted to capture in my own work. His colors weren't elaborate, but in the perfect combination. And Brail helped the LTS style become that let-it-all-go thing. He didn't get credit for a long time. When Brail and I finally met (we were already familiar with each other's work), I made it a point to get him into LTS. Some people would knock him for some of his techniques, and a few years later I would see it in their pieces.

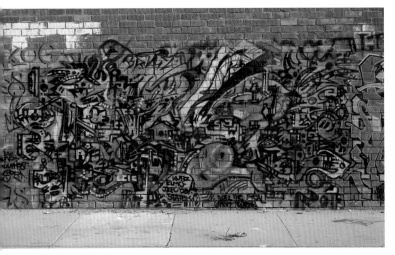

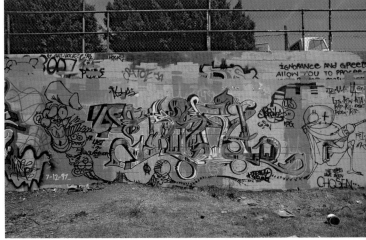

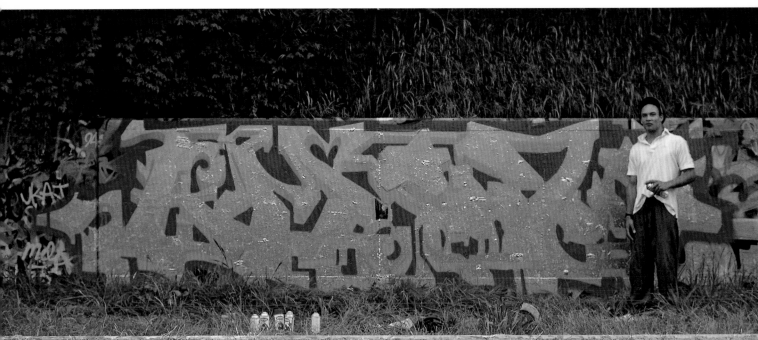

↙↙ BRAIL, Downtown, 1997 ↗↗ BRAIL, Belmont, 1997 ↑ SE ONE (Self Expression Opposing Negative Energy) in progress, Motor yard, 1994

SINER: People refer to the "LTS style," but I think it all originates from everything that people have done also. Some people from the crew were influenced by Self because he had some tighter stuff. And Brail, to me he's one of the sickest people out there; he definitely influenced L.A. style and people might not give him his credit. I remember when people were just doing simple pieces that anybody on the street could read and then we first start flipping the style and people were disrespecting it, saying "That's not even hip-hop, it's like some punk rock graffiti!" and I loved getting a reaction from it, so we kept taking it further, until people finally caught on that wildstyle's where it's at. Some people went into retirement because they couldn't keep up.

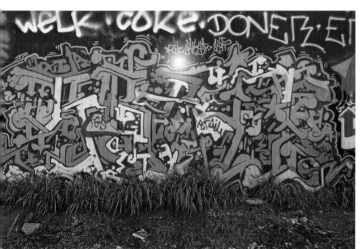

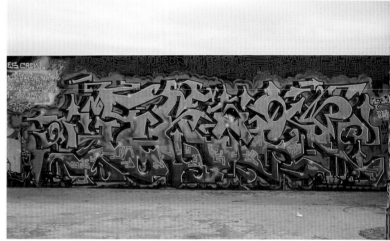

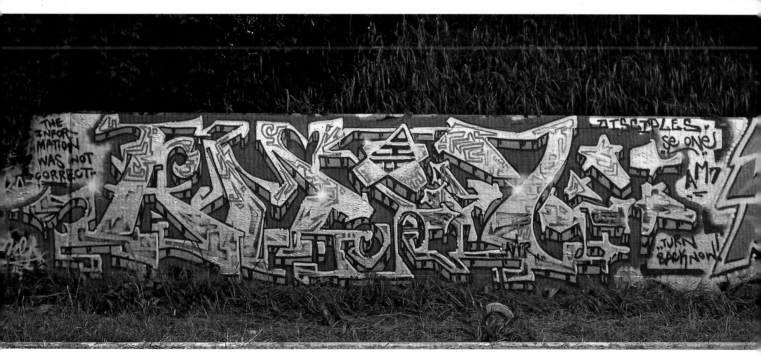

↖↖ **BRAIL**, Commerce yard, 1996 ↗↗ **SE ONE**, Venice Pavilion, 1994 ↑ *AM7*, completed

CRE8: Clever's work on walls had a big influence on a lot of people in South Central Los Angeles. He set the standard for a lot of the South Side styles and had a variety of letter styles. He traveled to New York often to see what they were doing. Him, Sphere (aka Able), Flame, LTS's Mark 7, Sane, Siner, Riot . . . they had that rough, raw street style that I admired. And when I was coming up, my mentor Bizarre said "If you want to see what it's all about, look at K2S's work." I call it chiseled.

ANGER: I was influenced by the K2STN family, especially Relic, but I knew the West Coast guys too, so my style is a combination of the East and West sides.

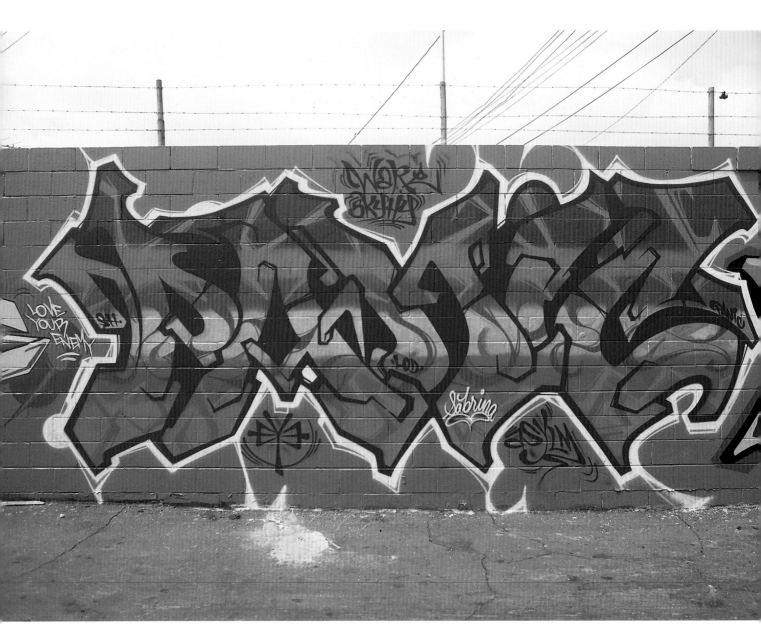

↑ PANIC, East L.A., 2005 ↗ East Side gang letters with West Side curves, ANGER and AZROCK, Melrose, 1993

ACME (SH): Panic, Bash, Size: all students turned teachers. Their influence can be seen throughout the years, Panic having the biggest. Saber and Revok, two of the freshest guys ever, being examples of Panic's influence. You could see so much Panic in what they would do. Years back we wondered if they knew or it just happened. You see, it's always been important to us that Panic gets his credit for all he has done, which is why it was nice to hear from both of those guys at different times, how much of an influence Panic had been on them when they began.

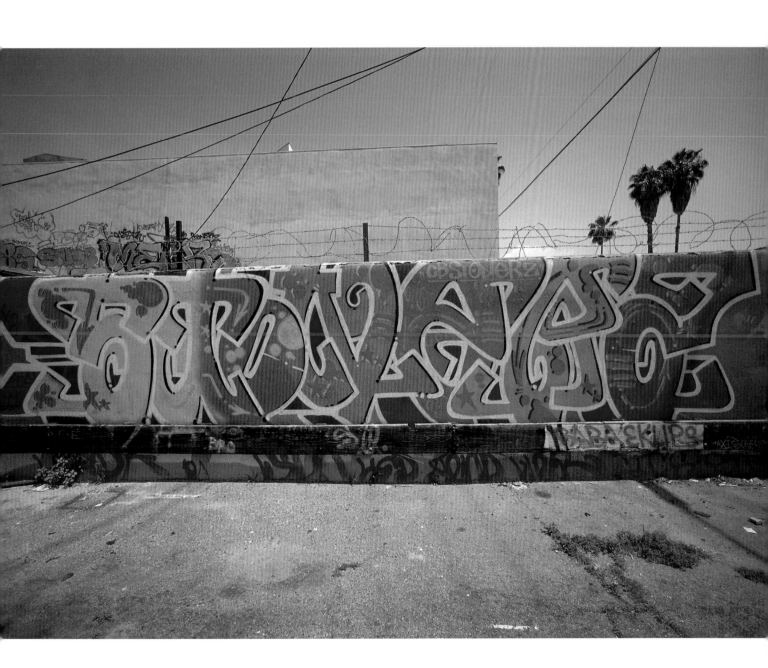

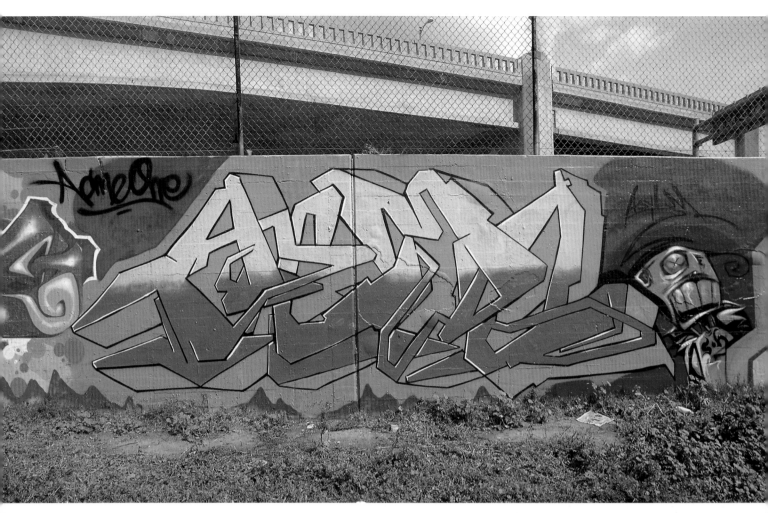

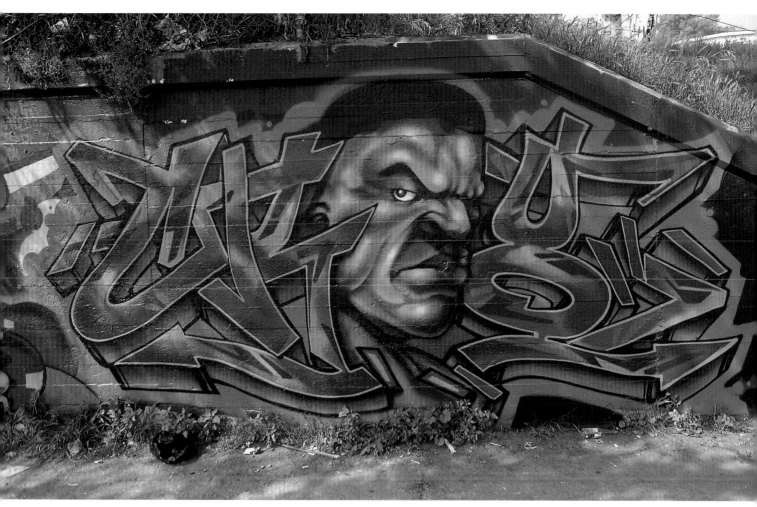

↖↖ **ACME**, Belmont, 2004 ↗↗ **CRE8**, Belmont, 2004 ← **RIOT**, Jefferson yard, late 1980s ↑ **CLEVER**, late 1980s

REVOK: Panic; sick as hell! I used to try to bite those cookie-cutter outlines he did for his clean, dope letters, and still to this day I can't do them! One of my all-time favorite East Side writers is Tempt because he embodied the traditional East Side style while incorporating all these different elements into it, even New York, West Side, and he always had a clean, bold, solid look. On the West Side you had guys from KSN like Rise and Rev, and Risk is one of my favorite writers. There were so many inspirations for me: Krush and Tyke, later on, were huge influences on me, Green and Dream. And Bash was really fresh. But if I had to pick one person that was my all-time favorite writer, just on the basis of style, it would be Charlie of DTK. Charlie is the Man: he had this hard L.A. foundation, but he also took aesthetic elements of the best New York writers and mixed it in . . . his style was the ultimate.

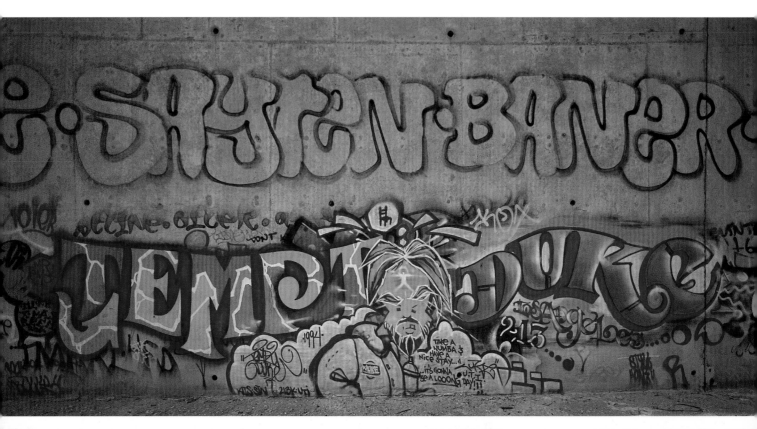

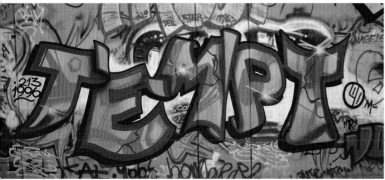
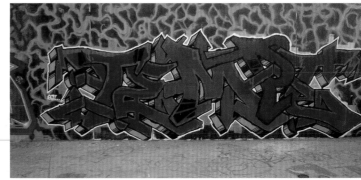

↑↑ **TEMPT**, **DUKE**, with character by **NUKE**, Arroyo Seco, 1994 ↖ **TEMPT**, Venice Pavilion, 1996 ↗ **TEMPT**, Venice Pavilion, 1997

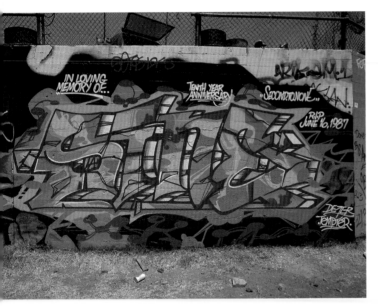
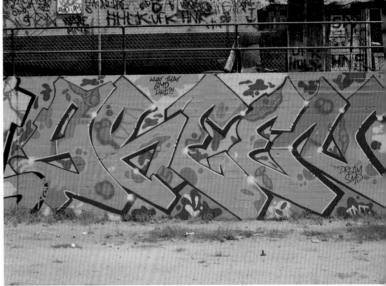
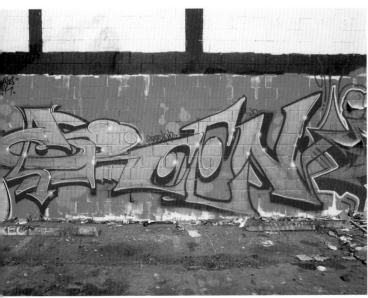
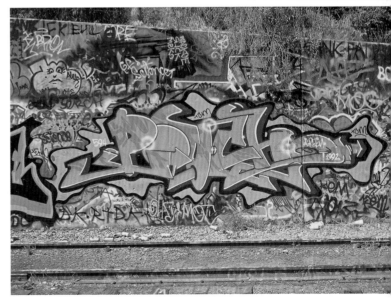

↖↖ Sine memorial, **TEMPT** and **DEFER**, Belmont, 1997 ↗↗ **GREEN**, Belmont, 1990 ↖ **GREEN**, South Central, 2004 ↗ **GREEN**, Motor yard, 1992

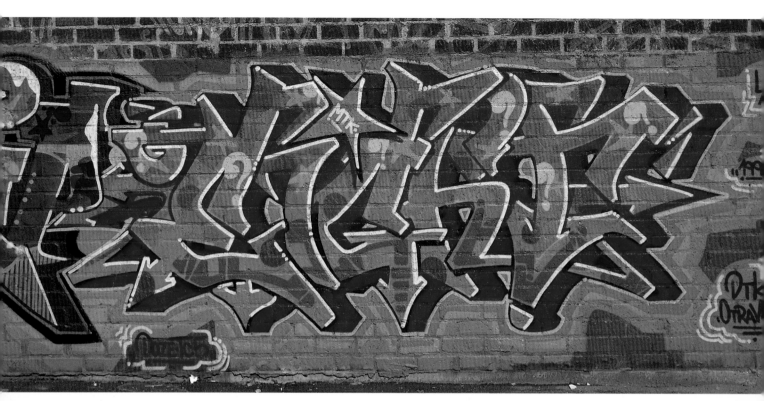

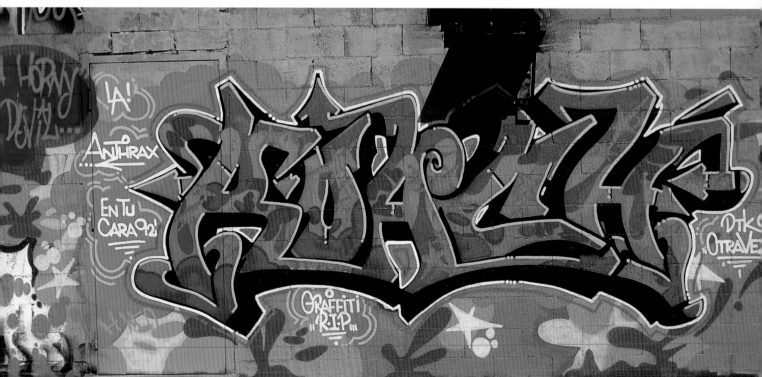

↑↑ *Eight*, **CHARLIE**, Artist District, 1992 ↑ *Roach*, **CHARLIE**, Artist District, 1992

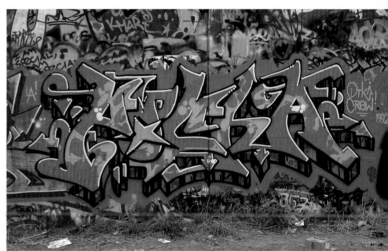
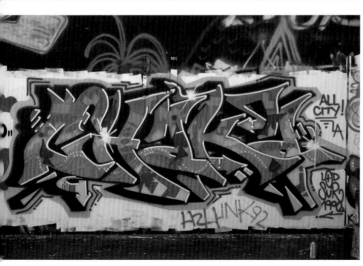
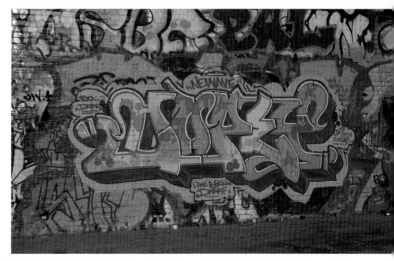

↖↖↖ *Perez*, **CHARLIE**, Artist District, 1993 ↗↗↗ *House*, **CHARLIE**, 7th and Santa Fe, 1992 ↖↖ *Ochoa*, **CHARLIE**, Motor yard, 1993 ↗ *Pocha*, **CHARLIE**, Motor yard, 1992
↖ *Chaka*, **CHARLIE**, Artist District, 1992 ↗ *Dopey*, **CHARLIE**, 7th and Santa Fe, 1993.

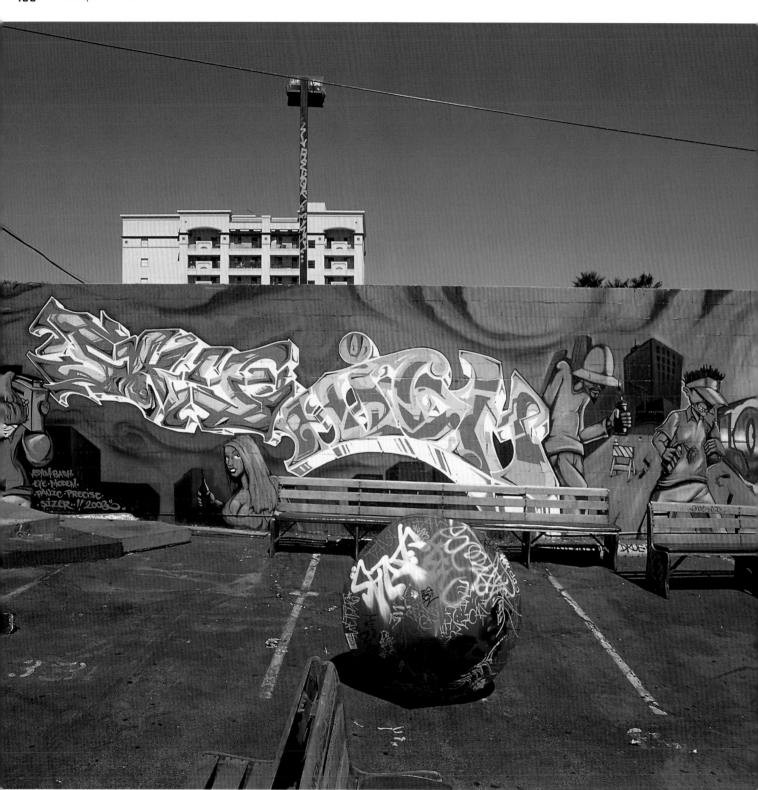

Street Life, **ASYLM**, **PANIC**, **BASH**, **MODEM**, **EYE**, **SIZE**, **PRECISE**, and **CZER**, Hollywood, 2003

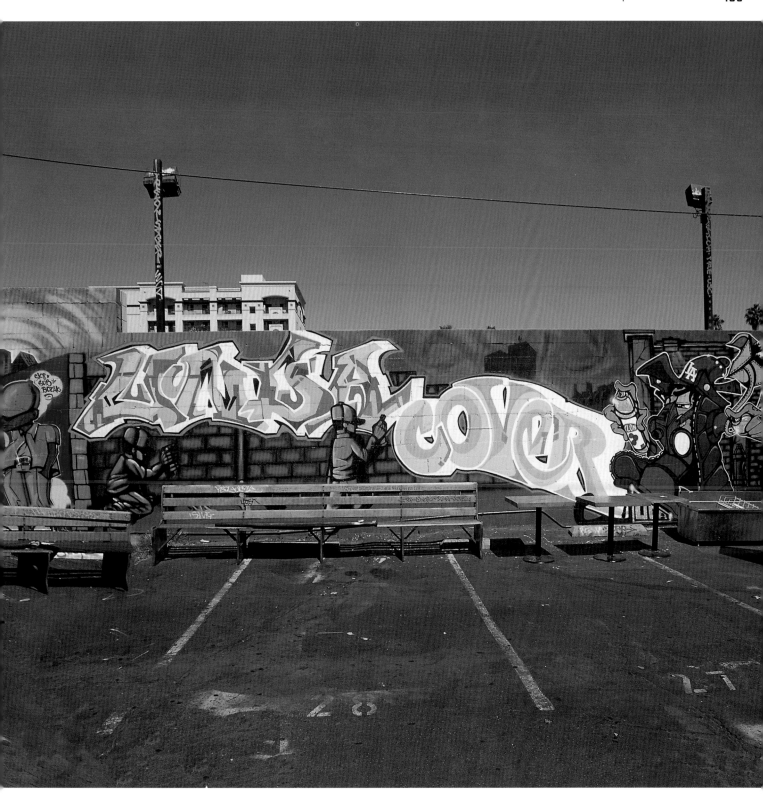

THE PERSONAL APPROACH

Graffiti writers draw inspiration from many influences, but the best writers do more than skillfully re-create what has been done before. Any good writer takes the best of what he has learned and takes it to the next level—that aesthetic twist is what any writer who wishes to make his mark tries to accomplish. Some writers emphasize design balance, almost architectural in their construction, while others are more concerned with a resulting naturalistic, visual flow. Superior artists know when their work is succeeding by their own goals, and when it needs to be reworked to achieve the desired effect.

RISK: I would look at my letters like they were dancing, or doing karate. I wanted my letters to all look like they were kicking and blocking, moving. My letters were always funky, definitely derived from New York graffiti because of learning from Soon. The difference was I put a West Coast twist on it, and colors were something where West Coast killed East Coast at the time. Our colors during the '80s to mid '90s were way more out there and creative, vibrant . . . not so confined to a black outline with a light color, the dominant approach in New York then.

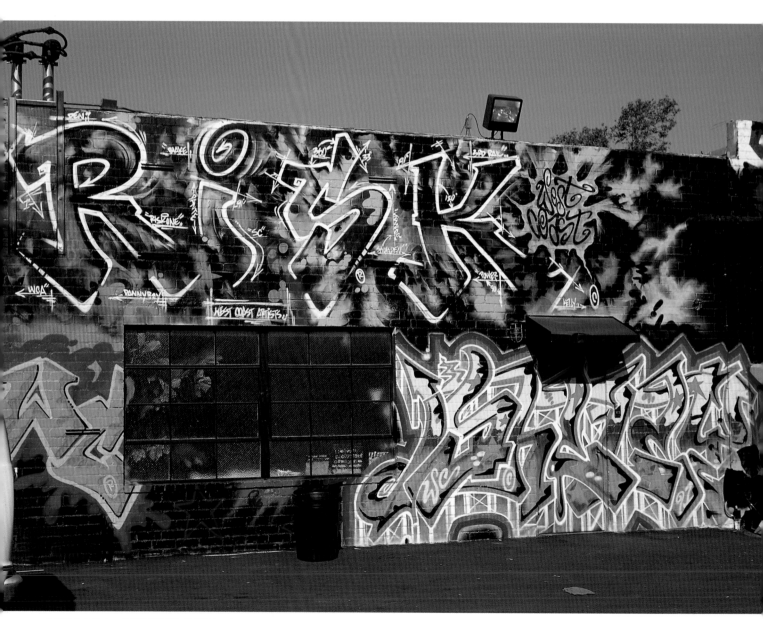

↑ **RISK**, Santa Monica ↗ *K2SSTN*, **PRIME**, with **RELIC**, **SLICK**, Belmont, 2004

PRIME: In the piece done with Relic and Slick, apart from the creative lettering, I wanted to really do something with the color scheme inside the letters and inspire people because sometimes they don't get too creative with it and it's just like gang lettering . . . I think the color scheme brings out the beauty.

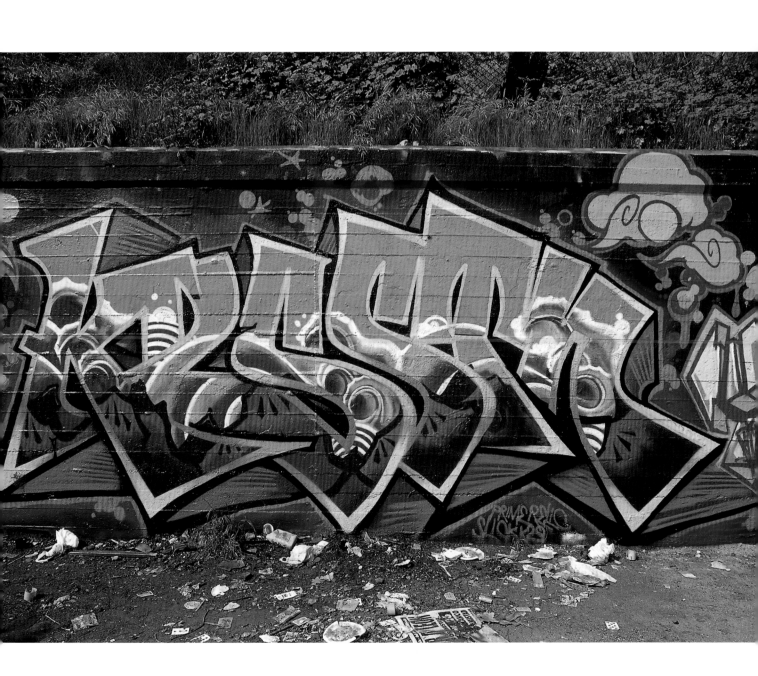

RETNA: There are a few letters that seem to have the same structure: R B K S A. It may be different for another artist, but for me those letters all have the same "skeleton." There was a point when I was doing pieces just composed of my favorite letters. The "R" and the "E" and then the lower case "a." In my early pieces I would take the "R" and flip it sideways; you would have the "a" so I had this symmetry going on, which I really like. My letter formation really started with Old English calligraphy and gang writing because that's what I used to see growing up. I would see on the walls how they would manipulate their letterforms, the "S," for example. My influences changed in '96 when I found *National Geographic* magazines with an article on Thai wood carvings, and there was an intricacy there that became part of what I do. My mom collected Asian pottery for a long time and I liked the surface patterns, so that was absorbed. I've also mentioned being influenced by Egyptian and Mayan hieroglyphs, and though it's not explicit, it's there Then it was a matter of finding how

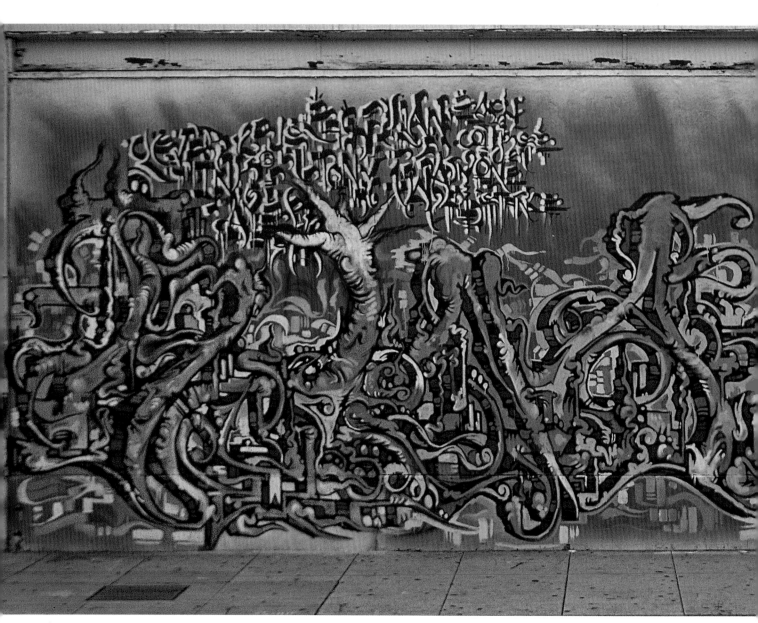

↑ **RETNA**, south-east of Downtown, 2000. The leaves in the tree contain the names of writers who have passed away. ↗ *Moseser*, **RETNA**, Commerce yard, 1996 → **RETNA**, Artist District, 2004
↘ **RETNA**, with Frida Kahlo by **MELLY**, Mid-city, 2005

all of those things merged. I became familiar with Chaz Bojorquez's work in '97, and it just seemed to hit, like when I first saw Self's work, where many elements were merged together, again with that imperial look, with that *cholo* breakdown and fine-art classic aspects. So my influences were not always graffiti related; they became broader than that; I felt there was a connection with these ancient cultures, because what's written on the wall is how we know about that society that happened long ago.

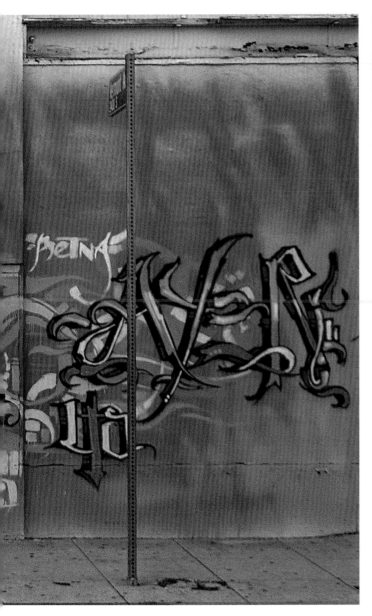

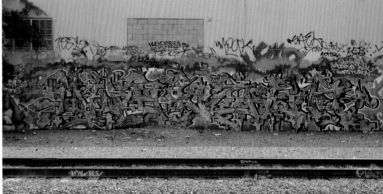

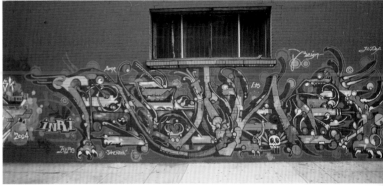

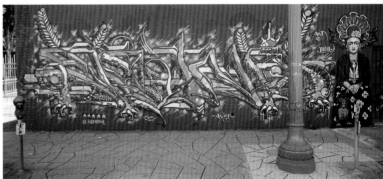

KOFIE: My letters evolved from sketching and progressively slicing things up, something I got from my character work, and then they became separate bits, and I wanted to make it break apart and float, so I started doing more shading, but I've slowed it down and my style is getting looser, but keeping a flow even though each letter is its own piece. To get the color blends, there's a lot of whipping going on and just tossing the paint.

ANGER: I like letters without gadgets or gimmicks. I like big fat clear letters.

PANIC: I'm a perfectionist and I like stuff to look sharp and for things to be where they need to be. And that's where the challenge comes in, to execute it to the standards in my head. I'm my own worst critic. People may like the piece and I'll see tons of flaws that I can't correct because I ran out of paint or time ran short, or I don't want to keep layering it because I feel that once you layer something too much, it gets lost and becomes something other than what you were aiming for. So I may reach a point where I accept the piece as complete even if I'm not thrilled about it.

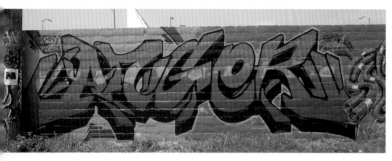

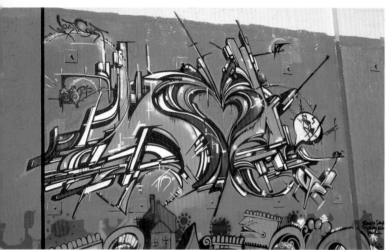

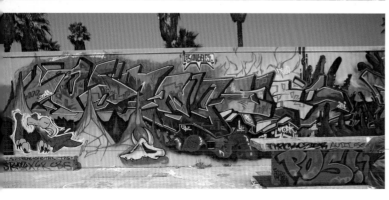

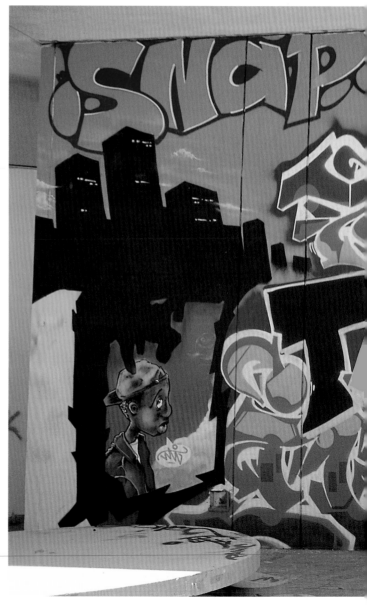

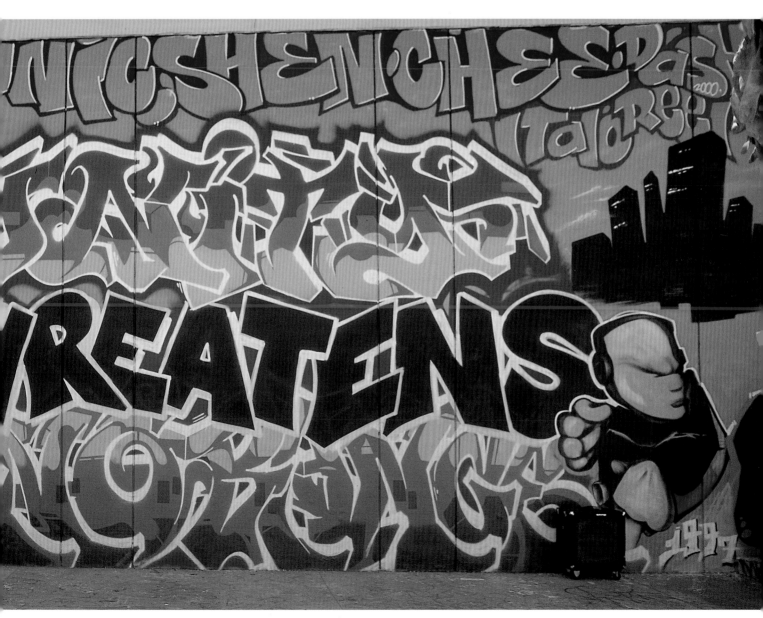

↖ **ANGER**, Melrose, 2006 ← **KOFIE**, South Central, 2004 ↙ **KOFIE**, Venice Pavilion, 1993 ↑ *Unity Threatens Ignorance*, **UTI CREW**, *Unity* and *Ignorance* by **PANIC**, character in lower left by **DASH**, Venice Pavilion, 1997

ATLAS: I'm so obsessed with precision that I can't do anything that has half-tones or blends, so everything I do is line-art or solid—basically, graphic design. I rely more on my initial design to pull through than on colors or tricks. I've always been hard on myself, with everything I do. It needs to be a certain way. The directions that certain letters of Beyond's would take, I still use to this day, like skinny to big, or how to balance out weight. I realized that if I squint my eyes to blur the focus and look at the piece as a whole, then I notice that one area is not as busy as another area, so then I improvise to balance it. My whole thing is freestyle improvisation. I never use a sketch because if it doesn't look like the sketch, it seems wrong, although I'm the only one that would notice, when in reality, I should accept it as a whole. As I improvise, I make sure everything is clean, proportioned, well balanced. And the amount of work you put into each letter shows: if I spend ten minutes each making the "A" look dope, and the "T," "L," "A" and then only two minutes on my final "S," guess what, that "S" is not going to look as sharp and flowing as the rest of it. I draw a lot, so I've already tricked my "A" out to where it's presentable; now to make the "T" compatible with that is a whole other thing, and every letter is a new problem to solve.

↑↑ ASYLM (left) ATLAS (right), El Serreno, 2005 ↖↖ ATLAS, El Serreno, 2006 ↖ ATLAS, Melrose, 2006 ↗ *Skate*, ATLAS, East L.A., 2006 ↗↗ ASYLM, Echo Park, 2002

ASYLUM: In my letters, I try to use few straight lines and have a rhythm more reflective of nature. It may also flow off of what I'm trying to do with a character. I now like having color at a focal point, but not having the whole piece be equally colorful, using color as a highlight. I used to work with a more muted gray scale.

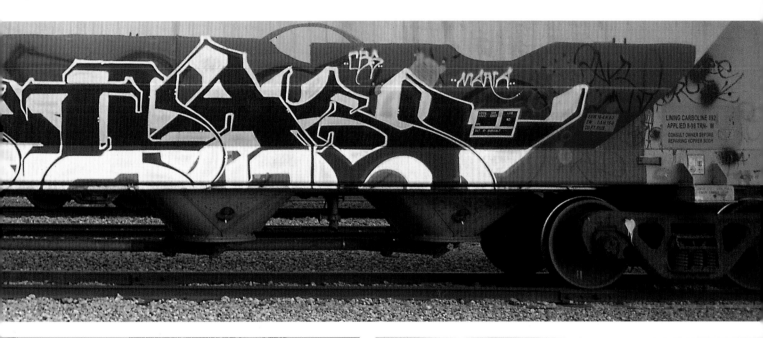

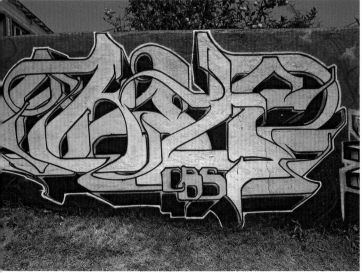

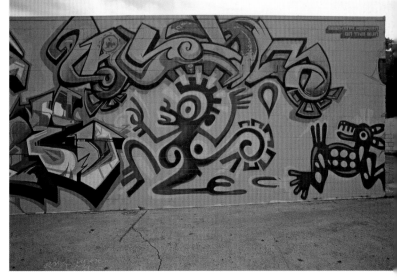

SABER: I started writing in '90, trying a piece right off the bat, before I even tried to catch a tag. I was way more impressed with piecing; that was my whole thing. For me, it was like a way you could make your own style, a puzzle-piece robot with letter. It all comes down to style, and using your name: each name has a "mantra," or structural/rhythmic possibilities that the letters of that name has to be played with to tap into the style. You have a certain structure you have to follow to make it an "A," for example, but you can do whatever you can to make that an "A" so you have a name and you look for all of the possibilities to achieve the next level. Some people don't understand the concept of style, which can be represented in a simple scratch on a wall to a full-blown mural: they just write their name. They haven't grasped the intelligence behind the name. That intelligence is a weird thing; you feel it more than think it. It's like riding a wave—you go with it. You're driven by the feeling first. With a piece everything comes down to balance. How to balance the ideas into geometric shapes and make it work within a cluster, and still make it say something, still justify it as a letter, but taking it to a new level.

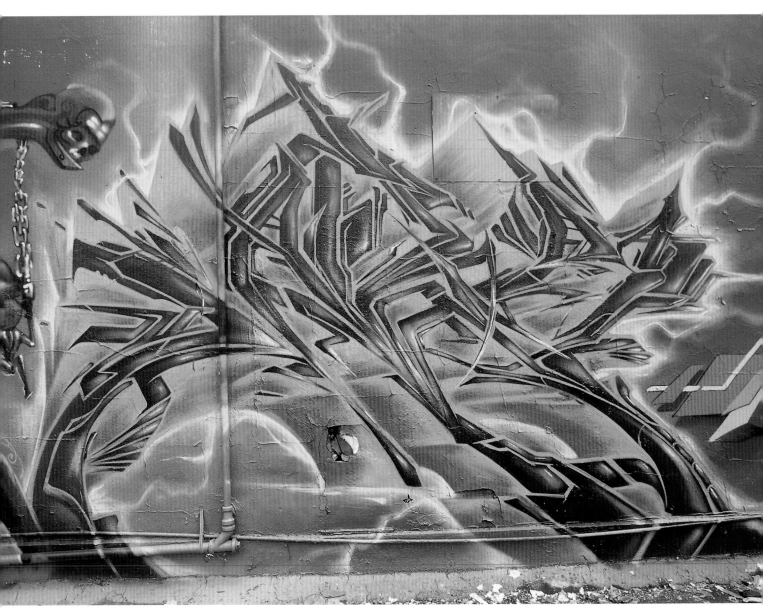

↑ SABER, Hollywood, 2003 ↗ SABER, Artist District, 2000

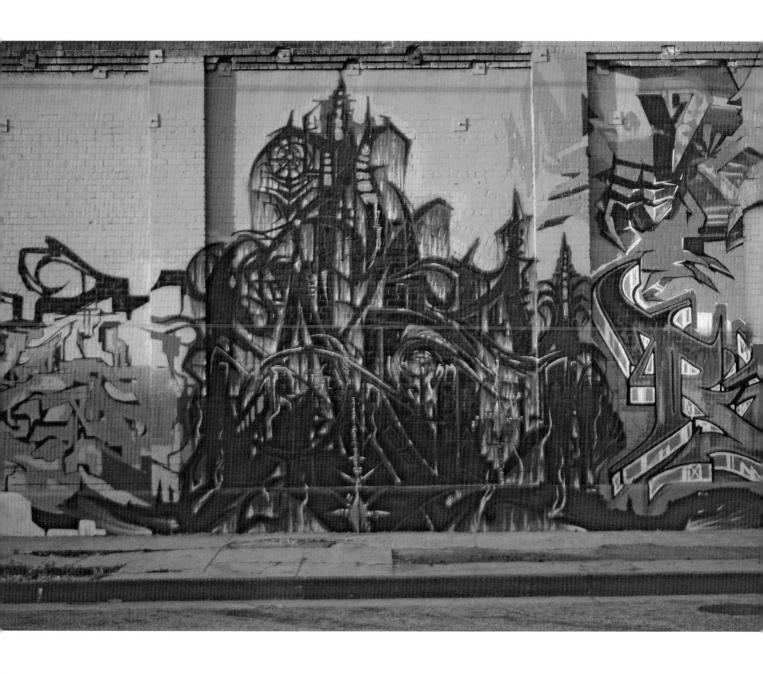

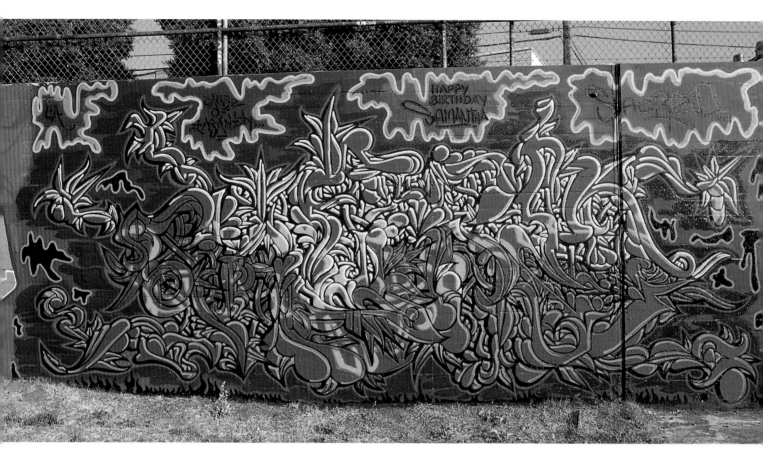

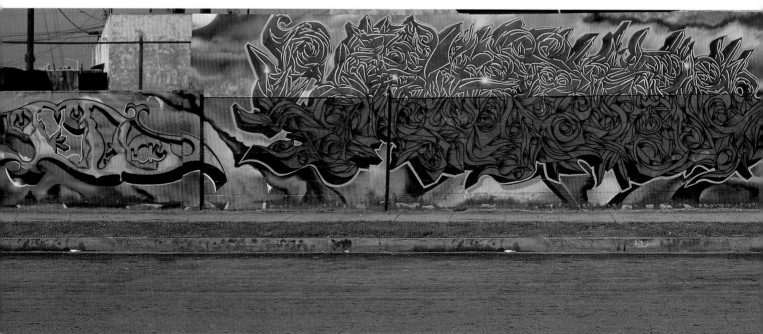

All writers have their inspirations. The following are a few more shots of writers often mentioned in that capacity. ↑↑ **SACRED**, Belmont, 1999　↗↗ **SACRED**, Belmont, 1997　↑ **SACRED**, East L.A., 1997

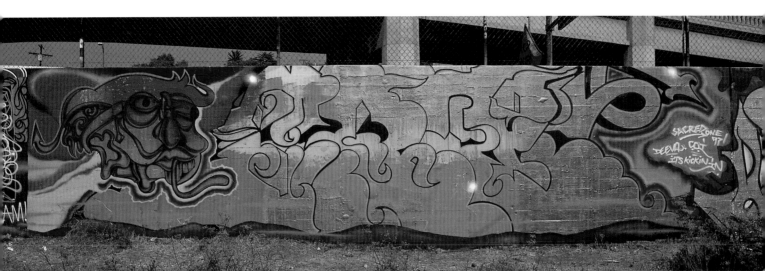

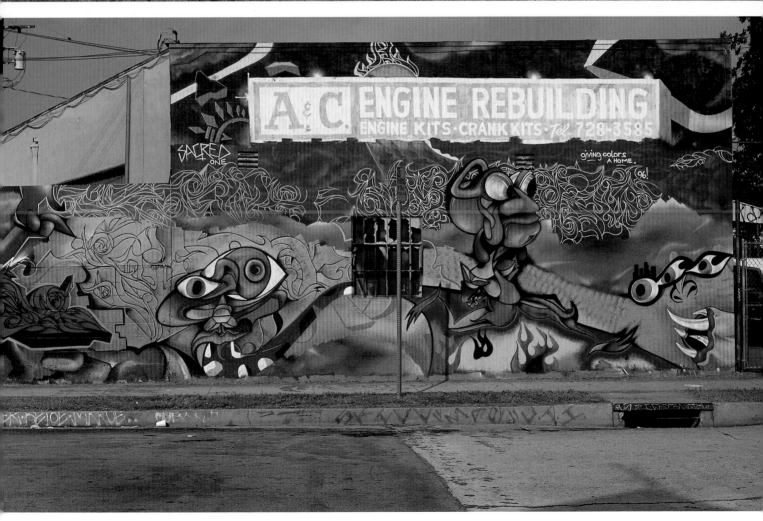

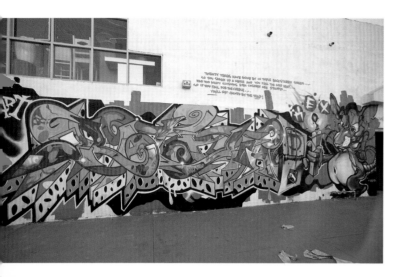

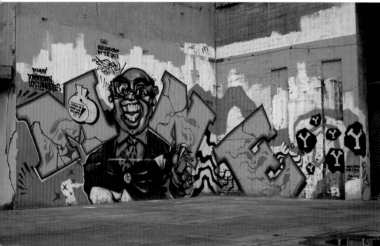

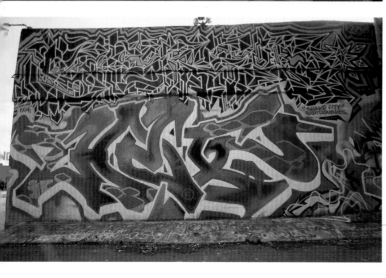

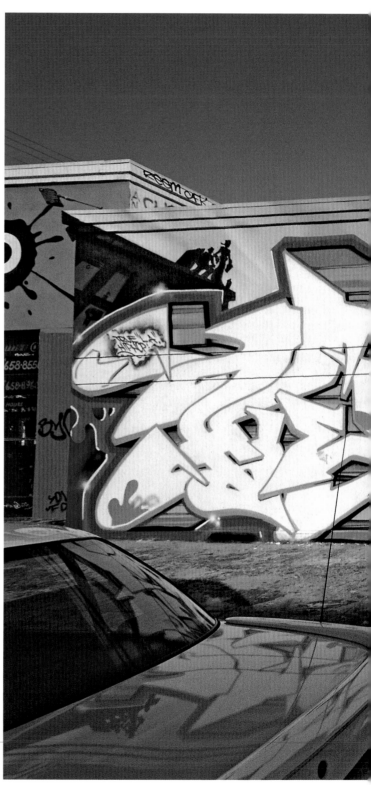

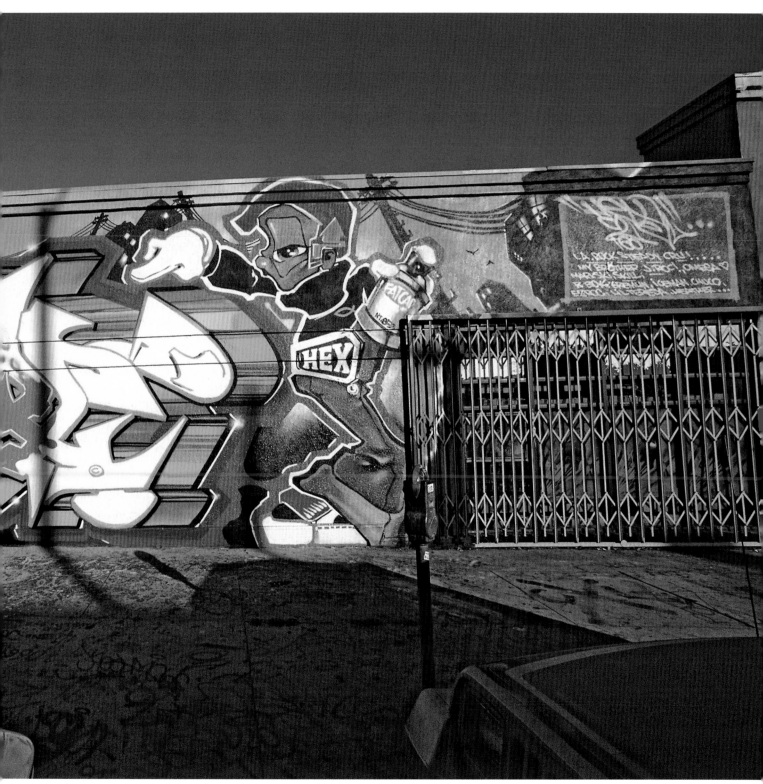

↖ **HEX TGO**, Melrose, 1992 ← **HEX TGO**, Brewery Artist's Complex, 1992 ↙ **HEX TGO** (below), **SACRED** (above), Melrose, 1994 ↑ **HEX TGO**, Melrose, 1992

↑ **MEK**, Sanborn, 1992 ↗ *Sena*, **MEK**, Sanborn yard, 1991 → **MEK**, Motor yard, 1991

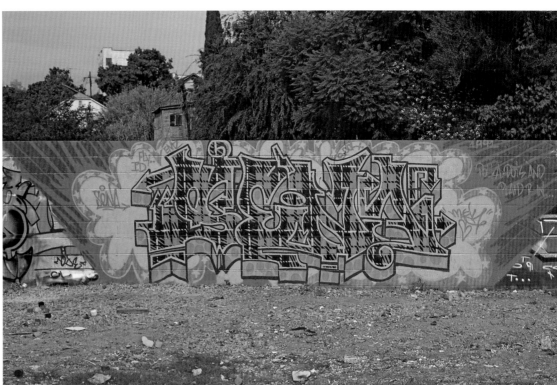

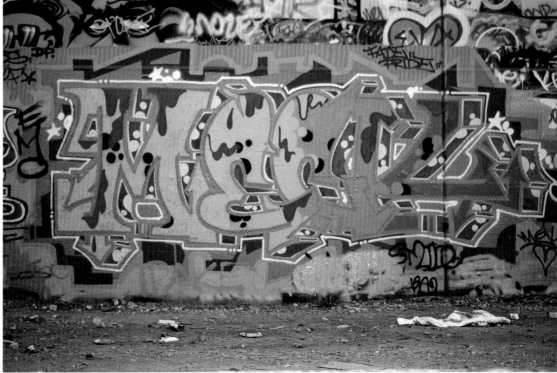

PUSHING THE ENVELOPE

The best artists are always striving for more, whether trying to refine how he or she renders a cloud of bubbles surrounding a piece, or a radical new letterform; those developments are often picked up and absorbed not only by L.A. artists, but also by the international graffiti community that stays informed of current trends through personal connections, magazines, and the Internet. The Exchange, created by Jersey Joe, provides participating writers with another means of artistic dialogue. Top writers in various cities, including L.A.'s Revok, Rime, Sever, and Ewok, are asked to create a sketch in their personal style, but a different writer must execute the piece. This artistic exchange challenges the executing writer, though free to alter the piece, to also learn the skills of the sketch writer.

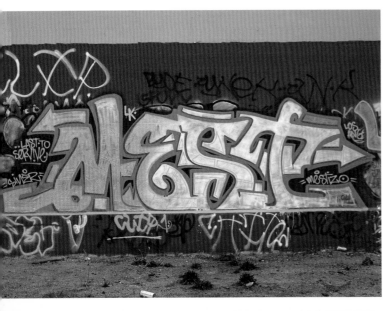
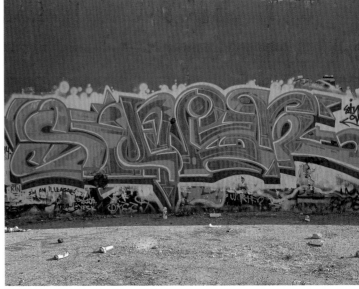
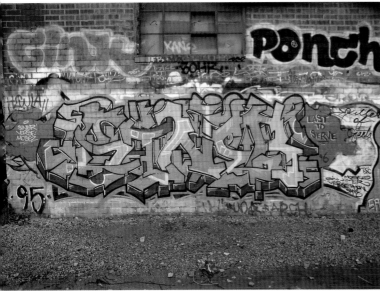
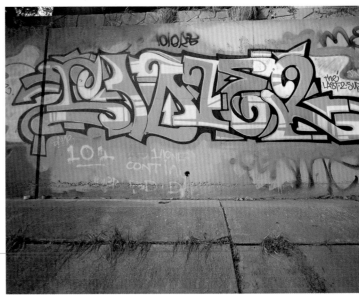

↖↖ *Mest,* **SINER**, Jefferson yard, 1994 ↗↗ **SINER**, Jefferson yard, 1994 ↖ **SINER**, Commerce yard, 1996 ↗ **SINER**, Arroyo Seco, 1994 → **SINER**, Mid-city, 2004

SINER: Sometimes I do a piece and I think it turned out wack, but then a month or a year later, I may look at it and think it's pretty dope! Certain pieces stand out and I fell in love with them, "Aw, man, that's my best piece right there," but the next one I'm going to do even better. You continue to keep burning yourself. Or learn from the last piece; you might do a little something in a section of one piece that you want to work more with in the next piece. And if you don't do it, somebody else will pick up where you left off, so you better be quick to keep developing it! I get tired of doing the same thing, so I push myself to do something different, and that's what excites me, wondering how a piece is going to come out. That's also why I used the name Mestizo; you come up with another name or word you want to put up. I used that name because I started learning more about my culture and Mexican folk art. People would see Mestizo and ask "What does that mean," and it makes them look at their definitions and their culture. I embrace both parts of that background, the Spanish and the indigenous.

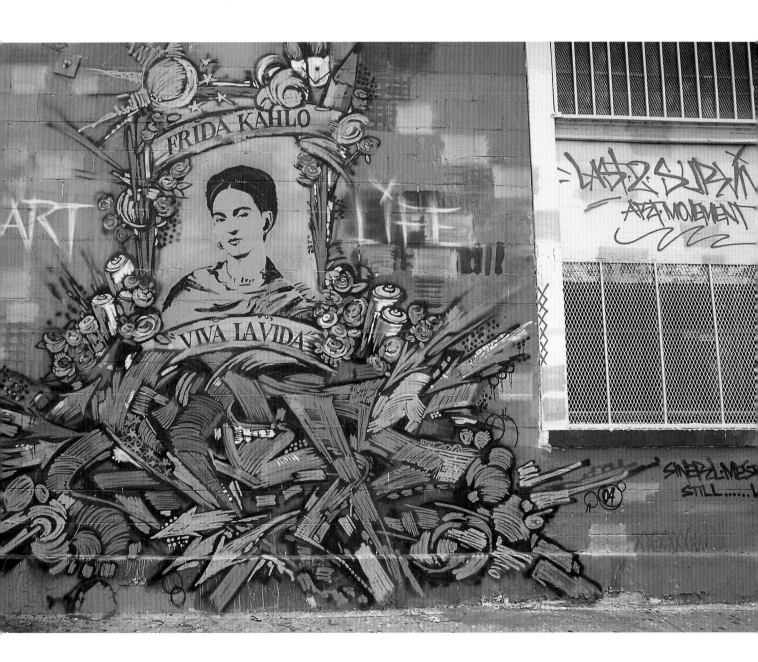

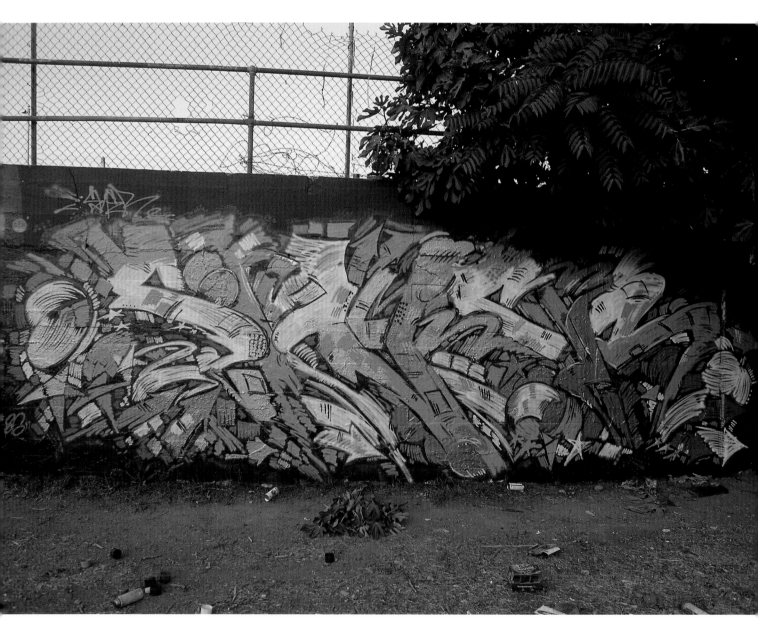

↑ **SINER**, Belmont, 2004 ↗ **SINER**, Artist District, 2006

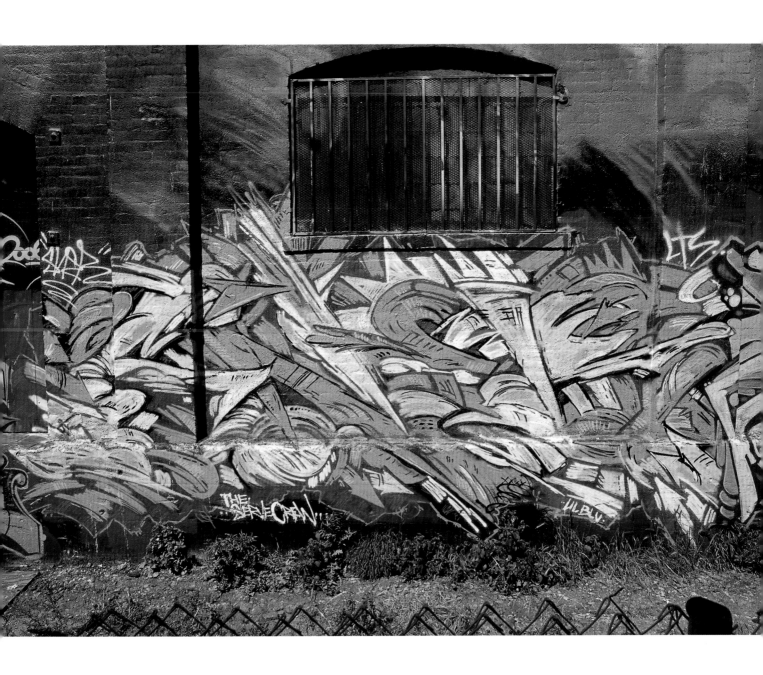

REVOK: Siner, there's one of my hands-down favorite graffiti artists ever. Because he's always tried to excel and outdo and reinvent himself. Even in 1988, not only was he dope back then, but he was completely different from everyone else. Then you look at 1990 and his stuff had evolved, always taking what he had learned and trying to do it better and come up with another new thing. And I've always looked at that as a great model for doing anything in life. What's the point of doing something if you're going to keep doing it the same way you've always done it and it stops being interesting? I look at my years in graffiti and I see there being chapters; I'll have an epiphany or a new idea and then I'll run with it and try to do it really well and then I'll come up with something else, and I always want to keep changing; I never want to stagnate, get stale. I think there are many things that make a writer a good writer, but that's something I've always valued and strived for. I never want to get too comfortable with one particular style. I think it comes down to ego. Some people get to a point where they get a certain amount of respect and props among their peers, and people start telling them how good they are, and the point where they accept that is the point they stop progressing. I try not to follow in those people's footsteps. I want to at least be

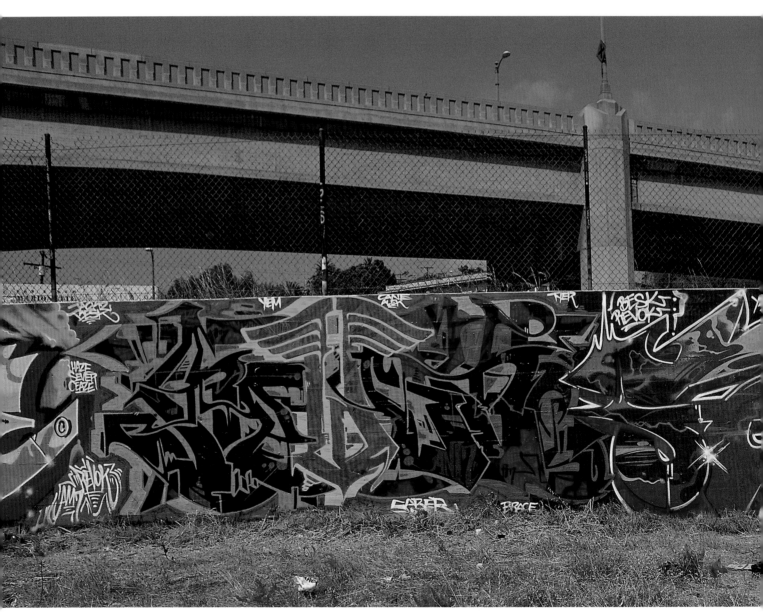

↑ **REVOK** (left), **TACKZ** (right), Belmont, 1997 ↗ **REVOK**, Hollywood, 2005 → **REVOK**, Artist District, 2004 ↘ **REVOK**, Soto yard 2005

in the pack that's in the forefront of things and not just because of what I've done in the past. I don't want to limit or restrict myself, so whenever I've done a series of pieces that are starting to get monotonous, I try to go completely off the path I've laid out and try something completely different just to test myself and push myself to evolve as an artist, graffiti or otherwise. I've always admired writers that don't allow themselves to get too comfortable and are never satisfied; it's usually the people that are miserable because they can never be happy with anything; they're always chasing after something they can never catch.

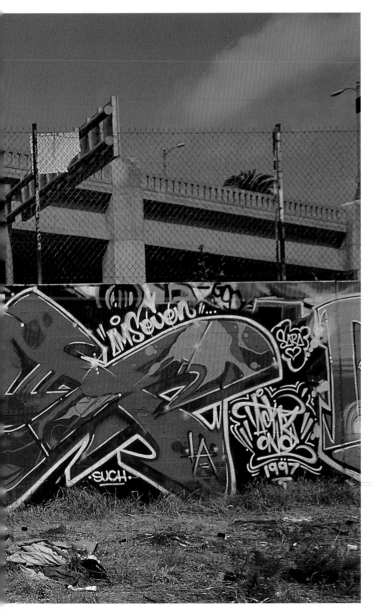

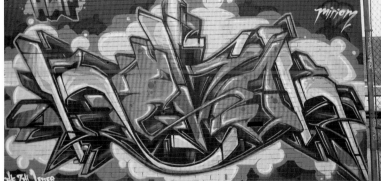

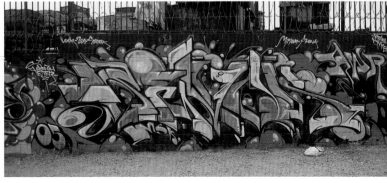

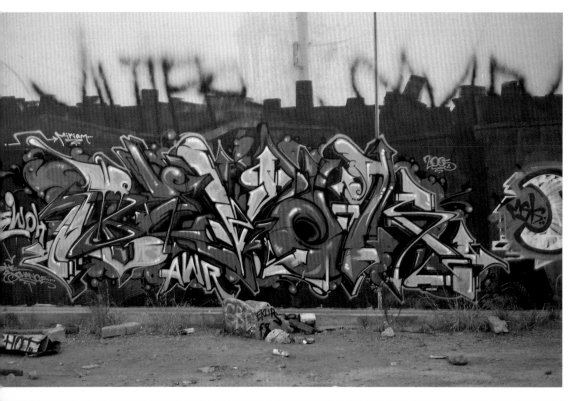

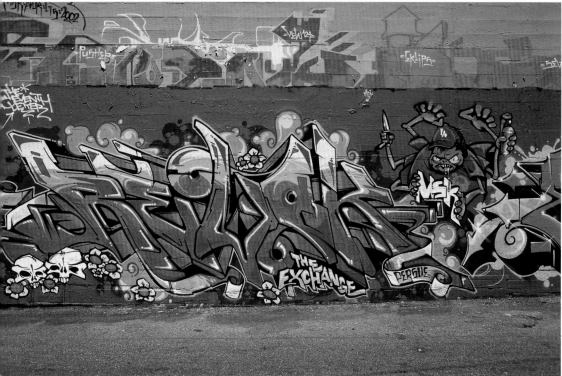

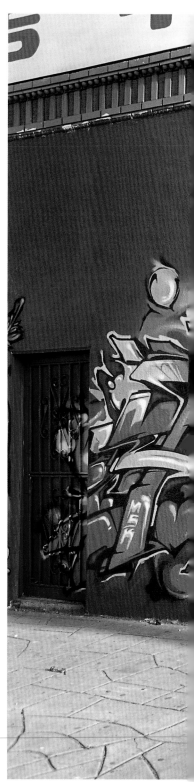

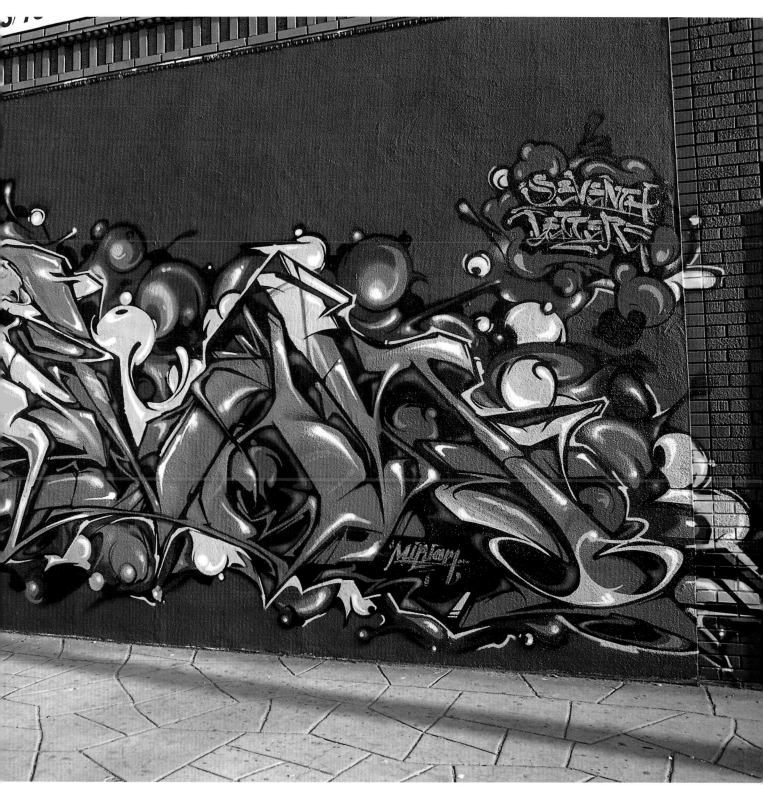

↖ **REVOK**, from a sketch by Ewok, Soto yard, 2005 ← **REVOK**, from a sketch by Persue, Highland Park, 2005 ↑ **REVOK**, Mid-city, 2004

ANGER: Revok is sick; he's what Risky was back in the day, he had the game together, the complete package with letters. Revok is bringing it different all the time and that's what's cool about him. He's willing to play with it.

RISK: I always came to the yards with some quirky little piece that would be way off kilter, not traditional. Whether I filled in with fluorescents when nobody was doing that, or doing things that didn't seem to make sense with the letters, I always did that and I'm more proud of it now than I was then. Because then, it was just for me, and outside of my boys the majority of people didn't get it. But now looking at the movement, I really feel proud of it because it was a rough, raw style that only now is accepted, and I can say I was doing it twenty years ago. I wish I had followed it up more because it might have led to a more defined style now. But that's just a testament that people should always go with whatever they want to do and not worry about anyone else's opinion.

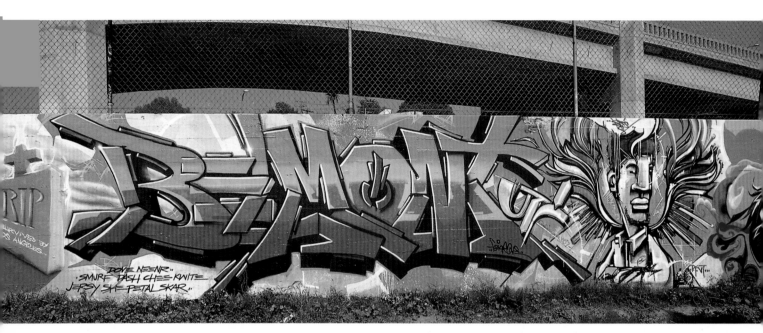

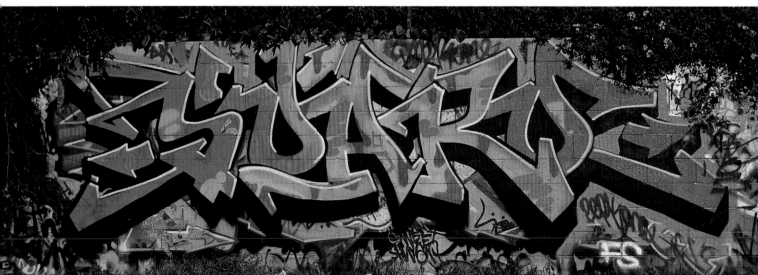

↑↑ Letters by **FEAR**, character by **KOFIE**, 2004 ↑ *Soaro*, **PERK**, Sanborn yard, 1991

FEAR: Changing my style from blended to segmented was a conscious effort on my part. I was not happy with my letters. They weren't growing into something I enjoyed doing anymore. I needed to break away from what I was doing and change it altogether because it was becoming uninteresting. My new style came about when I realized that instead of doing my outline first, I could buff the wall by painting the insides first, and then do the outline right over the fill. And the breaking up of the letters came from seeing all of the crazy breaks inside the color scheme, and I would make my letters go with that. Now I've grown to a point where I can bust my outline first and then do the insides. I took the letter and instead of bending it, I broke it into its sections, and shadowed it so you would see the sections. Kofie and I talked about it a long time ago when we had just started doing that in '96, noting that we were working in a similar way. I think it may be that we're both in UTI: Skill had such an important influence on me and one of the things I got from him and he got from New York were what I call "brackets." And I thought instead of making little ones, I'll make the letter a bracket. I see more and more guys doing that, like Twelve, and I've wondered why we're all doing that . . . is it something we've seen or are we all just influencing each other?

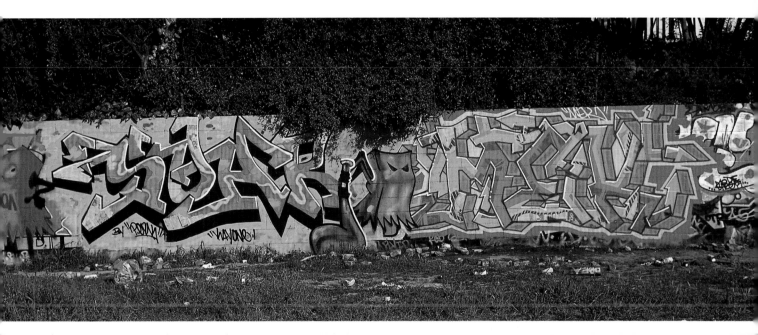

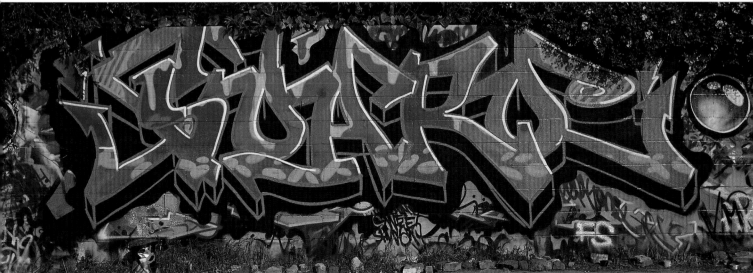

↑↑ **PERK** and **MEK**, Sanborn yard, 1991. Use of newspaper as fill ↑ **PERK** going over his own letters with alternate colors

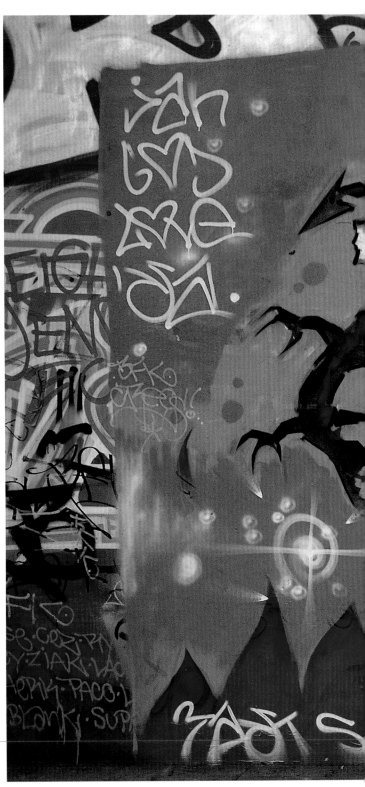

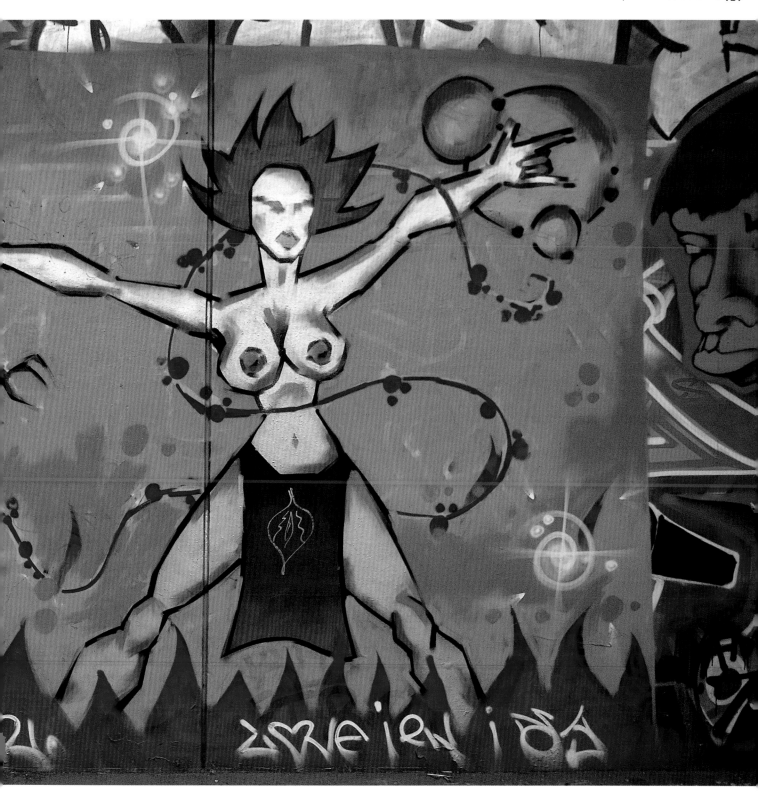

↖ Face, artist unknown, Belmont, 1992. Alternative materials ← **NASIM**, Venice Pavilion, 1995 ↑ **NASIM**, Venice Pavilion, 1995. Non-traditional subject matter

EXPRESSION

While graffiti provides writers with a means of self-expression, the nature of the work offers minimal tangible reward. In most cases, writers give full commitment to their work without financial payback. And due to the illegality of the practice, writers often put themselves in danger, facing arrest, and fines as well. The die-hard commitment of most writers is even more interesting considering the ephemeral nature of the work. Pieces may be painted over in hours or weeks, either by property owners, city workers, or other writers. It is this creative passion in light of all the obstacles that gives the best work its pop pulp energy. Like many people in creative arts, part of the impetus for painting is the escape it affords. When there is difficulty in everyday life, it can be greatly rewarding for writers to escape into a world of their own creation.

NEO: What still keeps me going is still that kid from back then. That special moment in time, when I saw the first things to inspire me, is still there. It's being alive, curious.

↑ **ZES** (right), **PYSA** (left), Lincoln Heights, 2003 ↗ **ZES**, Boyle Heights, 2005 → **ZES**, Downtown, 2001 ↘ **ZES**, Lincoln Heights, 2004 Following pages: **ZES** (left), **RETNA** (right), Downtown, late 1990s

KOFIE: I really like seeing someone's letter style, and I finally get to meet them, and I notice it's part of them . . . and I can really respect them when I see what they're about and it fits. What you see out there—my whole style—is me. At the end of the day I had to find out that whole thing; obsessive-compulsive, neurotic, my organization, my color palette reflects my moods.

ZES: It goes back to when I was an active little kid growing up in the streets and brought that energy into my letters and just enjoyed doing graffiti and expressing myself without caring what other writers thought about me. Every time I go out there,

I want to express something like if I'm painting in a rough neighborhood. I usually know an area because I have a friend that lives down the street. I know the vibe of the environment. I take all that in and throw it in. And it could be the simplest piece, but I want the people, kids around, to actually feel that through the edges and shapes, even if they may not understand what it says. Just that alone makes me feel I accomplished something. That's what drives me. I also do this as a memorial to Ayer to keep his name alive and show people he's still part of us. Any other reasons why I do this I'm still trying to figure out: I have a lot more living to do.

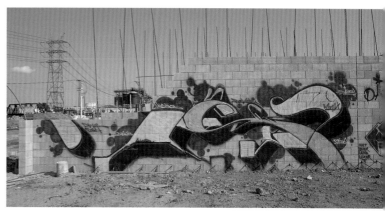

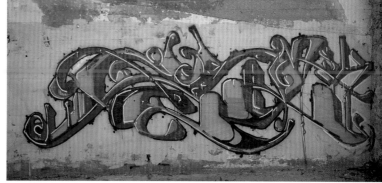

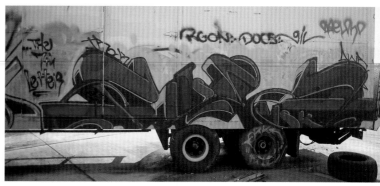

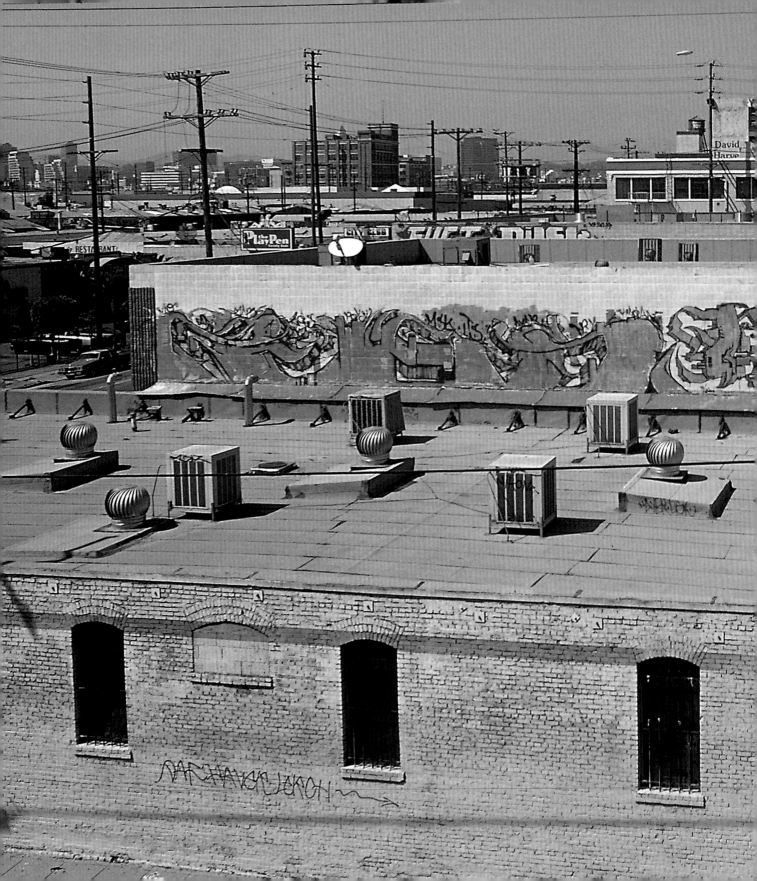

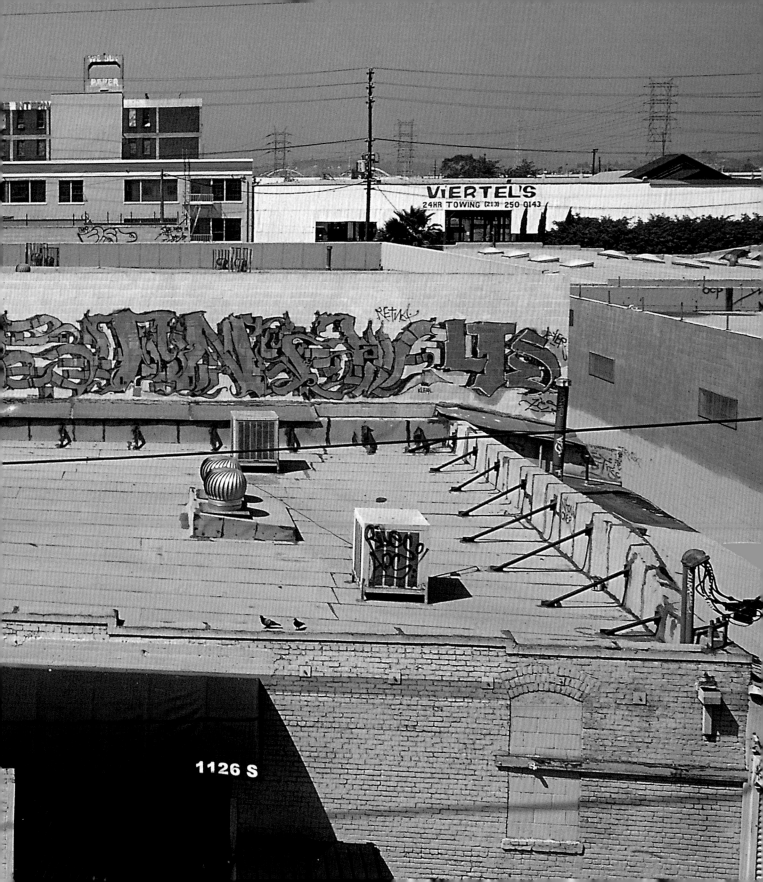

REVOK: Zes doesn't care about what's trendy at the time, what the latest technique is, what the best paint is, or the rules and guidelines that most writers operate under. When he paints a piece, you can see a lot of raw intense emotion in it. It's like this impulsive manifestation, an impression of him on the wall.

SINER: When you're doing a letter, you have to put feeling into it . . . See how the letter is moving. I remember seeing the Doze interview in *Style Wars* and he was explaining how letters move. He'll put an arrow low, like it's kicking, and arrows com-ing up from the top like it's charging. I felt that so much because when I do a piece, it's like you're putting arrows there for protection and they're coming at you. It's like bringing a part of the letter out, leading it over to another section and everything's coming together. And when you do a certain letter, it's like it's moving in a way like a dancer would move . . . like a flow. It's not stiff, unless that's what you want to get across, something sharp that's going to cut you up. Sometimes I'll do a piece that's blurry or bubbly because I like the feeling of being in disguise. And then there are

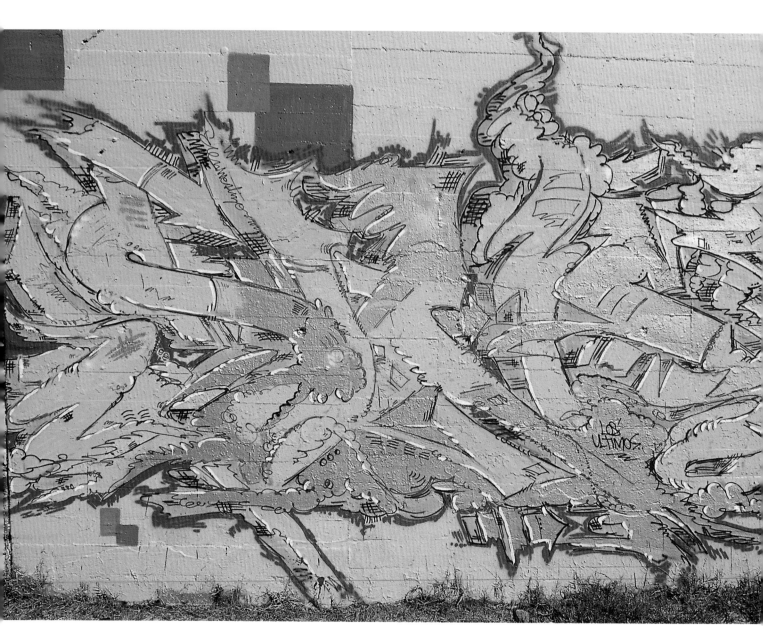

↑ **SINER**, Belmont, 2003 ↗ **REVOK**, 101s, 2006 → **REVOK**, Hollywood, 2005

times when I'll want to do a sharp piece that's meant to chop people up battle style. So much goes into it. When you're working with a piece, you're just working with the section that's right in front of you; it's this huge piece, but you just work bit by bit to complete it. And every part is connecting to the complete piece. And you step away from it and you almost don't believe what you put out there because you're just like "Damn! I know I was working on that section, but it came into this section and it just came together so beautifully." And you just have to step back and you think "Whoa! I created that!" And to have a good feeling about a piece . . . it's the best, when you give a piece some life. It's not just paint up there. It's like a living organism. You're caught up in the moment. If you have music playing, whatever music it is, it makes you move in a certain way; having K.R.S.1 bumping in the background, it feels like some real hip-hop shit, and it makes you work your piece that way. You get into some punk rock and your stuff is going to look thrashed and like destruction, and if you get all happy, you start doing bubble letters . . . which I try to stay away from.

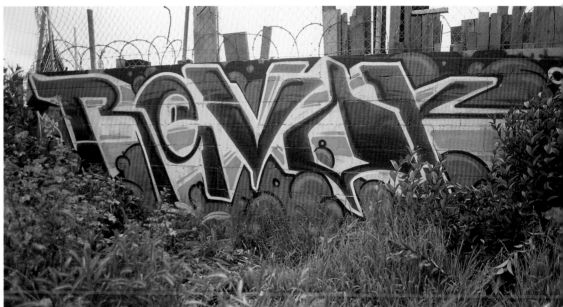

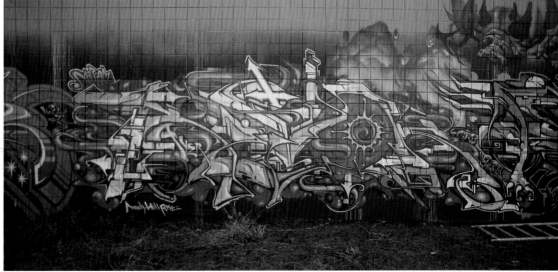

REVOK: It's all relative to what's going on in my life at the time and it comes through in what you see me do. I don't know if others see it, but when I look at it I know how I felt at the time. Maybe I'm in complete despair and it comes out in the work. Other times I'm on cloud nine, or inspired, or in a slump. I never stick to a regimen; I never go to a wall saying "This is what I'm going to do." I freestyle. I might have a rough idea of what I'm going to do, but I go there and wherever I am in my life, in harmony, or combative with everything around me, that's how I am at the moment and that's going to come out on the wall.

ATLAS: What doing graffiti gives me is the satisfaction of making something your own. When I was a kid growing up in my family, I would paint on things and have to suffer the consequences, but it was always worth it. I might have gotten the belt for it, but I was on top of the world when I did it.

CRIME: When I go to a wall, I embrace the feeling of putting the colors and the thought of what I'm feeling at that moment onto the wall. Whatever it is, I embrace it and let it flow, I don't try to control it, I let it flow on its own. I let it move. I let it have a breathing area.

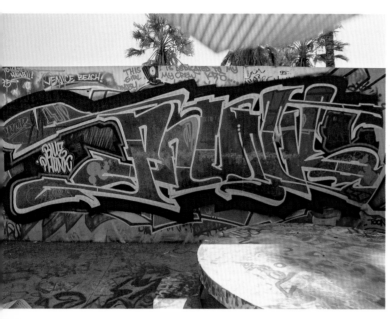
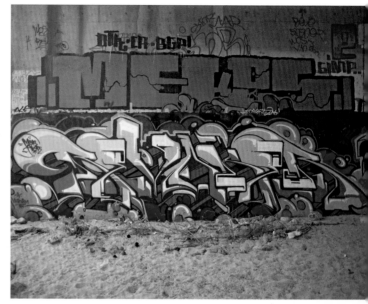
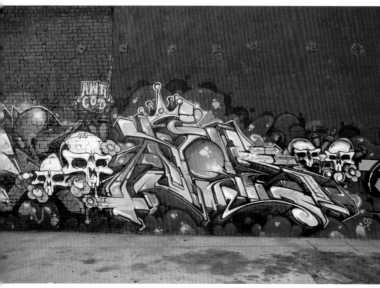
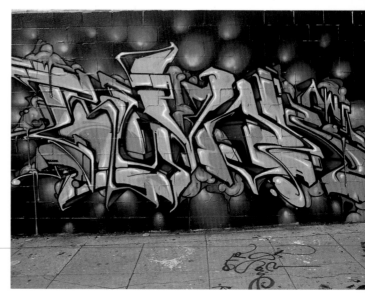

↖↖ *Phunk,* **TOONS,** Venice Pavilion, 1995 ↗↗ **REVOK,** SH yard, 2006 ↖ *AWR,* **REVOK,** Downtown, 2006 ↗ **REVOK,** Hollywood, 2006

RETNA: I've wanted to do paintings that were more powerful in a sense that when you looked at them there was a strong message behind it, not just design-ish. That message would have to do with racial and cultural fusion instead of "I'm This" and "You're That" . . . peace within diversity. I can't say I've reached that yet.

FEAR: Every now and then I'll do a sketch that I really like and try to put it up. But I've done that sketch when I'm in a certain mode at that particular time, and if I try to put it up on a different day when I'm feeling differently, it could be hard to freak the same style because I'm in a different mood. If I'm not doing well in life, my art is more wild, rough around the edges.

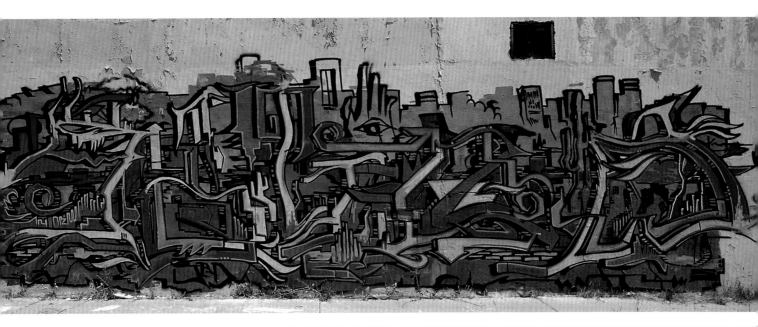

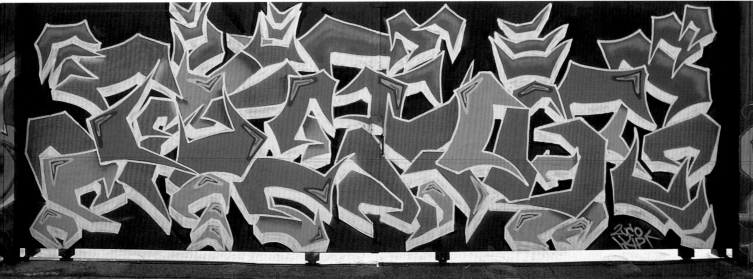

↑↑ **RETNA**, Mid-city, 1997 ↑ **ZUCO**, Mid-L.A., 2003

TOONS: Graffiti should have a similar base to Asian brush calligraphy in that there is much thought and preparation that goes before the spontaneous moment. Graffiti has that aspect: you're doing it at night, with low-light visibility, with limited space and time . . . and you're burning. It's pure creativity because it's forcing you to define yourself right there and then. There were difficult things going on with my family when I was younger, and when things got bad, I would grab my cans and find some isolated place and paint. And I remember how good it made me feel. Afterward, when I went home, things would be cool. I think that is what a lot of writers deal with. It's such an outlet. There was a time I was painting all these crazy monster characters, and I had to tell a religious relative that was disturbed by them that I painted those monsters so I wouldn't do something to somebody. People are lucky we do what we do, because there are so many people with so much anger, frustration, and pain and that they've chosen to do this rather than something more destructive should be commended instead of condemned.

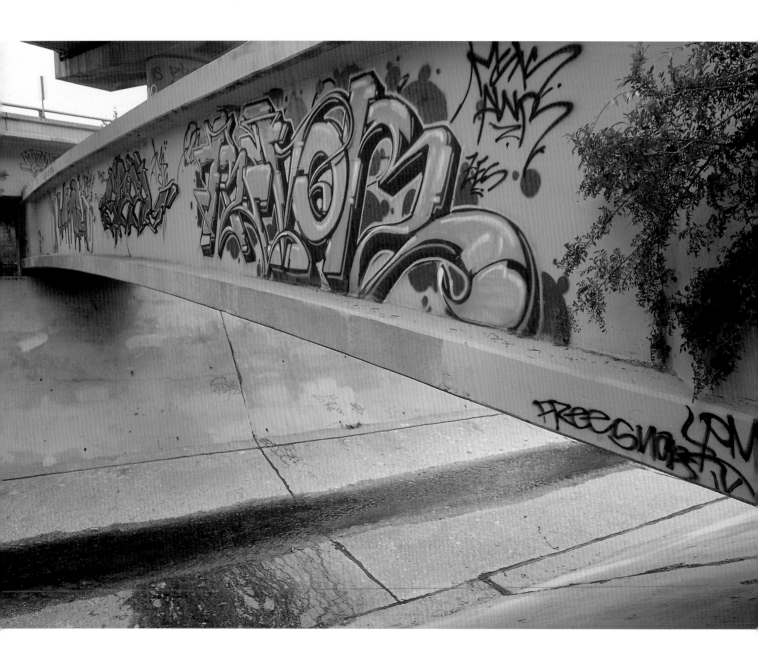

SABER: If I don't participate in it, I don't feel like I'm alive. Painting is where I find balance, calmness, and great self-satisfaction. If I can't do it, it takes me right down to hell. I go through withdrawal.

ZUCO: The whole jewel of it is that it's for me, and no one can take that away from me or buy it. Because at the end of the day, I'm the one that's happy and feeling complete to put those colors together or put that stroke there. And with everything going on in my life pulling me side to side, I can escape with that one piece because I'm responsible for putting it all together. You give that piece life.

CHAZ: Any work that any artist does is a self-portrait; it tells me what's on their mind and aesthetically how far they are willing to take this imagery. When I look at graffiti, I think, okay, they are willing to put their life on the line by climbing up that billboard or freeway bridge on a four-inch ledge to do their letters. So I don't see that much difference between a graffiti piece and a piece in a museum. I read it the same way. If a person can communicate, project a real personal engagement, if your line talks about who you are, that's what makes me think it's good art.

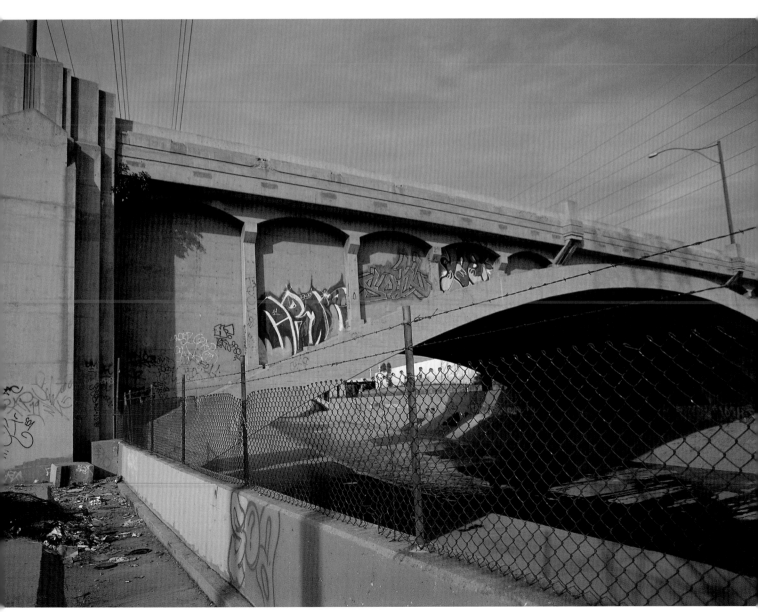

↖ REVOK, above Arroyo Seco, 2003 ↑ SAHL, 10E at the L.A. River, 1999

REVOK and **ZES**, 1999

GRAFFITI AS SOCIAL EXPRESSION

Graffiti is a social expression as much as it is personal. Those opposed to graffiti see it as a reflection of social breakdown, a decline in a sense of citizenship, the endpoint of a fashionable entitlement mentality—"We should be able to do anything we want."

Others believe graffiti allows youth to have a voice in society. And while there is no shortage of writers that think of what they do as vandalism, there are many writers who think of what they do as community beautification—doing pieces in locations that would otherwise be considered abandoned urban blight. There is also the idea that graffiti is the ultimate expression of artistic democracy; no gallery hierarchy to grovel to, no merchandising hustle; indeed, the absence of monetary gain being considered evidence of sincere artistic exercise. Along those lines of democratic expression is the feeling that all of the advertising in the face of the public is the true blight.

Graffiti pieces may also express explicit political and social concerns, including violence and survival in the streets, environmental degradation, the world in crisis, political corruption, and corporate greed. Pieces that deal with these issues can be seen as a continuation of the great mural tradition embodied by Mexican muralists David Alfaro Siqueiros and Diego Rivera. It is this kind of graffiti work that is most appreciated by political progressives who feel that, while graffiti is a legitimate youth movement, names-only pieces are ultimately too self-involved.

TOONS: Graffiti culture is a vehicle for people connecting. I love it when people come up to me and talk about it. That's why I'm out in the public—otherwise I'd just paint indoors and keep it to myself. When I'm able to transmit what I'm going through and who I am onto the wall, and people respond strongly to it, that's the greatest to me.

RETNA: When I'm doing art where money is involved, it changes things. That's why I like graffiti. For all the risks and things you're willing to put yourself through, the fights, arrests, hardships of the family, all these things you are willing to sacrifice to create a piece of art. That, to me, sends a strong message. There are not too many forms of art out there where you go through that struggle. I feel that graffiti is a true American culture . . . all these ancient cultures, the artists inscribed the work for the government to promote the religion and society: now we have this modern-day version that is defiant toward the government, that isn't a part of it in any way.

TOONS: I always tell people that if you want to know what's going on with a city, look at the writing on the wall: you can tell what skill level and what social problems are happening, what's going on with the youth. You look at the time when Chaka and those guys came around. You look at the tag style, and everything got really legible, real rough, and scribing came into the mix . . . all those destructive forms of writing came in, and style went out the window. It was like we were in survival mode, and that's when tag-banging jumped off, bus mobbing came in, ballistic day-type missions, writing just to get into the spotlight. As a response to that, you have anti-graffiti activists like Joe Conally, Graffiti Busters, and so on.

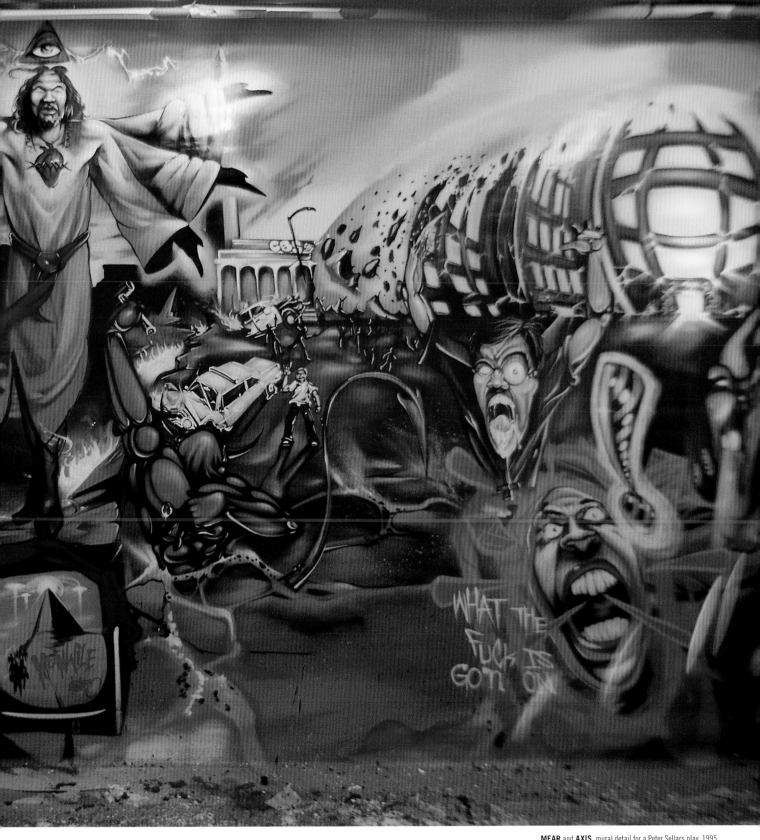

MEAR and **AXIS**, mural detail for a Peter Sellars play, 1995

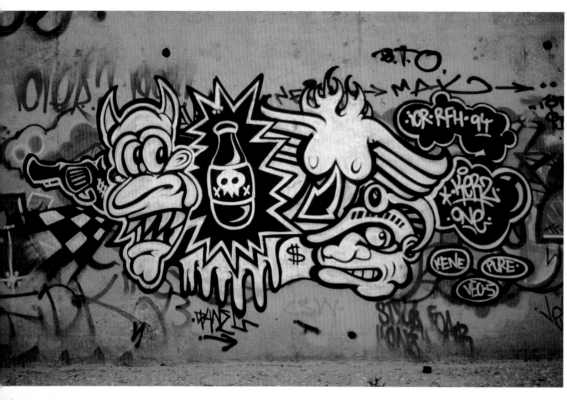

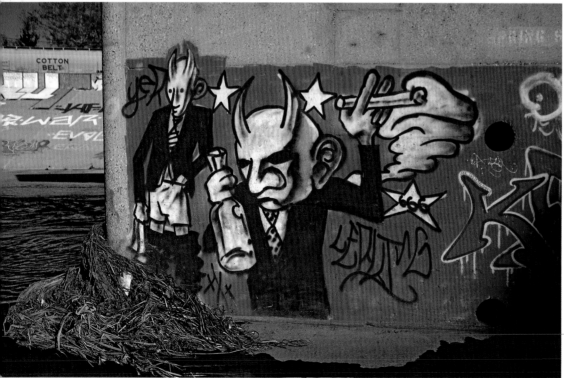

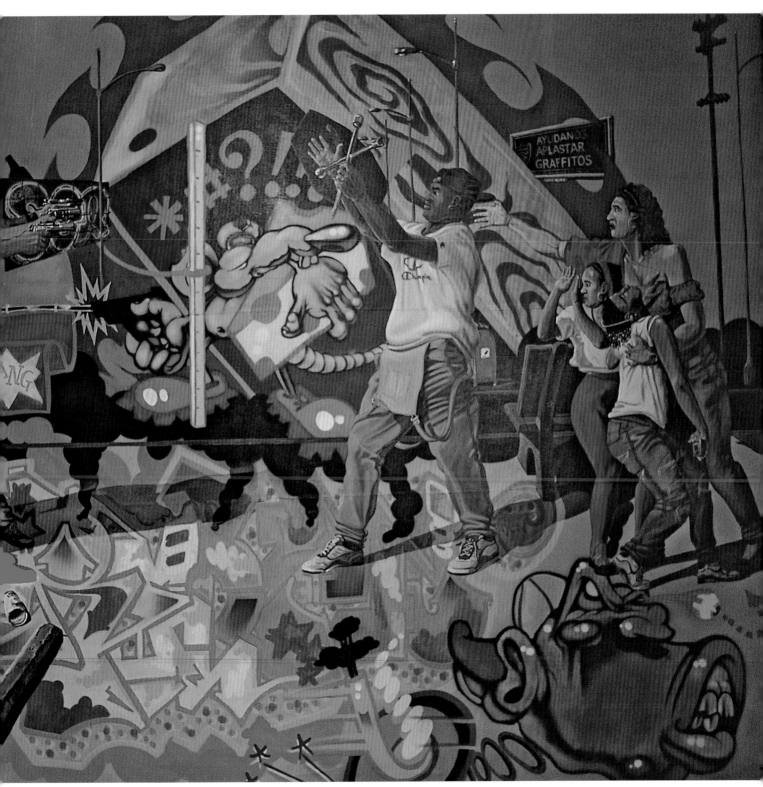

↖ **KERZ**, Arroyo Seco, 1994 ← **LURKING**, L.A. River, 2000 ↑ *The Big Rat Trap*, **RELM** and **SANDOW BIRK**, 1993

TECHNICAL CONTROVERSIES WITHIN THE GRAFFITI COMMUNITY

In any artistic endeavor, people inevitably form different camps of thought. There were heated arguments over "hot jazz" versus "sweet jazz" during the 1940s, and battles between supporters of Abstract Expressionism versus representational painting during the 1950s. Similar arguments on style and what constitutes a good graffiti writer are prevalent, too, in the graffiti world. There are a number of charged topics that remain on the minds of many long-time writers, including the question of what constitutes the most honest expression of graffiti. On one side of that debate are those that devote their activities solely to bombing, or illegally tagging and doing throw-ups (as some equate bombing only with throw-ups). Interestingly, those on the other side of the debate do not represent piecing as the most legitimate form of graffiti, but argue that writers should be well rounded in all areas, to have a balanced diet of tags, throw-ups, and pieces on one's activity roster.

A related debate concerns whether graffiti art has a legitimate place in a gallery setting. Bomber-snobs form one camp, saying that only illegal graffiti is acceptable, while others believe that graffiti is an established artistic endeavor worthy of gallery art so long as the exhibiting artist has a history of street work to complement the gallery work. A gallery artist working in a graffiti style is looked on dimly, and as riding on the coattails of "real" writers, if the risks of illegal work have never been taken. As a general rule, writers consider illegal work to be a requirement in the definition of "graffiti writer," although writers who have "retired" to legal or professional-only work are respected as long as they have put in considerable "street" time doing "illegals." That is one of the criticisms leveled against some 3D writers. Due to the complexity and time involved in 3D work, these writers prefer to stick to permission walls and are often not involved in doing illegal work.

Wheat-pasters, who illegally plaster posters of their own design across city walls, though taking some of the risks of writers, are generally not respected. They are seen as coasting on graffiti fame, and their work is criticized for lacking spontaneous creativity.

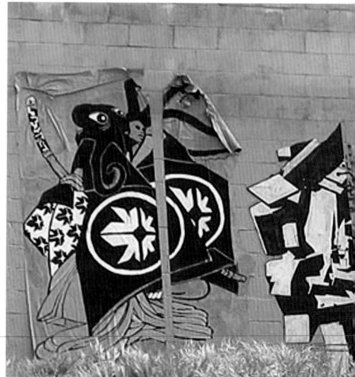

On a more prosaic note, writers look down on inferior craftsmanship (such as bad can control leading to inconsistent lines and unintentional drips) or lack of originality, and the lack of humility that would allow a freshman writer to take up space on a wall next to superior writers. Consistent among writers is the opinion that using tape or cardboard to make straight lines is only for the lowest of toys.

CRIME: The full package is tags, bombs, pieces. And those that can't rock pieces excuse their lack of skill by saying graffiti is only bombing. I want to see your brain breaking. I want to see how you can break it, how you can acquire something out of nothing. You have to be a graffiti artist before you can be a throw-up man, before you can be a block-buster man, before you can be a tag. If you don't have a piece, then you're nobody. You're limiting yourself from what you're supposed to be. The job requires all of the above. We recognize artists for their pieces. We see their writing, their art, what they represent, and we respect that. And then when we see their signature, we still love them because we know what they're about. We see their backbone, their strength. I don't respect bombers unless they have style and sharp letters.

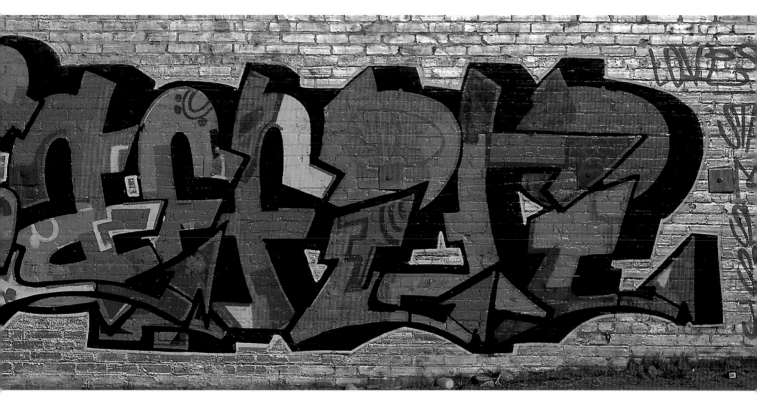

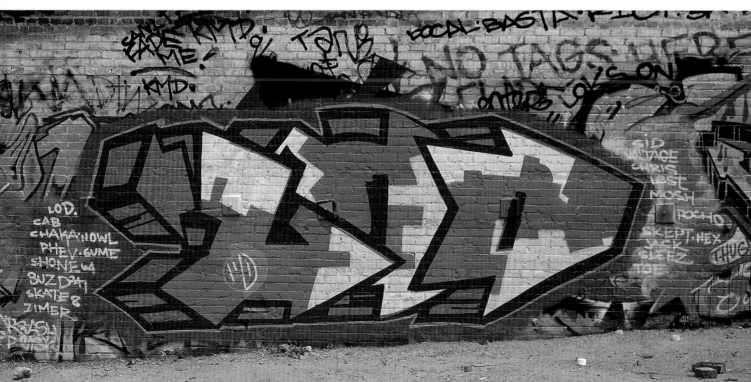

↑↑ *Graffiti*, **LOD** crew, Sanborn yard, 1991 ← Yem ↑ **LOD** crew, Sanborn yard, 1991

PANIC: I don't like sloppiness and stuff you can't sort out even if you try. I always looked forward to deciphering somebody's piece to see what it said and where the letters were. Now I see piecing and I kind of try, but I can't make sense of it; it's graff and done by writers, but it's sloppy with drips everywhere. Like it's a way to be a graffiti writer but without having to have any can control, where any average Joe can grab a can and do that, where you don't have to have any definition or sharpness. To me, the epicenter of graffiti is can control and to make your stuff look really sharp, which was how I was raised, looking at Risky's pieces and Charlie's pieces and early LOD, like Volt and Mosh . . . when you needed to be at that level to even paint. There was an early point when I felt I couldn't paint at the yards because I felt out of respect I needed to be up to par. That doesn't exist now; everything is mixed with everything. There's a lack of education and people not knowing what the foundation of graffiti was: you had to have style, originality, a unique name, and other words to go with it. Now it's just a big race to see how many times you can get your name up, where before you had to do different pieces whether it be your crew or somebody else's name, or a word like "freedom" or "knowledge" or whatever it might have been. Be versatile enough to do any given word at any given time. To do it solid and sharp and to have definition to your piece. For the characters to be placed right, and good backgrounds, piecing in books. It all went hand in hand, and that was the foundation I was taught in graffiti, and that's what I stick to today.

ALOY: I don't respect those that haven't paid dues that take wall space from those that have busted their ass backward to earn a spot at a wall.

CHAZ: People need to be able to recognize your work from across the street, and you better be saying something profound and unique. For me, art has to function. It has to engage you at the head (thoughtful construction/scale), the heart (message/passion) and the hand (craft).

KOFIE: Wheat pasters are generally not respected by writers. They are thought of as just promoting their Web site. Most poster guys could not do any spraycan art, so there's this other medium they can do, and they can get it out more visibly. They can get out legible letters and the common street head can see that all the time. If it's actually expressive street art, and not just the promotion of someone's Web site, clothing line, or a quick attempt at street cred, then it's appreciated. They are a separate world and there have been instances when they have caught fat lips from graff-heads. They are seen as crowding potential graffiti space with something not particularly personal or creative. Wheat pasters are often seen as art school kids that have gotten easy undue press and advertising after having caught the bug doing street stuff. It's kind of stinging when you've been doing stuff in the city for a long time and you're not really trying to get ads and press and all that, although acknowledgment is always nice, then you see these kids doing something for just a few years, and doing something really silly, and then they're designing toys and all this other stuff.

ATLAS: You'll notice that most people that do 3D don't do illegals, so I don't give them much respect, sorry. If you're not also bombing, you're just another artist, not a graffiti writer. If you had history and then retired, that's cool, but someone that has never painted illegally is not a graff writer.

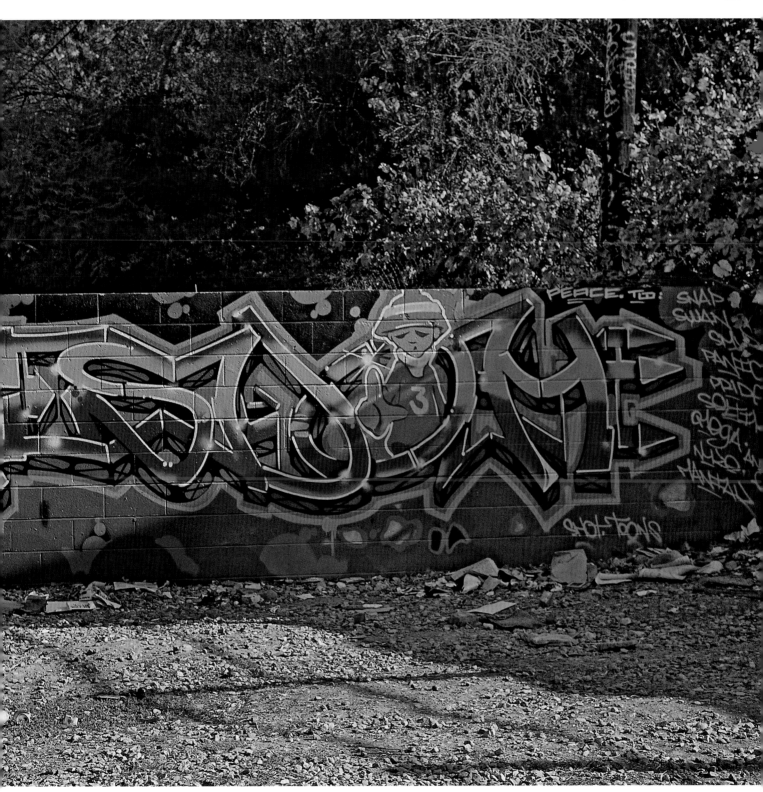

Wisdom, **SKILL**, Sanborn yard, 1991

SINER: There's always going to be that thing in the graffiti scene about the bomber or the piecer or that guy who just paints legals. And that it's just a toy that does tags, and everybody thinks they're more than the other person because of what they do. Who's to say what "keeping it real" means to you? I think it's about seeing where you can take your art, and you may start with spray paint, but if you get tired of being chased, you can put it on a canvas as long as you can get the same energy that you learned from graffiti.

AESTHETICS NOW

For some of the earliest writers who have been around since the graffiti movement in Los Angeles began more than twenty years ago, the stylistic and technical differences between the early days and now, and what influences currently dominate are both troubling and encouraging.

Many long-time writers witnessing the scene today see a lack of personal style among young writers, less originality, and more "biting" (unacknowledged plagiarizing of someone's style). They also mourn the lessening of crew and regional distinctions, which began to diminish in the early 1990s. These negative trends can be at least partly attributed to the ease of viewing graffiti in magazines and on the Internet.

On the other hand, many veterans are excited to see the ever-expanding approaches of writers who are going outside of the established canons of letter styles, distinctive styles, and a robust scene that is once again witnessing a revived interest in popular culture.

CRIME: Today there are some strong personal styles, more abstract, not just the usual interlocking arrows. There's so much collaboration and mixed influence rubbing off.

ZUCO: I still think Siner is in the forefront of L.A. because he and LTS have brought something besides block letters, wildstyle arrows, and a different kind of line. But Revok's is the most popular style right now and he does it right.

PLEX: Saber's technique is incredible now. Saber is already a graffiti icon with nothing to prove, and Revok is the next generation, has more story to tell.

CRE8: Too much of the new generation is not putting it down with solid flavor; you don't feel it when you see it. They think they're getting over on the older generation that knows what's up with style, but while there might be technique, where's the flavor, the fresh letters? Where's that flow, the connections, like Tempt or Dream used to do? Where's the soul to the art? Ayer, Revok, Retna, Klean, Kofie, Sacred: people like these developed unique styles.

TOONS: You look at a lot of pieces now and they don't *move*. You look at something from the '80s and it's rockin'. Too much new stuff has tricks and technique but no soul. But I'm not going to sit here and complain about how good it was back in the '80s; we need to *do*, represent, so the new kids can see what funk is all about. That's why I say to the older guys, "Teach and represent." That's the only thing that will keep the quality up.

PANIC: There are a ridiculous amount of writers now, and not all of the writers are of quality, so you get a lot of scribble-scrabble. That's a big difference; the quality painters have decreased in number. But there are still many talented painters now doing things that would not even have been thought of before, to where the experimental level has reached heights that I never thought would be done. Back in the heyday, everybody stuck to a format with your letters, your characters. You had a foundation for a piece, and now I see people going out of those bounds, experimenting more and doing off-the-wall stuff. I like 3D, realism, robotic-type stuff when it's done well. Looks really nice, but it's a touchy subject as to whether it's true graff or not. I guess nowadays it's anybody's claim what is or isn't. I like it when anything is done well.

SWANK: Styles were more particular to an area before kids got cars and particularly before the Net. Now everyone is exposed to everything, and though sometimes things seem more homogenized, maybe it's a good thing. You see things figured out and adapt those techniques and styles.

ASYLUM: Ten years ago, people were pushing the image. Now they're focusing more on letters and coming up with really good work.

→ *Somos La Luz* (*We Are the Light*), **CHAZ**, Melrose, 1999

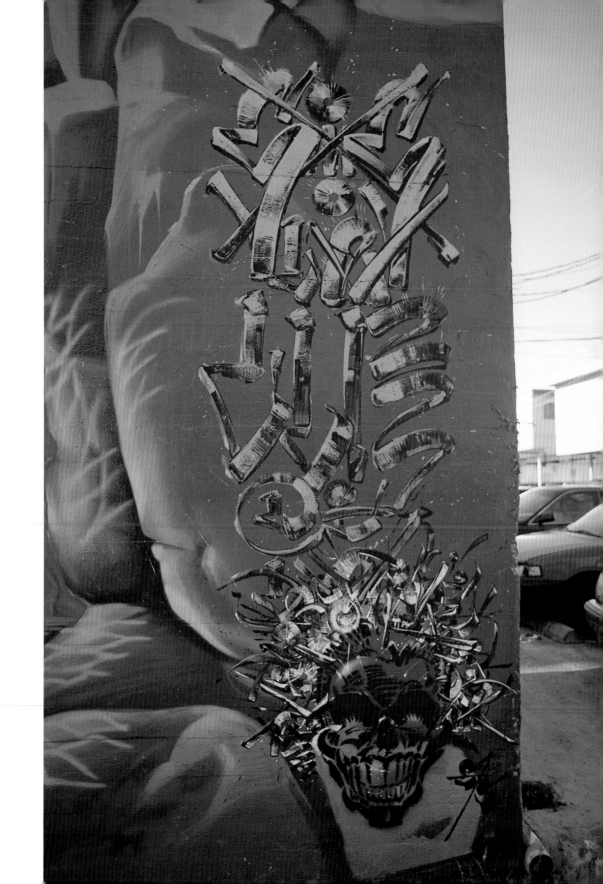

THE SOCIAL ELEMENT

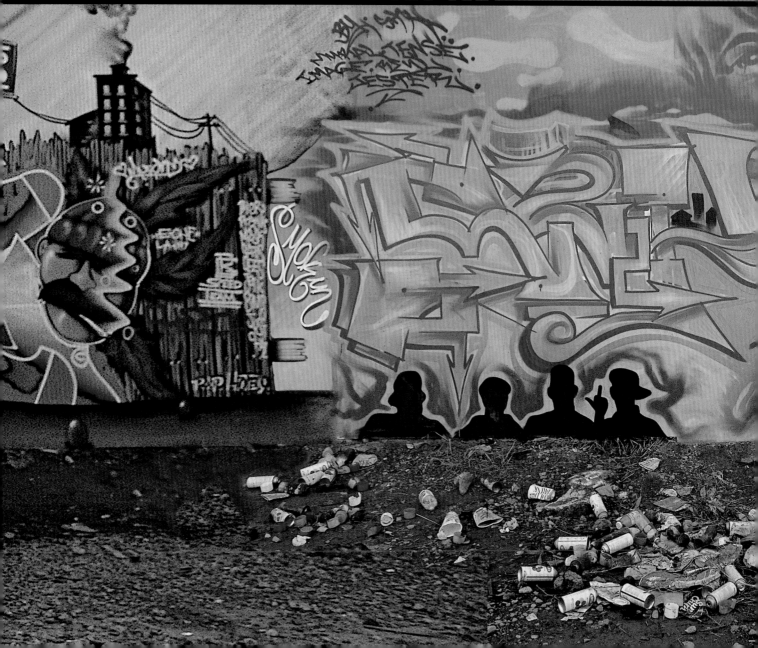

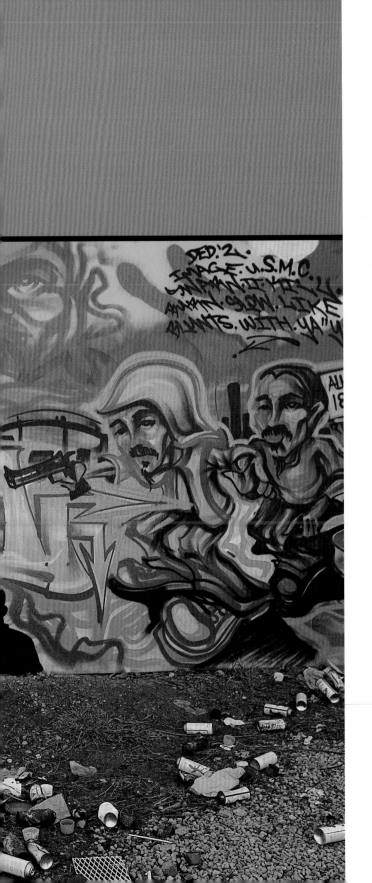

For most writers, much of their lives takes place within the social bonds formed around graffiti. Graffiti subculture, though fluid and with often-shifting associations, has a profound effect on its participants. Many of L.A.'s first crews were formed by teenage kids, who are now in their thirties. And many of them are still active. Those who grew up in gang-riddled neighborhoods saw the new style of wall writing to be something more creatively and personally oriented than gang writing. Teens who were already friends through school or who were from the same neighborhoods began to form crews. Other kids became involved through happenstance, seeing paint on the hands of another kid or markers hanging out of their pockets. Curiosity led to a conversation that for many led to life-long associations. Many friendships were formed at yards and other sites as they began to emerge. Writers were recruited as well, when an established crew saw someone with talent. Some writers, originally break-dancers, segued into graffiti after seeing it done at hip-hop events.

There will often be spectators at locations, particularly when they are permission walls, including writers' friends and younger writers wanting to see more experienced writers in action. Writers will often have "black books" (blank artists' sketchbooks, also called piece books) in which they show other writers pieces they have done, often in complete detail with color markers, that can serve as the working sketches for full-size pieces. Writers may also ask other writers to put a tag, throw, or quick piece in the book. At graff related gatherings, photo albums are also passed around, which include "flicks" (photos) of various writers' work.

CRE8: In '82, I was nine, third grade in South Central Los Angeles, and I was into the gang writing on the walls—the stuff that was neat and artistic captured my eyes. I would be in class doing my name or other people's names in those styles on paper. There were both black and Latino gangster styles, although I didn't distinguish them at the time. I just noticed the skill involved. I would do people's names for a quarter and when I got to four people I bought cookies at the lunch break. In junior high a guy introduced me to the Air Force crew of breakers. Bizarre One, older than me by several years, was one of them and he showed me his piece book, and I hadn't ever seen anything like that, pieces with markers and fresh color schemes; I was speechless. I eventually asked him to teach me, and he said he would teach me only if I was serious. He started to show me how to blend the markers and how to outline, how to do characters and make it all clean. At one point, he told me I could keep a piece book of his for a couple of days . . . well, I couldn't go to sleep, and my mom was getting on my case telling me to go to sleep. I slept with the book by my bed, and I'd wake up at two in the morning and study that stuff like it was serious literature, just soaking it up.

SINER: I am one of four brothers and we all started by break-dancing in '83–'84, and it was natural to get introduced to graffiti from there. I took on the more artistic part of it.

RETNA: I picked up graffiti in the third grade. After school there was a program called C.Y.O. where they had these Neighborhood guys from Santa Monica counseling us, and they would kick me down sketches. One of the main guys was Chubby, and I still have some of the letters. He was eighteen, and I would ask him all these questions that I didn't know anything about, and he would sit there and draw these very stylish block letters for me. The letters I most remember him doing were the "S" and "M," but the way he would do it . . . I think my "S" is still influenced by what I saw then in the third grade.

TOONS: The first time I saw a piece was a Bode-like character in '79 in Pasadena at an arcade. It was on a back wall and huge and it just drew me in. I thought "Whoa!" I couldn't figure out how it was done. My mother had exposed me to art starting at a young age, including mural art, but this was different. So the first graff I did was painting on my Converses in bubble letters, blocks, and Old English. In '81 this other breaker in my neighborhood was from New York, and he saw some of the shoes and drawings I had done. I was drawing animals a lot too; he said, "I didn't know you were down with art—let me show you the art I was down with in New York." He showed me piece books and photos of trains and I was blown away, and he told me it was done with spray paint and I was dumbfounded. After he showed me that, I had to do it. For outsiders it's hard to understand because anything you've been totally passionate about that you didn't know about before, you had to do it. I was totally captivated by it, like being in love. After that, any kind of spraycan I could find, I'd try to paint.

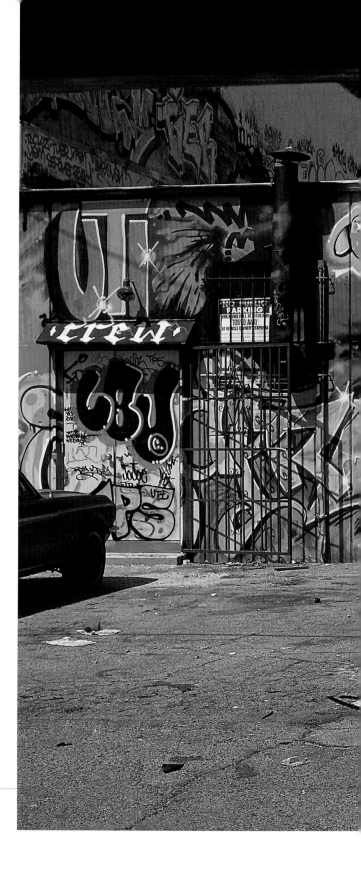

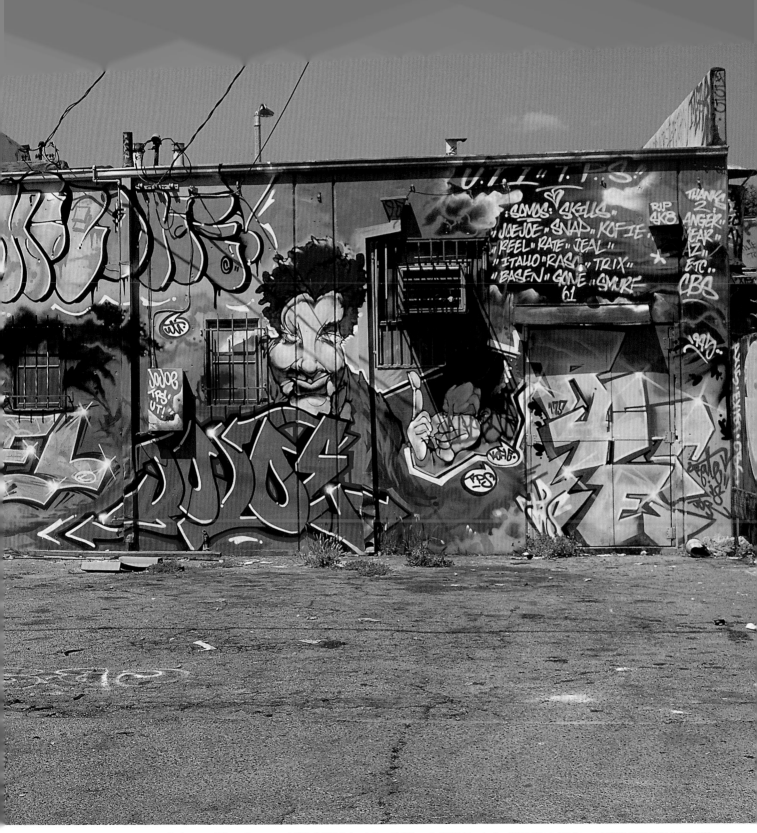

Previous page: **STK** crew, Commerce yard, 1995 ↑ **UTI**'s first production with **TPS** recruits **KOFIE** (characters) and **JO JO**. Silver bubble throw-up by **SKILL** at top center, Melrose, 1995

WISE: Because you traveled by bus or bike to see the yards, you eventually met everybody and had friends from all over the city at a time when most people were still regional and kids didn't get around. Again, as a kid, especially from the Valley, with limited travel options, it wasn't easy to be exposed to all that was being developed . . . no magazines, articles, or Internet back then.

RELIC: My friend Repo lived in Highland Park and grew up with the STN guys Defer and Skept. Baba was another one of my mentors, and those were the two I rolled around with most of the time. I consider Baba my older brother. When I stepped into the scene I was fourteen, maybe fifteen, and Baba was in his twenties and doing graff, so he would take me around to all of these places and introduce me to all of these writers. He had a car and none of the rest of us did. Repo and I could only get so far with our fake bus passes, but Baba would say "Hey, let's go to Venice to check out pieces. Or the Valley." This was probably '86. There were crews that I thought

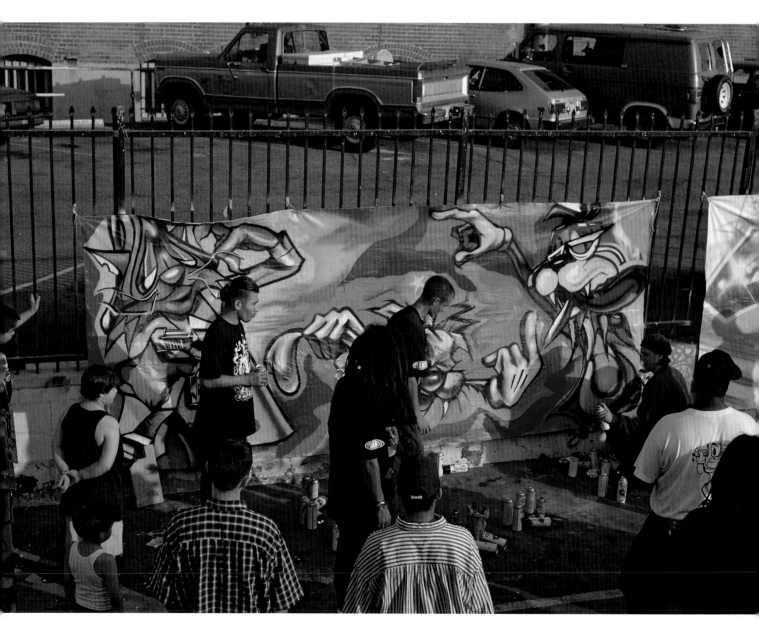

↑ **EXPRES**, Conart event, 1993 ↗ **UCA** gathering to consider recruitment of a new member, 2006

were really blossoming, that I really looked up to. In late '86 or early '87, Rage, who I knew from school, introduced me to the guys at UCA after I asked him to. I told them I wanted to be with UCA and they said "Well, you gotta do a couple of pieces for us to show us you're down." And while that was fine with me, Repo said "Hey, let's go paint at the Tunnel with an old friend of mine." So we went to the Tunnel and Defer was there and we ended up painting that day, and at the end of busting the piece, Defer said, "I hear you're trying to get into UCA . . . well, how about getting into STN." Def was talented in that way. He has a gift, seeing the goodness in people because he brought a lot of people into STN. The first time I met the guys in the crew because Def had told them about me, they welcomed me with open arms and treated me as though I had been there forever, and that was my first introduction to being part of a crew. And later on the guys in UCA heard I'd gotten into STN and invited me to their crew too, without having to go through all the drama of busting the pieces and everything. All of a sudden people were accepting me for the work I was doing. I also ended up in SH because I'm from Glendale, and there's a bunch of writers that came out of Glendale that I used to hang out with where we all went to school.

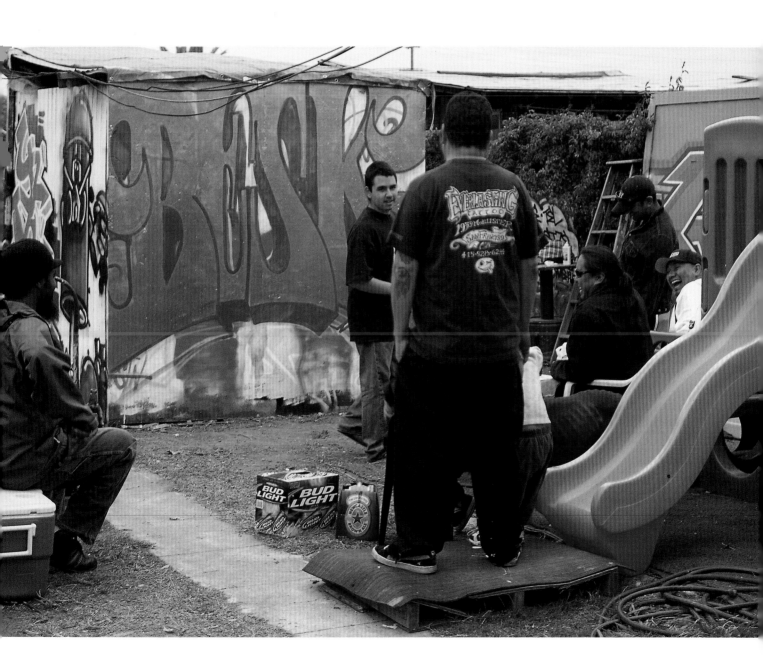

TYKE WITNES: My brother Sumet was tagging in Woodland Hills. He got me into graffiti and we started piecing in '88 in Agoura because that's where we met Krush, who lived in the Valley and did the same commute as us. There wasn't much in the way of piecing out there, so seeing his stuff was like leaps and bounds from what I even imagined. When I was young and doing tags, I couldn't find yards. So he would take me to yards and I'd see his drawings and see photos, and that was the next level of stuff to do. Sumet is a huge part of why AWR is where it's at because at the

time, Sumet knew Krush. He would show me sketches and was real cool with me and showed me a lot of stuff in the beginning and took me to yards and to where Krush battled Skill at the UTI yard in North Hollywood on the tracks. It should go down in history because it was just an off-the-top battle and it was a draw. Sumet was always the one hooking up with everybody, Fever and TCF guys Mystic, Booh, and Nyse. I just got around because I followed my brother. He let me tag along. There were just a handful of writers in Ventura County and Agoura so we tried to find each other; this included

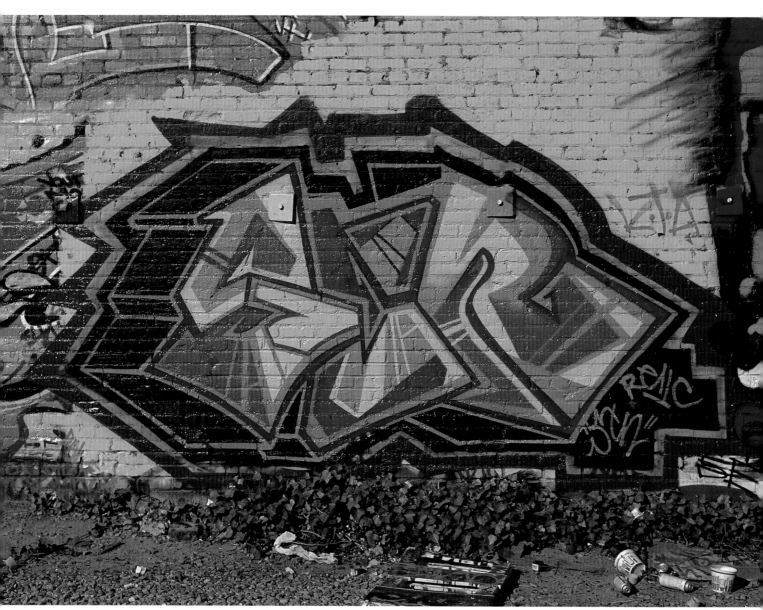

↑ *STN*, **RELIC**, Sanborn yard, 1991 ↗ *Paws*, **DELO**, Sanborn yard, 1992

Crises (who we found), Saber, Hazen, Bles, and Phable. There was this hidden yard that Phable found in the forest that we'd have to hike ten miles to get to. Sumet eventually hooked up with AWR and brought those guys with him. It was just after getting with AWR that Krush started killing it at Huntington Beach. He was in KSN before that.

NEO: We weren't thinking of ourselves as graffiti artists, just kids having fun, like skating, riding a bike, or break-dancing. Highland Park, met a lot of good people there: Panic, Acme, Baba, Repo. You recognized writers from the paint on them, or when you rode a bus and noticed somebody reading the tags and scribes.

FEAR: When Dove and I met respected writers, they were cool with us and would teach us things.

DOVE: . . . and that was a big thing; you perceive this person to be an icon, and when you meet them and they're down to earth, treating you like you're on the same playing field, well, that was influential in terms of how I carry myself.

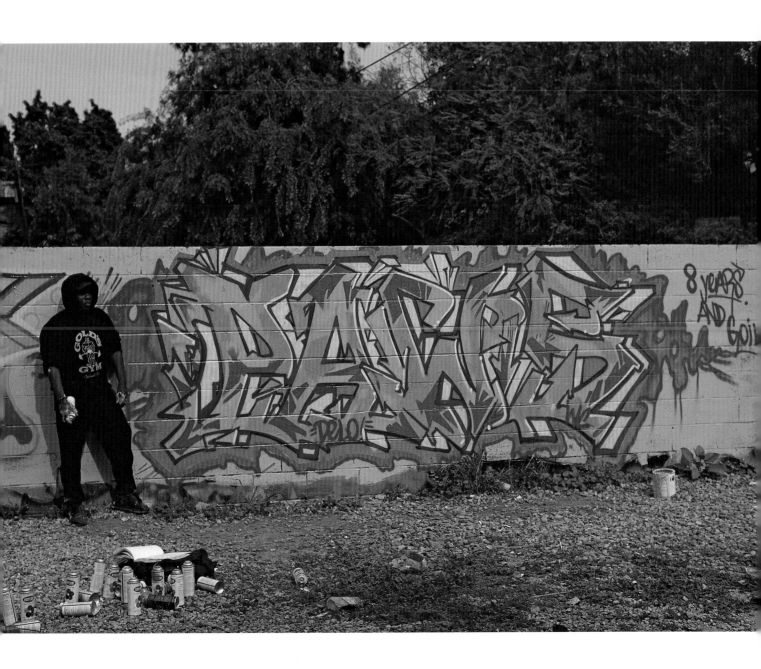

ECUMENICAL L.A.

While ethnic and racial tensions are an unfortunate feature of contemporary America, the ecumenical nature of graffiti culture, particularly in L.A., can be very encouraging. Most crews in Los Angeles consist of writers from a great mix of demographics: white, black, Latino (Mexican-American, Guatemalan, Salvadoran, Chilean, Ecuadorian, Puerto Rican), Native American, Asian and Pacific Islander (Chinese, Japanese, Hawaiian, Polynesian, Amerasian, Filipino, Samoan), European, Assyrian/Persian, and so on.

Even in cases where crew members consist of one race, there still appears to be camaraderie among crews. In 1985–86, the Soul Kings, Latin Lords, and Ivory Dukes: black, Latino, and white, respectively, were all friends with each other. So while the crews' names acknowledged pride in their background, all three crews were often written together, which was a way of showing that these crews weren't exclusionary and that they were proud to have such talented and creative friends of all nationalities. Later, around 1988, an all Asian crew, the Won-Ton Men was also formed, adding to the mix of languages on the walls that came to include Spanish, Chinese characters, Japanese (Kana and Hiragana), Hebrew, and Arabic.

PANIC: As for myself, I'm in a lot of crews (SH, LOD, OTR, UTI) because I've always been a person who has mingled with everybody. I took in this graffiti thing and have gotten to know a lot of cool people in different parts of the city. I usually run into someone I know wherever I go. Rich, poor, from any part of the city, any ethnicity and language or religion, everybody is represented in graffiti; it invites all and welcomes any. Writers accept each other for whatever you might bring to the table, and to me that's the greatest. Everybody can be free to be who they want, and that shows in peoples' art; some people are colorful, some are bland. It's a big soup.

ANGER: A lot were skaters before graffiti and into punk, stoner rock, and metal. There were punk gangs all from the Fairfax High School/Miracle Mile area. And they were all mixed gangs with whites, blacks, Latinos. When I got into CBS, I also got to know the West Coast and KSN guys and even though there were a lot into hip-hop, a lot pumped more off of rock. In the late '80s, early '90s there was so much collaboration of scenes taking place, in graffiti as well as in music.

RETNA: My mother is Spanish and Central American Native, my father is black, and my grandmother was Cherokee. Ayer was black and Mexican. Mid-city kids did have a lot of bi-racial mixes going on.

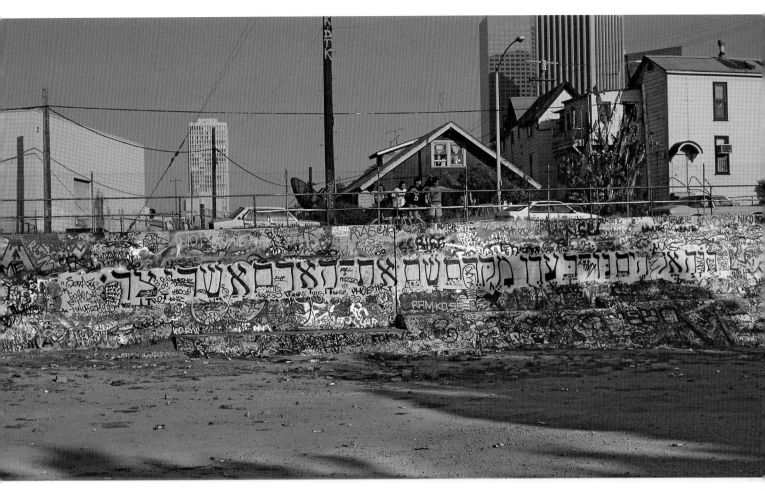

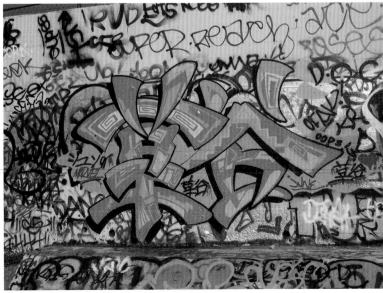

← **MARVEL**, Belmont, 1991 ↑↑ *God, who advances the human, which he created,* writer unknown, Belmont, 1991 ↖ **CHARM**, of **THE WON-TON MEN**, an all Asian crew, Belmont, 1991 ↗ **MARVEL**, Belmont, 1991

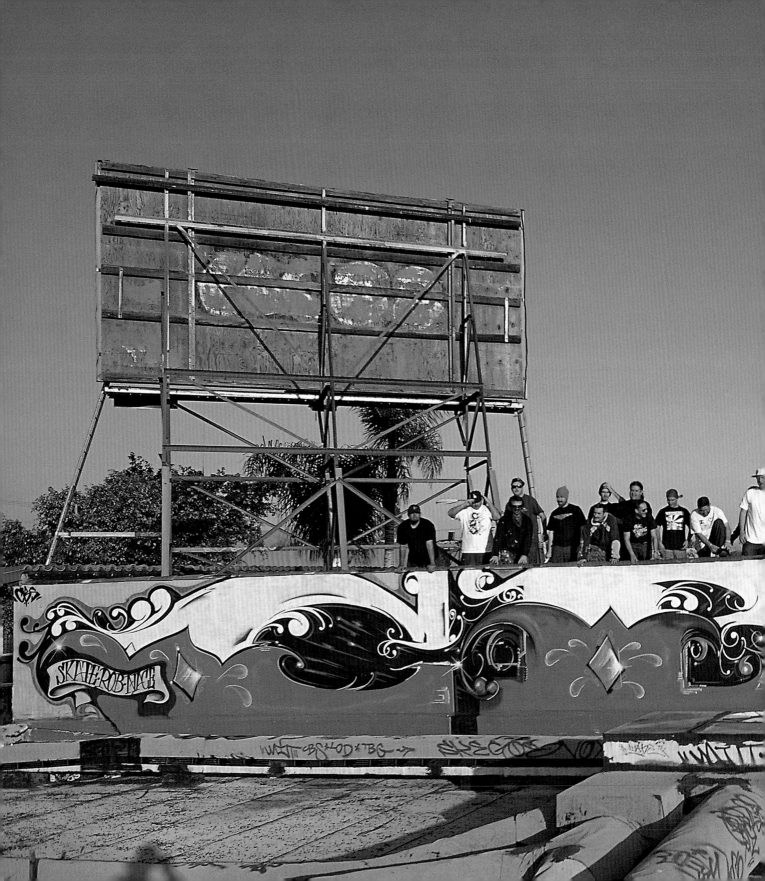

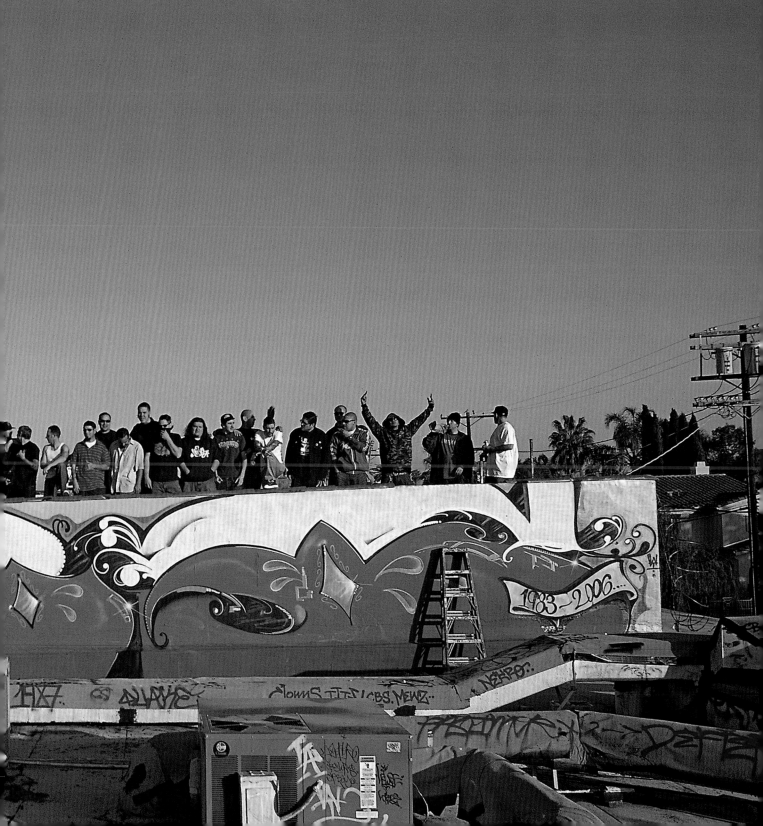

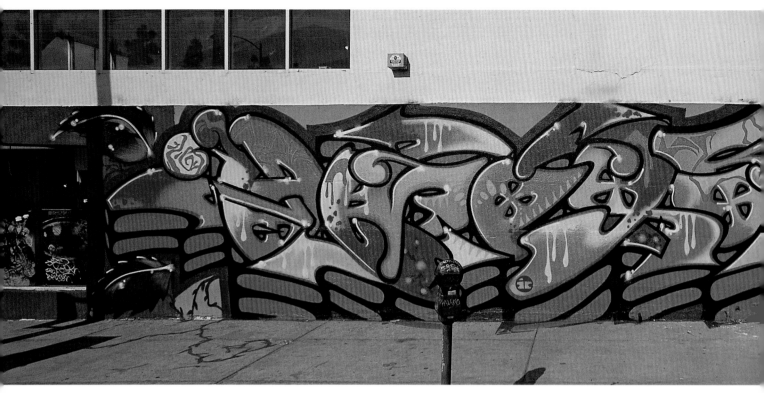

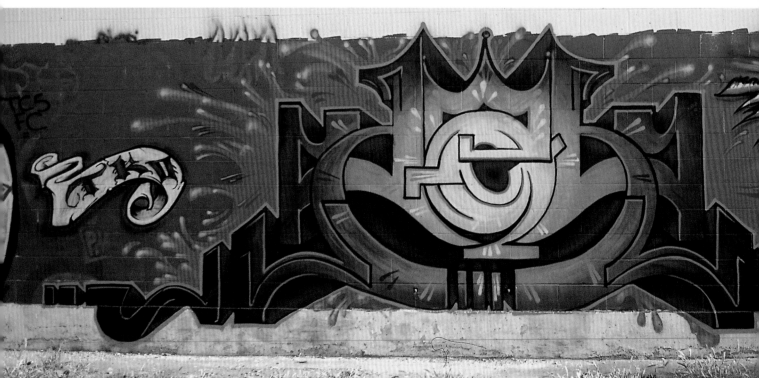

Preceding pages: **CBS** on Melrose store roof, 2006 ↑↑ **OMEGA**, Melrose, 1993 ↑ **JEL**, South Central, 2005

WOMEN IN GRAFFITI

While the graffiti underground is still a predominantly male bastion, women continue to make inroads and are no longer a novelty at walls around the city. Women writers have worked hard to develop personal styles, taking established technical vocabulary and tweaking their writing to reflect themselves in both forms and colors. Even in many of their names and crew names, women writers acknowledge their gender and have a distinct sense of humor as part of their graffiti identity, while others may choose ambiguity. But as in many areas of society that are male dominated, women have often had to endure condescending scrutiny before finally being accepted.

Two important early L.A. female writers were Omega UTI, who started in the late eighties and Blosm of CBS, NTS, and MTA, who started in the early nineties. Tribe of TKO and MSK has been active since the mid-1990s, though today is more active as a DJ. Jelous (Jel) of TKO, Sherm of WGS, and Jerk of GAW are all technically accomplished and stylistically distinct female writers presently doing pieces in Los Angeles. Other female L.A. writers covering the gamut of tags, throw-ups, and pieces, include Envy and Perl, both OTR FDS (Females Destroy Shit), Fusha TKO, Secret FDS, Chalk OTR, Deeva, Jeyd, Dotie UTI, Fuss UTI SKA, Fem aka Fetish WRS (Women Rock Society) MTA, Kudles OTR WRS, Wonder WRS, She, Spun Asia, Agony, Whine, and Petal.

SHERM: People will talk shit, and that's always going to happen no matter what, but at first I was confused as to whether I wanted to be known as a female writer or just for my work, so I didn't have a definition of myself. I knew I wanted to paint, and paint a lot, and really get my name out there. But now that I've built up years of work, I'm pretty comfortable with who I am.

JEL: I never really thought of myself as being a female bomber. I was just thinking I'm doing it because I can! I never really thought about it, whether another writer was male or female. The first time I painted in front of my crew, a Virgin Mary, some of them said "I think that's too hard for you," but I was so pissed off I just tuned everybody out and did it. For one piece, somebody lifted me to reach up higher, and they helped fill in a little so we could leave, and then someone came by and said "Oh I knew she couldn't do stuff by herself!" And for a while after that, until 2005, I didn't want any guys to help me with anything! I didn't want anyone to teach me anything, I'd learn it by myself. I didn't want anybody to think I had to have help. I didn't want to be one of those writer girls where people think "Oh, she came in through a dude, or her boyfriend did it." And I was right to do that because now when I accept help or a tip, people know I put in the time and it's my work.

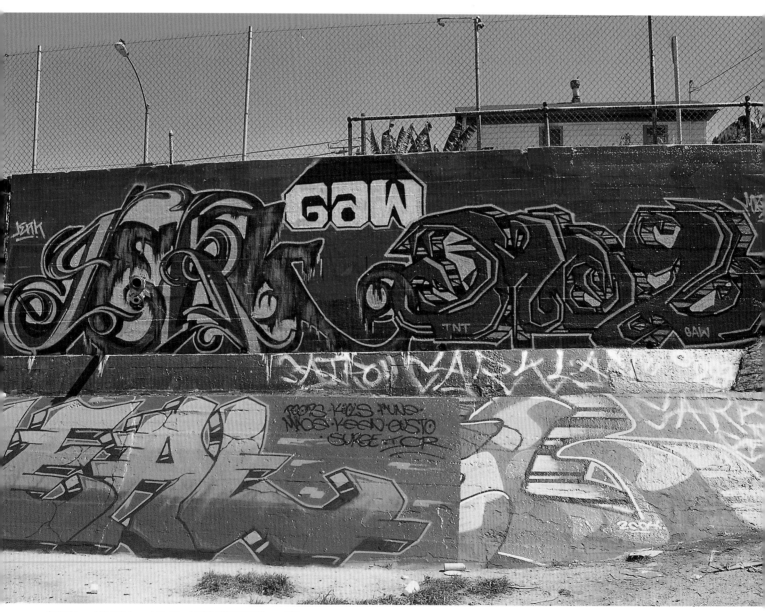

↑ **JERK** (upper left), **MOZ** (upper right), Belmont, 2004 ↗ **SHERM**, El Serreno, 2005

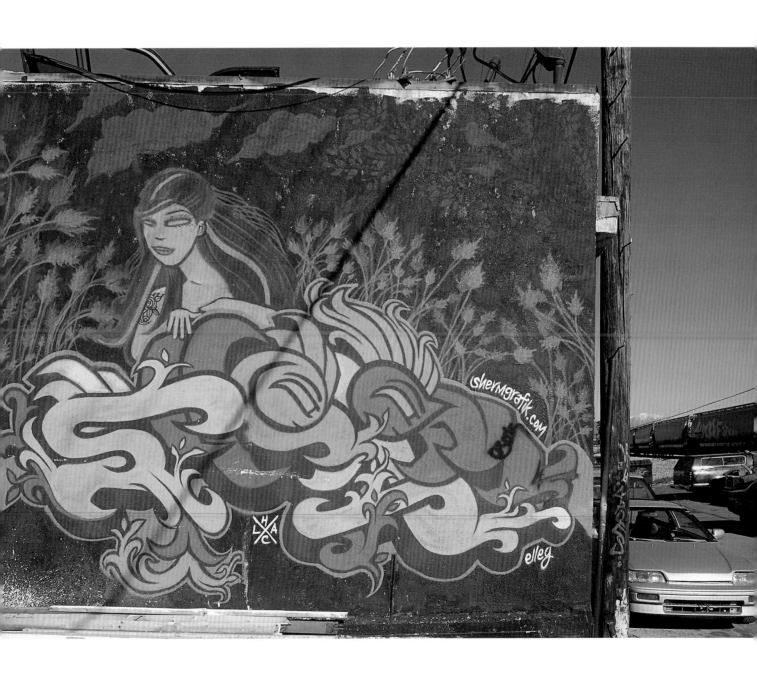

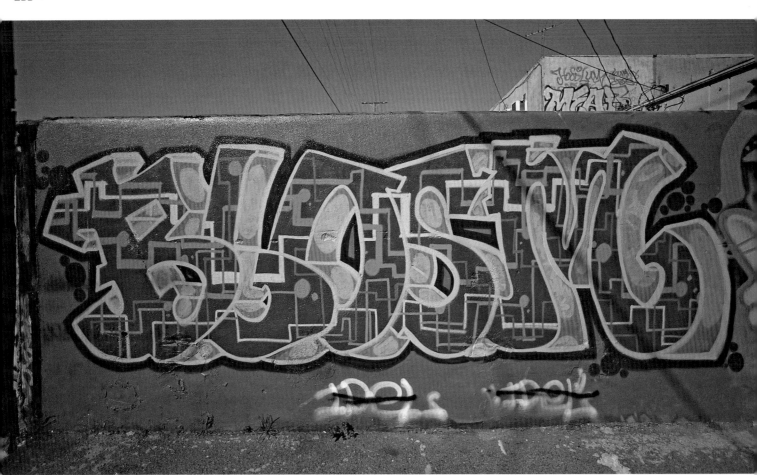

↑↑ **BLOSM**, Melrose, 1993 ↖ **OMEGA**, Sanborn yard, 1992 ↗ **SPUN**, under the 101S, 2004

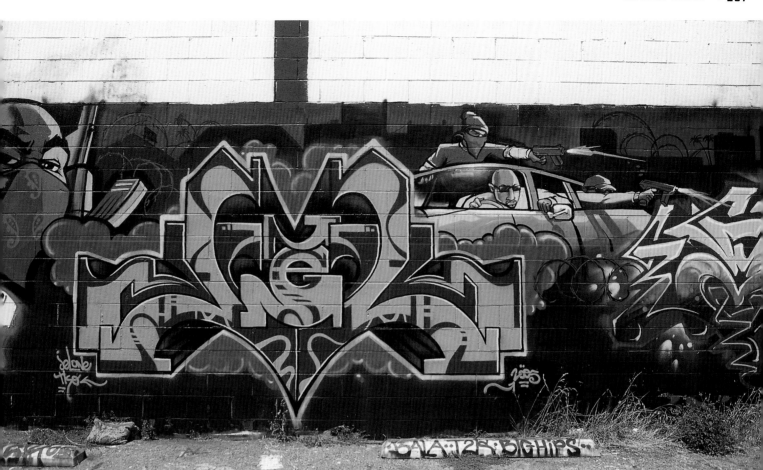

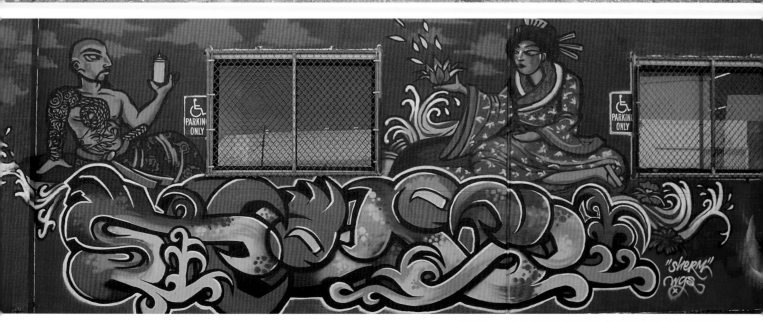

↑↑ **JEL**, characters by **ZERK**, South Central, 2006 ↑ **SHERM**, Lincoln Heights, 2003

RISKY BUSINESS

Every writer has a story to tell. They often involve daredevil feats, encounters with the law, or occupational hazards and injuries. Often recounted with the greatest humor and enjoyment, those stories are also badges of courage and evidence of their commitment, or craziness, which are passed around and contribute to the oral history of graffiti. There's the story about Saber impaling his abdomen on a metal fence spike on the way out of a spot. Or the one about a writer at Belmont who took a gun away from a gang kid who had been pointing it at him. The kid was chased out of the yard with his own gun while everyone ran in fear that the kid would return with the entire gang and many more guns. Or Elika's story about the L.A. riots. When police were racing around the city dealing with emergencies, he painted in plain sight during the day because he knew he would be the last thing they cared about. It's a rare writer who doesn't have tales of being chased, sometimes for hours, by law enforcement, and other times by gangs.

REVOK: Several of us were going up under the 7th Street bridge by the railroad tracks. I was finished and just waiting for the others to get done when we saw flashlights and feet coming out from behind a parked train. It was the railroad cops and we scattered every which way! Some of us hid down in the river and could hear the cops using our abandoned paint to diss our pieces. I went back a few days later and tried to clean my piece up.

ATLAS: I had a harness, and at one spot, a high freeway wall, I clipped the metal ridge to the railing from the street above and threw the belt over the edge. And right when I got part way down, I started to panic because I realized I tied the belt too low on the railing and didn't know how I was going to get back up, so I ended up sliding down to the end of the rope, which I had neglected to put a knot in for gripping, and let go while still half way up the wall—a really long drop.

JEL: I was with Bash, and he hadn't bombed in a long time, and I was bad-influencing him, "C'mon, let's go," and the police came after us. I had to jump from a very high fence—on the way down I thought "Why am I not landing yet?" I had to hide in a dumpster so long I fell asleep, about two hours, peeking out now and then, but still seeing flashlights searching backyards. Luckily, the dumpster was for somebody that sews, so there was soft material in there. The cops weren't even looking for me but caught me anyway because when I climbed out, I happened to pass by where they were getting donuts and coffee and I was all dirty and they asked me "What happened," and I said I was jumped. They said, "Oh really? We're going to ask you one more time. What were you doing? You weren't painting near here?" And I said, "Painting? What do you mean?" And they said "Look in the mirror and tell us one more time . . ." I looked in the mirror and saw I had gold paint all over my lips! I couldn't help it. I started to laugh! And I said, "Well, what do you want me to say then?" They were pissed, but let me go.

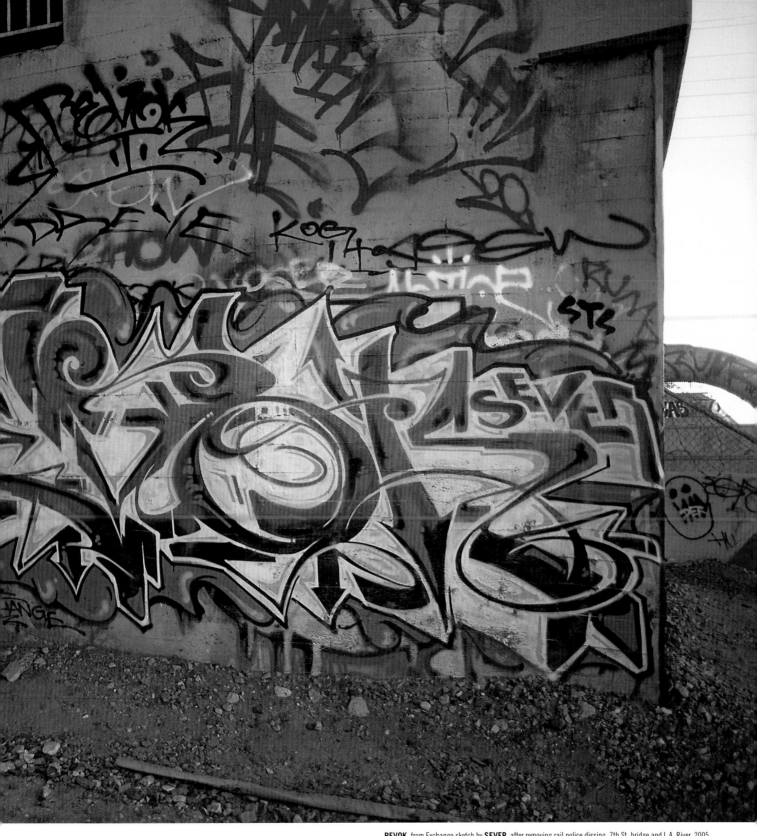

REVOK, from Exchange sketch by **SEVER**, after removing rail police dissing, 7th St. bridge and L.A. River, 2005

COMMENTS ON GANGS

ZUCO: I wasn't so much interested in breaking the law than in representing myself. I got into graffiti as another way of not getting into gangs. I have relatives that started gangs and I could have easily gone that way, but it seemed people were representing the wrong thing and fighting over things that didn't make sense. It's good to fight for something you believe in, but think about it; you believe in yourself, so why would you want to bring yourself the harm and sorrow that comes with that life? With gangs I saw people going nowhere, and why would I want to go nowhere?

SINER: Graffiti writers now feel it's fashionable to write gangster style, but back in the day if you did that, you'd get beaten. Some people now want to be all "street" and be the tough guy, but I just wanted to be seen as an artist.

RELIC: Where I grew up we had dual mentalities; the neighborhood where I was from, we had a lot of artists and that drew me to hang out with these guys . . . in addition to the graffiti writers in the same neighborhood, there were gangsters with the craziest hand styles that you've ever seen, and those hand styles are really influential in how they were incorporated into the graffiti. We were hanging around with the same people, but we kept the two things extremely separate, really undercover. When we were hanging out in the Neighborhood, we used the Neighborhood name, and when we went out writing we used our writing names. As far as my crew is concerned, we all grew up in areas like that, and it has a lot of influence in the style we do, so we have to mention it, but we don't want to glamorize it.

BABA: Being in a gang meant you were more confined to a territory, and being a writer you had carte blanche to travel around. Some gangsters hid behind being a writer to travel and jack people up. My gang activity was purely a matter of choice; we were bored white kids with nothing better to do. We were punk-rock gangsters; you got into a gang so you could go to shows without being jumped. Others were third generation and it was expected of you if you were in a Neighborhood. They probably heard every day on the way home from school "When are you going to get in?" The graff pulls some out of gangs, but a lot of them kept slipping. And a lot of them got into it because they wanted to be tough guys.

NEO: Some of us were brainstorming about why some people stop doing graffiti art, and we thought maybe because some of them were gang-banging at the same time and they associate those two, the art and the crazy stuff and maybe that's why they stopped. Some dropped the banging, some dropped the writing, and some dropped both.

PHIB: I liked the independence of non-gang graffiti, doing it when and how I liked. I feel sad for my friends that stayed in that life and aren't doing anything with their lives except being in and out of jail. Some of them look at me and realize I made the right decision to leave that behind. Graffiti has the potential to be taken in a direction that better benefits yourself and your family.

ALOY: Some of the old neighborhood guys see who I'm painting with now and want me to bring them in, but I don't have the time for that; I worked hard to get where I am.

ANGER: Sometimes there are complex conflicts between crews over past neighborhood associations. As for tag-bangers, they got sucked into gangs and out of graffiti in the mid-nineties.

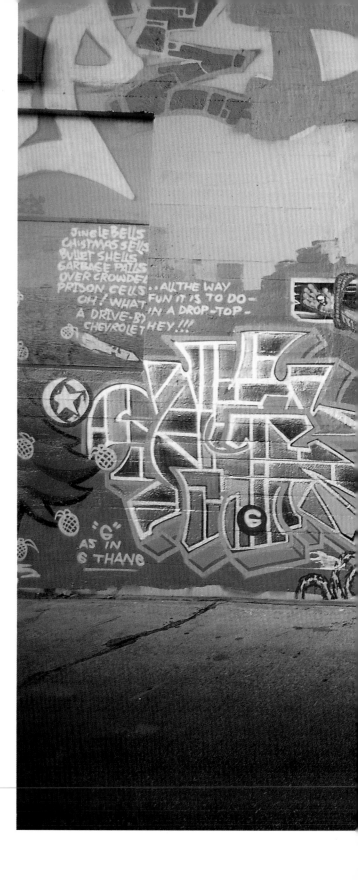

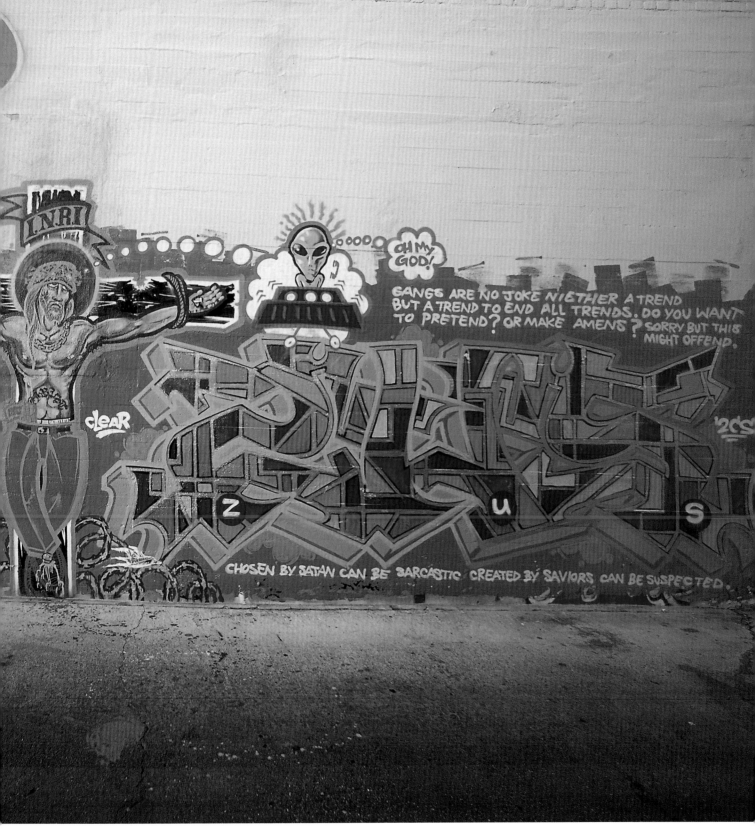

CIRCUS and CLEAR, Melrose, 1994

SHANDU: L.A. style had to do with the ex-gang-bang member factor, taking the influence from their background but doing art now.

EKLIPS: While many guys say that they would have been gangbanging were it not for graffiti, who knows? Maybe I would have gone to Harvard . . . we all had options.

ASYLUM: Graffiti may have taken me away from gangs, but graffiti can also hinder someone from having a decent life economically, with a successful career.

CREW DYNAMICS

Honesty is essential among crew members when critiquing each other's work. Whether they are working on a piece or production jointly or side by side, openness of dialogue allows crew members to discuss; how a color does or doesn't work, or advise on a letter connection. This social support helps writers push the envelope. And of course there is always competition, even amongst close friends, to outdo the other in terms of quality or quantity.

A central aspect of crew dynamics is the personalities of their leaders. There are many superior writers, but very few truly charismatic crew leaders. It is because of Skate's reputation as an inspirational leader that his memory is held in such high regard. Skate was given the reins to CBS when the founder, Hex, moved on to LOD. It was that second generation of CBS writers that became a major presence under Skate's leadership. Tragically, he was killed in June 1993 when hit by a train while out bombing.

RELIC: My main teachers were my crew, influential in my style and teaching me values. There used to be a community art center and we would just hang out and draw. And that's where I got a lot of my values, family values. My parents divorced when I was young, so I didn't have a male figure around me; so when I met my crew (and I was the youngest one there), I found people I could look up to as far as how to live as a man. And fortunately for me, they all had good heads on them, and were respectable people and they helped me become a good person. Less than half were from broken homes. We are not just interested in bombing. We get together more as a family. Baba was like an older brother, and exposed me to a lot; he likes to go out with different people, hang out with different vibes. When writers would visit from New York, they would stay with Baba and I was in the mix, and able to be around those experiences because of Baba. So here I was, a fifteen-year-old high school kid, and having Duster, this New York legend, come knocking on my window at two in the morning, saying "C'mon, Relic, let's go bombing!" This was some guy I'd seen on T.V. and videos and he's knocking on my door, through my older brother . . . it was an experience people only dream of.

BIG 5: Skate influenced me tremendously in terms of ethics and morals, what and what not to do; he lived for graffiti; he would wake up in the morning, we'd rack some paint, and the rest of the day would consist of painting in one form or another; either riding buses and catching buses all day, or we might find some legal spot or some yard. That was life back then, all we did.

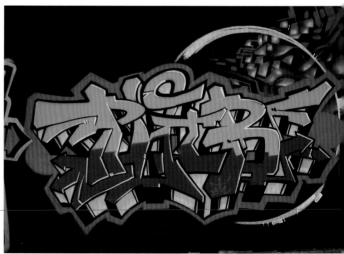

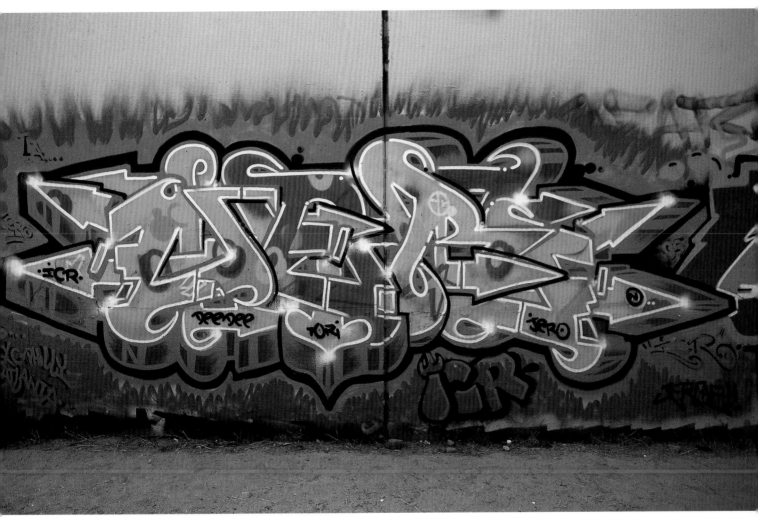

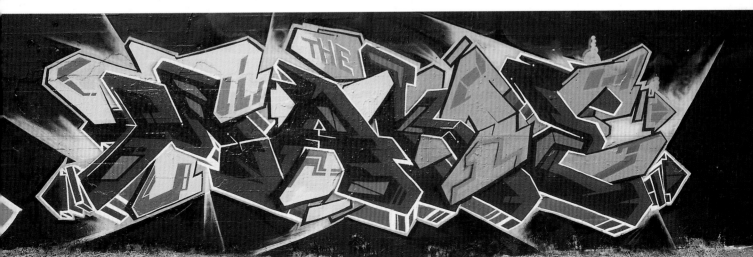

↖ **RABBIT/SINE**, c.1984. Gang hand-styles were practiced on paper before writing on a wall. ← **PHIB**, Artist District, 2006 ↑↑ **JERO**, Motor yard, 1995 ↑ **MAKE**, Belmont, 2004

BESK (UCA CREW): I used to hang around with Make; he was my mentor and taught me a lot of what I know, and he introduced me to writers I looked at growing up. K2S, STN, LOD, SH, OTR, COI are like an extended family; whatever function there is, not just painting, we're always together. A lot of members are from more than one crew, and we're all buddies and grew up loving the same thing. We know each other's families and kids. It goes beyond graffiti. Crews that don't have that come out and then disappear.

ASYLUM: I enjoy seeing friends' tags when driving around the city. It makes me feel like I belong here. I probably wouldn't feel comfortable in a city without graffiti.

SINER: It died out for me and I didn't start writing again until '92. But I'm blessed to have something to get back into, something that really saved my life . . . being without art, nothing was really good. Reintroducing art back into my life really saved me. And graff writers that remembered me from the '80s embraced me. When they respected you as an O.G. head, they encouraged you to keep painting, and because they gave you mad props, it was good to feel you were recognized. When I came back in '92, there were very few writers still active from the '80s, so they stuck together. When things revamped in 2000, people from the '80s were really happy to see you. They were like "Whoa, I haven't even met you before but it feels like I've known you through your work forever."

ZUCO: A "pride" is a pack of lions so we made a crew called the Lions of Graffiti; K4P. So when we say "Kill For Pride," we mean "accomplish something for the crew." Some writers guard their skills too closely because they don't want anyone to pass them up. I never have a problem painting with new kids because knowledge should be passed down, and if you continue to develop, you'll still be ahead. But I like painting with new kids because I want them to see what they can achieve, that there's a light at the end of the tunnel. Our crew is tight, so you'll never find a K4P that doesn't know all the other K4Ps. You can tell when people are united because it comes out in their artwork. K4P was one that established bombing your crew name in '92. Before, it was the individual name before the crew. The present generation of K4Ps are the ones that really established it.

JEL: In the beginning, my heart was in piece-bombing, so I was hooking up my stuff because I believed anyone could do a throw-up, but who can do a piece on a hot spot and get away with it. But after getting in TKO, people like Hael and Toomer influenced me with their thinking; two colors, you can see it from two blocks away . . . that's what you want! Then I realized that they were right, I can save piecing for a permission wall.

CHAZ: The L.A. distinction includes a gang unity mentality and is very much part of how we deal with each other: You don't get respect unless you give respect.

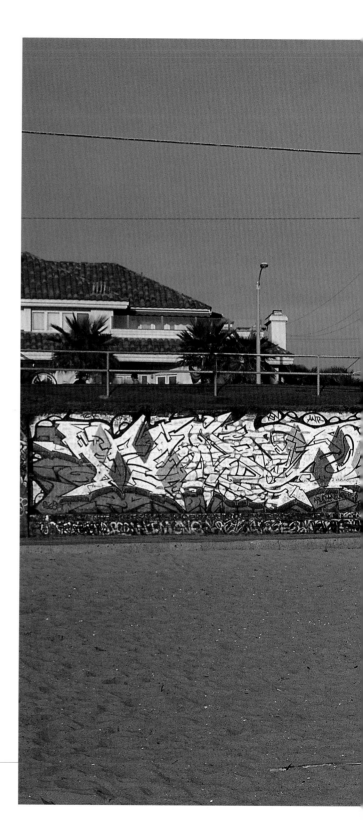

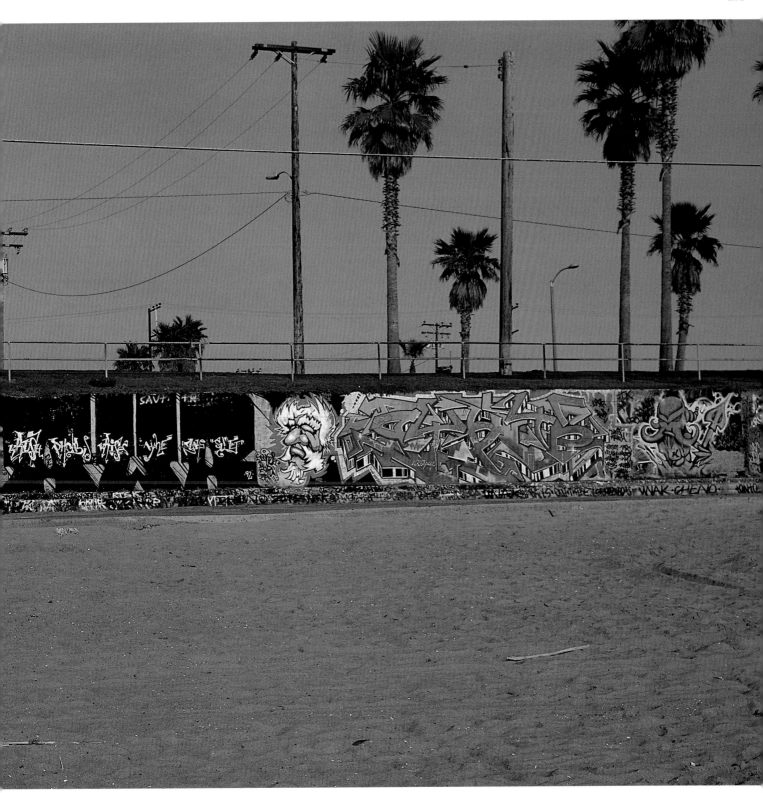

AWR production by **KRUSH**, **TYKE**, and **SUMET**, Huntington Beach, 1993

EKLIPS: The best day of my life was the day my mom looked at me and she said "I thank God for graffiti and what it's made you." She saw that I had gained manhood and leadership through it. I learned that from my family as well, but took what I learned from graff back into the family. Graffiti, specifically AWR/MSK saved my life, because at the end of the day I'm doing something I love. Ultimately AWR is not about graffiti, it's about being family. A lot got in and were wack, but they were surrounded by people like Krush. They had a master of tagging, a master of throw-ups, wildstyle etc., and willing to teach because they were family-oriented people. Baba, Gkae, Pure, all lived with me at my family's house at one time or another. We have a lot of camaraderie and community and that's the reason for our longstanding strength and evolution.

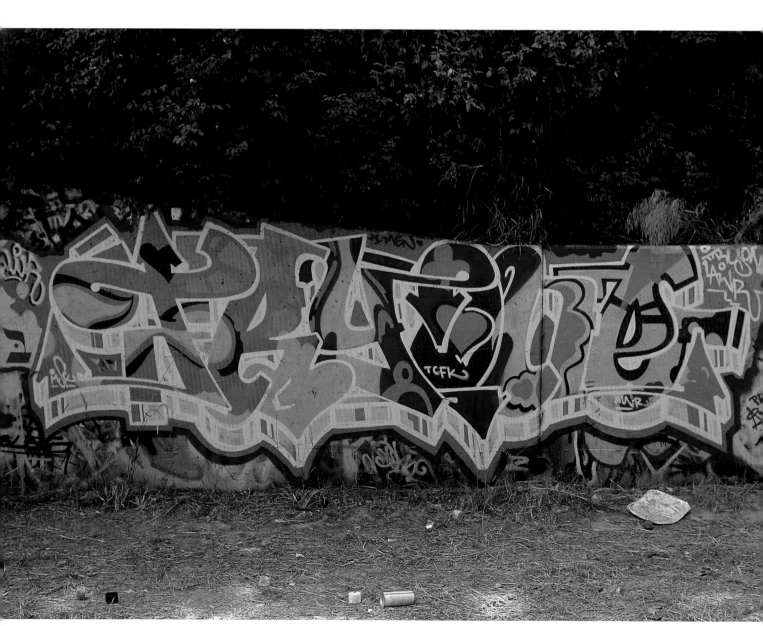

↑ *Try One,* **EKLIPS**, 1992 ↗ *K4P,* **BISER** and **ZUCO**, Belmont, 1999

WISE: Eklips is such a leader; I've never met a bigger father figure in this thing, ever. He not only has your back, but he educates people about what they should or shouldn't be doing. He has a natural talent for leadership and organization. There are few people like that, willing to put themselves aside for the benefit of their crew. It's a reason AWR/MSK has gotten so incredibly good, because they have a support team and communicate with each other. You can see it's a teamwork effort. In AWR, it's nice to see a case where people due respect get respect, and that often doesn't happen in many fields.

RISK: Eklips is what I'd call a sleeper. People don't know his capabilities or what he knows. *That* guy singlehandedly pushed AWR like I did WCA. He's truly a dope graff writer, and what he does is for him and he's never pushed his own work, trying to be a king. He has also managed to get his personal life and his career in tune and incorporate his crew into it. A real accomplishment.

JERO: ICRs all had one thing in common; we were all knuckle-heads that liked to fight and weren't going to run if something happened. Didn't matter what the odds were.

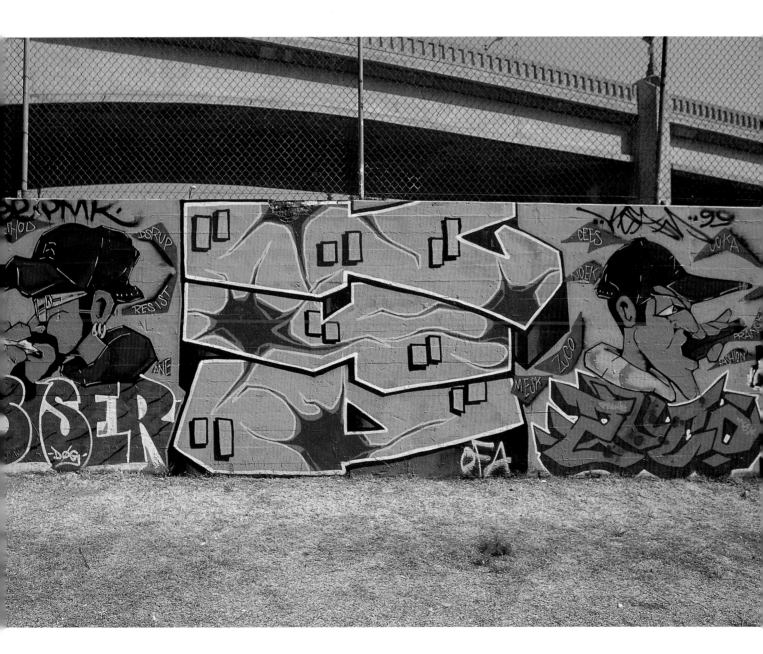

COMPETITION WITHIN THE CREW

Some crews, such as CBS and UTI, encouraged friendly competition within the crew at early formative stages to raise the energy and standards of the group's work or output as a whole. Others, such as the present generation of SH/LOD writers, are comfortably collaborative, perhaps because they are all long-established writers and their commitment to graffiti was proven long ago. In graffiti, writers try to excel in relationship to a peer or rival, just as it was for Lennon and McCartney, or Picasso and Matisse: one person's work inspired a response that is unlikely to have been there in isolation.

EKLIPS: There was friendly competition between me, Mystic, Path, and Self back in the day that was like little league; "Who's better this week?" I would come with some new stuff, then Mystic would come up with some stenciled branches. Mystic was hanging with Phever and Nyse and I was with the West Side guys, so we were picking up different things.

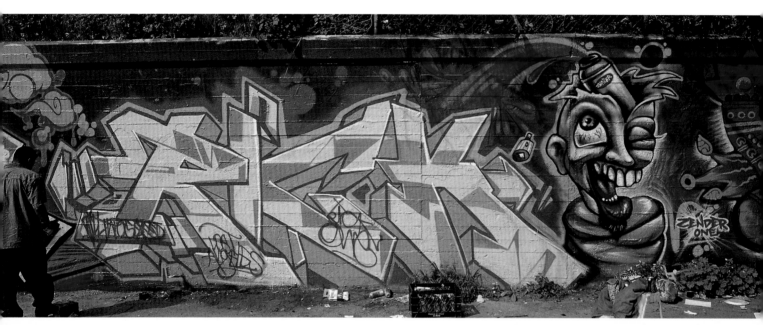

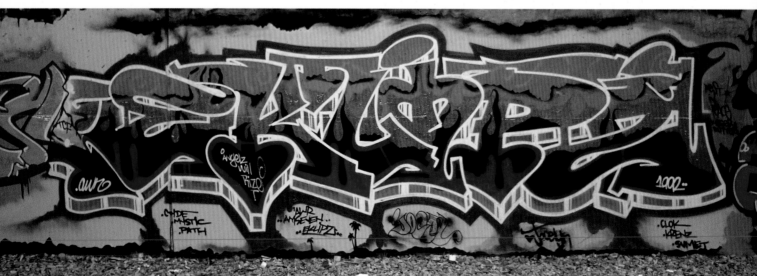

↑↑ **RICK ONE**, with character by **ZENDER**, Belmont, 2004 ↗↗ **TYKE WITNES**, **NYSE** (low right), U.C. Irvine, 2004 ↑ **EKLIPS**, Motor yard, 1992 ↗ **K4P** crew, Belmont, 2004

SINER: To me, graffiti's all about competition, and when I do a piece, I just imagine shredding people like I'm going to bust this piece and leave everybody way behind because I always want to be ahead of the game. So when I think about it, I think "This piece is going to cut 'em up!", and spit out the competition, even amongst your friends, and they want to outdo you, and you grow as a team.

RICK: I wanted people to know I'm going to come hard on that wall . . . I'm going to do my best to kill that wall and whoever steps next to me, I'm going to destroy them. I didn't drink, I didn't smoke, so my high was getting up.

TYKE: Ego is involved. You want to feel present and for people to know you're present . . . you don't want to fade away. Sometimes it's best to paint when it's competitive. And it is competitive, even with friends when there's no ill will, it feels like a battle. And if I don't come with that game plan, I don't like my pieces. The best pieces I've done are when I wanted to prove a point. Nyse put something together at UC Irvine and he brought a lot of writers in, and he had a lot of paint and you could do whatever you want. I went off the top too! There were judges there and money was at stake, and I thought I'm going to go for it and do some new stuff.

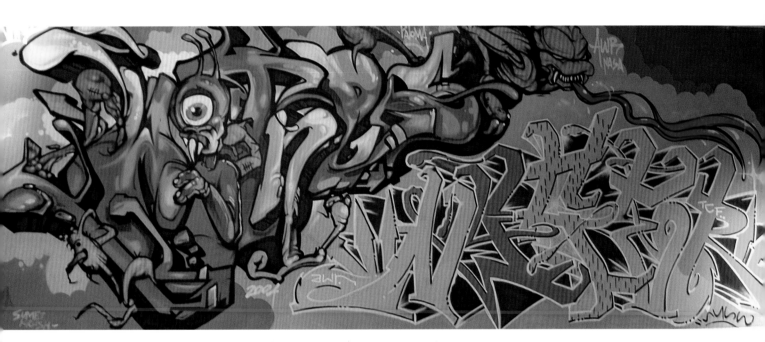

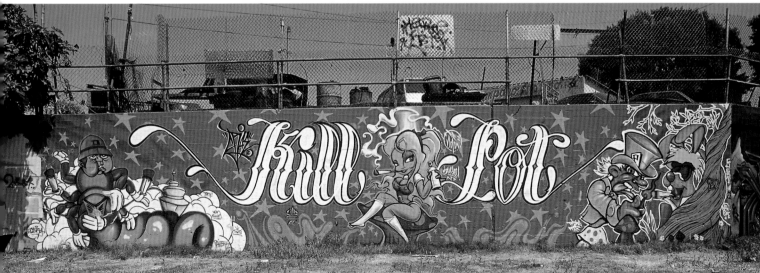

BIG 5: Something that I haven't seen anywhere else was that Skate would have battles within the crew to get up the crew. We had three or four groups with three or four people in a group, and we would go out and do illegals. Then when we would get together for group meetings. We would have photos and see who got up the most. I think in L.A., because we grew up with a gang mentality, your crew gets pushed before your name does. In any other city, you're always pushing your name before your crew, but with CBS, you'd go up on the freeway with a CBS piece and just tag your name next to your piece. And that may have changed since '92, but that's what we emphasized back then. And we accomplished what we wanted because everybody knows who CBS is from that time. K4P was like that too, which is why I don't even know who was in it because they pushed the crew name.

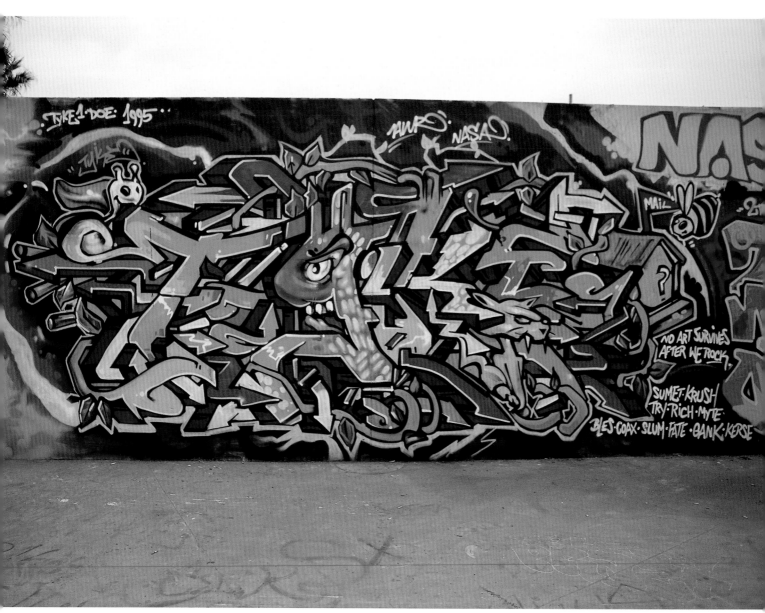

↑ **TYKE WITNES**, Venice Pavilion, 1995 ↗ **VERSE** (R.I.P.), Mid-city, 1997

FEAR: When I got into UTI and saw Skill run that crew, it was unbelievable; he had total control over sixty crazy guys. He was one of a kind. To inspire us, he would rate us for the quality of our work, one through sixty in the crew. You got a point if a piece was good, a point for doing a freeway and so on. I loved that because if you were really low on the list, it would make you work harder. Skill expected that if you were part of UTI, you weren't just there to chill, but to work hard and be self-motivated. It's a minority from each generation of writers that will take it seriously.

JEL: I like to see how big my friends are going so I can go bigger. Do and I battle that way all the time because he has these two fat distinctive letters. I pieced first, and did throw-ups later. I started to see the challenge of doing something simple with style.

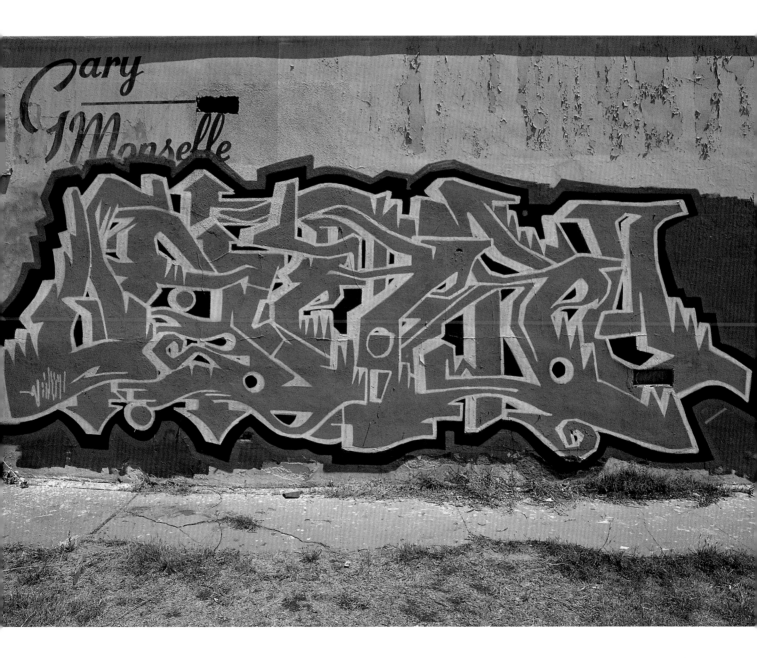

COLLABORATION

While there is both natural and cultivated competition within many crews, they are essentially collaborative at their base, with skill development as their foundation. Many writers hang out at each others' homes, working on sketches or painting a back-yard wall, developing color schemes, letter styles, and character images during their early development.

All of this comes together at the wall. Someone with superior letter styles creates the initial outline, while someone else starts to fill in. Then the original designer, accompanied by another crew member, cuts in the final outline while someone else works on the clouds or bubbles around the piece. Meanwhile other writers focus on surrounding character and background work to tie it all together, working under the direction of a primary designer or spontaneously off the cuff. As preparation for the production, one person has to get paint, another has to scope out the site or get a business owner's permission to paint on the wall. If it is an illegal production, there may be those who serve as "spotters," or lookouts. And in dodgier environments where there may be unfriendly crew rivalry, it's desirable to have "muscle" as part of the pack, who are only too happy to fight if the situation comes down to aggression.

Inter-crew collaborations may involve crews from the same city, different cities in the U.S., or international collaborations. The graffiti underground is not just an ecumenical American phenomenon, but an international one: the top artists may actually do informal "tours" to various cities and countries around the world, staying in other writers' homes while in town, and often working on a mix of permission and non-permission projects.

SHANDU: Primo Dee was the technical component of LABS and had letters down. We'd practice together at Rick's house for hours, sketching with Prisma pencils.

SINER: We influence each other naturally. If someone uses a brush, someone else might say "Hey, that's cool, let me use that!"

FEAR: I schooled Dove a bit, but then he started excelling and learning different things than I ever learned, so he started schooling me a little bit . . . we learned from each other. Graffiti's always moving, never staying still, so he might learn some of the new tricks that people were doing and he'd get them down before I would, then I'd ask him "How the hell did you do that?"

BABA: I use West Coast as an example, though WCA was the enemy. You had Wisk who could do throw-ups, and Miner who could go all-city with throw-ups, then you had Pjay who had some nice letters and cool solid colors, and you had Rival who was one of the most amazing letter guys you've ever seen, and Flame (Mr. Cartoon) who did amazing characters, and you had Cooz who did amazing characters, and Risk who came out with these styles that were amazing. But that's what I mean, you had a crew, and when you did a production back then, you had this guy to do characters, and this guy to do backgrounds, and the guys that were taggers or throw-up guys; they still had skill with a can so they'd be doing 3Ds and fill and things like this, so the whole piece would come off.

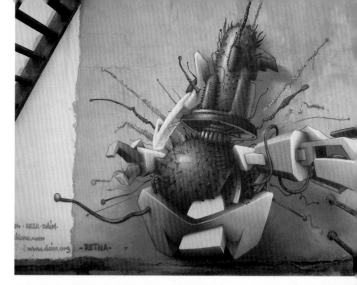

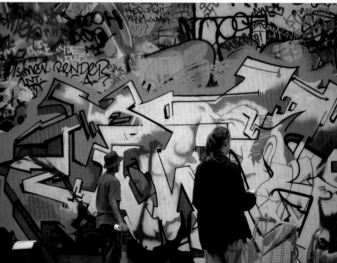

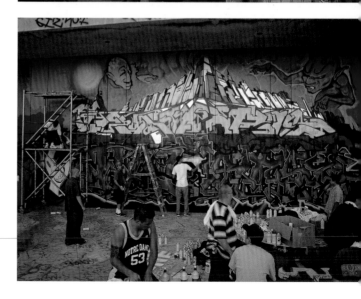

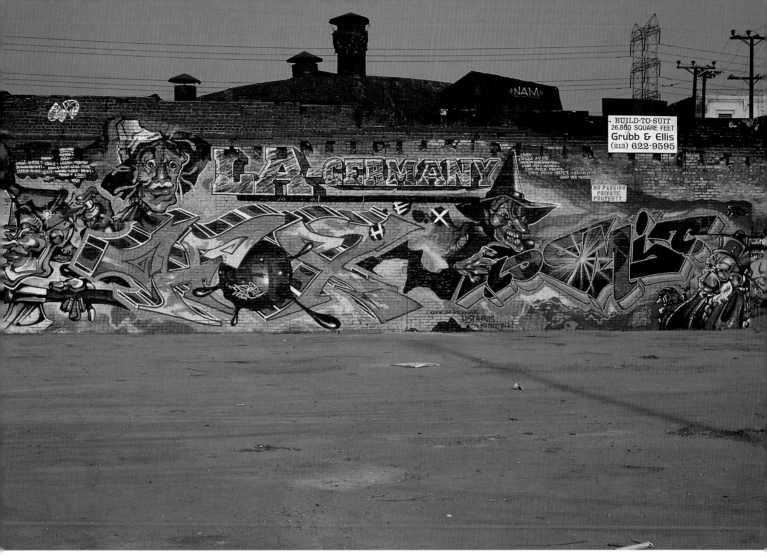

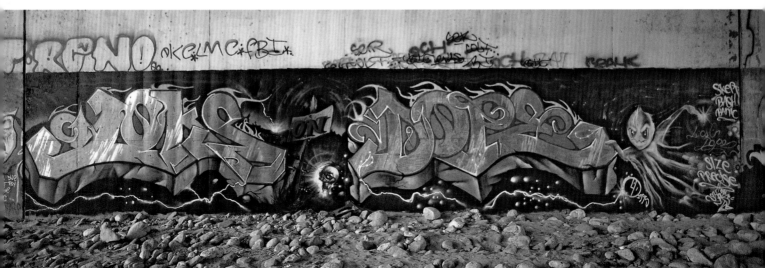

↖↖ **DAIM** and **SEAK** from Germany, Downtown roof, 2003 ↖ **KRUSH** and **EKLIPS** at Motor yard, 1993 ↙ **AWR**, Venice Pavilion during a rare city-sanctioned weekend organized by **SPARC**, 1993

↑↑ **HEX TGO** and **LOOMIT** from Germany, 7th at Santa Fe, 1992 ↑ **LOD** crew, SH yard, 1994

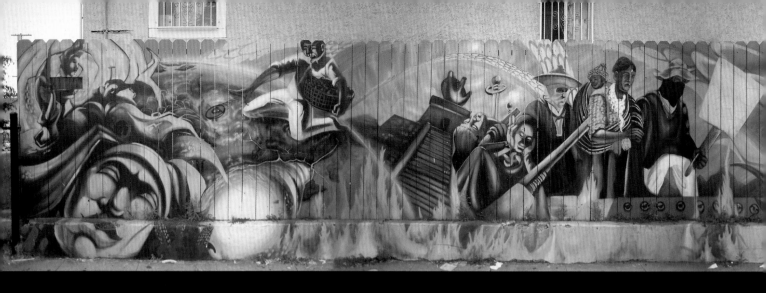

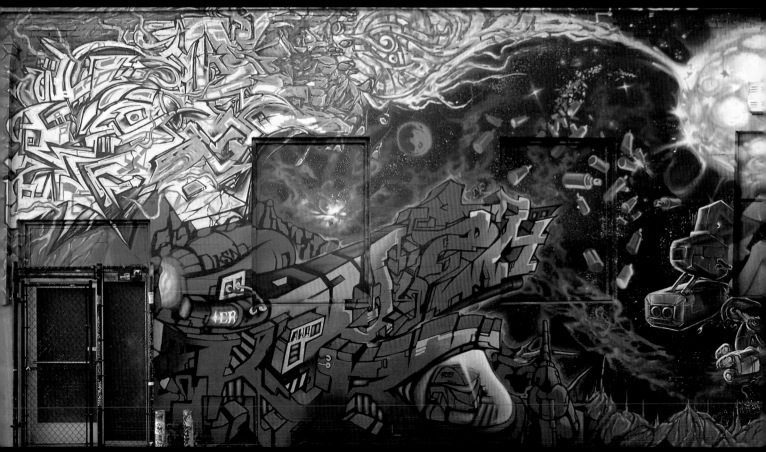

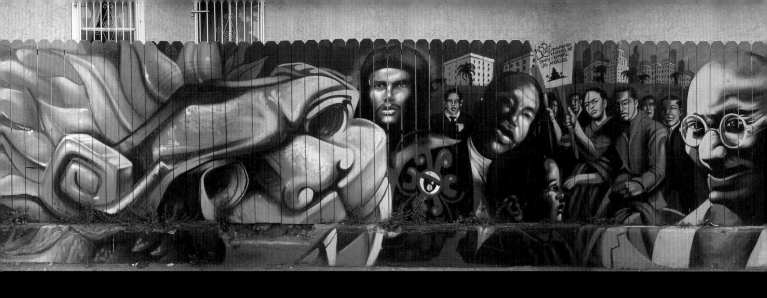
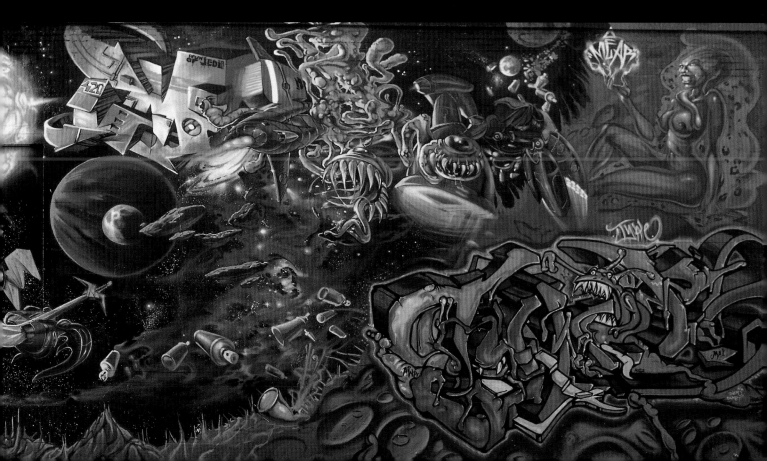

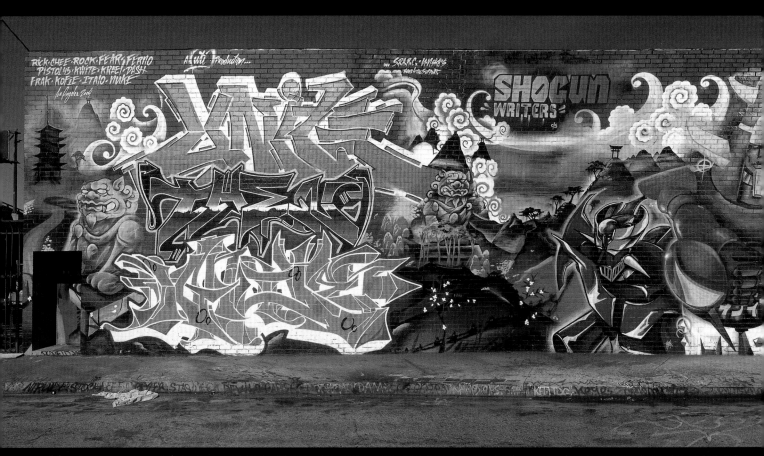

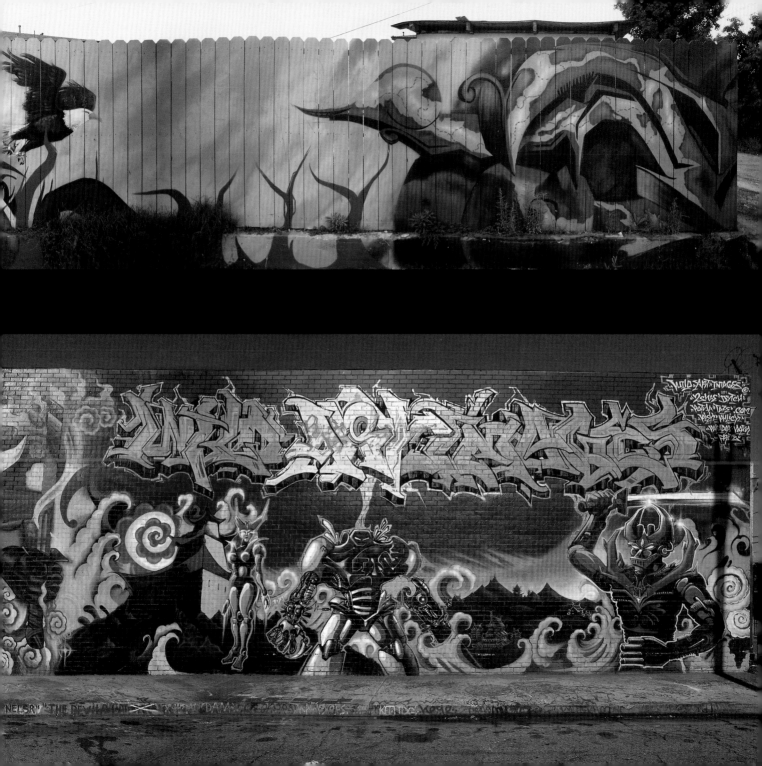

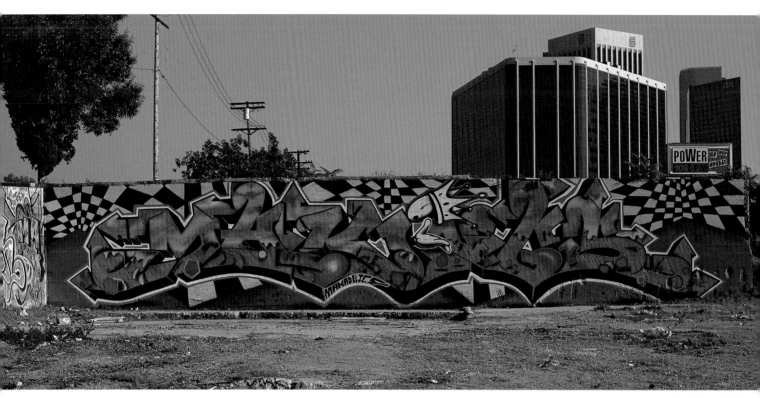

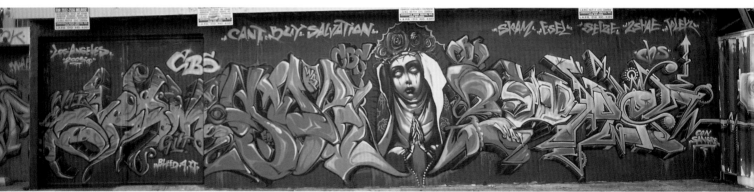

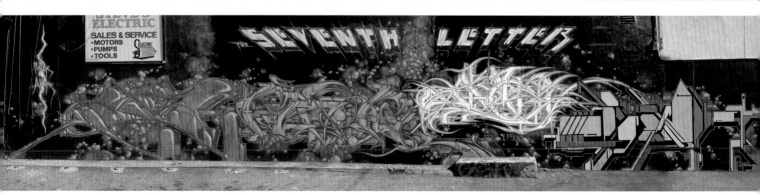

↑↑↑ **MAK**, Belmont Hill, 1993 ↑↑ **SRAM**, **ESEL**, **SEIZE**, **2SHAE**, **PLEK**, Melrose, 2005 ↑ **ZES**, **REVOK**, **SABER**, and **PUSH**, Hollywood, 2002

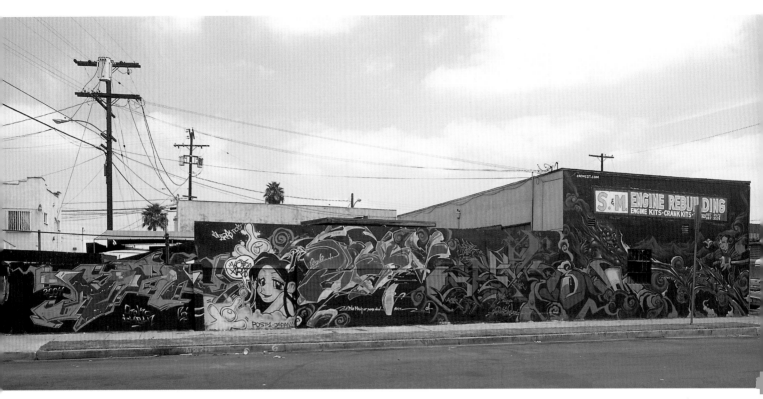

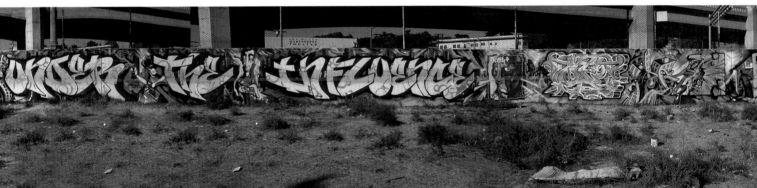

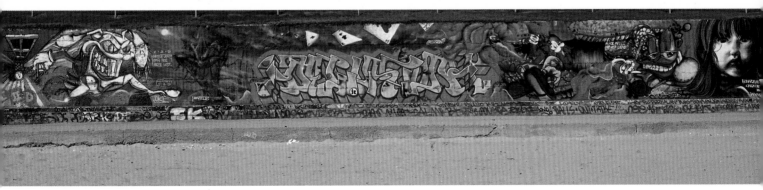

↑↑↑ **MAN**, **POST**, **SPURN**, **KRES**, **ASYLM**, and **VYAL**, East L.A., 2004 ↑↑ *Under The Influence*, **UTI** crew, Belmont, 1996 ↑ **C2D (CREATE TO DEVASTATE)** crew, Huntington Beach, 1992

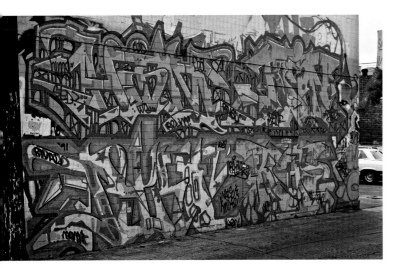

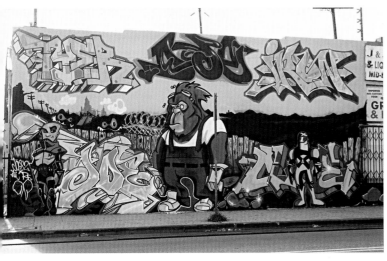

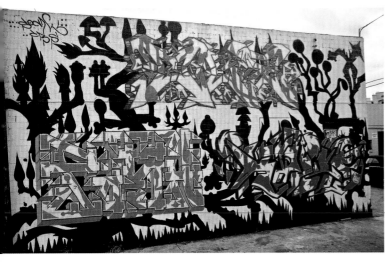

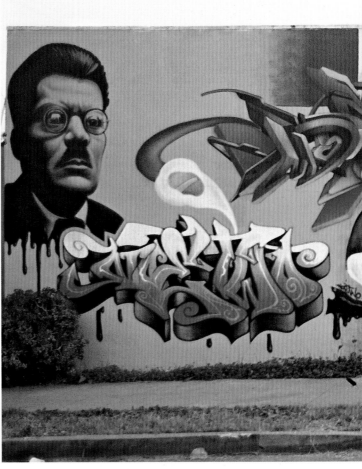

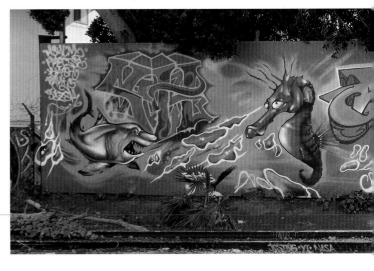

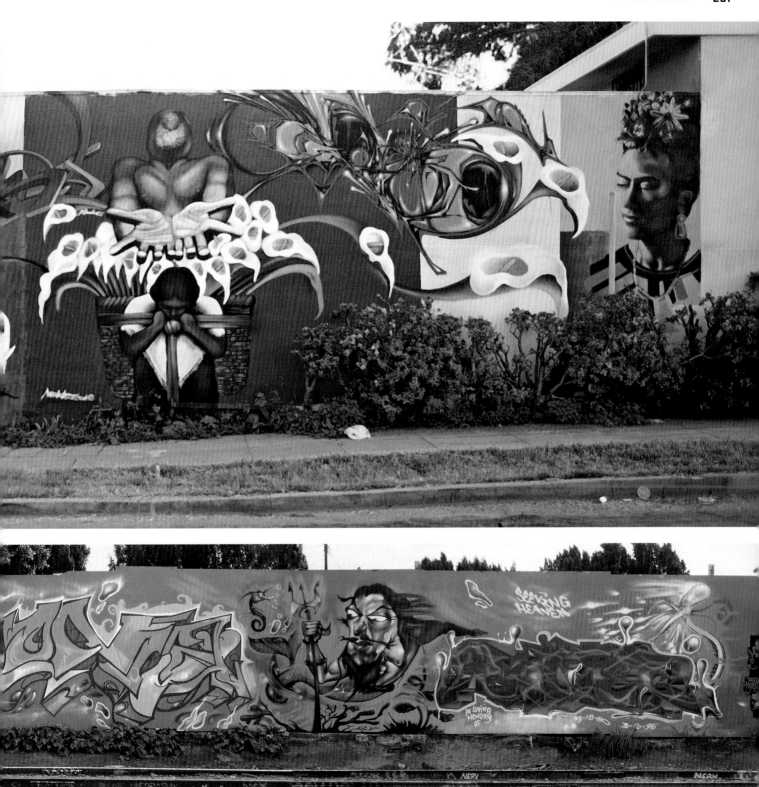

↖ **KSN** crew, Hollywood, 1991 ← **RF (RAPID FIRE)** crew, Hollywood, 2006 ↙ Plant silhouette production directed by **POSH**, **OLE'**, and **KOFIE**, Hollywood, 1997 ↑↑ **MARKA27**, **NOE2** and **CODAK'S** homage to Mexican muralists David Alfaro Siqueiros and Diego Rivera, Downtown, 2006 ↑ Sonia Walter memorial, **SH** crew, Commerce yard, 1996

PANIC: It's an encouraging thing more than a competitive one. I could walk away from my piece and one of the others could finish it and I would be happy with the result, and vice versa. We're all comfortable with our styles and we feed off of each other and make stuff work together. If anybody overlaps a piece, nobody is offended. In the end it always comes out decently. So we set no boundaries for ourselves. We paint, and whatever comes out of it, comes out of it. Sometimes we're dealing with a bad selection of paint, but we'll take whatever the situation is and make the best of it.

SIZE: When I paint, it's like a little social gathering because you're getting together with friends you hang out with, and it's a big part of it for me, something I really look forward to. I'm not competitive. If anything, I'm supportive because my painting friends are my influences.

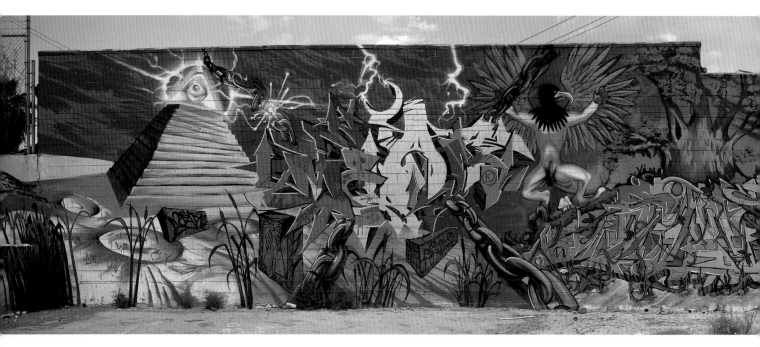

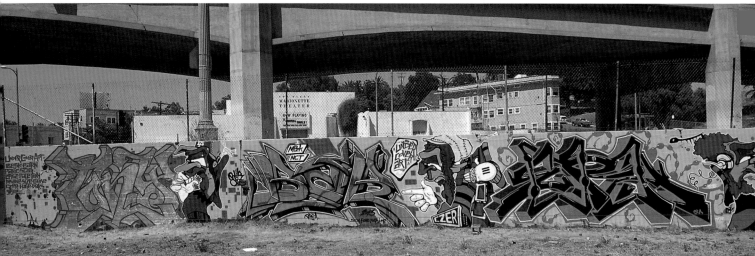

↑↑ **MEAR**, **SINER**, **RETNA**, **YEM**, **PHEVER**, Pico and La Brea yard, 1998 ↑ **UCA** crew, Belmont, 2003 ↗ **BESK AND MAKE**, Belmont, 1991

YEM (AM SEVEN): You have to create something to impress your fellow participants. The thrill comes from participating in this thing, and hopefully adding something to it. And we feed off of each other's involvement. You can almost feel it pulsing. At any given month, someone is leading that pulse. So when you're not participating, you can still be involved as a spectator and it's the same thing. And it's just impressive! It's great to see guys doing what they need to be doing; masterpieces, at whatever level they want to do. Also the development of each individual, that's an awesome benefit to see; the development of the person, their style, skills. And the word travels really quick when they're on it.

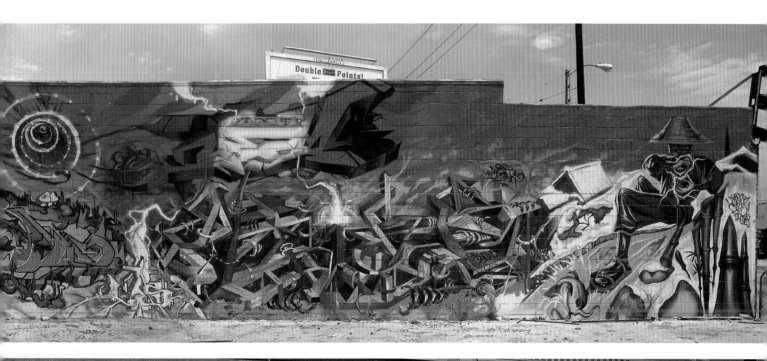

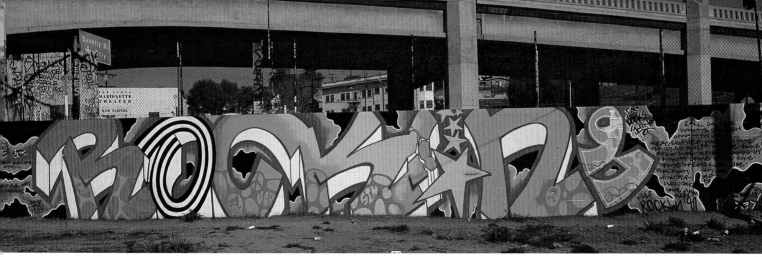

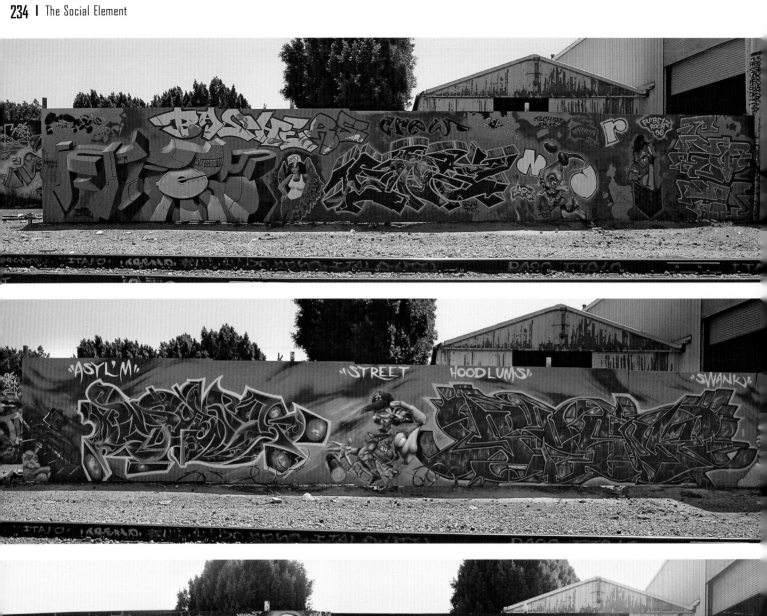

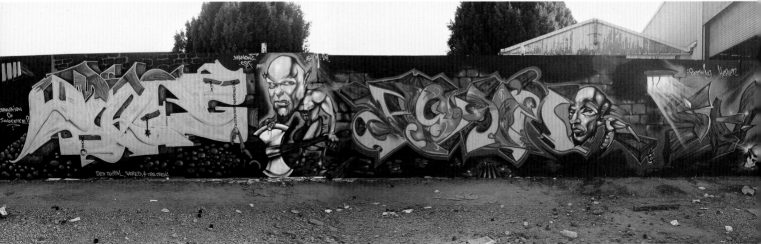

↑↑↑ **BASHERS** crew, Commerce yard, 1996 ↑↑ **ASYLM** and **SWANK**, Commerce yard, 1996 ↑ **MAN** and **ASYLM**, with characters by **PRECISE**, Commerce yard, 1995

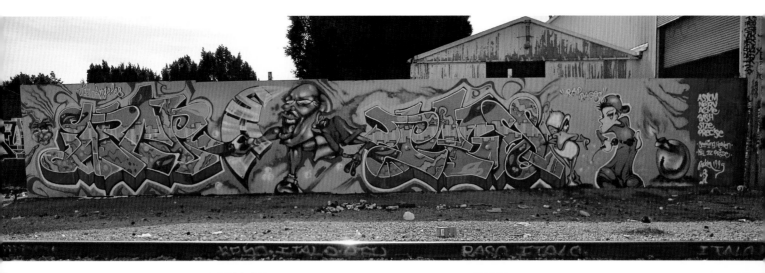

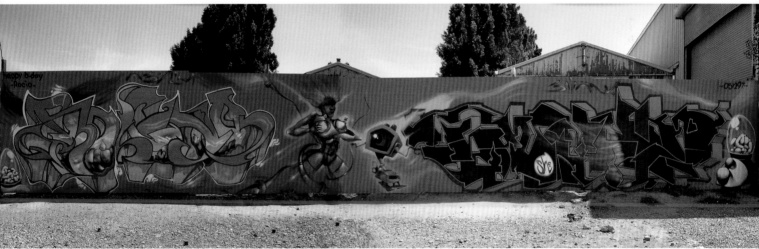

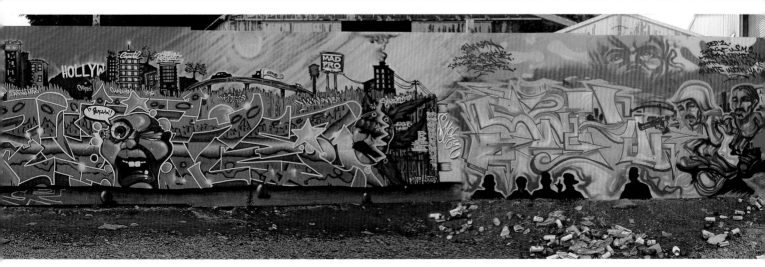

↑↑↑ *Rap Pages,* **SH** crew, Commerce yard, 1995 ↑↑ **ASYLM** and **SWANK**, Commerce Yard, 1997 ↑ **NERVE** and **STK** crew, Commerce yard, 1995

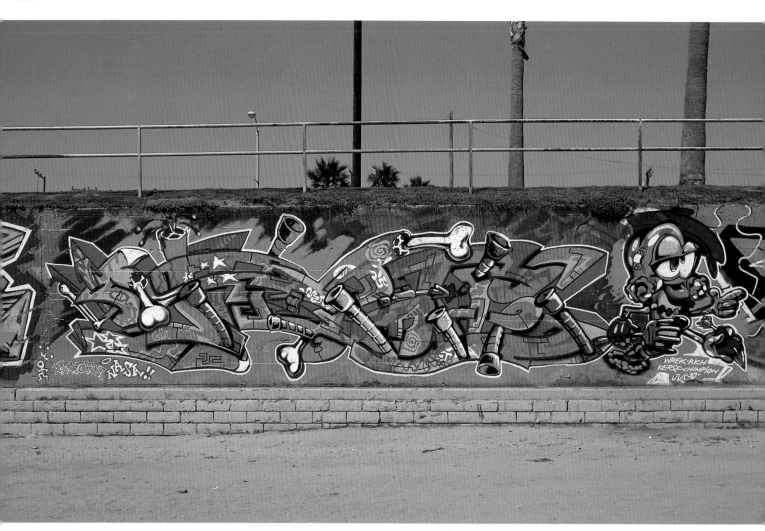

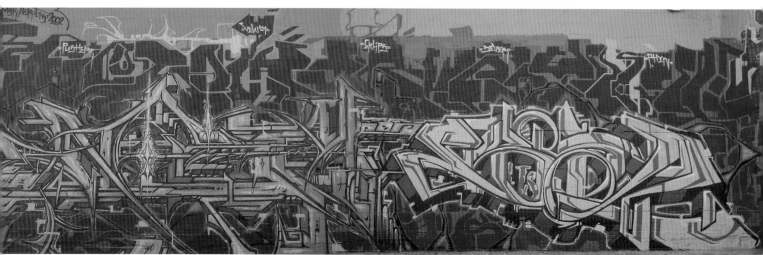

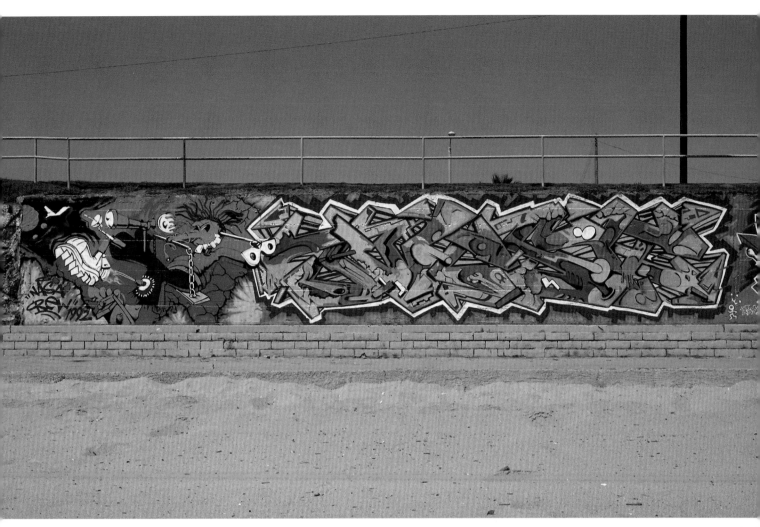

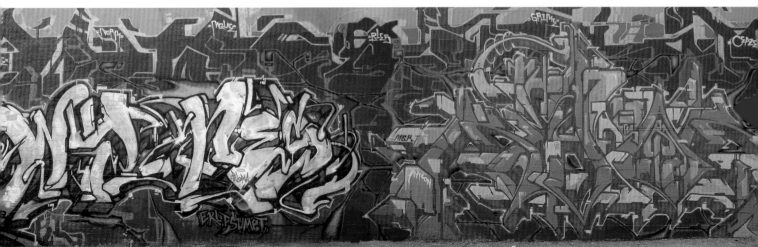

↖ **NASA** crew, Huntington Beach, 1992 ↗ **NASA** crew, Huntington Beach, 1992 ↑ **AWR/MSK: SABER**, **PYSA**, **TYKE WITNES**, and **REVOK**, with background by **KRUSH**, Highland Park, 2004

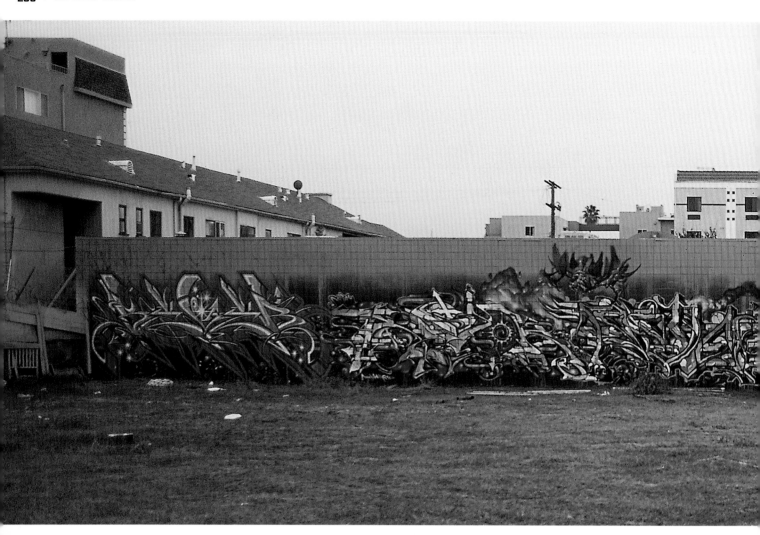

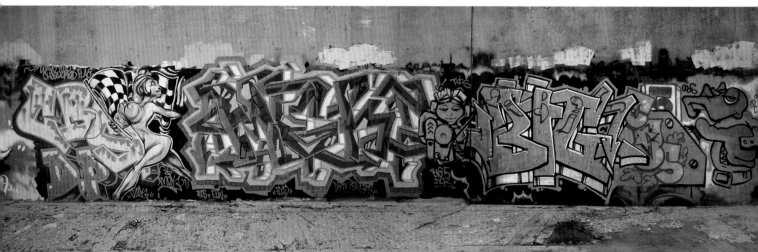

↑↑ **THE SEVENTH LETTER: SEVER**, **REVOK**, **RETNA**, **DAME**, **RIME**, **SABER**, with characters by **LOTUS** and **MIDZT**, Hollywood, 2005 ↑ **CBS**, Arroyo Seco, 1994. Following spread: **UTI** crew at the Sears yard, Boyle Heights, 1997

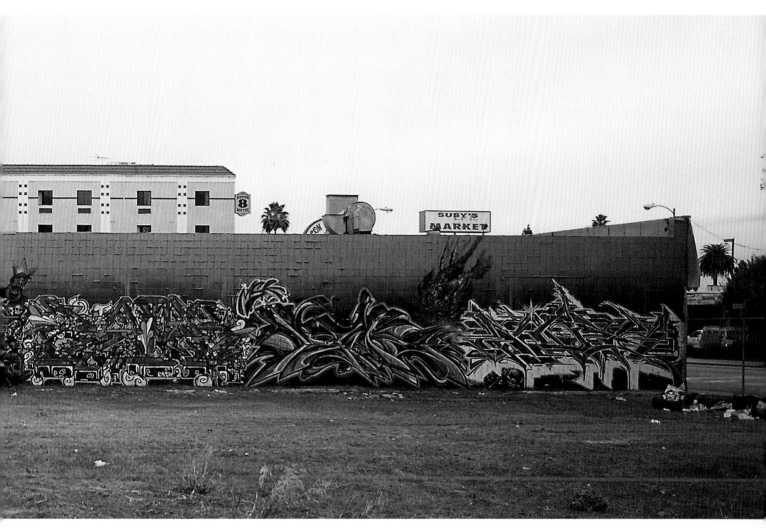

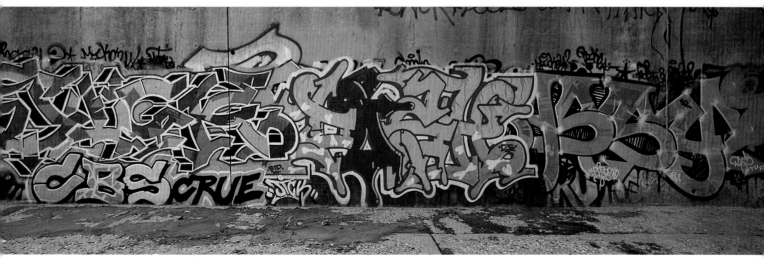

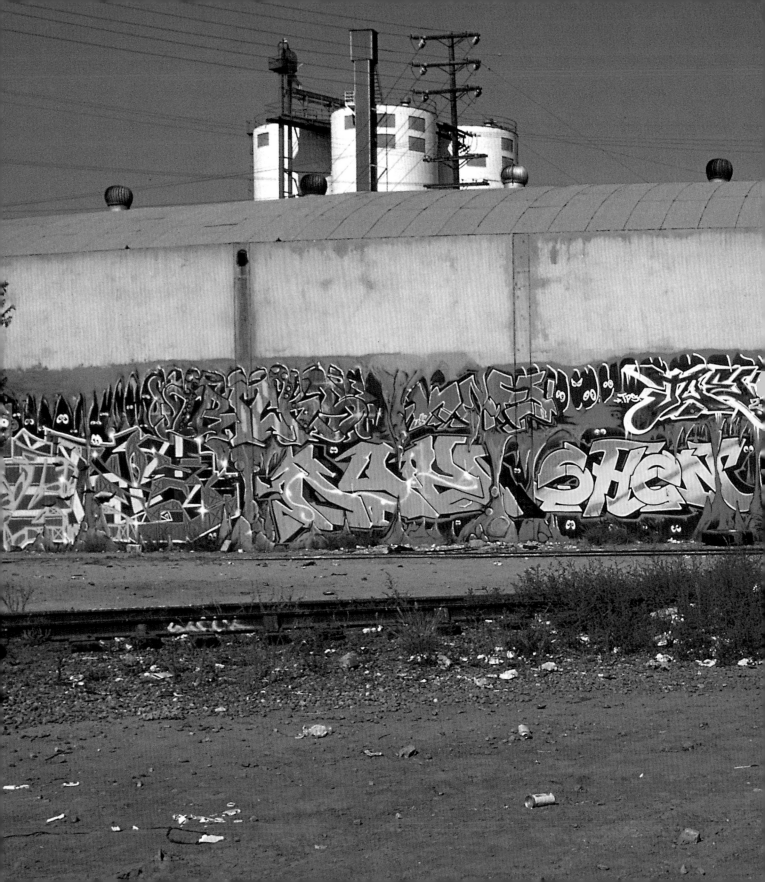

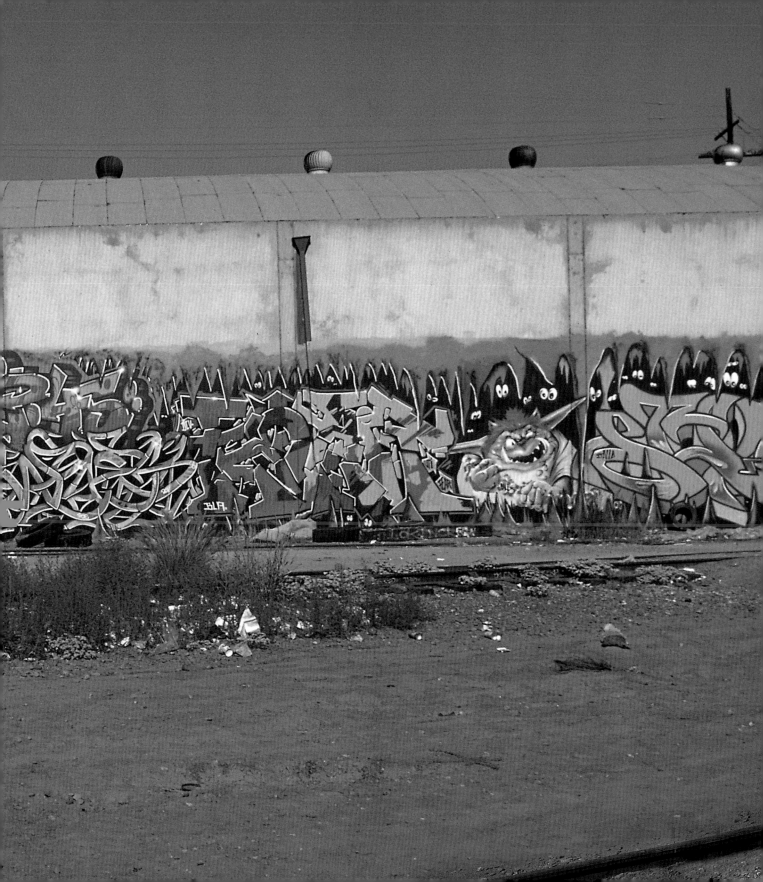

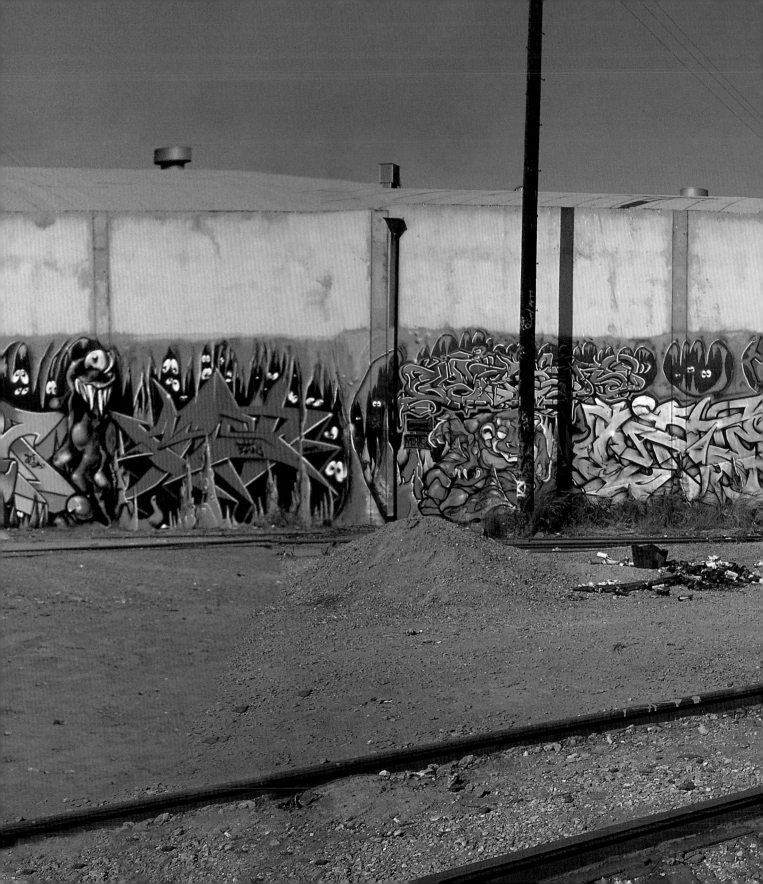

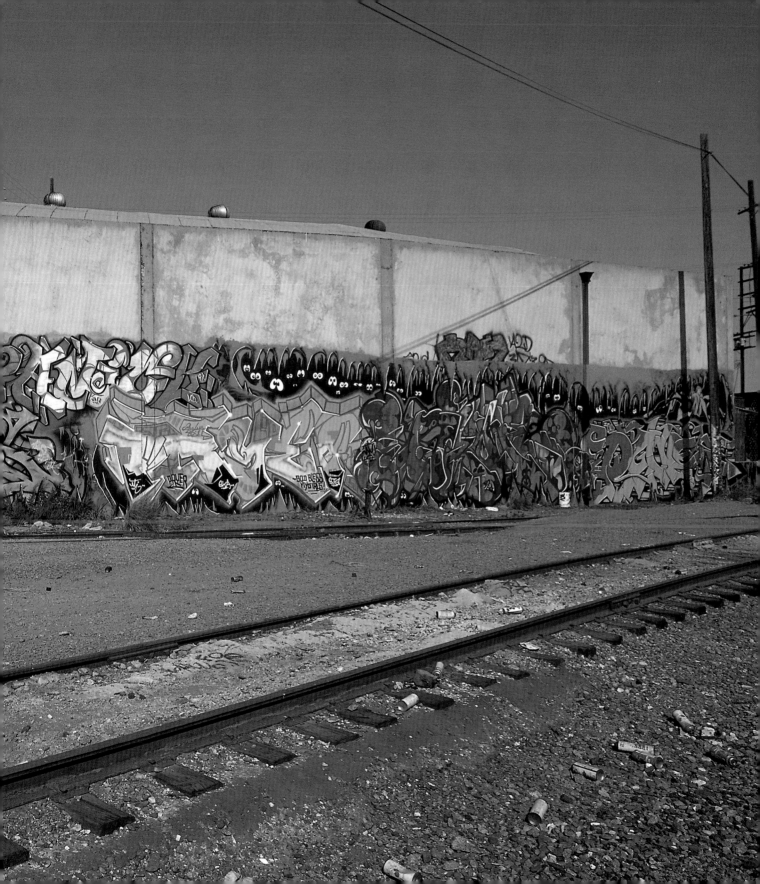

MENTORS

While most writers in Los Angeles travel around the city to see what other writers are doing and what is developing, taking inspiration from the graffiti community at large, most writers have mentors. Many admirable and even old-fashioned traditional social interactions can be found in the graffiti world, particularly apprenticeship. Writers or crews will often take apprentices, teaching young writers anything from gathering materials to "routes" (streets, areas, or buildings to be hit regularly) or yards and how to get up, to technical and aesthetic pointers. It is a rare writer who develops in relative isolation. Writers express gratitude toward their early patient mentors in shout-outs that are placed around pieces, even years after that early schooling.

SINER: Sane showed me the ropes. He would do the final outline for me so it would be clean, and we would do pieces together until I was able to knock it out myself. He brought me along to look out for him when he painted, and showed me color technique and things like how to fade and taught me the visual principles of graffiti, as well as how you should feel about it, that you should add something new to it, bring something new to the table. Not just reproduce something, but create something other people might learn from. And then people might pick up where you left off. We all influence each other. You were grateful for your mentors, so "put them up" when you did a piece.

CRE8: Rish was my second mentor and when I saw the pieces on paper he stuck up on his wall, well I can close my eyes and still remember how my mind was blown. He used a rapidograph to make his lines clean and sharp and had unique color schemes. And he painted on walls and that blew me away, so there I was every weekend over at his house. I was b-boying and now into the graff scene and paying my dues working on my piece-book skills, although I hadn't pieced on a wall yet. That came in '87 when Rish told me that if you want real respect as an artist, then you had to go beyond tagging and learn to piece.

JEL: I brought Bash in to help me do a professional job, and he is the reason I started doing characters. At first I said, "I can't do that!" And he sketched out some buildings and he said, "Just do this." He showed me what to do and then I did the rest. And then he gave me a character, and said "Do that." I said, "I can't do that." But with his encouragement, I did it. He said, "Look at all the characters you're doing in your book . . . you can do that on a wall." He would give me little tips and then walk away to let me work on it.

PRIME: I'm amazed and I'm proud that a lot of people have been influenced by me to develop their art skills. It helps people, kids, cope with life, to create art, and maybe save them from drugs and gangs. It's a really positive thing. You can say a lot of things up there, and you paint it free for people or yourself. No one can buy it and take it home!

ACME: One thing about almost every single member of SH/LOD—we truly believe in bringing up the youngsters. We know the importance of this; if this art form is to survive and grow. That is one of the most satisfying aspects of years in graff—to have positively influenced a person through your work.

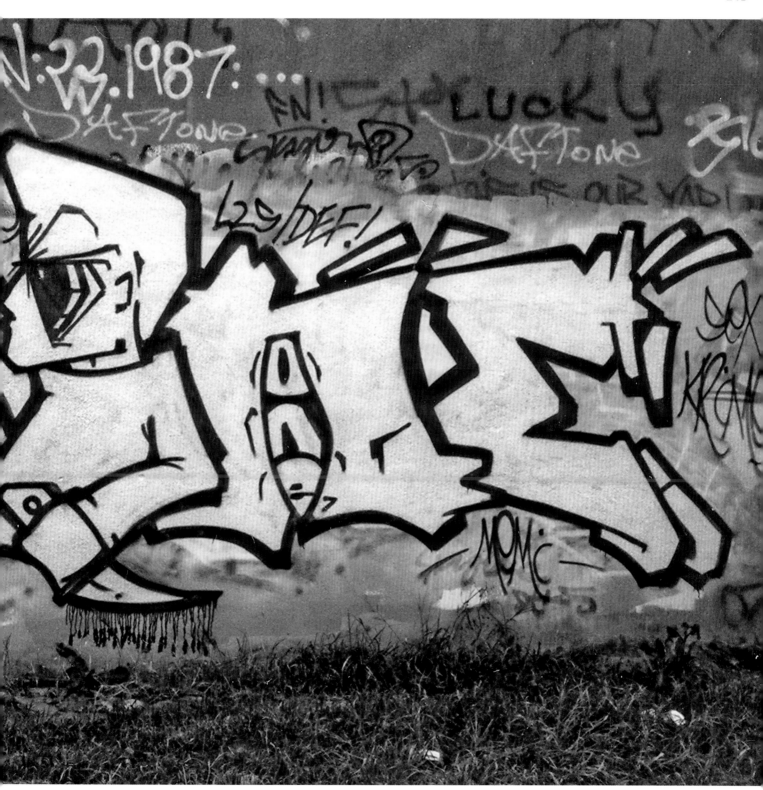

SANE, Jefferson yard, 1987

RETNA: One of the main things that helped was meeting good people along the way who gave me guidance and that extra push. When I met Siner, Self, Phase 2, Jimer, Mear—all those people helped me become who I am. All those people that gave me an opportunity, or sat down and gave me that little talk; there may be a lot of people I'm forgetting to mention, but it all helped and influenced me, whether it be their artwork or just the way they carried themselves. So if I see some kid I think has potential, I'd like to help him out because that will continue to make L.A. a dope cultural graffiti center. I had a chance to show Self/Thesis3 my sketches after taking on his influence and he showed me a lot of love. It's that generational evolution that graffiti's all about. I think I was really cocky at some point and I remember Ayer telling me "Man, anything you've drawn, somebody has drawn ten times better than you!" In art there are influences upon influences and it just keeps going.

CREW STANDARDS

Standards for getting in and staying in a crew vary; they are general and verbal in some cases, but specific and written in others. Some crews expect a minimum amount of piecing and bombing, while others are based solely on friendship. Loyalty is expected toward fellow crew members, including instances where physical confrontation occurs with unfriendly rivals. But, if being chased by the authorities, "everyone's on their own, and good luck" is an acceptable policy. While rivalries and conflicts naturally arise between crews from time to time, crews generally do not want members who make trouble. Weaker leaders tend to have more trouble-causing crews.

UTI's Skill was well known for his high level of organization. Under his leadership, UTI produced newsletters, announcing lightweight, middleweight and heavyweight team battles; crew roll calls, past and present; a call on members to write to incarcerated crew mates and most importantly, "The Rules of the Crew."

1. Throw-up over a tag, piece over throw-up, production over piece; don't go over anything you can't burn.

2. No talking behind people's back.

3. Solve problems by talking first.

4. Solve problems face to face, not on the phone. Phone only to set up a meeting.

5. Equal rights to express views, but respect elders.

6. Keep a record of everything you do or cool thing you see. Take photos, notes, a record. You'll be glad you did.

7. Work as a team. Help each other come up and to stay positive. Don't support one another's alcohol and drug addictions. Always keep learning, growing, reading, and drawing.

8. Be self-motivated and carry your weight.

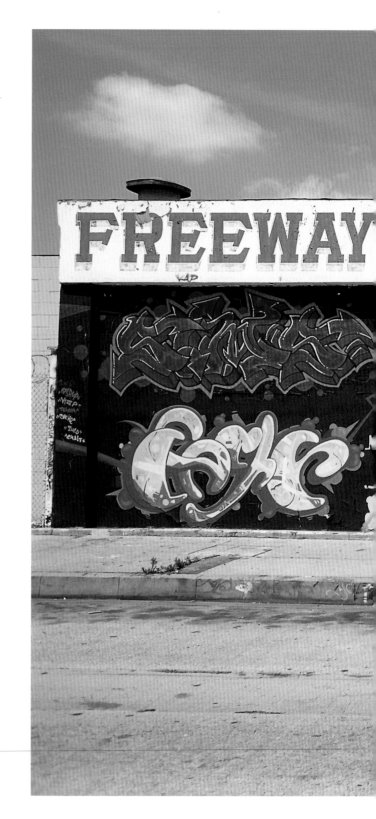

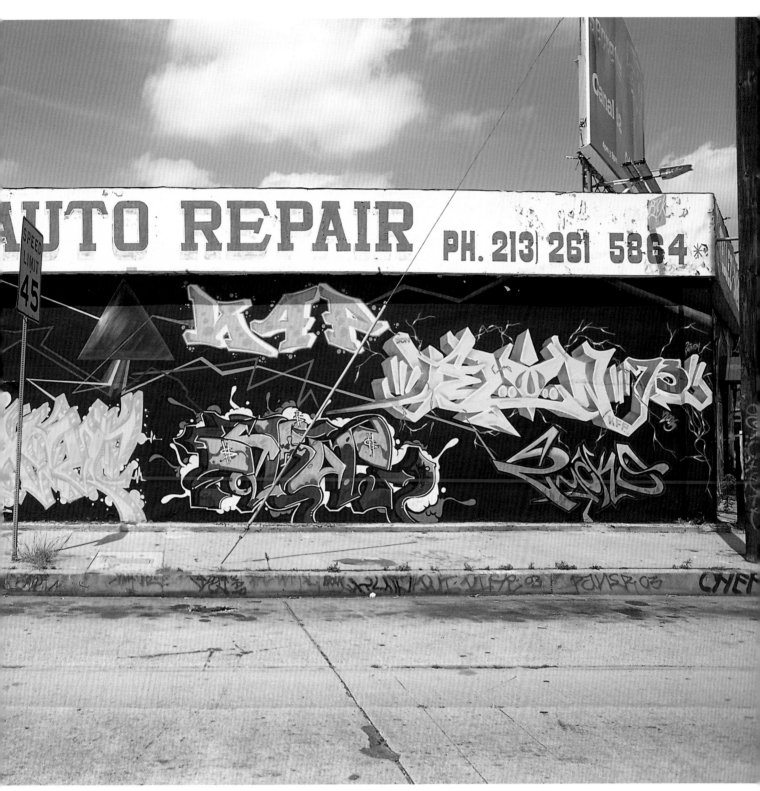

K4P crew, Commerce, 2005

ANGER: A lot have gotten the boot from our crew because if you can't hold your own in every circumstance and start to slack, we'll let you know. They know when they get in the crew we're not interested in having someone just ride our wave. Members have put in mad work and mad time, so if you're not going to come in and make your mark, go where there's no path and leave a trail, then it's not going to happen. If you want to be in this crew, your career starts *now*. Skate was a great teacher and made the new kids aware of other writers around the city and he pushed you. On our second meeting, he said "Anger, you're wack. You have to get better." And when I came up with my own style, he said, "Yeah! That's dope!" When I got out of incarceration (where I came up with the new-style throw-up), he said, "You have to get that up and I'll roll you around and you won't get busted. If I have to jump on a cop car so you get away, I'll do it." And you knew he would be true to his word. CBS has been my family and flows through my blood. I try to look out for them, and with the new ones coming in, I try to make sure they have jobs and know what's wrong and what's right. For example, don't tag on a tree, and when you go somewhere where there are other writers, introduce yourself and represent. Be proud you're with CBS. Writers need to have a sense of community and it's important that your crew teach the younger generation as you get older.

SINER: What I tell people in the crew is, don't create beef you can't handle yourself: you're part of this crew so handle yourself with the utmost respect. Don't do something stupid because you got crew, because we're not about banging. We're a group of artists that like to paint together and bounce ideas off of each other and push each other to grow.

TOOMER: I know for a fact I'll be going to prison for what I've done, but I don't care. I'm willing to risk my freedom and my life to do graffiti. I'm a two-time felon. My house has been raided multiple times. The cops all know me. I've been shot at, stabbed . . . so if I can still do it, then there's no excuse for those that call themselves writers not to write. Tribe's not writing now because the minute she does something, she'll get raided. And her life has gone in a different direction, DJ-ing now, but she still promotes graffiti however she can. The difference between me and Tribe is that she has some money now and they'll take it away from her, but I don't have shit, so they ain't going to get anything. You can't be afraid to lose anything. Crew rules: Number one: Members shouldn't mess with members; it always causes drama. Rule Number two is: You Work (paint). Nobody is above that: this is not the Boy Scouts or a knitting meeting. This is a vandalism crew. But still the basics; no going on churches, cemeteries, homes. Public space, yes.

VOX: I tell my crew members that are coming up: there are two kinds of people; people that rock shit, and people that talk shit. So the ones that are talking are mad because we are rocking.

ZUCO: People see the technical skill in our work and don't understand how long it took us to get there; the hard work, the battles, the chasings, the late nights and the hard days at work after the night before.

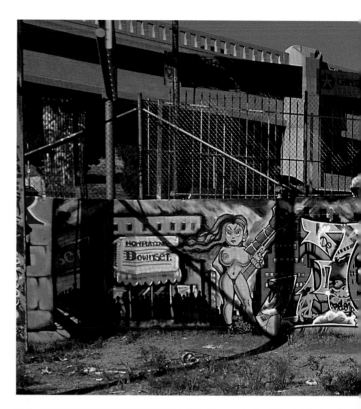

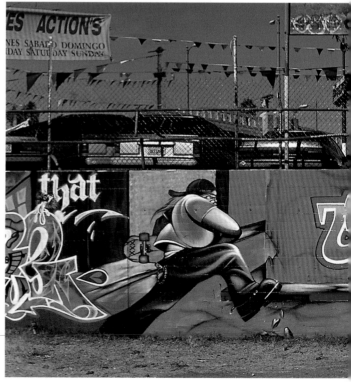

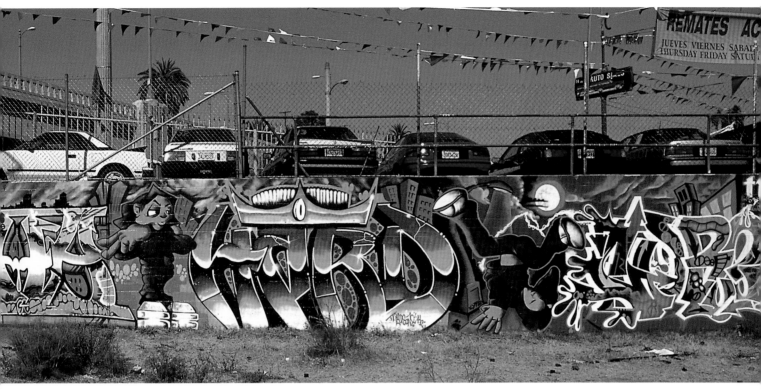

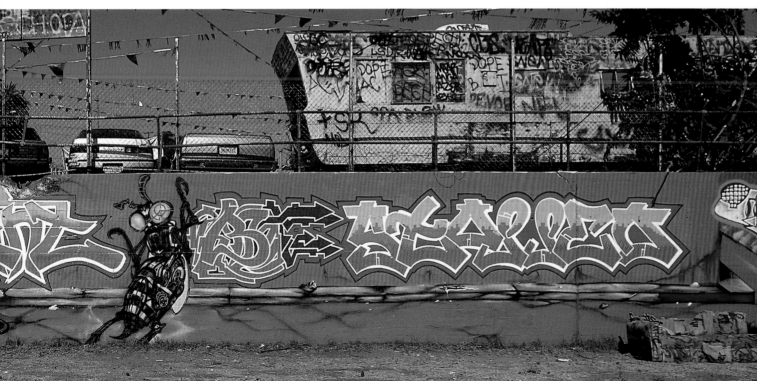

The Hardcore That Can't Be Stopped, Belmont, 1996

Opening crowd at an ICU opening, 1995

SOCIAL ELEMENTS NOW

Despite the tremendous amount of activity on the city's walls and lots, many veterans believe that too many of today's writers regard graffiti as a fad. This belief may stem from the idea that life is easier for writers today than it was in the formative years. Difficult environments lead to deeper commitment, and easier conditions tend to lead to a generation of dilettantes.

Another widely held sentiment is that appreciation for the tradition of graffiti has diminished, as evidenced by the common lack of respect for established writers who are "gone over" by neophytes. Even though the public at large may see graffiti as mindless anarchy, the early writers had a profound respect for experienced writers and the walls where work was found, and approached the execution of their own pieces with a sense of responsibility toward a tradition. But now, more than twenty years after the start of modern graffiti in Los Angeles, there is reason for optimism as evidenced by the development of some skilled artists. Ultimately it will be up to future generations to preserve graffiti traditions.

REVOK: Before, you used to bite somebody's style, you'd get knocked out! But graffiti is softer than it's ever been; you used to be checked on your actions. Before, you had to really struggle and fight to stay alive and uphold your name in the scene, to stand your ground, and it's not that way anymore.

ZES: The way I was brought up—you disrespect my stuff, you'll get screwed up. Whatever it takes for you to understand that you don't do that again. These days it's not like that, although for me it hasn't changed.

REVOK: The community as a whole is soft and don't do anything about people going over work inappropriately, so kids think that's okay. It's like the African proverb "It takes a whole village to raise a child." Now the attitude is "Oh, it's all good. I'm just expressing myself. Sorry dude." Like that makes everything okay—and it doesn't. In my day, if you went over somebody, you'd better be ready to go toe to toe with them.

ZES: But the writers that don't understand respect are usually "season" writers. They just do it for a couple of seasons and are done because they don't have the art. That or they're just tag-bangers. One of the two, and you can count the ones that do have the art.

REVOK: A lot of the writers that you see today consistently that are good—in the upper echelon of the club—those guys have been around for a long time. It didn't used to be that way. There used to be tons of new young writers coming up. And there still are, but most of them come up for a summer and a fall and then you never see them again. On the other hand, Zes, for example, while he's only been writing since '95, he's been up in the streets (not just weekend legal walls) every single one of those years since then, even though he's got a kid. And in every one of my seventeen years of writing, I've been in the streets doing work. And mark my words, ten years from now I'll still be doing it, even if not as much as I'm doing now. And that's what a graffiti writer is . . . if you're a graffiti writer, then you're doing graffiti! A lot of these people are doing shows and galleries, publishing their own books, and they never did shit and they're not doing shit. Five years from now no one is going to remember them.

The new generation is not coming up on the same playing field where only the strong survive. It's like it's all fun and games now. It used to be after school you'd need a bat or a lock because you'd be going up against thirty fools because whatever crew you had beef with, you'd run into them somewhere and have to go head to head, outnumbered or not. And it wasn't about gang-banging, it was just about trying to survive to get notoriety on the walls. And that's why you're not seeing kids sticking around for a long time because they haven't had to make a difficult commitment to do it in the first place. It used to be the filter that weeded out the weak from the strong and now anybody can come out and do some stuff and then quit to go to art school. It's been diluted. I know I just sound like a grumpy old guy ranting about "in my day . . ." I see some kids whose graffiti is good, but I question their commitment and want to see them prove themselves.

ZES: If they're risking their freedom to put their name on the wall, then I give them respect, but you have to have a history, and if it's weak, it's going to go with you no matter how dope you get.

SINER: People go over a burner now with worthless bubble letters. Back then, people would be happy to just watch and learn. There are people that didn't get to paint until they really learned to do something on paper before they even tried to paint on walls.

TOOMER: People can go in and out of the bombing scene if they've put in time and have history. But if they've never done anything, and just doing it because they're bored or because their friends are doing it, they won't be taken seriously. They're like people dipping their toes in a pool: either dive in or do something else.

SIZE: Some writers get into it and get up quick, get caught a bunch of times and they're out, and then spend the next years talking about that short time they were active.

SWANK: Yards were open. Now with less yards, legal walls are it, and that pushes you into the controlling party's agenda. Free collaborations were cool. Even illegal yards were often okay to paint at because police would often pass by. The main concern was whether you were able to get a photo before someone went over you. If it lasted a week it was cool. It's hard to find a place to do your own thing now.

SABER: Not having yards is a real drawback for kids coming up these days, and one of the reasons for the lack of commitment in new writers; yards help build a community, where a weekend hobby can turn into an obsession.

JERO: There's less respect now. For example, some new kid takes the name of a legend and won't even put a number to distinguish himself [e.g., Rick2 to distinguish himself from Crime/Rick One]. I mean, what the hell is wrong with you?

BESK: The scene's so large now that it's hard to know everybody. And there's not as much respect. A lot of the new writers don't have the respect for one another that we had coming up. I think that's gotten lost. Too many of the young artists haven't done their homework, learning the history of graffiti. They don't learn from the past. They think the last person they saw get up is as far as their sense of history goes. If you go to art school, you study art history to learn about the pioneers of art; it should be the same thing with graffiti art. If you're serious about what you're doing, I think that's the most important thing you can do . . . to learn about what's been done. I wanted to know everything. Some of the guys coming up now think it should be an honor to meet them instead of it being an honor for them to meet the artists that preceded them. A lot of these cats don't even know who Shandu is or Crime. Graffiti is not just you getting up on a wall. It's a lifestyle . . . It's what you live. If all graffiti is to you is "I want everybody to know me!" then you have no love for it. It's more than that; you want to know the people, to be involved. And that's how knowing the history will make you a better writer, or at least a more rounded one.

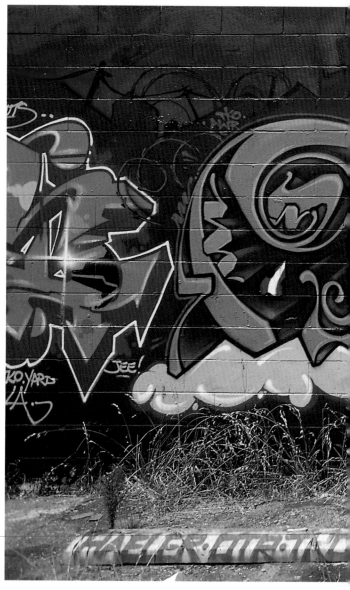

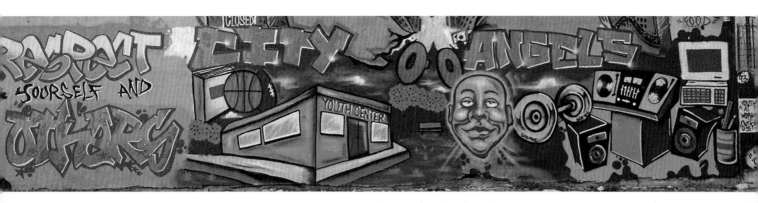

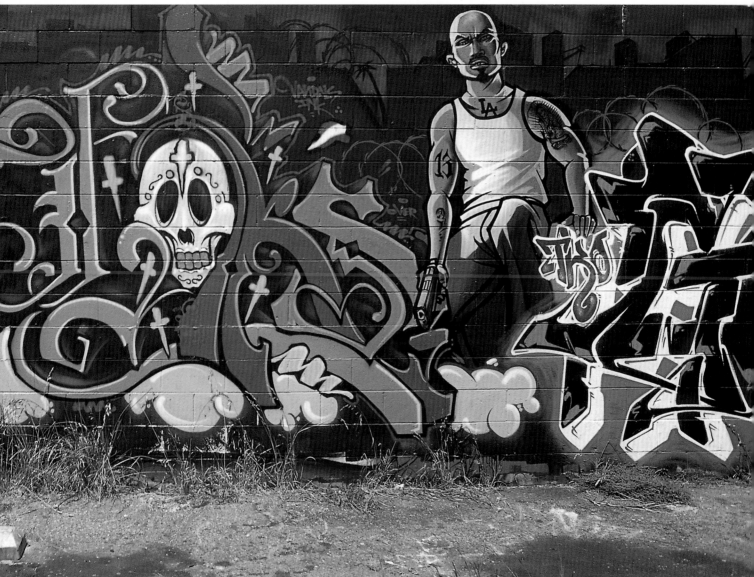

↑↑ writers unknown, Slauson tracks, 1993 ↑ *Tlok*, **TOOMER**, characters by **ZERK**, South Central, 2005

NEO: We had the desire to meet the other artists and see the styles they did. It used to be you tag, bomb, piece, and do productions, and now a lot just bomb. There's a lot less respect, crews crossing out each other. One thing I notice with the young kids of high school age now is that it's not common anymore to share piece-books. Sharing pieces with each other and doing pieces for each other. It used to be that everybody talked about who's who and what school they went to and what kinds of styles were being developed and what kind of markers were they using. I don't see that anymore with the kids I've talked to. Some kids make less effort to get to yards to see the styles; they just buy the magazines and go on the Internet.

TOONS: There is no unity in graffiti culture. I tell people to stop running their mouths and start busting; that's what we're supposed to do. Stop rappin' and make that shit happen.

CAREER ARC

Since the beginning of the graffiti movement in Los Angeles in the early 1980s, thousands of writers have come and gone. The artists in their early to late thirties are a select group, though most respect those who have retired after years of bombing and either leave the scene or decide to move exclusively into a professional art career, possibly integrating their graff skills into that career. Some retirees remain part of the social circle and enjoy seeing their friends still "getting up" on the walls.

Many things may lead to a retirement from street graffiti. The death of a close crew member, drug addiction, tiring of being chased or in jail, having a family. Some burn out after years of intense production. Some left crews to avoid heading in a negative direction, perhaps toward gang activity, or because they weren't backed up when they had beef with another crew or writer. Regardless of the reasons for changing direction, it's rarely an easy decision. For all of the problems that a life of street art can bring, the level of excitement felt during the best of those times can be difficult to match.

Anger: When I want to paint, I have to find time in my busy schedule because I'm not just Anger from CBS, I'm also Elias, a husband, and daddy to my kids. People have to understand that they were someone before they became this entity, this graffiti name. Kids don't understand that they're not going to be this entity for the rest of their lives . . . it's a chapter. And if you want to continue it, you have to make it fit into the rest of your life; it just doesn't happen by itself. Furthermore, graffiti is about freedom and if you're ending up in court or jail all the time you are going in the opposite direction. If you're in jail, you can't do shit, and you're nothing for the movement; you're just another person sitting in jail. If you're out here, you're active, socializing, kicking down knowledge, and able to have a life, able to be a father and a husband.

BIG 5: Graffiti is something that takes over your life. I used to say I'm retired, but I'm always going to be Big 5, and I'm always going to be a graffiti writer . . . I'm always going to catch a tag and want to do a piece here and there. Because a lot of us older guys have been around so long in the scene, we've seen generations of writers come and go. They write for four or five years and they stop. Once I was doing it when I was ten, there was no way I was going to stop when I was eighteen after having put in so much work. So as my friends stopped writing, I would find new friends that were writers, usually the new generation. And those guys would usually drift off and then I'd find the newer generation, so it seemed I was hanging out with younger and younger people as I got older. They did it because they were young, didn't have a job or a care in the world, just out having fun and doing some damage. So the last several generations, I would tell them "You're going to last two or three years" and they would say, "No we're doing this forever." They're all gone now. I'd say the majority of guys around in the late '80s still consider themselves writers and they're still somewhat involved in the scene. And then for the generations that followed that, it was just more of a trendy thing . They were just doing it because their friends were doing it. It seems to fluctuate every six or seven years when there's a big boom of writers, and some will last a lifetime and most will die off.

ATLAS: I say I'm going to stop because one more photo looks just like my last one . . . do I need that? Plus, do I need that much more heat? Hell, what *does* happen when the shit hits the fan and they kick my door in?

CRIME: K2S is not really bombing anymore, but we didn't sell out, we just grew up. If you love to paint and can make a living at it, you should.

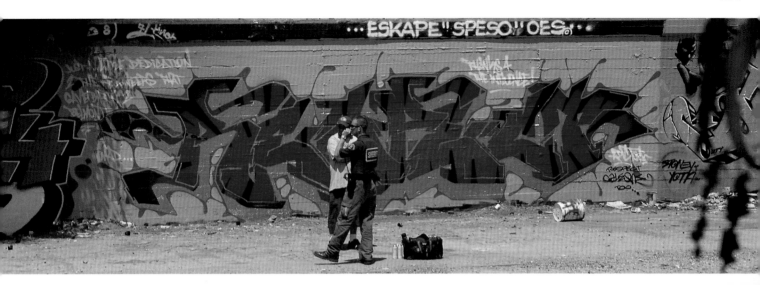

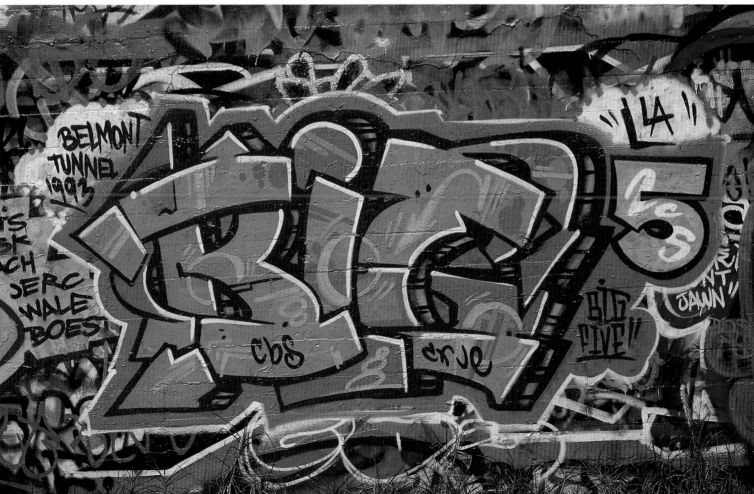

↑↑ **ADICT**, getting sweated, Belmont, 2004 ↑ **BIG 5**, Belmont, 1993

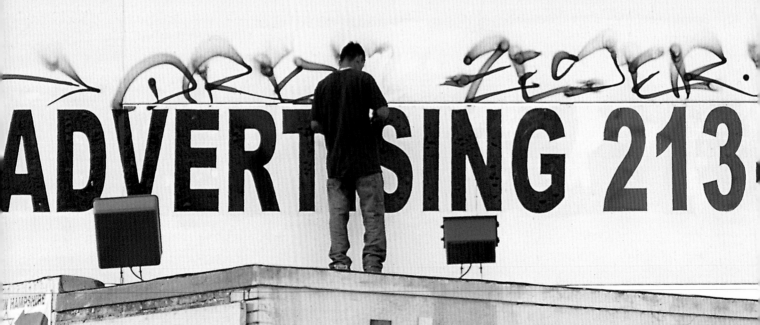

There is a wide variety of intentions among those doing illegal work. For some, the intention is to get up in an obscure location, in a place where one can relax and concentrate. For others, the intention is to get up in a difficult location where dangerous climbing, for instance, may be required. For some writers it's a matter of availability and legality is secondary, while for others the goal is to be as boldly public and illegal as possible. One way to define the degree of vandalism, beyond legal definitions, is whether or not the graffiti gets in the way of the public's or businesses' ability to function. Bombing a billboard front is clearly more vandalistic than a billboard back. An alleyway piece or tag on a dumpster is clearly less vandalistic than anything on a storefront window. Most writers target city property and "limbo" property but not private property and homes. The broken-window theory, the idea that property owners who do not immediately remove graffiti are more likely to be hit by more graffiti is also valid.

RELIC: I'll never write on a church because my art ain't bigger than God.

KOFIE: I'm more likely to tag something that's already been hit. Although rather than tag, I get more excited to pour paint on a section, drop in color, for example, on power boxes. What gets hit when writers are together depends on where they're at, who they're with, and what they have on them.

SIZE: As a kid you don't know the value of anything, but as an adult I wouldn't etch a store window.

NEO: It was about having fun; when we grew up, we didn't know we were devaluing property.

SHERM: As you get older you get more conscious of the effect of your actions.

Previous pages: An employee painting out Dreye and Zeser, 2006 ↑ **SABER**, **REVOK**, Wilshire Center, 2003 ↗ **PYSA**, Hollywood, 2004

ZUCO: I got into piecing to beautify my community because that's what the colors were doing—motivating people. I wanted kids walking home from school to see something besides oppressive gang graffiti, and they have a chance to know there's other colors around, to know that a spraycan do different things. I'm getting older and more mature, and my wisdom's taking over my physical craziness.

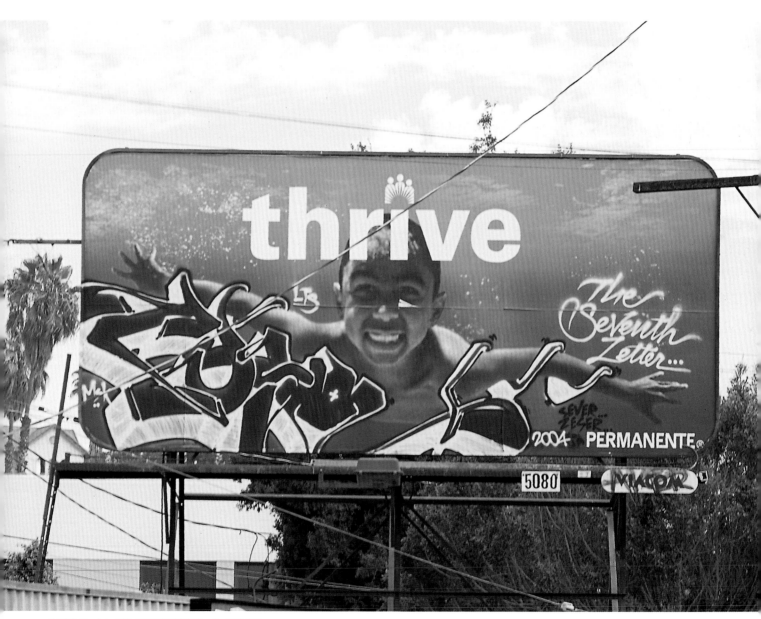

↑ **PYSA**, Silver Lake, 2004 ↗ **SHEPARD FAIREY** poster, **TANK**, 2004

↑ **RUGER**, 110N, 2006 ↗ **MSK** tag, 101N, 2006 ↘ writer unknown, 101 freeway, 2005

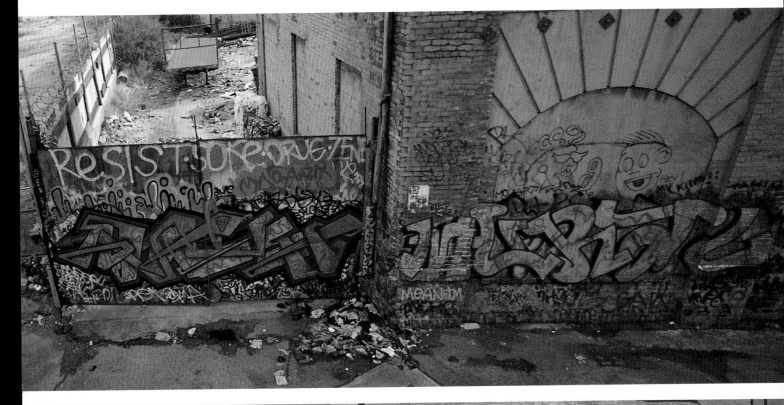

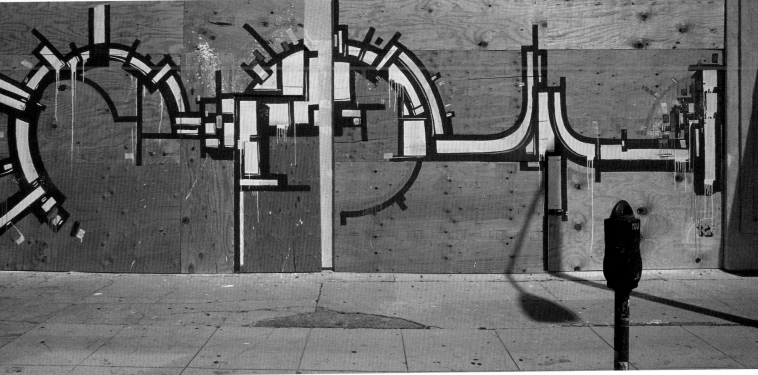

↑↑ **ANGST** on the fence, 7th St. and L.A. River, 1993 ↑ **KOFIE** on temporary boards, Hollywood, 2004

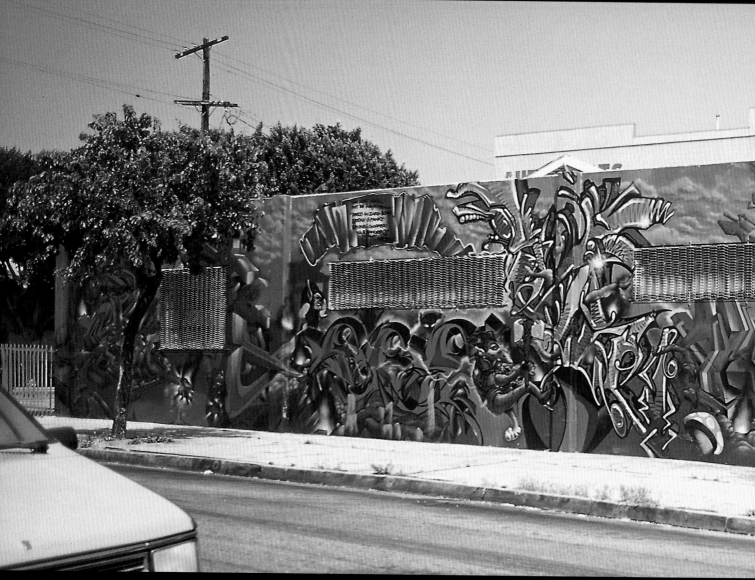

VISIONS CREW permitted production, East L.A. 2006

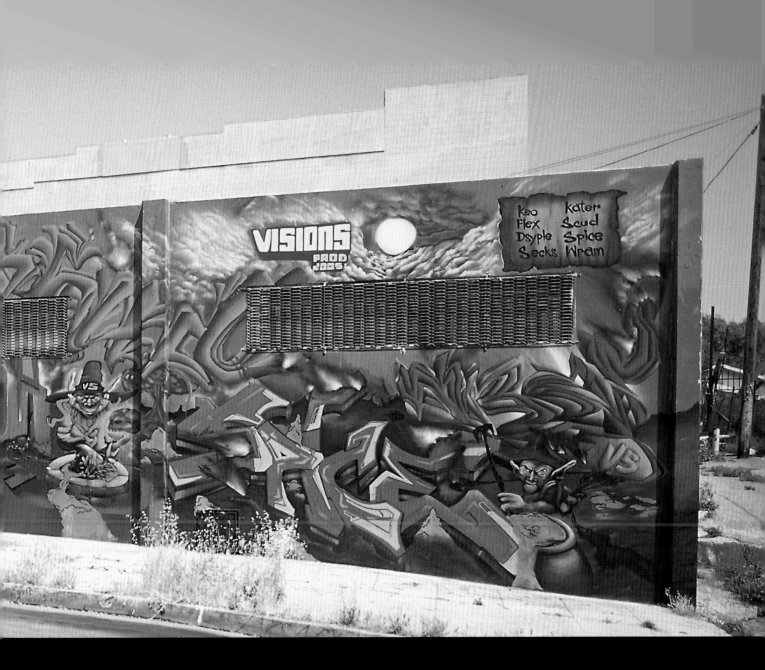

LEGAL ISSUES

There are many laws regarding graffiti—agencies of enforcement, county and city abatement departments, community assistance and regulation, and volunteer organizations to paint out graffiti—a tremendous amount of financial and human resources that could be used to benefit the public elsewhere—a good reason why the official response to graffiti has escalated. Today $400 in damage to property classifies graffiti as a felony,

Los Angeles is $1600. Acid bath is a felony even to possess. And as bombers get bolder, enforcement gets cannier, monitoring graffiti Web sites and forums to find out who's who and where activity may be. Private organizations have also popped up in outrage over graffiti's increasing popularity. The Nograf Network Inc. has called for a boycott on all Coke, Sprite, and Atari products until the companies agree to cease supporting

LOCATION, LOCATION, LOCATION

Graffiti artists are constantly surveying the city for new places to "hit." Some spots are chosen for visibility, some for their obscurity in hopes that their piece will stay up longer, others because they're easily available, and some are locations where only other writers pass through.

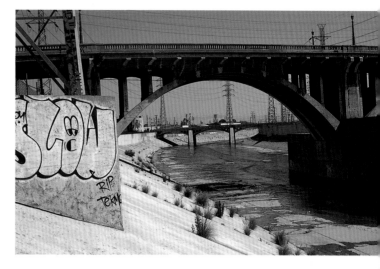

Writers most commonly hit alleys, washes, freeway walls, backs of signs, "hangovers" on bridges, freights, truck sides, and building tops. Some spots are hit regularly, and others only on one occasion. Construction sites are also popular and often condoned because most of the surfaces are temporary. Yards, ranging from the illegal areas along railroad tracks to walls with owner permission, can remain active for months or years. Important yards and areas in Los Angeles history include Belmont Tunnel (1984–2004), Venice Pavilion, Motor and National, Melrose Alley, Sanborn, Commerce, Slauson tracks, Sherman Way tracks at Whitsett, Seventh and Santa Fe, Huntington Beach, Whittier and Indiana, Arroyo Seco/L.A. River, Highland Park, El Serreno, Pico and La Brea, The Blue Lagoon, West Coast tracks (Pico and Sepulveda), Levitz warehouse walls, Woodman tracks, and Orbach's.

Melrose and some walls on Slauson Avenue and Highland Park are the few remaining places left in Los Angeles for public-permission painting in which writers are given free rein. Other permission walls are still available, but are closely guarded by crews or individuals with a direct relationship to business owners. Belmont wavered over the years between being writer friendly and unwelcoming due to conflicts with police or local gangs. Ownership of the Belmont area was also unclear. The small west wall was Metropolitan Transit Authority property, and therefore technically illegal, whereas the long east wall was owned by the used-car dealer, who gave permission to the writers. But the final years at Belmont provided writers with a relaxed place to paint and a community area, where on any given afternoon one could find writers from around the city painting side by side with locals playing *Pelota*, an Olmec variation of team handball, while a group of men played cards, and on weekends somebody might be cooking food for the crowd while a musician or two played guitar. This ended when the Meta Housing Corp. bought the land for development in 2004.

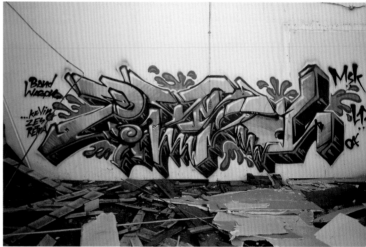

KOFIE: I miss Belmont not just for painting at, but also for the fun of driving down the hill and seeing something new that inspired you.

ATLAS: It's awesome to live through the whole experience of that day. There's always something: that one bum in the alley that's going to talk to you the whole time you're there, that put you in that zone. Or that kid on your back asking a hundred questions so that you can't even get into your piece, and you don't want to diss them because your painting is in their hood, and you could get a reputation as an ass, and that could be a problem. I was a legal eagle until I joined LTS who were down to bomb. I bomb a lot in the day, like trains, or I pull over on the freeway and catch a tag, just because it's in the glove compartment [the marker] . . . it's calling me, you know, like it's in there and it's vibrating. I swear, if I don't have it on me, I fiend, and if it's there, yep, it's going to go down, because I see this spot runs, or this is the intersection where you can see it.

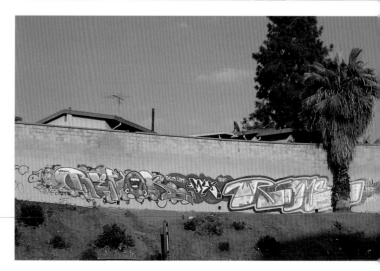

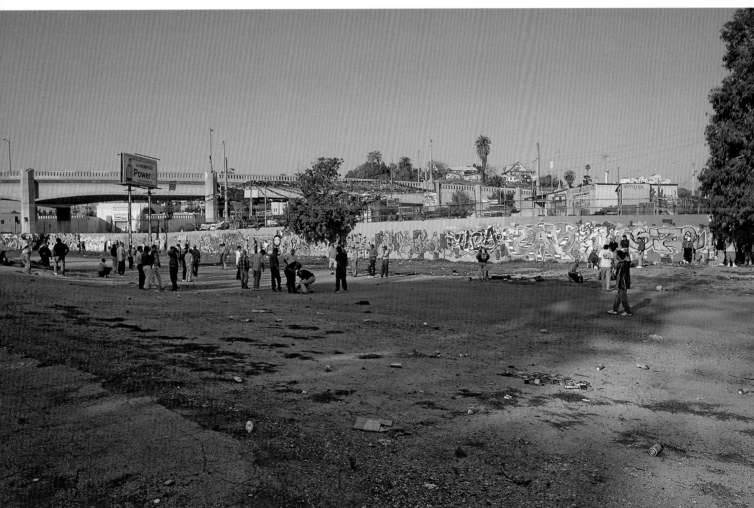

↖ L.A. River ← **PYSA**, at demolition site, Downtown, 2005 ↙ **REVOK** and **RIME**, 101N, 2006 ↑↑ "Hangover" tags, 5S, 2005 ↑ Pelota players, spectators, and writers at the wall, 2003

JEL: If the wall is a buff I'm not going to waste my time. I'm going to go where it's going to stay up. If there are a lot of tags there and they don't take care of their building, then it's cool. My idea of a chill spot is different than some of my friends; something that's in your face but not too exposed, but will be a landmark. I look for escape routes before painting, just in case.

SABER: I was limited by the bumpy surface of the door as to how much detail per square inch I could do. With a flat, clean wall we can break it down to a couple of square inches. The rougher the surface, like the roll-up door, you're limited to a larger surface to break down.

ATLAS: There are poles you get up by "dry-humping," but there are ones that I can't even reach around that Zes has gotten up. I've seriously injured my knee climbing poles for sticker bombing.

ASYLUM: Your feeling may be different if it's legal or illegal because of the stress involved, but when you're in the flow and it's coming out well, you remember that's why you do it. And you start developing your instincts, to chill out and see if any law is passing by.

YEM: Yeah, you have limited time, and you think, if I'm going to get caught, I want to do something amazing, the most complex thing I have time for, my best letters, background, characters. Try and tie it all in. You're in there and yet it's going in slow motion, you can even hear the movement of your arms, a car in the distance, a can being tossed around by somebody. You take moments to take quick glances around, you have your ears open . . . you're using all of your senses. It's an amazing feeling if you can create something within that particular time because you're going fast. And the crazier the spot, the faster you have to work, and the rush you get from that is the best feeling. You try to get a photo as soon as the light comes up.

NEO: O.K., let's say we were going to do a whole illegal production . . . so on our way from point A to point B, we had to take a bus. We'll catch a tag on the bus bench, the bus, and walking from the bus to the location.

JEL: I used to do all this colorful stuff on the street, but I realized it doesn't hurt me as much if people cap over my throw-ups because I know I have a thousand more still out there. I want to be an all-around writer: trains, bombs, pieces. I have different styles for different things, including a style for trains, so they don't think I only have one style of throw-ups.

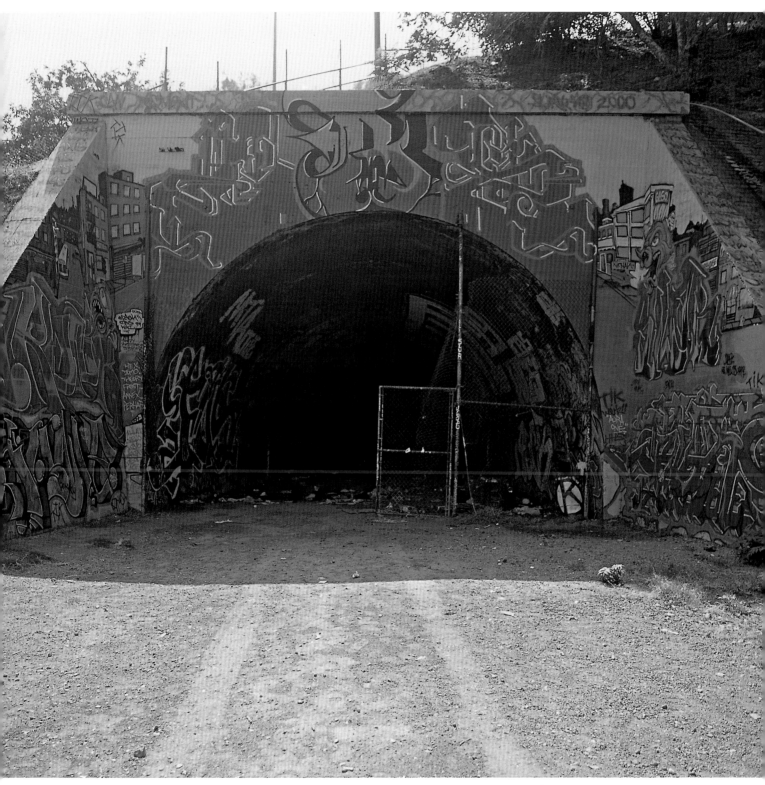

↖ **SABER**, Echo Park, 2006 ↙ Demolition and response, Belmont, 2004 ↑ The Belmont tunnel, **CBS**, including **ATLAS**, **AURA**, 1999

SINER: If you're going to be out there as a graffiti artist you need to know the rules and learn a little history of where you're painting, respect the neighborhood you're in, and not act like a knucklehead or people will check you. If they think you're trying to claim a piece of their turf, they'll sweat you. Painting in someone's neighborhood and going over the wrong piece: people have gotten killed for that. If you come with respect and they see that your intention is to beautify and bring some color into the community and the youth, they love you for it and leave you alone. And that's all translated from how you act. I try to bring a positive attitude when I paint.

TOOMER: You have to be humble and respectful to the streets, or you could easily get killed. There are some neighborhoods where they don't care who you are, whether what you're painting is permission or even being paid for . . . it's coming down, unless it's a Virgin Mary. You can't just go into the projects and do what you want. I developed my piecing when I was on probation and the police were heavily on my ass. So finding permission walls is like legal bombing because my name is still on there. People come by and ask if I'll paint something at their home, and I'm not interested: I'm not an artist. I'm a vandal. If I had my way, it would just be a giant silver-and-black TLOK blockbuster across the entire building, but then it wouldn't be seen as a mural and the owner wouldn't have that. The gangs would also see it as a potential threat and won't have it. So a colorful mural with characters is not a threat to anyone and it slides by.

KOFIE: The West Side was much milder gang wise. You would be light with your stock when you went to Belmont during certain periods.

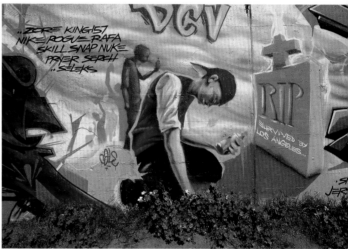

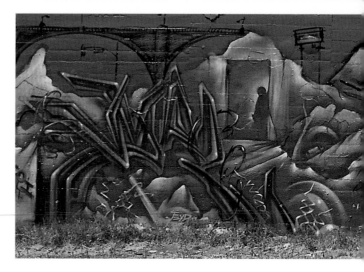

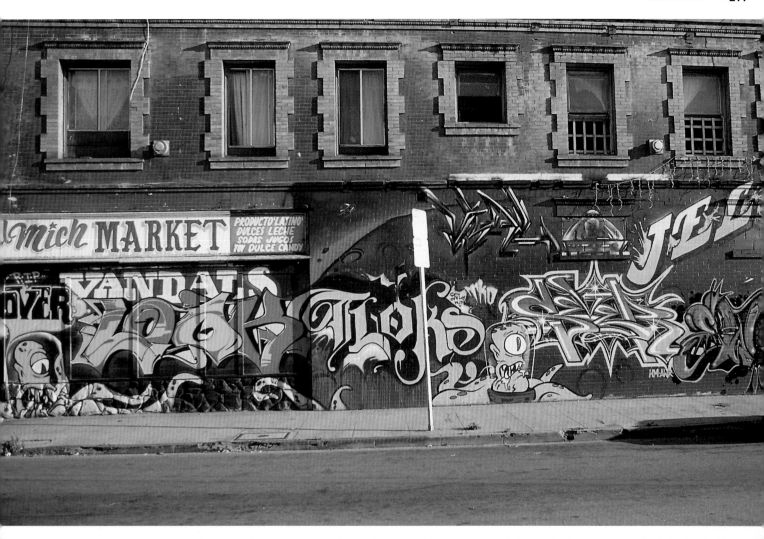

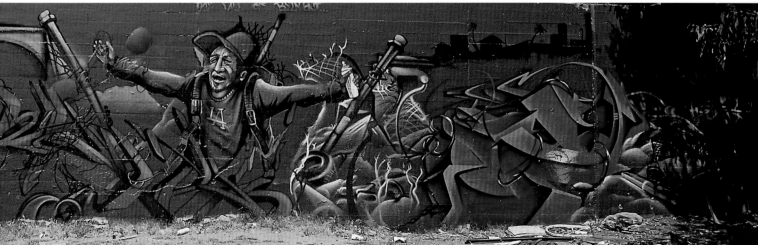

↖↖↖ **ATLAS**, Madonna and hummingbird by **ASYLM**, 710S/60W, 2005 ↑↑ **TOOMER'S** ("Tlok") wall, with guests, South Central, 1995 ↖↖ **CALE**, Belmont, 2005
↑ **VYAL**, **MARKA27**, and **RUKUS** farewell piece to belmont, Belmont, 2004. Following pages: L.A. River, 10E overhead

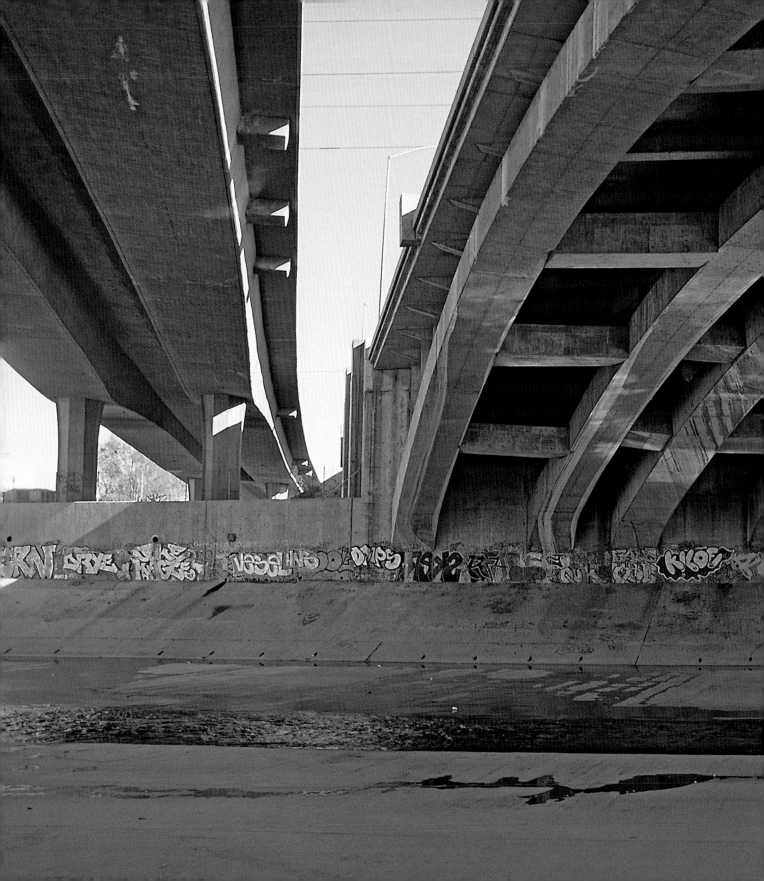

FREIGHTS

Freight train graffiti has become its own distinct subculture within the broader graffiti underground. As in other cities outside of New York, writers began painting on trains not only because they provided an easy novelty surface to hit, but also because it was the closest writers inspired by New York subway graffiti could get to emulating their heroes. The first generation of L.A. freight writers included Charlie, Risk, Power, and Strip, who all painted walls as well. Some writers became so enamored with freight writing that they painted trains almost exclusively.

BIG 5: I was hanging out with Skate and he was talking about the Woodman train yard. Even though I hadn't painted a train yet, I had to know everything I could about it. He eventually took me to the yard for the first time, and after that, that's all I cared about: I didn't care about painting walls at Melrose or Motor yard, I just cared about trains. If you have permission and are working on a wall for days, then it's not graffiti anymore; to me graffiti is vandalism. The feel, smell, and sound of the train yards was it for me . . . I would wake up dreaming about freights. And from '92 on that's pretty much all I did, with the exception of a few walls and freeways. I'm thirty-two now and can finally accept what Baba said, that I was a king of the trains. I probably have five

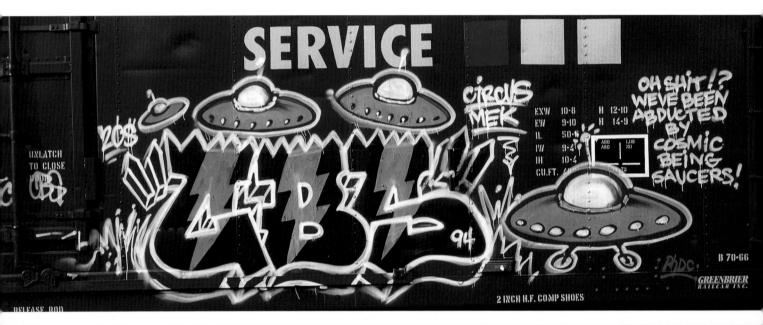

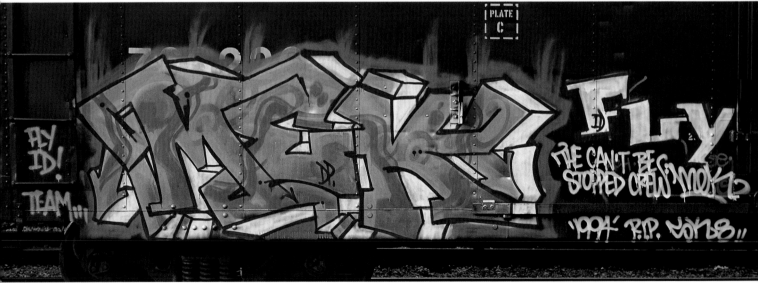

↑↑ CIRCUS, 1994 ↑ MEK, Budweiser yard, 1994

hundred photos of trains I did and that's not counting the six cameras I dropped running out, or the shots that didn't come out right. So I did maybe six or seven hundred. There are guys doing a lot more now, but most of them are in parts of the country where you can walk into a yard in the middle of the day and no one cares. L.A. is not like that. A friend, Con BA, from out of town came to stay for a while, and he was tripping on it because we were getting chased every night, helicopters with lights, and he said we don't get this in Baltimore where you could paint all day long and nobody would trip. He said every train writer should do a term in L.A. just to really be a writer.

ATLAS: Some people are all about trains, but to me, they're barely illegal . . . they're chill. I tell them if you want to do difficult illegal spots, do streets. Some train bombers are snobs, like that's the most legit thing to do. When they ask me to go with them, I say 'no' because we have to drive super far, we're going to paint two things, spend four hours asleep in the car, and drive back.

JERO: I concentrate on freights because I got tired of walls getting dissed, and it travels. In New York, you wanted to go on trains to be seen all-city, but with freights here, you're seen all-country. For freights, I do readable letters with style, not unreadable wildstyle.

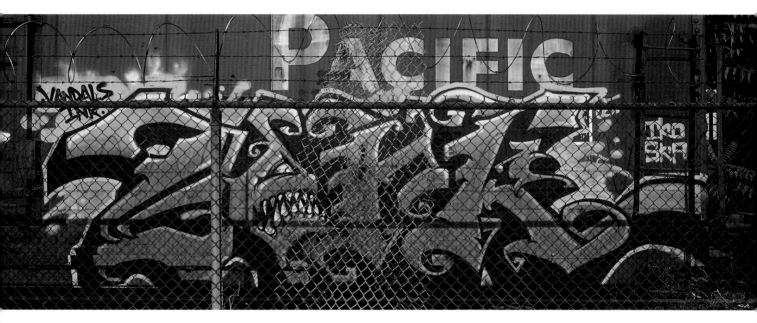

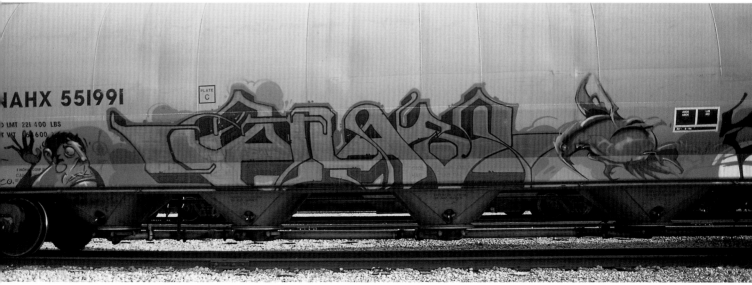

↑↑ ZERK, Maywood, 2005 ↑ ATLAS, with characters by ASYLM, El Serreno, 2006

VIEWS ON MURAL BOMBING

Graffiti on public murals is a particularly heated topic even among writers, who believe that murals are prime targets for taggers because they are not often buffed, as the city must ask an artist to repaint the mural. However, many top writers, including those who have done years of illegal work, are hesitant to paint over mural work. To Dash 2000, one of the founding members of UTI, going over a public mural, freeway or otherwise is grounds for dismissal—a distinct difference from crews where there is general disapproval of bombing on murals, but no crew consequences. While respect for other art forms in general is the primary basis of this rule, it is equally emphasized and enforced to help writers avoid attention from legal authorities as bombers and crews who hit murals have always been a high priority for anti-graff forces. Unfortunately for the public that enjoys public murals, there is a trend toward mural bombing amongst a fringe of writers.

NEO: I think it sucks that they're tagging murals, but when it's layered with multiple throw-ups it looks like a collage and it inspires me. Maybe because the ugliest stuff inspires me, like old garages and junkyards. So I can't say it's bad or good. I just go by my visuals.

ANGER: Stores, you're innocent bystanders . . . nothing personal. I love vandalism. I'm in this because of vandalism, not because of pretty pictures. You're going to be seen more on a freeway than a street. Everybody's trying to one-up each other; so you're going to end up with some shit that's unethical; that shouldn't be, but it's called graffiti. We don't ask permission for what we do.

ATLAS: That could be me forty years from now, getting commissioned to do a mural, and do I want kids bombing it? Not really. If it's got graff on it already, I will, but I would never start it.

SHANDU: I tell other writers, young and old that a piece or mural should be respected, freeway murals too. I grew up with that stuff, thinking we could have done that. We had rules, codes, unwritten rules of graffiti, the manifesto; you do your work, you want to be known, but you don't do it over people's work. No going on churches; even though you're an outlaw, you have some morality. I think the cross-out thing triggered a lot of hate in the community. We didn't do that, and tried to pass it on to the next generation.

The guys that do tagging on murals are trying to get attention. I'll ask them "Why are you dong this?" . . . as much as I want to just clip 'em right there! I'll tell them "That's just awful what you did." One bad apple does spoil the whole barrel, unfortunately.

Artist unknown, with toy tags, East L.A., 2002

SINER: There were times we went over already damaged murals, trying to use what was left of it, but I still didn't feel good about it because those murals should be respected. There are freeway murals by great artists that are getting ruined, like the Frank Romero—who influenced me to get loose because I like his brush strokes—and to see people continue to destroy his piece even after he fixes it, it makes me not want to even be part of the so-called graffiti scene. It makes us all look bad. It's like that saying "Young souls of a lesser art" because graffiti is seen as a lesser art, but if we want to get that credibility as artists, then destroying other people's art doesn't make any sense. It takes us backwards. Dozens and dozens of beautiful murals are getting destroyed. I never thought I would drive into East L.A. and see those murals destroyed because these are our people doing this work for us, and for us to destroy it . . . man. I'm into it for the art and I'm going to respect other people's art.

BESK: One thing I cannot stand, it just irks me when I see it, is when kids write on murals, any murals, whether on the freeway or the street. It brings us, as artists, down ten notches. If anybody asks me, I'll tell them "Dude, that's wack! You shouldn't be doing that shit!" We struggle to make people understand it's an art form, but when we paint on someone's mural, how can anyone accept us when we're destroying art? I think it's totally counterproductive and there are plenty of walls to write on.

ZUCO: Going on murals is not the quality of a leader; it's the attitude of a super-star . . . arrogant, like he shouldn't have any rules. We should respect artists. I respect art in general, and if they got a chance to do a mural, they probably paid their dues to get there. Hell, I get angry when people just try to side-bust me.

CRE8: Why do those clowns have to go on a mural? That it's not graff isn't the point; respect what you see. That attitude is not a sell-out; respect art whether it's good graffiti or a freeway mural. For that matter, hit a mailbox or a bus bench rather than a nice office building. And mom and pop stores struggle; leave them alone.

REVOK: Honor among thieves. I've gone outside of my own borders before and done stupid shit, but as a rule of thumb I always try to a) never screw up people's personal property and b) hospitals or religious sites and c) respect other people's art, graffiti or otherwise.

CHAZ: As a group we are maturing, so we have to come up with answers to issues such as respect of public murals. I'm fifty-seven and the thirty- to forty-year-old will listen to me, the eighteen- to twenty-year-olds will listen to them, and the teens will listen to the eighteen- to twenty-year-olds.

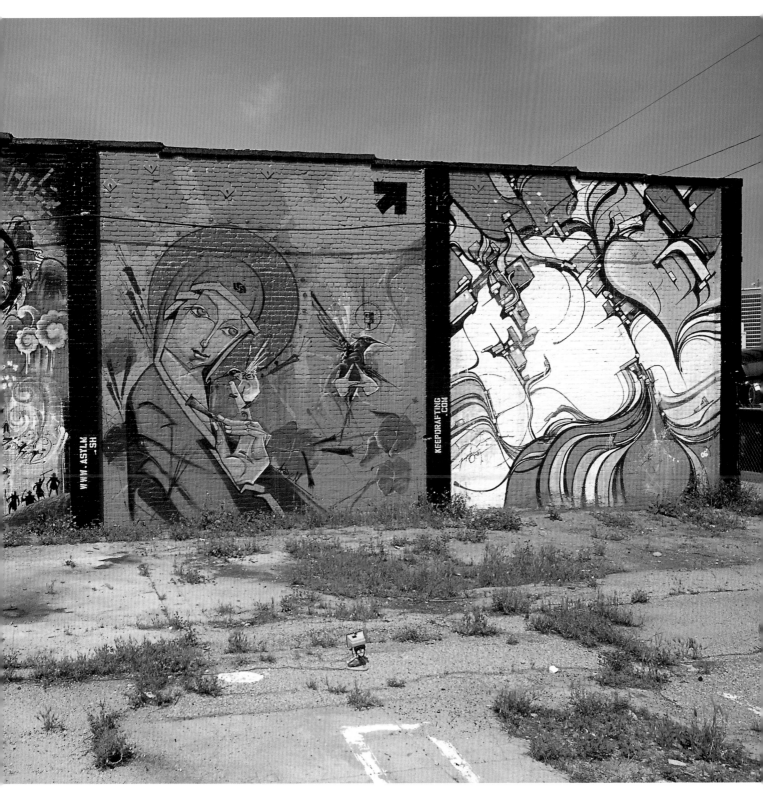

Left panel: **NUKE**, **DASH2000**, and **TWELV**. Middle panel: **ASYLM**. Right panel: **KOFIE**, Artist District, 2006

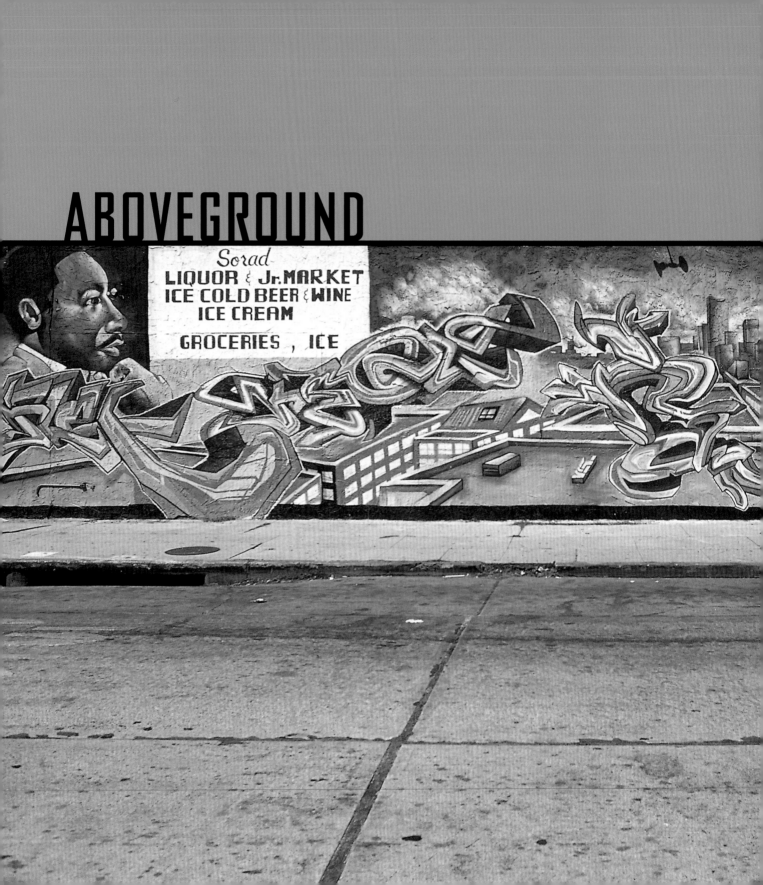

ABOVEGROUND

Many writers have used graffiti as a springboard to a very rewarding aboveground life, while others prefer to remain underground and off the radar as much as possible. Graffiti may have started as an entirely underground movement, but today, while the underground energy still provides key inspiration, many aspire to take their skills, reputation, and energy into aboveground careers.

Some writers have gone to school to develop specific commercial skills, and others have developed careers in a do-it-yourself manner. Youth marketing today is viewed as highly profitable, and that includes anything that has the aura of street credibility, including graffiti, which today is used in numerous ad campaigns.

Many writers have become graphics professionals, designing everything from CD covers to company logos. Krush and Coax are now making substantial livings with computer graphics and movie poster design. Michael Delahaut has worked as senior designer for Wieden + Kennedy on campaigns for Nike, Calvin Klein, and ESPN among others. In fashion, The Seventh Letter, Third Rail, Tribal, and Conart were all started by L.A. graffiti writers. A number of writers have trained to be professional sign painters, including Siner, Aybon, Zuco, Sims, Mesk, and Gylt. Since there is a close relationship between graffiti and hip-hop in general, it is not surprising that graffiti has led many writers to music careers.

WISE: Ad agencies and those who might use the talents of writers used to just tell someone on their staff "just copy it!" but now they want legitimacy and they are more willing to hire the people that deserve the work.

ASYLUM: Advertising companies should know that there are now graffiti writers fluent enough in the various approaches to graphics and media that they would be capable of creating ad campaigns in a professional manner, rather than getting non-graff designers to do something that looks "street."

VOX: People say graffiti's a bad influence, but honestly, it's the video games, commercials, shoe ads that promote graffiti, because they're the ones giving all the jobs, even Sunkist.

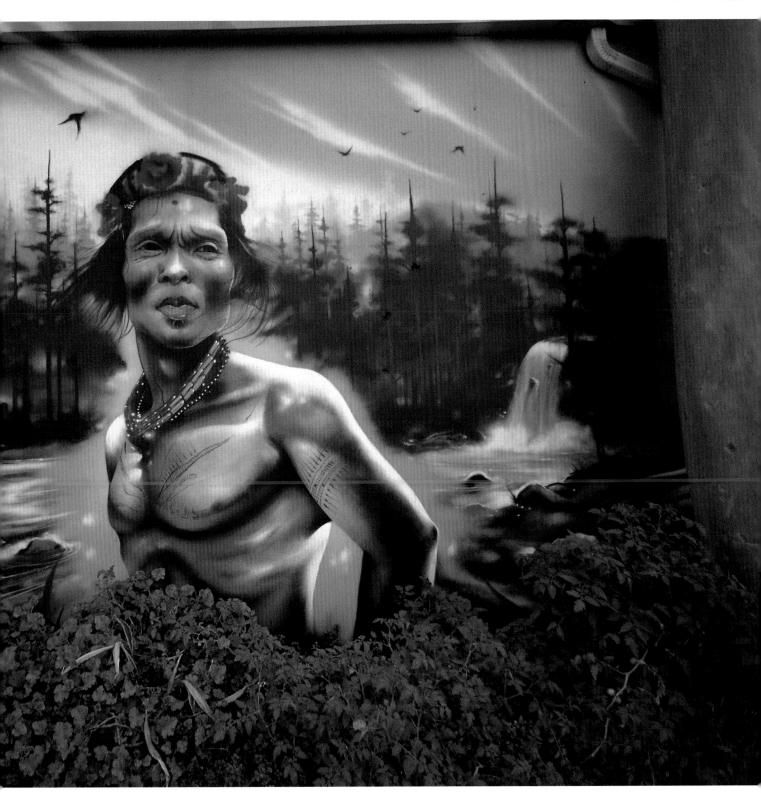

GALLERY ART

A number of Los Angeles venues have aided in representing graffiti art in a gallery setting. Crewest, established by Man One of COI crew, is the only gallery in Los Angeles solely devoted to shows involving graffiti-related artists and subjects. ICU Art is an art production company, that represents artists and works as artist advocates. ICU holds periodic gallery shows at various venues, including "paint outs" at the remaining Venice walls. ICU's director, Stash Maleski, was at the forefront of the community movement to save Belmont Tunnel. Other galleries, such as the now defunct 01 Gallery, held some early seminal shows that included a great mix of artists like Chaz Bojorquez and Robert Williams with Big Daddy Roth. Other galleries have also featured graffiti themed shows, but what many of these galleries share is the overlap with "lowbrow" art, a growing genre that graffiti sits comfortably next to.

Writers at shows can be found working not only in aerosol, but acrylic, charcoal, graphite, and mixed media. Push has also worked with ceramics as has Saber along with wood

and metal. There are mixed views in the graffiti community regarding gallery art, as some writers encourage aboveground careers, while others will always believe that only illegal graff is legitimate.

Today many major museums and institutions have also taken notice. Chaz Bojorquez's work is in many collections including the Smithsonian's and the Los Angeles County Museum of Art. Gajin Fujita, an active member of K2S/STN crew, was featured in a two-man show at The Los Angeles County Museum of Art in October 2005.

RETNA: The street art feeds the fine-art version of graffiti. To prepare for the gallery work, I first have to do street work, which gives me a different kind of inspiration.

ASYLUM: It pains me that non-graff artists that cop graff style are too often better at promoting themselves in the gallery and pro scene. We need to be better at sending out the bios and pushing it.

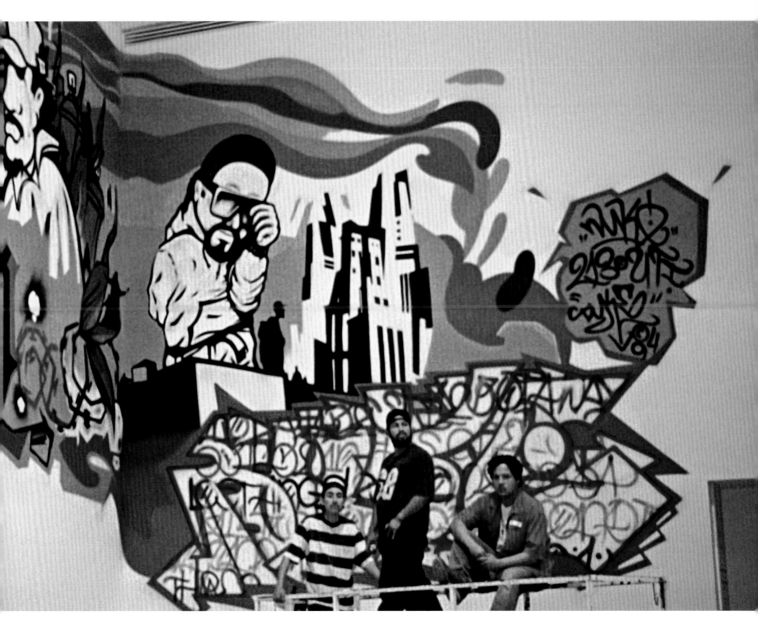

↖ *Riot Scene*, **RELM**, **ICU** event, *Notes from the Underground* show at Conart, 1993 ← Metal piece (approximately 7' by 10'), **SABER**
↑ **TEMPT**, **DUKE**, and **NUKE** painting the Temporary Contemporary Museum of Art (now the Geffen Museum of Contemporary Art), 1994

GALLERY: insert **CD-ROM** to view these pieces and hundreds more. **1 KRUSH**, Venice Pavilion, March 1996 **2 KRUSH**, Venice Pavilion, 1992 **3 ARES**, Melrose, 1995 **4 TWO TONE**, Venice Pavilion, 1995 **5 SPLIT**, Belmont, 2004 **6** *WGS*, **VOX** and **RUKUS**, El Serreno, 2004 **7 SOUTH CENTRAL KINGS**, Motor yard, 1992 **8 SELEK**, Belmont, 2004 **9 PHYN**, Motor yard, 1994 **10 DYE**, Motor yard, 1993 **11 RUET**, Belmont, 2004 **12 DYE**, Motor yard, 1993 **13 ARBY**, Mid-City, 2005 **14 ELIKA**, El Serreno, 2006 **15 HENSE**, South Central, 2004 **16 VEO** (aka **VYBE**) and **SIMPLE**, Artist District, 1993 **17 VYBE**, Chinatown, 1993 **18 DREYE**, Artist District, 2006 **19 DREYE**, Hollywood, 2006 **20 DER**, SH yard, 2005 **21 GROOV**, Motor yard, 1992 **22 DAME**, East Hollywood, 2005 **23 ESK31** (left), **SER** (right), Belmont, 1997 **24** *Excel*, **RAGE**, Motor yard, 1991 **25 LOOK**, Melrose, 1994

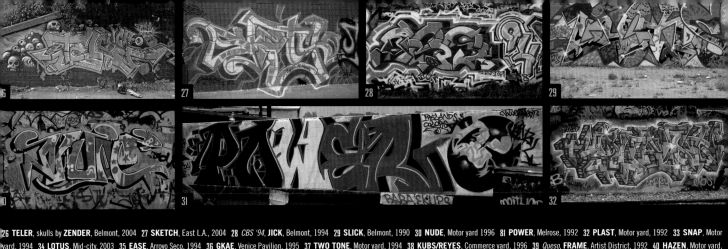

26 **TELER**, skulls by **ZENDER**, Belmont, 2004 27 **SKETCH**, East L.A., 2004 28 *CBS '94*, **JICK**, Belmont, 1994 29 **SLICK**, Belmont, 1990 30 **NUDE**, Motor yard 1996 31 **POWER**, Melrose, 1992 32 **PLAST**, Motor yard, 1992 33 **SNAP**, Motor yard, 1994 34 **LOTUS**, Mid-city, 2003 35 **EASE**, Arroyo Seco, 1994 36 **GKAE**, Venice Pavilion, 1995 37 **TWO TONE**, Motor yard, 1994 38 **KUBS/REYES**, Commerce yard, 1996 39 *Queso*, **FRAME**, Artist District, 1992 40 **HAZEN**, Motor yard, 1992 41 **PHOBIA**, Artist District, 2001 42 **AURA**, Artist District, 2003 43 **EROK**, Belmont Hill, 1994 44 **KENE**, Motor yard, 1994 45 **NUKE**, Arroyo Seco, 1994 46 **AYBON**, Belmont, 2003 47 **BRACE**, Motor yard, 1994 48 **SHVER**, Motor yard, 1994 49 **CAB**, East L.A., 2004

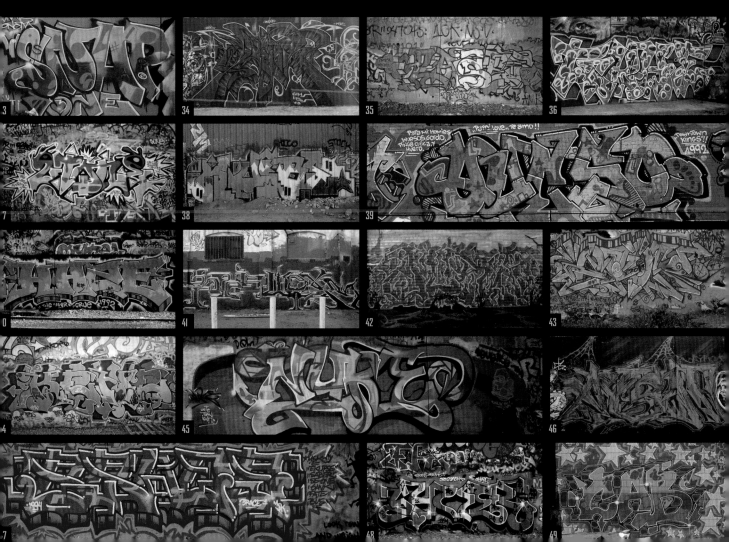

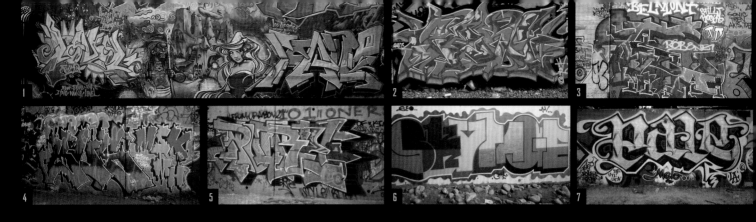

1 **FEAR**, **DOVE**, **KOFIE**, **ITALO**, **NUKE**, and **LEVEL**, Downtown, 2003 2 **AERO**, Motor yard, 1992 3 **ROB ONE**, Belmont, 1997 4 **BUS**, Motor yard, 1996 5 **PURE**, Arroyo Seco, 1994 6 **SKYPAGE**, SH yard, 2005 7 **PALE**, Belmont, 2001 8 **ADEO**,
MAN, **HOZOI**, (detail), South Central, 2000 9 **DUCE**, Belmont, 2004 10 **SHANDU**, **CALE** character, Belmont, 2004 11 **PLEK** (left), **2SHAE** (right), **BELMONT**, 2004 12 **RUET**, SH yard, 2005 13 **TACKZ**, Motor yard, 1998 14 **STRIP**, Melrose,
1994 15 **USE** (Yard Rats), Belmont, 1997 16 **SPURN**, Belmont, 2004 17 **UTI** crew, piece with Grandmaster Flash lyric, "It's like a jungle, sometimes it makes me wonder how I keep from going under." Compton, 1994 18 **NUKE**, East L.A.,
2005 19 **JUST195** with **NASA**, Huntington Beach 1992 20 **JUST195**, Venice Pavilion, 1995

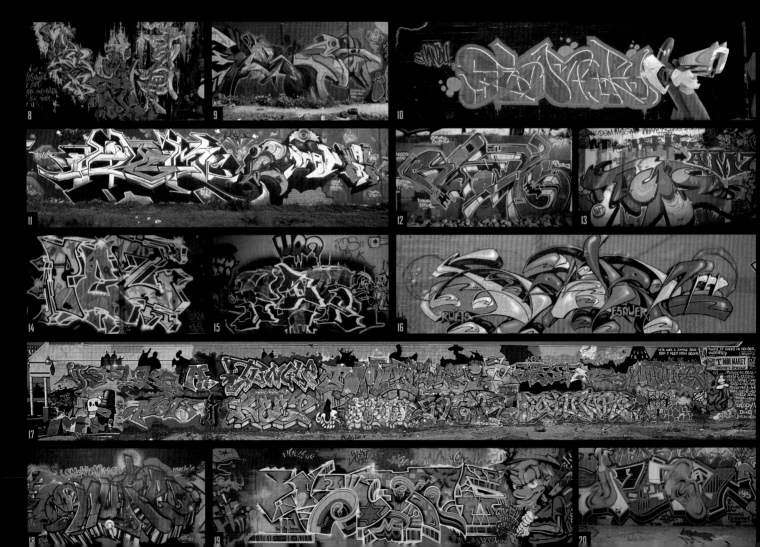

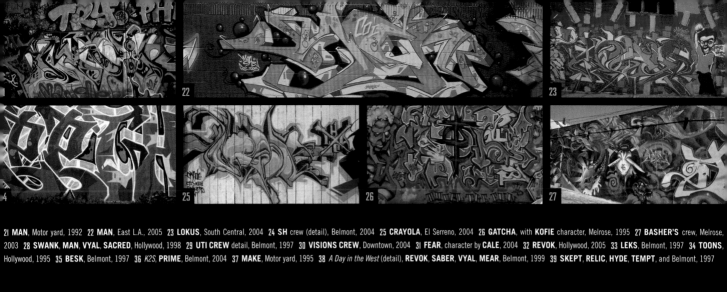

21 **MAN**, Motor yard, 1992　**22** **MAN**, East L.A., 2005　**23** **LOKUS**, South Central, 2004　**24** **SH** crew (detail), Belmont, 2004　**25** **CRAYOLA**, El Serreno, 2004　**26** **GATCHA**, with **KOFIE** character, Melrose, 1995　**27** **BASHER'S** crew, Melrose, 2003　**28** **SWANK**, **MAN**, **VYAL**, **SACRED**, Hollywood, 1998　**29** **UTI CREW** detail, Belmont, 1997　**30** **VISIONS CREW**, Downtown, 2004　**31** **FEAR**, character by **CALE**, 2004　**32** **REVOK**, Hollywood, 2005　**33** **LEKS**, Belmont, 1997　**34** **TOONS**, Hollywood, 1995　**35** **BESK**, Belmont, 1997　**36** *K2S*, **PRIME**, Belmont, 2004　**37** **MAKE**, Motor yard, 1995　**38** *A Day in the West* (detail), **REVOK**, **SABER**, **VYAL**, **MEAR**, Belmont, 1999　**39** **SKEPT**, **RELIC**, **HYDE**, **TEMPT**, and Belmont, 1997

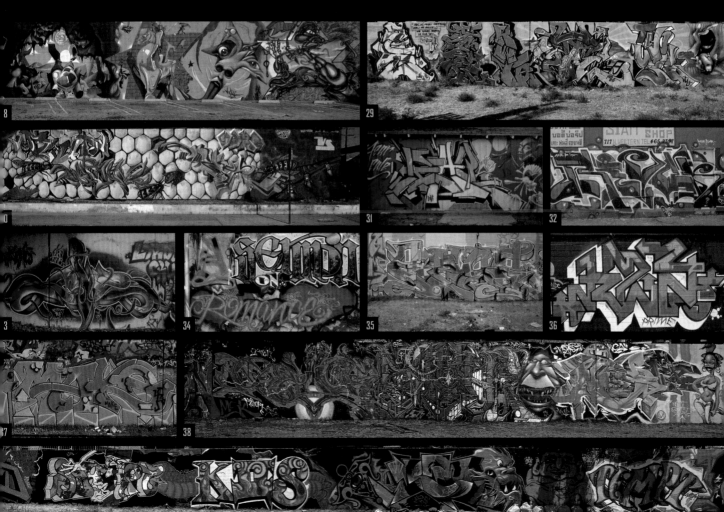

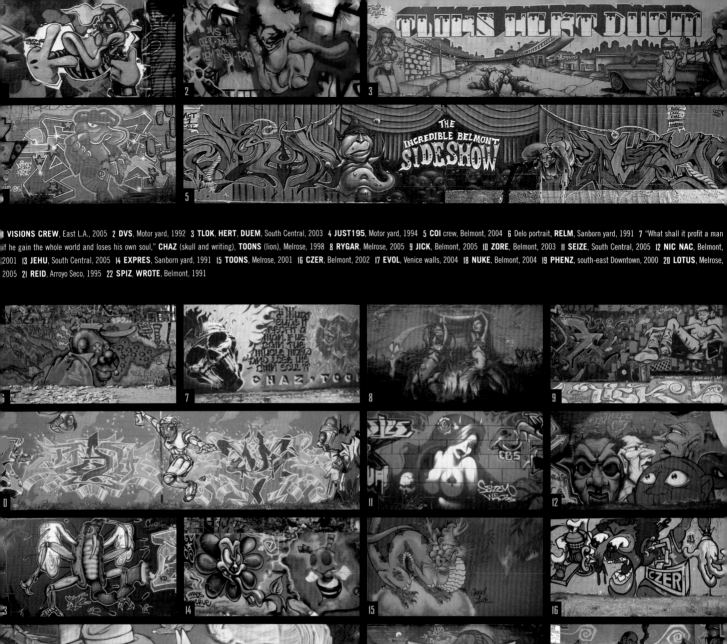

1 **VISIONS CREW**, East L.A., 2005 **2** **DVS**, Motor yard, 1992 **3** **TLOK**, **HERT**, **DUEM**, South Central, 2003 **4** **JUST195**, Motor yard, 1994 **5** **COI** crew, Belmont, 2004 **6** Delo portrait, **RELM**, Sanborn yard, 1991 **7** "What shall it profit a man if he gain the whole world and loses his own soul," **CHAZ** (skull and writing), **TOONS** (lion), Melrose, 1998 **8** **RYGAR**, Melrose, 2005 **9** **JICK**, Belmont, 2005 **10** **ZORE**, Belmont, 2003 **11** **SEIZE**, South Central, 2005 **12** **NIC NAC**, Belmont, 2001 **13** **JEHU**, South Central, 2005 **14** **EXPRES**, Sanborn yard, 1991 **15** **TOONS**, Melrose, 2001 **16** **CZER**, Belmont, 2002 **17** **EVOL**, Venice walls, 2004 **18** **NUKE**, Belmont, 2004 **19** **PHENZ**, south-east Downtown, 2000 **20** **LOTUS**, Melrose, 2005 **21** **REID**, Arroyo Seco, 1995 **22** **SPIZ**, **WROTE**, Belmont, 1991

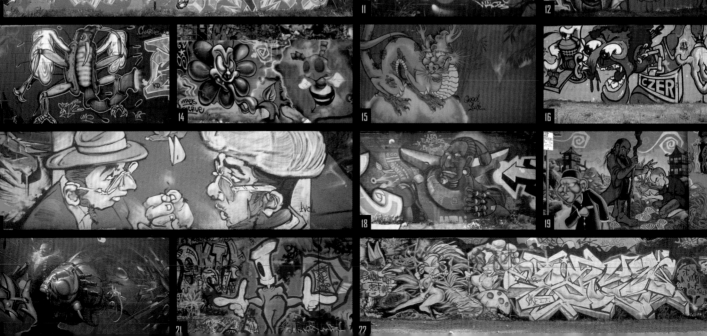

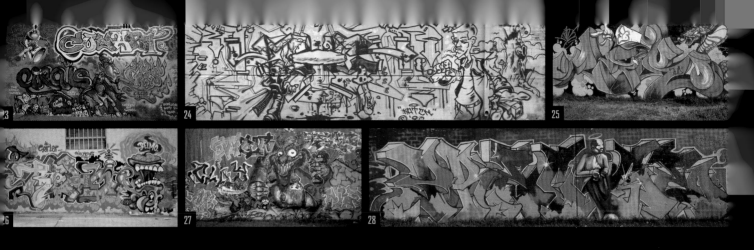

23 **CIRCUS** (below), **MEAR** (above), Melrose, 1993 24 **KATCH**, Commerce yard, 1996 25 **MANDOE** and son, **BASH** character, Belmont, 2004 26 **RELM**, Hollywood, 1992 27 **UTI** *Bode Star Wars* wall detail, **KOFIE**'s character, 1998 28 **PRECISE**, Belmont, 1997 29 **KATCH**, **JUST195**, **RICH**, **T-DEE**, **SABER**, East L.A., 1995 30 **TOONS** and **HERT**, Huntington Beach, 1992 31 **TWIST**, Venice Pavilion, 1996 32 **JIGZ**, Venice Pavilion, 1995 33 **ASYLM**, Belmont, 2004 34 **SKILL**, Motoryard 1994 35 **NYSE**, Venice Pavilion, 1995 36 **EXPRES**, Melrose, 1993 37 **SINER**, Pico/La Brea yard, 1998 38 **MESPI**, Echo Park, 2005 39 **VYAL**, **MARKA27**, and **JNUB**, East L.A., May 2004 40 **LOTUS**, Melrose, 1994

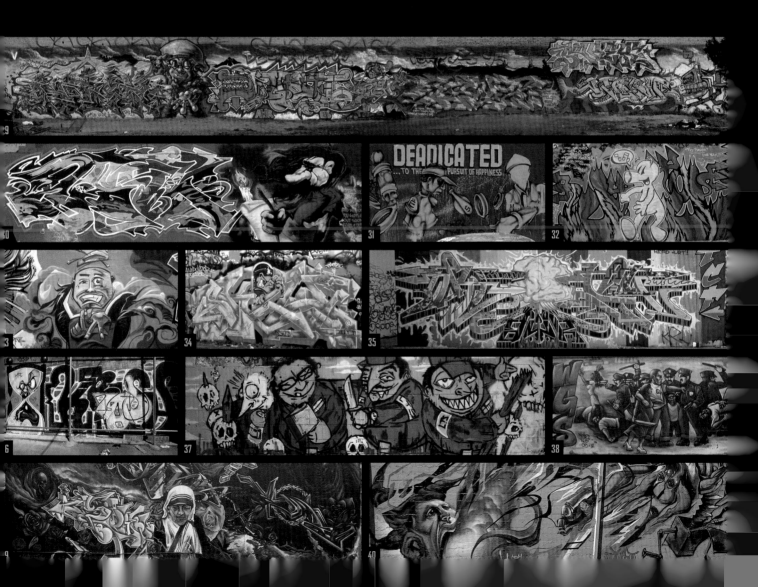

AFTERWORD

Graffiti culture is a fascinating world, which runs at once parallel with and on the outskirts of society. It has been a great pleasure to be able to speak at length with some of L.A.'s most prominent and infamous writers, some of whom had never been interviewed. They were open with me regarding their views and the telling of this story would not have been possible had it not been for their participation. I enjoyed meeting the wide variety of personalities involved, each artist reflecting not only their own personal development, but the cultural influence of the specific areas they grew up in, along with the collective imprint of Los Angeles itself. Artists from the East Side, West Side, North West, South Side, Valley areas, and down to Orange County all made significant contributions to L.A.'s evolution. I believe I understand my own city better for having been involved in this endeavor. The verve and dedication that the best artists show serve as an inspiration to those involved in any creative process. Who would have thought that when this form of graffiti began more than thirty years ago, it would develop into the international phenomenon it has become. I look forward with excitement to see what the next generations develop.

VISIONS CREW (detail), East L.A. 2005

CREWS AND ROLL CALLS

There are many more crews in Los Angeles than are listed below. Some are not on the list because they are primarily tagging or bombing crews, and this book has focused on crews that include piecing. Some newer crews are also not included. Not all crews are listed with starting dates or have incomplete or missing roll calls. In any event, roll calls often border pieces, so look and you may find them.

ACTIVE CREWS

AWR (All Writes Reserved, Angels Will Rise, ArtWork Rebels) 1988, and MSK (Mad Society Kings, Minds Seeking Knowledge) 1989. The borders of these crews are blurred enough to put the list together: Eklips, Baba, Fuse, Sharp, Delta, Side, Combo, Sight, Krush, Coax, Revok, Gkae, Sever, Saber, Phyn, Retna, Keyes, Norm, Amandalynn, Ewok, Mque, Mr. Cartoon, Chunk, Trigs, Pysa, Grime, Bles, Mystic, Rime, 2 Tone, Pure, Hense, Heyn, Wise, Fate, Zes, Aloy, Buds, Kick, Tribe, Toomer, Dame, Stormie, Push, Else, Reed, Traver, Screw, Hazen, Crises, Phable, Reckin, Cyde, Wanto, Sect, Kress, Alert, Sist, Lier, Path, Oxrox, Jaco, Keser, Bus, Brace, Booh, Just195, Shiver, Myte, Sumet, Tyke, Rich, Buck50, Agua, Resume, Risk, Vision, Selfish/Self/SE One/Thesis3, Gusto, Ceaze, Steel, Hael, Rebel, Rage, Lone, Lapse, Havok, Chico, Bruin, Grave, Bugs, Brock77, Excel, Earsnot

Bashers was founded in 1991 by Maxx, Trek, and Steven. Emuse, Asher, Rg, Craola, Glory, Konker, Deph, Steam, Koed, Menso, Devi, Setel, Dulock, Uzay, Blue Star, Reverend, Koi, Spine, Cook, Same, Mantis, Sae, Slayer, Emuse, Asher

CBS (Can't Be Stopped, City Bomb Squad), founded in 1984 by Hex. Skate, Rob One, Nace (R.I.P.), Perk, Meck, Anger, Axis, Tren, Duel, Strip, Azer, Phever, Posh, Simple, Natoe, Epik, Tyer, Circus, Xist, Deas, Aura, Esel, Potna, Vox, Atlas, Kasl, Crayola, Split, Mers, Chip, Unit, 1987, Bleek, Quake, Leks, Use, Defy, Pastime, Bizar,Toper, Met, Speakeasy, Nic Nac, Haste, Sram, Clown, Skeg, Plek, 2Shae, Dytch, Augor, Neko

COI founded in 1989 by Sacred, with Séance, Flask, Suet. Man, Oiler, Dcline, Marka27

DCV (Def Crown Vets) founded in 1988 by Fear, Bellfower/Cerritos center. Dove

D2R (Down To Rock) Dseaze, Mers (not the CBS Mers), Ween, Eyons, Lyfer

GAW (Ghetto Art Warriors) Midst, Jerk, Moz, Cruz, Duce, Brek, Gumz, Skerp, Motel

I2W (In To Win)

K4P (Kill For Pride) 1988–89 Jack/Dante (of STN), Worry, Steel, Sleak, and early generation also included Neask, Mesk, "all retired one way or another." Second generation: Zuco, Biser, Sims, Mezzo, Crae, Dsrup, Noek Pin, Cache, Exalt

KOG (Killer Of Giants) founded in 1992 by Siner. Fishe, Sloth, Dreye, Arby, Mutes, Futur, Esque, Stae, Versuzs269, Rask, Yikes, Taboo, Exile, Kyles, Korea, Ratas, Kub, Wisk, Senem, Kreads, Ased, Klean, Kryst, Jher 451, Jams

K2S (Kill To Succeed) 1985: Crime/Rick, Prime, Cartoon (not Mr. Cartoon), Defer, Sine, Skept, Relic, Slick, Catch, Heaven

LAW (Los Angeles Writers)

LOD (Loks On Dope) 1988: Hex, Sleez, Mosh, Volt, Tempt, Chris, Toe, Joe G, Panic, Size, Chaka, Wisk, Lest (R.I.P.), Stanz, Cab, Oil, Hael, Skate, Colt45, Duster (from N.Y.), Precise, Fever, Unit, Poncho, Skept

LTS (Last To Survive, Last To Serve) 1987: Sane, Mark 7, founders. Siner, Riot, Made, Russ, Disk, Reveal, Aybon, Klean, Locus, Verse1, Jimer, Brail, Jesk, Jiec, Dreye, Fish, Kyle, Arby, Verse (R.I.P.), Rats, Temer, Sroek, Cre8, Demer, Yeski, Kat, Pysa, Zes, Jrock, Swae, Ayer, Ink5, Focus, Rusty, Swift, Maedae, Shae

NTS (Notorious, Never Take Second)

OTR (On The Run) founded by Price, Dex, Odie, Regie, Drew in 1985. Size, Kade, Odie/Volt, Mosh, Eler, Nex, Exam (R.I.P.), Screen, Sleez, Prell, Joust, Sure, Like, Hael, Kane, Gaze, Tar, Tore, Busk, Tame, Problem, Real

PDB (Please Don't Buff) '93, Turn and Spurn founders, with Arco, Ruet, Esque, Haboh, Regis, Gush, Slay, Ewso

RF (Rapid Fire) 1996: Clae, Dye, Trixter, Kofie, Tyer, JoJo, SGP, Skeg

RTN (Rocking The Nation) 1989: Cre8, Choice, Flex 2, Wiser, Aces, Demmer

SH (Seeking Heaven, Sky High) 1989: Dre, Precise, and Acme, founders. Panic, Bash, Size, Asylum, Swank, Ware, Soph, Siren/Ax, Fene, Kero, Cloud9/Odin, Jast, Dcline, Pride, Brief, Dmise, Redge, Quest, Relic, Eye, Modem, Mel, Cisk

SKA (Still Kicking Ass, Spray Kan Artists) '88 Pryer and Toxic, founders. Phib, Aloy

STN (Second To None) 1985: Founders Make/Time, Sine, Doc 43. Tempt, Relic, Cash, Comic, Defer, Teler, Sketch, Repo, Baba, Eye

TKO (TaKingOver) Toomer, Zerk, Duem, Jelous, Lyfer, Tribe, Do, Guer, Perl, Fusha, Evol, Hael, KE42, Kosh, Colt45, Resq, Asper, Sesto, Adek, Dut, Empire, Kast, Zoueh, Iksoe, Odds, Semi, GS1, Doner, Stash, My1, Jinx, Syek, Sega

UCA (Under Cover Artists) 1985–86: Chase, founder. Earn, Besk, Czer, Teler, Stag, Size

USC (UnStoppable Criminals, Use Superior Creativity) founded in 1986–87. Hert, Render, Mose, Drue, Toons, Debel, Desek, Sier, Silk, Aiz, Juise, Kranerr, Raise

UTI (Under The Influence) was founded in 1986. First Wave, mid 80's & up: Skill, Swanist, Snap, Nuke, Dash, Ghost, Flash, Omega, Smurf, Theme, Crisis, Master, Maniak, Monter, Flex, Seltick, Reos, Mural, Angst, Luthos, T-Spoon, Skez, Shone 64, Panic, Phooe, Nue, Thiser, Basen, Blinky, Sener, Resen, Scene, Spek, Sole, Feer, Freek, Erny, Pride, Order, Plast, Design 9 The Mad Dreamer, Rome, Rike, Kid Krael, Rock, J-SKI, Dino, Drex, Creatore, Dmise, Hush, Pest, Shot 47, Econ 2001, Dizzy, Fene, QVO, Loki, Griff, Kazoo, Jes. Griff (Honorary Member Via Skilly), Never (Old School). Posse: Count, Quest, Scoob, Tiny, Scrappy, Ski. Second Wave, mid 90's to current: Chee, Kwite, Woez, Dove, Fear, Pistol45, Frak, Selek, Pryer, Fuss, Deal, Reel, Phib, Resist 122, Raso, Italo, Rick, Steam, Thus, Boosm, Vade, Kofie, Joex2, Gacha, Clay, Dye5, Minto, SGP, Pale, Twelv, Moka, Phixer, Ferno, Chill, Tool, Mutual, Nic Nac, Oil, Dotie, Brief, Bruin, Sector, Chico, Miles, Rob One, Plek, Swab, Thanx, Kaper, Budget, Serch, Never, Resl, The Mac

VC (Visions Crew): Keo, Ekura, Spice, and formerly Scud and Wram

VT (Visual Team) Kofie, Crayola, Swank, Axis, Twelv, Vyal

WAI (Wild Art Images, Wild Ass Images) 2Shae, Plek, Reds, Potna, Gozer, Crayola, Sram, Deas, Speakeasy/Spe

WCA (West Coast Artists) founded in 1985 by Risk, Rival, Pjay, Miner, Cooz. With Rak, Sed, D-rock, Design, Ace, Cazar, Tane, Piro, Peno, Flame/Mr. Cartoon, Wisk, Delo, Mec Ser, Mear, Skate, Slick, Power, Vision, Jimbo, Severe, Vice, Brisk, C-jay, Vulcan, Bates, Raide, Create, Cool Boy, Dye, Ash, Soon, Mist

WGS (We're Going Skating, We Got Skills, We Got Soul) WGS founded with Vox, Chemist in 1993. Sherm, Czer, Rukus, Moon, Serk, Page, Grism, Savager, Phorm, Epik, Trus, Fred

W247 (Working 24/7) Gabe88, Felon

SEMI-ACTIVE CREWS

AM SEVEN (Amidst Majority's Garbage ["G" being the seventh letter], Angels of Madness Seven [days a week], All Mediums Seven): Krenz/Yem, founder in 1990, and presently members more active outside of L.A. Thesis 3, Tacks, Besk, Make, Peak, Bamps, Hefner, PM, Revok, D'ger, Dew, Pen, Dae, Sever, Dunze, Net1, Ceaze, Daoh, Pher, Nick, Brace, Haze, Sundae, Kare, Zouh, Ounze

BC (Burning Competition, Blue Crew) 1987: founded by Wisk, Clae, Dye, Ash

ICR (The merged initials of In Control and Civilized Revolution crews): Pure, Jero, Cress, Poops

KSN (Kings Stop at Nothing, Kids Stop at Nothing) 1985: Rise, Dread, Rev, Sire, Phyn, Wise, Sooz, Relm, Grem, Rage, Krush, Grave, Cano, Eklips

MAK (Modern Art Kids) 1985: Biser, Mandoe, Neo, Definer, Skeo, founders.

NASA (No Art Survives After, Nasty Artists Strike Again): Kerse, Rich One, Just195, Chimpione, YT

SCRA (Southern California River Assassins): Deas, Vade, Budge

TPS (The Private Sector, The Philly Style, Troopers, The Phat Shit) 1992: JoJo, founder. Kofie, Gatcha, Trixter

INACTIVE CREWS

AIS (Artists In Style) 1983: Jero, Duke, Jack (not the STN Jack)

BFM

DEF (Doing Everything Fresh): Clever, Mr. Cartoon

DP (Def Productions): Odin, Dazzle, Joke

DTK (Down To Kill, Damn Those Kids) 1985: Charley, Blinky, Frame, Genius

DV (Double Vision) 1984: Presto, Blast 69, Scandal, Deeco, Sarde

GFA (Graffiti Force Artists) 1984–85: Grem, Plex, founders.

KGB (Kids Gone Bad) 1984: Skept, Some One, Syte, Skan, Craze, Mach5, Jake, Hyde, Defer

LABS (Los Angeles Bomb Squad) 1984: Crime/Rick, Shandu, Primo Dee, Risco

MGA (Master Graffiti Artists) Scribe

MGM: Scribe

OOCA (Out Of Control Artists) circa 1984: Rage, Wise, (founders). Nyse/Ozone

PET

RTA (Rapid Transit Artists)

SMD (Smoking Much Dust, Suck My Dick): Dream, Green

STP

TCF (The Chosen Few) 1985: Wise and Rage, founders, Nyse, Mystic, Booh, Surf, Fever

TCS (Tough City Squad): Skate

TWA (Today's Writing/Wicked Artists) 1985: Geo

UFK (Us Five Kings/Us Fucking Kings/Un Foreseen Knowledge/Uzis For Kids/Ultra Fat Kaps/Us Fierce Kannibals) founded in 1988–1989 at Woodman yard: Pure Kaze/Ganas Lurk Else, Jero, Grim, Bash, Emmer

UNT (Untouchables) circa 1989: Sleez, Mosh, Volt, Same, Hex

VOB

WCK (West Coast Kings), a select short-lived mix of what was supposed to be the best of WCA and KSN)

YL (Young Lords) 1985: Soon, Legit, Risk, J-cool, Max 1000

YR (Yard Rats): Use, Esk31, Ser, Betl, Laps, AR, Ozie

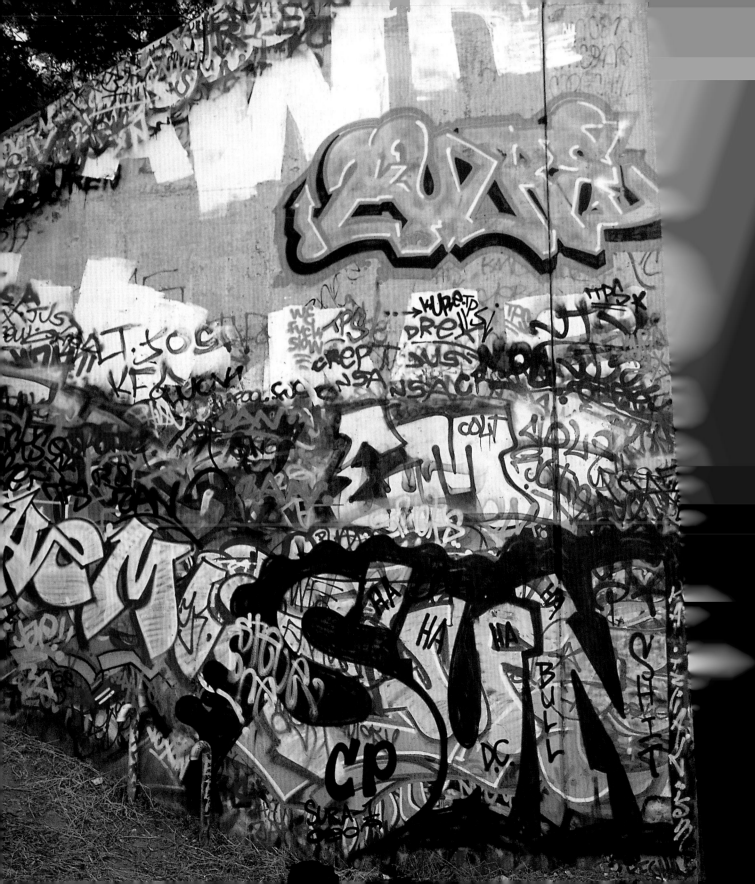

GLOSSARY

all-city (n/v): to tag, bomb, and piece across the city beyond one's neighborhood

battle (n/v): A contest of piecing abilities between crews or individuals. To participate in a contest of piecing ability.

b-boy (n): a break-dancer

bite (v): to copy or plagiarize someone's style

bomb (v): to prolifically do illegal work

border (n): a line that surrounds the entire piece

buffed out (adj): covered with a single color of paint, either as graffiti abatement or as preparation for a piece

burn (v): to do better than the competition

burner (n): a superior piece

bust (v): to do (usually) piecing work

can control (v/adj): control of the paint

cap (v): to disrespect another writer's work with spray paint

catching tags (v): the act of tagging

characters (n): a rendering of humans, animals, or fantasy figures

cholo (n): a Latino gang member

coin (n): an old-school term for 3D edging derived from the lined edges on dimes and quarters

connections (n): the blending of modified aspects of letterforms for aesthetic purposes

cracks (n): faux cracks on letter surfaces

destroy (v): to do something extreme

diss (v); dissed (adj): From "disrespect." To deface another writer's piece.

down (adj): 1. Committed. 2. To put you down: To let you join.

dripper (n): a tag with deliberately dripping ink

(including previous page) Tunnel at Motor yard, 1995

dust tags (n): a tag in the available surface dust created by using a finger

fade (v): to blend a color transition smoothly

fat cap (n): either a spraycan tip that makes a wide spray, or a physically fat spraycan tip that allows for a crisp, controlled line

fill (n): the area inside letterforms

flicks (n): photographs. flick (v): to photograph

flip the script (v): to alter, modify, or abstract letterforms

fool(s) (n): Guys, rascals. May or may not be derogatory according to context

getting up (v): the act of doing graffiti in any form, usually illegally

half-stepping (v): half-heartedly

hand style (n): a stylish tag

hangover (n): a tag, perhaps on a freeway bridge that is accessed by hanging over the edge.

heads (n): People. Not to be confused with 'pothead,' as used in the 1960s.

heaven (n): a tag or piece on a spot that requires climbing

hooked up (adj): Stylishly or complexly done; (v): To make stylish or complexly done.

jock (v): to ride too closely, as when a writer finds a new spot and suddenly others are trying to write there as well, bringing unwanted attention

kill (v): to do extremely well

king (n): a graffiti writer at the top of their craft

landmark (n): a spot that is obscure or difficult to access that may remain for a long time

line (of bus or train) (n): a particular route on which a tagger may pay special focus

legal beagle/eagle (n): a writer who only creates legal pieces

mobbers (n): a group of kids who tag a bus in a group

new jack (n): a newcomer

O.G. (adj): lit. "original gangster," but in graffiti circles simply means a writer from the early days

outline (n): the "sketch" of a piece, or a line that clearly denotes the outside edges of the letterforms

over-spraying (n): spray paint that spits out of overly pressurized cans

phantom cap (n): a term for a spraycan tip that makes a thin line

piece (n): A graffiti mural of at least moderate complexity. Short for "masterpiece".

production (n): a mural involving more than one writer, usually with images or a background unifying individual pieces within the mural

rack, racking (v): Stealing. Derived from "taking it off the rack."

rock (v): Synonymous with "bust." To do piecing work.

roll call (n): a list of crew members that may accompany a piece

scribe (v): to tag something by scratching or etching with a hard or sharp object

side-bust (v): to paint right next to a respected artist's piece to give the appearance of being associated with that artist

steez (n): style

stock tips (n): the factory-issue tip on standard spray cans

tag (n/v): A writer's name. A writer's name done calligraphically. To put up your name.

throw-up (n): a quickly outlined simple letter form, often, but not necessarily done in "bubble" style

tight (adj): well executed

toy (n): one who lacks skill, understanding the unwritten rules of the game, or both

whips (n): calligraphic forms that peel off of letters

wildstyle (adj): graffiti technique using highly complex, intertwined, and modified letterforms

'zine (n): fan magazine, graffiti magazine

RESOURCES FOR FURTHER READING AND VIEWING

50mmlosangeles.com

artcrimes.com

Crewest.com

graffitiverite.com/
cb-cholowriting.htm

guerillaone.com

Infamythemovie.com

jerseyjoeart.com

TheSeventhLetter.com

seymourpaint.com

Freight Train Graffiti by Roger Gastman,
Darin Rowland, and Ian Sattler

Painting the Town by James Prigoff
and Robin Dunitz

Walls of Heritage, Walls of Pride by James
Prigoff and Robin Dunitz

RESOURCES ON ARTISTS

asylm.sh

crewest.com

ICUart.com

keepdrafting.com

lostmag@yahoo.com

michaeldelahaut.com

relic1.com

Retna.com

revok1.com

saberone.com

stylepig.com

swanky.sh

PROPS AND SHOUT-OUTS TO: Jim Prigoff, who pushed me to do this project; Roger Gastman, whose insight and advice made this a much better book than it otherwise would have been; Michael "Wise" Delahaut for his help and expertise; Mandy Patinkin and Kathryn Grody-Patinkin for invaluable material assistance and encouragement; Ingrid Lilligren for being the sweetest part of my life; Harry N. Abrams, Inc. and Jon Cipriaso for editing; and Jenn Cash for layout; Jeff Atherton and Paul "Hurricane" Schaeffer for beyond-the-bounds generosity with their expertise; Nuke and Joe Connolly for contributing to the CD-Rom; and of course the artists who contributed each of their own perspectives, including Rick One/Crime, Chaz Bojorquez, Shandu, Sherm One, Swank One, Eklips One, Prime, Krush One, Kofie One, Jelous, Siner, Stash Maleski, Grave, Relic One, Saber One, Besk One, Baba, Tyke Witnes, Neo One, Zuco, Plex One, Wise, Man One, Cre8, Aloy, Phib, Acme One, Teler One, Jero, Anger, Big 5, Revok One, Zes, Retna, Size, Make, Vox, Panic, Fear, Dove, Atlas, Asylm, Toons One, Risky, Toomer, Yem, Gkae, Glory, Drew, Arco—you guys made the book come alive.

PHOTOGRAPH CREDITS: Courtesy of Blades Bojorquez: 10, 119; Courtesy of Michael Delahaut: 20–21, 23, 24, 25, 32, 33, 35, 108, 109, 245; Courtesy of Eklips: 29, 118, 120, 133; Courtesy of Roger Gastman: 203; Courtesy of James Prigoff: 26, 39; Courtesy of Rick One: 84; Courtesy of Skept: 26, 116, 212 top; Sketch courtesy of Toons One: 60; Sketch courtesy of Tyke Witnes: 60; Courtesy of Yem: 184 bottom

For further information about this book, go to **GraffitiLA.com**

INDEX

Page numbers in *italics* refer to illustrations.

Editor: Jon Cipriaso
Designer: Jenn Cash

Library of Congress Cataloging-in-Publication Data

Grody, Steve.
Graffiti L.A. : street styles and art / by Steve Grody ; foreword by James Prigoff.p. cm.
Includes index.
ISBN-13: 978-0-8109-9298-6 (hardcover)
ISBN-10: 0-8109-9298-1 (hardcover) 1. Street art—California—Los Angeles.
2. Graffiti—California—Los Angeles. I. Title.

ND2638.L67G76 2007
751.7'30979494—dc22
2006035442
Text copyright © 2006 Steve Grody

Illustrations/photographs copyright © 2006 Steve Grody, unless otherwise indicated
in Photograph Credits

Printed and bound in China

10 9 8 7 6 5 4 3 2 1

HNA
harry n. abrams, inc.
a subsidiary of La Martinière Groupe

Harry N. Abrams, Inc.
115 West 18th Street
New York, NY 10011
www.hnabooks.com